D1071693

Race and Vision in the Nineteenth-Century United States

Race and Vision in the Nineteenth-Century United States

Edited by Shirley Samuels

Introduction by Shirley Samuels

LEXINGTON BOOKS
Lanham • Boulder • New York • London

Published by Lexington Books
An imprint of The Rowman & Littlefield Publishing Group, Inc.
4501 Forbes Boulevard, Suite 200, Lanham, Maryland 20706
www.rowman.com

6 Tinworth Street, London SE11 5AL, United Kingdom

British Library Cataloguing in Publication Information Available

Library of Congress Cataloging-in-Publication Data Available

ISBN 978-1-4985-7311-5 (cloth)
ISBN 978-1-4985-7312-2 (electronic)

Contents

PART 2: DEMOCRATIC VISIONS

List of Illustrations

Acknowledgments

For the most part, these essay writers only "met" each other through the process of developing ideas for this collection; I am grateful for their feedback as we developed the volume into its present form. I am very happy to acknowledge the assistance of Philippa Chun, who worked with me on the final revisions and image permissions for each essay. Several of these essays initially appeared in two forum sections that I edited for the journal *J19: A Journal of Nineteenth-Century Americanist*s. These selections have been revised since their initial publication in that journal. The earlier versions of the essays from Christine Yao, Irene Cheng, and Jennifer Greiman appeared in Volume 3:1 (2015), pp. 121–130 and pp. 130–137, and Volume 3:2 (2015), pp. 421–428. They are reprinted with permission of the University of Pennsylvania Press.

Introduction

Shirley Samuels

The contributors to this collection of essays, *Race and Vision in the Nineteenth-Century United States*, visualize the appearance of racial categorizations in alternately democratic and anti-democratic cultural projects. Organized into two sections, "Articulate Spaces" and "Democratic Visions," these essays analyze how authors, artists, musicians, architects, politicians, and scientists groped toward a democratic surveillance of how bodies can appear in public. Bookended by the architectural visions of the author of the "Declaration of Independence" and the controversial images of Kara Walker, the essays in *Race and Vision* present new attention to the range of forms in which visions of race and democracy appear.

The fraught relation between race and vision in the United States appears as early as the eighteenth-century political cartoons that portray the continent as a Native American woman besieged by the attention of white European men who seek to subdue her.[1] But such pictorial modes of identification did not have the same persistence as the identifying strategies in the project that the controversial ethnographer Louis Agassiz undertook in the early nineteenth century to photograph for signs of racial difference.[2] Writing in the late eighteenth century, Thomas Jefferson used the visualizing of racial difference in *Notes on the State of Virginia* (1785) to justify the practice of slavery in terms of a relation between visual difference and affect. These historical items appear to contradict how, in his overview of such codifying relations, the critic Stephen Best refers to the "emptiness" of the "visual archive of slavery."[3]

The archive of slavery does contain provocative images that appear in novels and autobiography, especially in the illustrations to such controversial works as Harriet Beecher Stowe's *Uncle Tom's Cabin* (1852)—which famously showed the character Eliza crossing to freedom on precarious ice floes

1

on the Ohio River—and in such celebrated works as the several versions of Frederick Douglass's autobiography (1845, 1855, 1881). The scene presented by Douglass where he recalls watching as a child the beating of his aunt Hester by a white man, in a jealous rage has become infamous as the "blood-stained gate, the entrance to the hell of slavery." The scene had become so often re-ferred to that in her influential book *Scenes of Subjection: Terror, Slavery, and Self-making in Nineteenth Century America* (1997), Saidiya Hartman called for a moratorium on quoting from that scene of horrified witnessing.[4]

The scene to which Douglass refers contains the sound of violence as well as the sight of suffering. As a kind of rebuttal to the position set out by Hart-man, the scholar Fred Moten has twice returned not only to the scene but also to the ways that Hartman understands it visually. He argues for the impact of sound rather than sight in his recent *Black and Blur (consent not to be a single being)* (2017) and the earlier book *In the Break: The Aesthetics of the Black Radical Tradition* (2003). In the preface to *Black and Blur*, Moten discusses the relation between "*performance* and *object*" [nouns in italics].[5] Provid-ing a genealogy of how to look at bodies in conditions of race in the United States, he refers to the field-defining essay by Hortense Spillers, "Mama's Baby, Papa's Maybe" as it elucidates how the conditions of slavery insist on a "theft of the body."[6] Writing both with and against Saidiya Hartman, Moten uses her account of how (not) to read Frederick Douglass to open both books.

In the first book Moten explicitly defies Hartman—and reproduces the en-tire scene, reprocessing what might be seen in terms of what Douglass might have heard that night. The very prohibition seems to serve as an incitement. Yet Moten seeks both to reproduce the scene and to revise its impact with a focus on sound instead of sight. As he puts it, in *In the Break*: "Between look-ing and being looked at, spectacle and spectatorship, enjoyment and being enjoyed, lies and moves the economy of what Hartman calls hypervisibility." Posing the question of impact as auditory or visual, Moten argues for sound.[7]

What has been called the long nineteenth century in the United States codi-fies race in terms of both vision and sound. From the minute spaces of musi-cal notes on a page that contains small dancing figures to the larger spaces of statues and pediments, these essays notice how the performances of race in sound and visuality appear together. The mapping of the larger space of the nation in relation to the architecture of the home has a racial significance as well. In *Picture Freedom: Remaking Black Visuality* (2015), Jasmine Nichole Cobb argues for attention to the "archive of Black visuality."[8] Cobb calls slavery "A Peculiarly 'Ocular' Institution" and invokes the "white ontology of the gaze." Examining the features of the house, Cobb refers to the parlor as a dominant element in the domestic architecture of the middle-class home, and yet she asserts that the concept of the "parlor fundamentally contradicted

the lives of Black women in the context of slavery."[9] That architectural detail, the insistence on a domestic space that appears to exclude inhabitants, might be seen as the bridge between the ways that the house speaks to race as at once a visual and an auditory preamble to its inhabitants.

To inhabit the United States in the nineteenth century, whether in a house, a field, a city, or a state, those who would be citizens work to become visible. While attention to the technology and effects of photography preoccupies me in the first half of this introduction, the second half turns to how the essays in this collection present several other dimensions, including the three-dimensional imaging of stereoscopes, the representation of race in sculpture, and the scope of political cartoons. How to develop an awareness of particular spaces that might have been seen as neutral in racial terms includes, for instance, the first essay's attention to the gridding of new states.

The provocations to what might be called the geometry of cultural geography appear throughout to express the dimensions of matters such as race and sexuality that are at once visual and topological. Here a landscape of relations appears, relations that are not always visible through the first operations of sight, but that become apparent through their persistence in space and time. As the first essay shows, through an examination of how Thomas Jefferson wanted to grid the spatial and political presentation of the early United States, the operations of a geometric approach to geography are not free from a desire to control the relations of bodies in space. To display the relations of racialized culture and democratic vision in the nineteenth-century United States always involved images. From the engravings of presidential faces circulated in newspapers to the broadsides of recruiting posters in war times, from the circulating *cartes-des-visites* that carried a simulacrum of identity through the newly developed technology of the photograph to the portrait paintings of Mary Cassatt and Thomas Eakins, from the crowds lined up to view the statue of "The Greek Slave" to the circulation of coins and stamps, the relation between particular representational images and the mass commodification of portraits has made for a recognizable trade in visibility.

Inhabitants of the nineteenth-century United States became accustomed to images in public display in ways that make the relation of imaging technologies and modern identifications of the subject inescapable. This collection of essays exposes how concepts of identity and race were conveyed by imaging technologies in architecture, paintings, scientific discourse, sheet music, theater, and, finally, through a twenty-first-century visual commentary on racial practices of the nineteenth-century United States. Throughout these essays, the juxtapositions with literary practice involve some of the best-known writers, such as Herman Melville and Harriet Beecher Stowe, as well as the technologies of performance involving theater and music.

Scholarly work on photography has taken ideas about images into the realm of critical theories of vision, technology, and the production of racial discourse. Such critical investigations as those carried out by Marcy Dinius, Shawn Michele Smith, and Laura Wexler have begun to expose the intractable interest in combining the surface of an image with ideas about American identity.[10] Recent work on Frederick Douglass as the most photographed American of the nineteenth century has begun to expose the extent to which the combination of an image that can circulate and the profound consequences of manufactured celebrity might overlap.[11] That self-fashioning through photography might be a compelling way to imagine the presentation of race and celebrity suffuses images of whiteness as well as the otherness imagined to attach to racialized identities in the period.

What was once imagined as a process that skinned the surface of the visible world, an activity that Oliver Wendell Holmes memorably described as the practice of photography, also emphasized what one sees at the surface of the skin. The relation between seeing what occurs at the surface and understanding how surface images might produce a model of identity appeared very early. Some overlap and confusion between the surface that can be viewed and the eye that views emerges in one of Holmes's evocative examinations of how the development of photography changes the idea of a body. He notes the change photography makes in memory, alluding to the mirrored surface of the daguerreotype as capturing a sight that earlier meant that "The man beholdeth himself in the glass, and goeth his way, and straightway both the mirror and the mirrored forget what manner of man he was."[12] To see a reflection that vanishes, a self-imaging provided by the mirror that appears to have both memory and cognition, was forever challenged by photography. The development of imaging technologies produced a new kind of remembering and transformed the idea of a subject by fixing the image to the glass, so that the man in the mirror remains when the body departs. This uneasy fixing of identity, at once temporal and permanent, became a nineteenth-century preoccupation that continues today.

Describing the daguerreotype as a "mirror with a memory," Holmes expressed fascination with an invention that he found changed the nature of the world (129). Later twentieth-century commentators, such as Susan Sontag and Roland Barthes, continued to find in photography an emotional shift in how subjects encounter both the world and themselves. For Sontag, in *Regarding the Pain of Others*, the intimacy with death expressed by the camera in the nineteenth century emerges as an ambiguously manipulative way to fix moments of battlefield horror. In *Camera Lucida*, Barthes reacts to a photograph of an assassin in terms of his impending death and famously describes the relation between "studium" and "punctum" as a way to discriminate be-

tween the effect of photography that lingers or that pierces, fixing spatiality and temporality to the moment of looking at the image.[13]

As he presents a philosophical understanding of how the emergence of images heralds an archive newly to be developed, Holmes continues, "*Form is henceforth divorced from matter*. In fact, matter as a visible object is of no great use any longer, except as the mould on which form is shaped" (161). His prescient account of photography's influence asserts that "Men will hunt all curious, beautiful, grand objects, as they hunt the cattle in South America, for their skins, and leave the carcasses as of little worth." Emphasizing the position of archives in shifting the text on which the world is inscribed, Holmes continues: "The time will come when a man who wishes to see any object, natural or artificial, will go to the Imperial, National, or City Stereographic Library and call for its skin or form, as he would for a book at any common library" (162). Given his invocation of the value attached to images stored as though they could be checked out like books in a library, Holmes did draw a limit. After viewing corpses on the battlefield as he searched for his son, Holmes finds that the photographs of corpses, often produced as stereographs, that emerged from Mathew Brady's studio made him want to bury the images, "as we would have buried the mutilated remains of the dead they too vividly represented" (12).[14]

The representation of corpses has an indelible origin in the earliest photographs of family members photographed in death to be preserved in the home.[15] As well as investigating archives, this collection addresses the technological shifts that made attention to vision a crucial index of both modernity and subjectivity in the nineteenth-century United States. These assertions do not overlook, for example, the delicacy of the lyric voice as implicated in the world of vision, but rather ask, once photography has emerged on the page as a means to reproduce sight, whether the format for establishing an intimacy between reader and viewer depends on language or on sight. Some of the essays show that a world constituted through questions of visibility privileged whiteness. Even the surface of the page raises the question of how images reflect readers, as the daguerreotype once reflected the face of the viewer. The tarnish on the surface of the daguerreotype, as one essay suggests, includes an idea of patina. That is, a physicality of vision that mimetically appears as the residue of the story of the object might be understood as inherently present (as adhesive formation) even as the gaze of the viewer becomes part of that residue.

The idea that a representation of identity involves the human subject identifying racial signifiers in sculpture, architecture, and painting as well as photography hints at the ways that the viewing subject brings a preconception of race and ethnicity to the moment of viewing. Jonathan Crary once claimed

about the 1850s that they reconfigure "relations between an observing subject and modes of representation"; by this view, the development of photography "effectively nullifies most of the culturally established meaning of the terms observer and representation."[16] His reaction, much like that of Oliver Wendell Holmes more than a century earlier, includes attention to the problem of the body. Crary proposes that "the body, including the observing body," has become "a component of new machines" and, relatedly, that subjectivity has become a "precarious condition of interface" with such technologies.[17] The essays in this collection resist as much as they engage subjectivity as a fixed entity. The shifts that involve race become particularly significant. To read the essays collected in *Race and Vision* is to find bodies produced as political entities in the overlaps between photography and other arts.

These essays also introduce the mechanics of sound, the movement of bodies on a stage and in dance, and the acts of witness engaged in by audiences up to and including the recent spectacle of commodity consumption as art displayed when viewers lined up in Brooklyn to see Kara Walker's "A Subtlety," with its invocation of sexualized viewing practices in the nineteenth century. The exposure of bodies to the viewing audience leads to questions about race and visibility that we have only begun to consider. That is, the relation of sight to literary culture is not static, nor, of course, limited to the nineteenth century, and these essays remind us to watch out for the effects of the visual production of bodies.

The first section, on "Articulate Spaces," configures attention to space through looking at architecture and landscapes, including the landscape of the stage. This section opens with an essay by Irene Cheng that takes us to a familiar location, Thomas Jefferson's Monticello, to ask about how architectural design might invoke racial visions. The essay proposes that readers investigate the idealized form of the human body in relation to the structure of the octagon as a desired architectural model. And it asks how this model might further conceal and expose a relation to racial ideology in spatial concepts such as the mapping of the territory of the United States into grids.

Continuing the attention to landscapes, Wyn Kelley's essay on the relation between photography and Arctic vistas considers the *Arctic Regions* paintings of William Bradford alongside Herman Melville's late poem, "The Berg." Kelley suggests that the relation of arts like painting or poetry to photography often involves, and also questions, an interim position for the artist as physically present in the display of the artifact. Next, Brigitte Fielder considers how the movement of bodies might be constructed in an interpretation of how "the waltz and the march produce bodies in motion." The "event of the integrated ball" meant that the movement of bodies might result in competing forms of racial mixture and the essay vividly explores that anxiety.

In a polemical address to the questions of the visibility of race in art, Kelli Morgan addresses the complications of Edmonia Lewis's sculptures of emancipation in her essay. Thinking carefully about the effects of binocular vision on concepts of magical sight in the development of the stereograph, Cheryl Spinner looks at Holmes's essays on photography as well as his disturbing novel *Elsie Venner*. As she focuses on abolitionist political cartoons, Martha Cutter analyzes how the visual technologies of the illustrated newspaper coupled with the contingencies of slavery at once challenged and reified assumptions of blackness.

The second section, "Democratic Visions," turns to asking about how particular sights might engage statements about democracy. Adena Spingarn introduces the way that P. T. Barnum's museum staged *Uncle Tom's Cabin*, mingling curiosities with a critique of northern attitudes about race. Christine Yao's essay treats scientific racialism and the peculiar developments of phrenological readings of heads as it looks at Herman Melville's *Benito Cereno*. In the essay by Jennifer Greiman, the color green operates at once to suggest a patina on metal and to produce an extended riff on the translation of "*couche*" from Tocqueville's *Democracy in America*. It might mean a varnish, like the surface coating on a painting that you can see through, or a sign of wear and metallic decay. But as a sign of decay on valuable metal, for instance, the way that the copper coating on the roof of federal buildings turns green, patina has a different significance. For Greiman, as the "bluish-green that forms on the surface of oxidized copper or bronze," the green of patina evokes an extended investigation of how Melville's writing might align the color green and ambivalent feelings about democracy.

In looking at the sculptural frieze designed for the United States Senate, Kirsten Pai Buick proposes a reading of the sculpted commentary on nationalism in relation to embedded racial identities. The next essay, by Kya Mangrum, takes on how a compelling photograph enables commentary on the self-representation of Frederick Douglass. And the final essay by Janet Neary looks at Kara Walker's *8 Possible Beginnings* to think about the legacy of nineteenth-century slavery practices in visual terms.

Together these essays show a logic of propulsion rather than accretion in the new visions of the self, a vision at least partially produced by new technologies. The emphasis that the commentator Oliver Wendell Holmes once placed on photographs as a philosophical shift in human identity seems well warranted: "form is henceforth to make itself seen through the world of intelligence, just as thought has long made itself heard through the art of printing." To emphasize form suggests also a synaesthetic shift in perception as thoughts may be heard on a page that is held by the viewer, and forms are seen to convey the skin of the human in a way that the body of the human at once houses the eyes and the ways that vision lingers on the skin.

The delicacy of the lyric voice in Holmes's reactions is still implicated in the world even as the delicacy of the process of making portraits, a process he describes at length, is embedded in a logic of subjectivity and representation. The relation of language to vision that he proposes also engages the way that vision operates in relation to a sense of temporality. Threading through questions of temporality and the question of how to interpret moments might be an inquiry into what ways the matter of text overlaps (or not) with the text that says: this is what happens, this is when the photograph was taken.[18]

One of the most disturbing and compelling archives of nineteenth-century photographs I have examined is a series of albums assembled by and on behalf of the surgeon Reed Bontecue. These photographs of wounded soldiers were produced to illustrate forms of treatment for wounds suffered during the Civil War. In the case of the Bontecue photographs, the text inserted by the surgeon is interspersed with handwritten updates that say: lived, discharged, died of "exhaustion."[19] How do photographs produced during and after surgical treatment for bullet wounds act out the question of evidence? And, especially, for what are they evidence? Identity, treatment, location, or event? In each case, the style and texture of the event appears as a matter or insistence on recollection, re-inhabiting, re-living.

In foregrounding vision as a formatting of the racial as well as the democratic contracts of the nineteenth-century United States, these essays produce both a cultural contract and the contrast that vision makes with literary representation. The contract about vision that was slowly established in the nineteenth-century relation to the photograph involved a concept of reality and truth telling, a concept violated from the beginning through manipulations of depth of field, of focus, of scale. The possibility of double exposure meant that "spirit photography," for example, had a vivid and influential existence in presenting inchoate forms as images that enabled memories of the dead.

These essays present incidents and events that invoke both the contracts of race and the contracts of vision. Two examples could still be included here. The first is from the world of visual culture, and the second from literature. For the first, we might invite the appearance of the Haitian/Ojibwe sculptor Edmonia Lewis, who interposed her body between spectators at the 1876 Philadelphia Centennial Exposition who reportedly pushed her aside as they came to gaze on her 3,000 pound marble statue of Cleopatra. The large white marble body of the sculpted woman at once highlights and obscures the small body of the woman who sculpted her, whose "cartes-des-visites" images retain her identity. For the second, we might look at a novel like Harriet Beecher Stowe's *Dred*, which contains a scene that combines the sight of near-white children with the pathos of the mother who will kill them to keep them from being sold into slavery. *Dred* is infused with sentimental

pathos and yet the pathos sometimes distracts from the violent cruelty of the moments where women and children are hunted down or starved. These moments tend to be rendered off stage or mocked on purpose in "local color" exegeses of the faintly Shakespearean variety, rendering dialect and small heroism in the form of white lower-class characters whose status in the world of the novel remains lower than that of escaped slaves. The set pieces in the novel that involve legal matters of inheritance slowly flesh out the opening scene between a man and a woman who are in the woman's bedroom not for sexual activity—it turns out that they are brother and sister, after all—but to sort out receipts that have been turned into the apparatus of her fashionable appearance. Such a rendition of the economy of slavery literally embedded into the economy of the family stands behind the explications of vision that this collection presents.

What then is the relation between these concepts of visibility and the formation of the visible citizen? This topic appears in several recent works, such as Irene Tucker's *Racial Sight* and the work on race and identity by Anthony Appiah, especially in *Lines of Descent: Dubois and the Emergence of Identity*.[20] It also absorbs attention in recent collections such as the work on Frederick Douglass as the nineteenth century's most photographed human.[21] This collection of essays takes these questions further. Throughout the volume, questions rise about what democratic family might be seen in the process of becoming as matters of vision and technology coincide. The essays ask what identity can be given to the face or the idea of racial formation when it is acknowledged at once as fictional and as constructed. And they propose visual and written fictions of identity embedded on the law's doorstep. These essays bring the reader closer to the problematics of raced identities in the new visual and technological age of the nineteenth-century United States.

Attention to reproduction and representation in terms of race must be at once theoretical and historical when the field of study is the nineteenth-century United States. For example, the question of ethics remains when reproducing photographs that show dead bodies whether in battlefield debris or hanging on trees as a result of mob violence. Such sights provoke mourning rather than the gloating shown on the faces of white spectators, but those white faces must also be taken into account in attention to race and visual culture. The faces that belong to bodies on the battlefield, the faces that have been burned off among the savage fires of lynching, these can no longer look back from the long horrors of nineteenth-century violence. We can look back from the relative safety of a twenty-first century obsessed with vision and interpret as best we can what these unseen faces might have to say to us if they could open their eyes. The importance of focusing on fraught political scenarios from the nineteenth century is at once enhanced and mitigated by the sense that these stories have

not reached a conclusion.[22] The ghosts that speak from these images use something other than language in moments of recognition that we can neither see nor hear. In this collection of essays we begin to find language to approach the sounds they heard and the sights they saw.

NOTES

1. See, for instance, my reading of this archetypal scene in *Romances of the Republic: Women, the Family, and Violence in the Early American Nation* (New York: Oxford, 1996), 4.

2. For the difficult conjunction of race, visuality, and science in the nineteenth century, see Molly Rogers, *Delia's Tears: Race, Science, and Photography in Nineteenth-Century America* (New Haven, CT: Yale University Press, 2010). For further examples of early photography and African American identity, see Jackie Napolean Wilson, *Hidden Witness: African American Images from the Dawn of Photography to the Civil War* (New York: St. Martin's, 2000), Darcy Grimaldo Grigsby, *Enduring Truths: Sojourner's Shadows and Substance* (Chicago: University of Chicago Press, 2015), and Jasmine Nichole Cobb, *Picture Freedom: Remaking Black Visuality in the Early Nineteenth Century* (New York: New York University Press, 2015).

3. See "Neither Lost nor Found: Slavery and the Visual Archive," in *Representations* 113:1 (2011): 150–163. For attention to the visibility of race, see also, Tavia Nyong'o, *The Amalgamation Waltz: Race, Performance, and the Ruses of Memory* (Minneapolis: University of Minnesota Press, 2009). (The political cartoon of the "Amalgamation Waltz" has been treated by Martha Cutter.)

4. Saidiya Hartman, *Scenes of Subjection: Terror, Slavery, and Self-making in Nineteenth Century America* (Oxford: Oxford University Press, 1997).

5. Fred Moten, *In the Break: The Aesthetics of the Black Radical Tradition* (Minneapolis: University of Minnesota Press, 2003), viii, and *Black and Blur (consent not to be a single being)* (Durham, NC: Duke University Press, 2017).

6. Hortense Spillers, "'Mama's Baby, Papa's Maybe': An American Grammar Book," reproduced in *Black, White, and in Color: Essays on American Literature and Culture* (Chicago: University of Chicago Press, 2003), 152–175.

7. Moten, *In the Break*, 1. Staging encounters about sensory perception and race also appears in Jennifer Stoever's *The Sonic Color Line: Race and the Cultural Politics of Listening* (New York: New York University Press, 2016).

8. Jasmine Nichole Cobb, *Picture Freedom*, 19.

9. Cobb cites Paul Gilroy on "display and spatial belonging" and says, "I mobilize the idea of the parlor as a metaphor for thinking through projects of domesticity and domestication that take place through the visual culture of their interior space" (16, 17). See also, Erica Armstrong Dunbar, *Fragile Freedom: African American Women and Emancipation in the Antebellum City* (New Haven, CT: Yale University Press, 2008).

10. To interpret images as part of American Studies has become a vital field. For example, see Alan Trachtenberg, *Reading American Photographs: Images as His-*

tory: Mathew Brady to Walker Evans (New York: Hill and Wang, 1989) and Marcy Dinius, *The Camera and the Press: American Visual and Print Culture in the Age of the Daguerreotype* (Philadelphia: University of Pennsylvania Press, 2012). More recent work has developed the relation between visual fields and understanding how they determine ideas about race. See, especially, Shawn Michelle Smith, *American Archives: Gender, Race, and Class in Visual Culture* (Princeton, NJ: Princeton University Press, 1999), and Shawn Michelle Smith and Maurice Wallace, eds. *Pictures and Progress: Early Photography and the Making of African American Identity* (Durham, NC: Duke University Press, 2012).

11. John Stauffer, ed., *Picturing Frederick Douglass: An Illustrated Biography of the Nineteenth Century's Most Photographed American* (New York: Liveright, 2015).

12. Originally published in the *Atlantic Monthly* in 1859, "The Stereoscope and the Stereograph" was reprinted by Oliver Wendell Holmes in *Soundings from the Atlantic* (Boston: Ticknor and Fields, 1864), 125–126. Further references are in parentheses.

13. Susan Sontag, *Regarding the Pain of Others* (New York: Farrar, Straus and Giroux, 2003); Roland Barthes, *Camera Lucida: Reflections on Photography* (New York: Hill and Wang, 1981). Key writers on photography include Jonathan Crary, who, in *Techniques of the Observer: On Vision and Modernity in the Nineteenth Century*, asserted that the conditions for viewing photographically predetermined the emergence of its technology (Cambridge, MA: MIT Press, 1990). See also, James Elkins, *The Object Stares Back: On the Nature of Seeing* (New York: Harcourt, 1996). As his title suggests, Elkins becomes fascinated with objects that seem to look at the viewer. In *Burning with Desire: The Conception of Photography* (Cambridge, MA: MIT Press, 1999), Geoffrey Batchen extends Crary's fascination with photography's pre-conditions. See also Shawn Michele Smith, *American Archives*. Using a phrase from Judith Butler, Smith proposes that "the surface politics of the body" work to "establish social boundaries founded in the name of discursively naturalized interior essences," 4–5. See a further interrogation of violence and the image in Ariella Azoulay, *The Civil Contract of Photography* (New York: Zone Books, 2012).

14. For commentary on the problem of photographing the dead, see Susie Linfield, *The Cruel Radiance: Photography and Political Violence* (Chicago: University of Chicago Press 2012).

15. See the collection of Stanley Burns as held in the extraordinary Burns archive. https://www.burnsarchive.com/.

16. Crary, 1.

17. Crary, 3.

18. Given his investment in photography, a contradiction appears in the comments that Frederick Douglass makes about the impact of photography in his "Lecture on Pictures," given in Boston on December 3, 1861. According to Douglass, "Pictures, like songs, should be left to make their own way in the world. All they can reasonably ask of us is that we place them on the wall, in the best light, and . . . allow them to speak for themselves." See "Pictures and Progress," the title by which the lecture came to be known, in *The Frederick Douglass Papers*, ed. John W. Blassingame, vol. 3, 1855–1863 (New Haven, CT: Yale University Press, 1985), 452–453. The original manuscript is in the Library of Congress: https://www.loc.gov/item/mfd.22004/.

19. These photographs are collected in bound volumes housed in such locations as the Library of Congress and the Kroch Library at Cornell. Each collection contains slightly different photographs and shows different forms of use, including typed captions and handwritten emendations.

20. Irene Tucker, *The Moment of Racial Sight: A History* (Chicago: University of Chicago Press 2013); Anthony Appiah, *Lines of Descent: DuBois and the Emergence of Identity* (Cambridge, MA: Harvard University Press, 2014). See also, Alexander Weheliye, *Habeas Viscus: Racializing Assemblages, Biopolitics, and Black Feminist Theories of the Human* (Durham, NC: Duke University Press, 2014).

21. On the first topic, see John Stauffer, Zoe Trobb, and Celeste-Marie Bernier, *Picturing Frederick Douglass: An Illustrated Biography of the Nineteenth Century's Most Photographed American* (New York: Liveright, 2015). On the second, see Shawn Michele Smith and Maurice Wallace, eds., *Pictures and Progress*. See also Shawn Michele Smith, *Photography on the Color Line: W. E. B. Du Bois, Race, and Visual Culture* (Durham, NC: Duke University Press, 2004). And see Shelly Jarenski, *Immersive Words: Mass Media, Visuality, and American Literature, 1839–1893* (Tuscaloosa: University of Alabama Press, 2015).

22. The idea of being haunted refers as well to the account that George Saunders provides of the Civil War dead in *Lincoln in the Bardo* (2017).

BIBLIOGRAPHY

Appiah, Anthony. *Lines of Descent: W. E. B. Du Bois and the Emergence of Identity.* Cambridge, MA: Harvard University Press, 2014.

Azoulay, Ariella. *The Civil Contract of Photography.* New York: Zone Books, 2012.

Barthes, Roland. *Camera Lucida: Reflections on Photography.* New York: Hill and Wang, 1981.

Batchen, Geoffrey. *Burning with Desire: The Conception of Photography.* Cambridge, MA: MIT Press, 1999.

Best, Stephen. "Neither Lost Nor Found: Slavery and the Visual Archive." *Representations* 113 (2011): 150–163.

Cobb, Jasmine Nichole. *Picture Freedom: Remaking Black Visuality in the Early Nineteenth Century.* New York: New York University Press, 2015.

Crary, Jonathan. *Techniques of the Observer: On Vision and Modernity in the Nineteenth Century.* Cambridge, MA: MIT Press, 1990.

Dinius, Marcy J. *The Camera and the Press: American Visual and Print Culture in the Age of the Daguerreotype.* Philadelphia: University of Pennsylvania Press, 2012.

Douglass, Frederick. "Pictures and Progress." In *The Frederick Douglass Papers (Volume 3)*, ed. J. W. Blassingame. New Haven, CT: Yale University Press, 1985.

Dunbar, Erica Armstrong. *A Fragile Freedom: African American Women and Emancipation in the Antebellum City.* New Haven, CT: Yale University Press, 2008.

Elkins, James. *The Object Stares Back: On the Nature of Seeing.* New York: Harcourt, 1996.

Grigsby, Darcy Grimaldo. *Enduring Truths: Sojourner's Shadows and Substance.* Chicago: University of Chicago Press, 2015.

Hartman, Saidiya V. *Scenes of Subjection: Terror, Slavery, and Self-making in Nineteenth-century America.* New York: Oxford University, 1997.

Holmes, Oliver Wendell. "The Stereoscope and the Stereograph." In *Soundings from the Atlantic.* Boston: Ticknor and Fields, 1864.

Jarenski, Shelly. *Immersive Words: Mass Media, Visuality, and American Literature, 1839–1893.* Tuscaloosa: University of Alabama Press, 2015.

Linfield, Susie. *The Cruel Radiance: Photography and Political Violence.* Chicago: University of Chicago Press, 2012.

Moten, Fred. *Black and Blur.* Durham, NC: Duke University Press, 2017.

———. *In the Break: The Aesthetics of the Black Radical Tradition.* Minneapolis: University of Minnesota Press, 2003.

Nyong'o, Tavia. *The Amalgamation Waltz: Race, Performance, and the Ruses of Memory.* Minneapolis: University of Minnesota Press, 2009.

Rogers, Molly, and David W. Blight. *Delia's Tears: Race, Science, and Photography in Nineteenth-Century America.* New Haven, CT: Yale University Press, 2010.

Samuels, Shirley. *Romances of the Republic: Women, the Family, and Violence in the Literature of the Early American Nation.* New York: Oxford University Press, 1996.

Saunders, George. *Lincoln in the Bardo: A Novel.* New York: Random House, 2017.

Smith, Shawn Michelle. *American Archives: Gender, Race, and Class in Visual Culture.* Princeton, NJ: Princeton University Press, 1999.

———. *Photography on the Color Line: W. E. B. Du Bois, Race, and Visual Culture.* Durham, NC: Duke University Press, 2004.

Solnit, Rebecca. "The American Civil War Didn't End." *The Guardian.* November 4, 2018.

Sontag, Susan. *Regarding the Pain of Others.* New York: Farrar, Straus and Giroux, 2003.

Spillers, Hortense J. "Mama's Baby, Papa's Maybe: An American Grammar Book." *Diacritics* 17, no. 2 (1987): 65–81.

Stauffer, John, Zoe Trodd, Celeste-Marie Bernier, Henry Louis Gates, and Kenneth B. Morris. *Picturing Frederick Douglass: An Illustrated Biography of the Nineteenth Century's Most Photographed American.* New York: Liveright Publishing Corporation, 2015.

Stoever, Jennifer Lynn. *The Sonic Color Line: Race and the Cultural Politics of Listening.* New York: New York University Press, 2016.

Trachtenberg, Alan. *Reading American Photographs: Images as History, Mathew Brady to Walker Evans.* New York: Hill and Wang, 1989.

Tucker, Irene. *The Moment of Racial Sight: A History.* Chicago: University of Chicago Press, 2013.

Wallace, Maurice O., and Shawn Michelle Smith, eds. *Pictures and Progress: Early Photography and the Making of African American Identity.* Durham, NC: Duke University Press, 2012.

Weheliye, Alexander G. *Habeas Viscus: Racializing Assemblages, Biopolitics, and Black Feminist Theories of the Human.* Durham, NC: Duke University Press, 2014.
Wilson, Jackie Napolean. *Hidden Witness: African-American Images from the Dawn of Photography to the Civil War.* New York: St. Martin's, 2002.

Part 1

ARTICULATE SPACES

Chapter One

The Racial Geometry of the Nation

Thomas Jefferson's Grids and Octagons

Irene Cheng

In the vast corpus of writing on Thomas Jefferson, only rarely are his political and architectural thoughts considered together. On one hand, we have interpretations of Jefferson as a paradigmatic Enlightenment/liberal/radical/imperial/racist ideologue (depending on who is writing) and, on the other, some version of Jefferson as a gentleman-architect who brought his uniquely reworked versions of European classicism to America. This chapter explores the relationship between Jefferson's political and spatial praxes, and argues that he saw spatial design as an important means of realizing his ideal of a liberal, agrarian republic. Two specific geometric-spatial figures were central to his work: the land survey grid and the octagonal house. These figures comprised two halves of a spatiopolitical project, joining the territorial scale to the scale of the house, the nation, and the individual, in a latent yet unmistakably utopian vision. Together, grid and octagon constituted the spatial armature that would help bring about Jefferson's ideal polity in which each white male citizen would exercise sovereignty over a square of territory, while residing in a house that would both manifest and help produce the attributes of rationality and autonomy requisite of liberal subjectivity.

Jefferson's belief that geometric forms could literally help shape a future society—similar to how a written constitution directs a future polity—was predicated on an Enlightenment faith in the possibility of remaking the world in a more orderly and reasoned image. This image, while ostensibly universal, was in fact deeply imbued with racial particularity and hierarchy. The grid both materially facilitated and rationalized a system of land tenure that enabled white Americans' expropriation of land from Native Americans. Concomitantly, the octagon manifested an aesthetic ideal of the private, rational liberal subject able to exercise visual sovereignty over his surrounding domain. The ideal

geometries of Jefferson's utopian vision supported forms of sovereignty that entailed freedom and equality for some, enslavement and dispossession for others.

JEFFERSON'S GRIDS

The 1785 land ordinance grid—the system Jefferson helped to invent for organizing and selling the United States' land holdings west of the Appalachia—has often been depicted by historians as a product of pragmatic political necessity, colored by Jefferson's unique Enlightenment zeal for ordering systems. The land grid, it is said, emerged as a solution to several issues confronted by the Continental Congress toward the end of the Revolutionary war, including a crushing war debt and the pressures from squatters and speculators eager to settle the Northwest territory.[1] The expedient sale of public lands would address these problems. Beyond pragmatic necessity, however, Jefferson's grid embodied a particular utopian vision of the future nation—a society divided and subdivided into farms held by individual small landholders who were imagined as the constitutive units of an ideal republic.

Jefferson became involved in the project of territorial organization when in 1784 Congress tasked him with leading committees to address two sets of questions. The first set centered on how to establish the boundaries of new states, how these states should be administered and governed, and whether slavery would be permitted therein. The second set of questions focused on how to organize the sale of public lands in these new states. Jefferson's solution for this pair of problems was essentially a series of nested grids. The Northwest would be "scientifically divided" into states along lines of longitude and latitude, subdivided into townships, and divided again into square lots, prior to sale. These general principles were codified in the Land Ordinances of 1784 and 1785 (though slightly modified from Jefferson's original conception), resulting in the rectangular land survey system that has profoundly shaped the landscape of the American West. Although addressing immediate and pragmatic problems, Jefferson himself saw the task in utopian terms. In coming up with the state and land survey grids, he was drawing a blueprint not only for the western territories, but for the future of the republic itself. As Drew McCoy has argued, whereas Madison envisioned the future of the nation as a process of development through time, Jefferson saw the future in terms of expansion through space.[2] The western territories would not only offer a "safety valve" of rural land that would forestall European-style urban crowding and unrest in America; it would also be a space for remedying existing ills: thus, Jefferson proposed that slavery would be prohibited in the new states—an idea that Congress rejected.

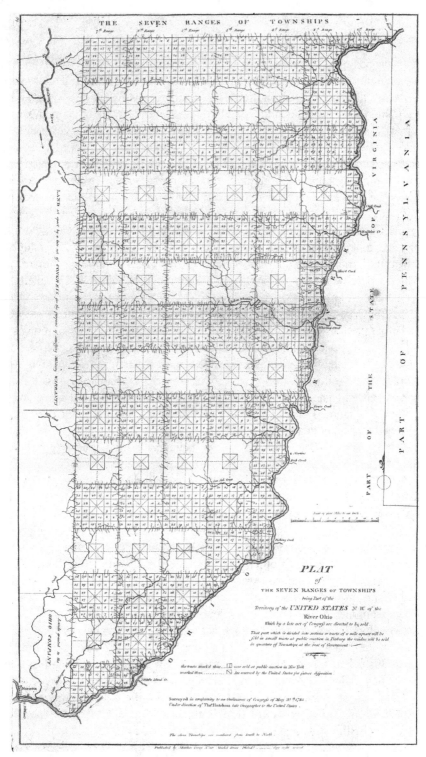

Figure 1.1. Plate of the Seven Ranges, from *Carey's General Atlas*, 1811 edition.
Courtesy of David Rumsey Map Collection, www.davidrumsey.com.

In proposing a system for dividing the western territories, Jefferson, the paradigmatic American Enlightenment figure, could not resist seizing the opportunity to modernize and rationalize. His idea was essentially to impose a decimal system onto the land, something he would later try to do with a system of weights and measures (unsuccessfully) and its coinage (successfully). Like the French republicans who invented new calendars, territorial divisions, and measurement systems in the wake of revolution, Jefferson believed that establishing systems of organizing and gauging matter, time, and space, would be part and parcel of defining a new form of sovereignty. Instead of units like "feet" and "chains," which originated in customary and inherited practices, his new systems would be keyed to universal astronomical and physical phenomena. States would each be two degrees, or 120 nautical miles, tall, and easily subdivided into 100-square-mile units or "hundreds," which would be further subdivided into individual lots. Jefferson adopted the Anglo-Saxon term "hundred," a word that may have originally referred to a plot of land large enough to sustain approximately 100 households.[3]

Throughout his life, Jefferson saw a link between the geometry of territorial organization and the nature of democracy. In the debates leading up to the passage of the Land Ordinance over the size of new western states, he advocated dividing the Northwest into a relatively tight grid, proposing nine small states (given idealistic names like "Sylvania" and "Polypotamia") in the space where Congress eventually delineated five.[4] Following Montesquieu, Jefferson believed that republicanism worked best in compact states with relatively homogeneous populations. Small states, he believed, were the most appropriate form to accommodate unruly, independent-minded westerners engaged "energetically" in republican self-government. A small grid, in other words, would foster more locally centered, democratic government. In contrast, James Madison argued during the debates over Constitutional ratification that an extensive republic encompassing a greater diversity of views and populations would work better. In a large state, Madison believed, opposing "factions" would contend with each other, preventing any one party from dominating. Most concerning to Madison was the specter of the "lower" classes gaining power and instituting radical measures. In large states, he hoped that "a rage for paper money, for an abolition of debts, for an equal division of property, or for any other improper or wicked project, will be less apt to pervade the whole body of the Union than a particular member of it . . ."[5] At stake, therefore, in the 1780s debate about the size and shape of new states was nothing less than competing visions of American democracy.[6]

Jefferson was more sympathetic than most of the other founders to the rumblings of radicalism from below in the early republic, even opining that "a little rebellion now and then is a good thing, and as necessary in the politi-

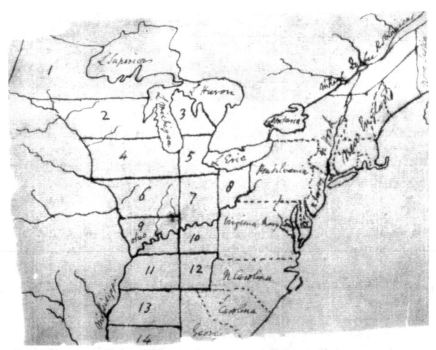

Figure 1.2. Map showing Jefferson's initial proposal for division of the Northwest territory into states, drawn by David Hartley, 1784 or 1785.
Courtesy of William L. Clements Library, University of Michigan.

cal world as storms in the physical."[7] As numerous scholars of the "radical" Thomas Jefferson have pointed out, throughout his life he advocated for a vision of America as a spatially extensive republic in which property would be widely distributed rather than concentrated in a few hands. As a legislator in Virginia in the 1770s, for example, Jefferson proposed policies that would have widened landholding by giving every landless white man 50 acres of free public land, and abolished entail and primogeniture laws that favored preserving large estates intact. Legislators, he wrote to Madison in 1785, "cannot invent too many devices for subdividing property."[8] The grid was an ideal spatial device for accomplishing Jefferson's goal of subdivision, since the square section could be (and was) divided recursively into 160, 80, or 40-acre lots over the course of the nineteenth century.

Yet the grid's self-similarity also made it a perfect figure of Euro-American imperial expansion. As Philip Fisher observed some time ago, it created a "Cartesian social space, one that is identical from point to point and potentially unlimited in extent."[9] Infinitely expandable, the Land Ordinance grid

was a crucial spatial device for converting lands from a Native American property regime based on communal ownership to European-American system of private property over the course of the nineteenth century. In the process, the homogeneous grid cultivated racial homogeneity as well: imperial expansion would be compatible with racial excusion. As we have already seen, Jefferson favored a tight grid not only because it enabled greater subdivision and more equal distribution of land, but also because it would ensure small states with relatively homogeneous populations of like-minded citizens. There can be little doubt that Jefferson saw his gridded, expansive American utopia as populated principally, if not exclusively, by white Americans. An advocate of colonization for black Americans, and removal or absorption for Native Americans, Jefferson wrote in 1801 that he envisioned a time when "rapid multiplication" of the country's population would "cover the whole northern, if not the southern continent, with a people speaking the same language, governed in similar forms, & by similar laws," without "blot or mixture on that surface."[10] As Anthony F. C. Wallace has cogently argued, Jefferson's ideal America was "an ethnic homeland, European in origin and spirit, agrarian in economy, governed by republican institutions derived from old Anglo-Saxon and even pre-imperial Roman models."[11] The grid was the overdetermined spatial device singularly capable of embodying and helping to realize Jefferson's utopian vision. With its associations with Enlightenment rationality, Anglo-Saxon "hundreds," territorial expansion, and recursive property division, the land ordinance grid melded equality, exclusion, and erasure into one tangible figure.

JEFFERSON'S OCTAGONS

If the grid was Jefferson's designated figure for shaping the polity at a territorial scale, the octagon was his spatial device for forming, and expressing, the mind of the nation's constituent liberal citizens. As an architect, Jefferson was obsessed with octagons. The figure's telltale 135-degree angles appear again and again in his drawings, materializing in the form of single bows, double-, triple- and quadruple-projections, and freestanding volumes. He used them for myriad programs—a chapel, courthouse, observatory, prison, but above all, in his designs for private dwellings, including his own houses and several residences he designed for friends and neighbors.[12]

Rather than positively identifying Jefferson's motivations, my task here is to try to understand the overdetermined meanings that octagonal geometry held for both Jefferson and other Americans—in other words, to understand Jefferson's octagons as cultural artifacts. Sifting through Jefferson's likeli-

est sources reveals that the octagons had multiple valences, each entailing a distinct understanding of the human subject and its relation to architecture. Whether they echo the Renaissance belief in ideal Platonic bodies, or the Enlightenment's faith in geometry as the ultimate form of reason, or even a Sensationalist interest in how certain figures could influence sight and sound, together, these overdetermined sources produced a sense of the house as both representation and shaper of an ideal subject—specifically, a liberal subject. By liberal subject, I mean the autonomous, private, property-bearing, "free" man conjured by political theorists like John Locke and Jean-Jacques Rousseau and invoked in Jefferson's writings. This, the freehold farmer, was always conceived as white and male and, as we saw above, comprised the foundation and end of the republic—the man who could "administer" "with his own eye" a piece of land. For Jefferson, the house—and particularly, the octagonal house—was a tool to both represent and produce the liberal subject.

RENAISSANCE HARMONIES

One of the clearest influences on Jefferson's use of octagon forms is in the classical aesthetic tradition, within which ideal geometries like the circle and cube were venerated. Jefferson's earliest known design incorporating an octagon form, dating to the 1770s, was a sketch for an eight-sided chapel, probably intended for Williamsburg.[13] On the back of the sketch, Jefferson cited Palladio's plates of the circular Temple of Vesta as his source. In characteristic fashion, Jefferson played with the precedent loosely, converting the pagan temple into a church, and turning the circle into an octagon.

Circles, and by extension octagonal forms, in architecture had been imbued with analogies to human bodies since the classical era.[14] By the late eighteenth century, such anthropomorphic overtones lingered, while the implicit racial hierarchies attendant on them intensified. Jefferson's writing on racial difference in terms of aesthetics mirrored pervasive Euro-American prejudices about the relative beauty of different human forms. In *Notes on the State of Virginia*, Jefferson explained the differences in the physical appearance of the races as one of geometry and expression: white bodies had "a more elegant symmetry of form." Furthermore, white countenances allowed "the expressions of every passion by greater or less suffusions of colour" whereas black faces were plagued with an "eternal monotony . . . that immoveable veil of black which covers all the emotions."[15] Such statements point to the intertwining of race and aesthetics in the late eighteenth century, as well as the contradictions confronting physiognomic metaphors in architecture. Jefferson's preference for symmetry in architecture may seem far from his praise for the symmetry

of white bodies. Yet given the long tradition of architectural theory connecting bodies to architecture, it is difficult to see how these beliefs about beauty did not reinforce one another. The perfect symmetry of one form could only be apprehended through contrast with the dissymmetry of less beautiful bodies.

ENLIGHTENMENT CALCULABILITY AND PROOF

A second explanation for Jefferson's fondness for geometric forms is his well-known love of mathematics. Among his drawings for Monticello are two sketches in which he explored adding octagonal bows to his original

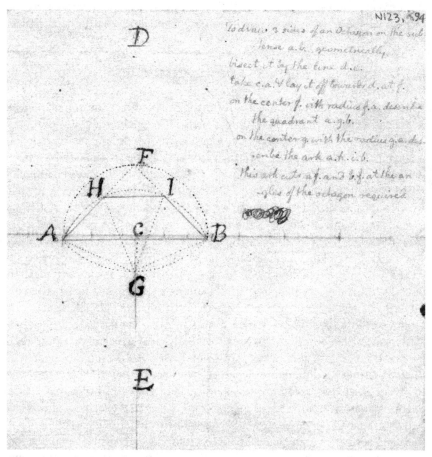

Figure 1.3. Thomas Jefferson, Sketch labeled "To draw 3 sides of an Octagon . . .,"
c. 1771.
Courtesy of the collection of the Massachusetts Historical Society N123, K94.

rectilinear design for the house. Given the ostensibly pragmatic ends, it is striking that Jefferson rendered these octagons in the form of abstract geometric proofs—a series of logical steps undertaken with a compass and divider.

He described his steps thus:

Bisect [the line] by the line d.e.
take c.a. & lay it off towards d. at f.
on the center f. with radius f.a. describe
the quadrant a.g.b.
on the center g. with the radius g.a. des-
 cribe the ark a.h.i.b.
this ark cuts a.f. and b.f. at the an-
 gles of the octagon required.[16]

For Jefferson, drawing the octagon was much more than a practical design problem. Like many eighteenth-century men, he saw Euclidean geometry as a way of training minds to think. John Locke had advocated mathematical learning as "a way to settle in the mind a habit of reasoning closely and in train."[17] As taught in eighteenth-century textbooks, geometry was equated with the production of proofs. In a typical exercise, the student began with a set of definitions (for example, of point, line, and surface), a limited set of self-evident axioms, and then solved propositions by proceeding through a series of logical steps, undertaken with the help of a compass and rule. Jefferson echoed Locke's linking of geometry and rationality when he advised his grandson that mathematics "gives exercise to our reason, as soon as that has acquired a certain degree of strength, and stores the mind with truths which are useful in other branches of science."[18]

Yet here again, the notion of a universal reasoning subject encountered the contradictions of racial ideology. In spite of the egalitarian spirit behind Jefferson's educational policies, he did not deem all Americans equally fit to enjoy the edifying effects of mathematical instruction. In *Notes*, Jefferson wrote disparagingly of African Americans' capacity to learn geometry: "Comparing them by their faculties of memory, reason, and imagination, it appears to me, that in memory they are equal to the whites; in reason much inferior, as I think one could scarcely be found capable of tracing and comprehending the investigations of Euclid."[19] Following Jefferson's logic linking citizenship with reason, a people who lacked the capacity to reason geometrically could, by extension, be excluded from the corpus of rational democratic citizens. Here we meet one of the fundamental contradictions of liberalism: formal claims of equality, as Elizabeth Dillon notes, were undermined by countervailing assumptions of innate inequality among subjects.[20]

SENSATIONAL OCTAGONS

In Renaissance architectural theory, buildings evoked the harmony of the universe and the human body. By the end of the eighteenth century, such symbolic understandings of beauty were increasingly supplanted by a focus on the sensory effects of aesthetic forms—a shift often identified with the birth of modern aesthetics. The new theory was heavily influenced by contemporary English sensationalist philosophy, which posited a mind shaped through sensory perception of the exterior world. Sensationalism influenced English architecture by placing greater attention to the effects of geometric forms on the perceiving subject. This modern aesthetic approach constituted a third source for Jefferson's interest in octagonal architecture.

The view of architecture as a practice in the manipulation of perception can be found in the book that was likely the direct source for a number of Jefferson's eight-sided figures, Robert Morris's *Select Architecture* (1755). Of the fifty plates in the book, nine feature octagonal shapes—most in connection with garden follies and country houses. Morris described the eight-sided elements in his architecture primarily in perceptual terms—as objects meant to be viewed both from without and within. In his notes on an octagonal pavilion, he explained: "A Building of this Kind would be an Object seen at a Distance" and would contribute to creating "a new Succession of pleasing Images" in the landscape.[21] Octagons, by this account, were not just objects to be seen, but objects to enable seeing—optical devices, in a sense.

The new perceptual approach to architecture had a political dimension. Within architecture, sensationalist theory was most prominently manifested in picturesque designs of houses and gardens for landed estates in England, and out of changes in the structures of property ownership in seventeenth-century England—specifically, a historic shift from feudal patterns of land tenancy that included unenclosed commons to absolute individual ownership. As land became increasingly privatized and consolidated, estate owners lavished attention on pleasure gardens and pursued a vision of rural ease and naturalism. Octagonal architecture was a product of this new aesthetics of territorial possession. Eight-sided forms were associated with garden follies, with spaces of retreat that allowed owners to look out over privatized and domesticated landscapes. The power to see was here linked inextricably with the power of possession.[22] The octagon was an aesthetic technology enabling this visual sovereignty, a sovereignty intimately connected with ownership of property.

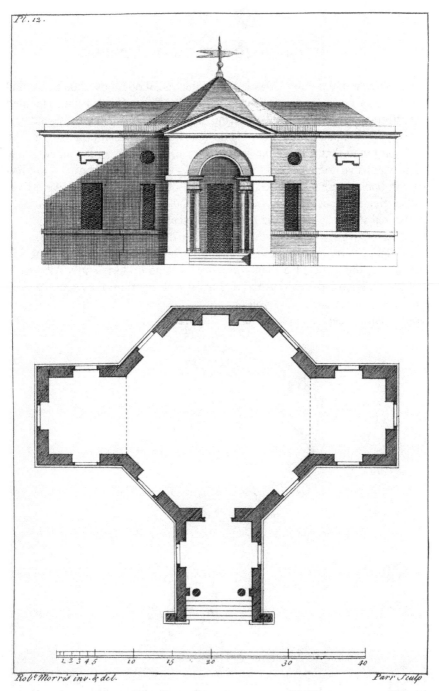

Figure 1.4. Robert Morris, *Select Architecture*, 1755 ed., plate 12. "A Pavillion intended to terminate the Boundaries of a Garden, on an Eminence, where an agreeable Prospect may be had round the Horizon. . . . I made so many Windows in it, for the more easy obtaining a Variety of views."

Robert Morris, *Select Architecture*, 1755 ed., plate 12.

AN EIGHT-SIDED AGRARIAN REPUBLIC

There is little doubt that Jefferson prized the visual qualities of octagons and the sense of optical mastery over his land that they afforded him. He sited Monticello on the top of a hill, allowing him to step outside his house and easily survey the plantation below. He designed the octagonal projection of the main parlor so that it faced onto a large lawn, providing an immediate view of an expansive domesticated landscape. Whereas the typical bows in English pattern books were three-sided, Jefferson's in the first Monticello were five-sided, yielding spaces suffused with light and air and permitting even more unfettered visual access to the exterior landscape.

Jefferson was so enamored of octagons that over the years, when friends and neighbors would occasionally ask him to sketch a plan of a dwelling, his drafts frequently included eight-sided forms. One of Jefferson's Albemarle County neighbors recounted a conversation with the third president: "as you predicted he was for giving you Octagons. They were charming. They gave you a semi-circle of light and air."[23] Sometime before 1802, for example,

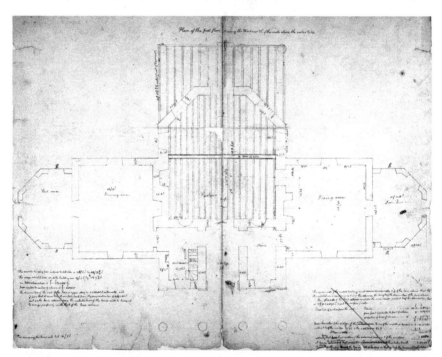

Figure 1.5. Thomas Jefferson, Monticello, ground floor plan of first version showing octagonal additions, 177.

Courtesy of the collection of the Massachusetts Historical Society N49, K24.

Jefferson provided his friend George Divers with a plan to add an octagonal wing to a traditional rectangular two-room house in Albemarle County. And around 1817, Jefferson produced a design for his friend Governor James Barbour, for a property just outside Charlottesville. The house is a smaller variation on the plan for the second Monticello, featuring a central projecting octagon housing a parlor, flanked by two double-loaded wings. This plan—a rectangular house with a central projecting octagonal parlor—would become something of a type in Jefferson's oeuvre, one that Hugh Howard would call "a paradigm for Jefferson's agrarian ideal."[24] Of course, most of the houses that Jefferson designed were not for yeomen engaged in the day-to-day labors of the farm but rather for wealthy plantation owners, gentlemen who relied on slave labor. While this may appear a contradiction, it was a contradiction that existed at the heart of republican political theory, which held that gentlemen of leisure—that is men who owned property but did not have to physically work on it—made the best citizens.

PRIVACY AND PUBLICITY

Jefferson's houses were prostheses that granted their owners the power to survey their properties. They manifested his liberal utopia of freehold farm ownership by generating a visual field organized around the eye of the autonomous owner. The houses' octagonal bows did more than just "express" a political ideology; they were imagined to actually reinforce and produce it. Sensationalist theory encouraged just such an instrumental understanding of polygonal architectural geometries.

To see the uniqueness of Jefferson's approach to octagonal forms, it may be useful to compare his view with that of John Adams, who likewise betrayed a fascination with eight-sided rooms and described their special properties in visual terms. Whereas Jefferson the architect was engaged in literally producing an optical field, for Adams, the views were metaphorical. In his book *Defence of Constitutions*, Adams wrote that Americans should regard the history of Greece as a kind of "boudoir"—which he explained as "an octagonal apartment," mirrored on every side, a form that was found in European houses." Elsewhere, Adams described the *Defence* itself as an "American boudoir" that would allow the newly formed American states to "see themselves . . . in every possible light, attitude and movement. They may see all their beauties and all their deformities."[25]

These passages from Adams lend further evidence for the argument that octagonal architecture was associated with visual effects productive of liberal subjectivity in early-nineteenth-century America. Only for Adams, instead of

enabling the vision of a sovereign subject outward, octagons produced a re-flected gaze, enabling introspection and self-understanding. This capacity for self-reflection is one of the constitutive fictions of Enlightenment liberalism: Only subjects capable of self-knowledge are competent to engage in self-government, consent, and dissent. Yet whereas Adams used the octagon room as a metaphor for self-inspection (albeit based presumably on actual octagon rooms that he had seen or heard about), Jefferson the architect believed that eight-sided architectural forms could literally and materially produce specific effects on sentient subjects—by enabling a simultaneous enjoyment of retreat and visual surveillance.

Besides enabling house owners to experience visual dominion over their properties, Jefferson became aware of yet another visual dynamic produced by the octagon that we can relate to the production of liberal subjectivity: the defining of private and public domains. Jürgen Habermas has argued that the separation of private and public spheres is a constituent feature of liberalism: the bourgeois public sphere relies on the prior demarcation of the conjugal family as a private domain. According to Habermas, it is in the intimate sphere of the family that bourgeois man is created—a private subject with a "saturated and free interiority."[26] These privatized individuals then enter into the public sphere to rationally debate their previously constituted and known needs and desires.

Early Americans understood this distinction between public and private life. Politics was seen as the sphere of gentlemen acting on a stage, visible to all and constantly subject to the judgment of others. In republican theory, politics was a temporary duty, to be followed by retreat to one's private life. Jefferson's writing is littered with reflections on this separation of private and public spheres and an insistence on distinguishing between his duties as a citizen on the public stage and his life as a private farmer. As early as 1775, he wrote to a friend of his yearning to "withdraw myself totally from the public stage and pass the rest of my days in domestic ease and tranquility, banishing every desire of afterwards even hearing what passes in the world."[27] Based on his statements, Joyce Appleby has argued that for Jefferson, "The private came first. Instead of regarding the public arena as the locus of human fulfillment where men rose above their self-interest . . ., Jefferson wanted government to offer protection to the personal realm where men might freely exercise their faculties."[28]

At Monticello, Jefferson made a number of architectural interventions to increase the privacy of the house. In 1809, following his retirement from two tumultuous terms as President, he ordered the construction of what he termed "porticles" outside his bedroom window—essentially a box made of Venetian blinds. As the house was overrun with guests, both invited and uninvited, Jef-

ferson's octagons, which had allowed him maximum visual access to survey his plantation, became a kind of curse. The public was now perched outside his bedroom window, producing an uncomfortable blurring of his public and private spaces.

In search of refuge from his "public" home, Jefferson began in the 1800s to design a private retreat at Poplar Forest. The house, a freestanding octagon in concept, had the geometric purity of a mathematical theorem. Its central dining room was a perfect 20-foot cube, illuminated only from above by a skylight. The house was as close as he could come to realizing the conceit of a garden pavilion-as-house. Here again Jefferson was interested in using octagons to create a visual link to the outdoors. The primary public space is

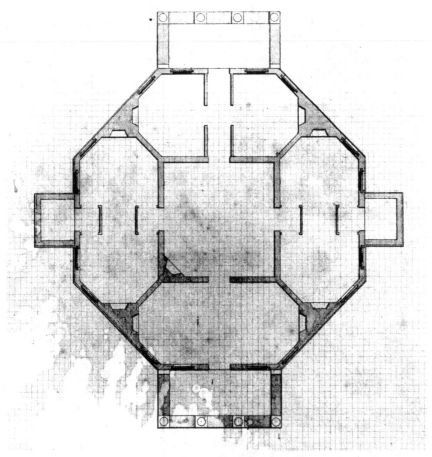

Figure 1.6. Thomas Jefferson, Plan of Poplar Forest, undated, drawn by John Neilson.
Courtesy of University of Virginia, Special Collections Department, Thomas Jefferson Papers, N350.

an elongated octagonal parlor with two windows and a door opening onto an elevated covered porch, with no direct access to the ground. He ordered workers to excavate the land below the porch, so as to make the house appear higher. Jefferson could walk out onto the porch and gaze out at his property but not actually walk out onto the land. In other words, vision was primary. Jefferson could indulge the dream of a rational, enlightened self, able to see all, yet free of prying eyes and a judging public—a panoptic fantasy of an eye looking out with no returning gaze.

Yet the house was also full of contradictions, particularly related to the myth of independence that Jefferson attached to it. As at Monticello, these tensions are manifested in the cross-section of the house—in contrast with the geometric purity of the plan. Although he imagined it as a space where he could retreat in solitude, at least one and maybe more enslaved people accompanied him during his stays at Poplar Forest. In his initial plan Jefferson had neglected to include stairs connecting the living spaces above and the work spaces below. After construction began, he asked his builder to add the stairs, acknowledging, if grudgingly, the interdependence of freedom and slavery.

AMBIGUOUS GEOMETRIES

Jefferson's octagons, like his grids, were ambiguous figures. The grid was a prime tool for converting public, common land into private property, establishing one of the bedrocks of a developing American capitalist society. The grid also implied an endless replicability—a reminder that Jefferson's agrarian republicanism was dependent on a seemingly insatiable imperial expansion that relied on the expropriation of Indian lands and erasure of Indian systems of land tenure. At the same time, Jefferson believed the grid's capacity for distribution and division harbored the possibility of a more radical form of democracy—one premised on spreading wealth, and therefore power, more widely and facilitating small-scale, direct political deliberation. But the grid's promise of equality was never truly universal: the inhabitants of Jefferson's extended, squared-off territory were to be individual white farmers. The exclusivity of his utopian vision of America was reinforced in his architectural designs. The geometry of these designs evoked older humanist analogies to the harmonies of the human body and cosmos, the Enlightenment idealization of reason, and sensationalist aesthetic principles—all of which affirmed an ideal, sovereign subject. The imagined inhabitant of these houses was implicitly—and sometimes explicitly—rational, free, white, and male. Ensconced in his private abode, able to survey the surrounding landscape, this inhabitant was the master of his property, his individual square of the Jeffersonian grid. In the decades

to come, the liberal, individualist, and racially exclusive valences of the grid and octagon would become ascendant over their more radical, egalitarian, and democratic potentialities.

NOTES

1. On the history of the survey system, see William David Pattison, *Beginnings of the American Rectangular Land Survey System, 1784–1800*, no. 50 (Chicago: University of Chicago, 1964) and Hildegard Binder Johnson, *Order Upon the Land: The U.S. Rectangular Land Survey and the Upper Mississippi Country* (Oxford: Oxford University Press, 1976).

2. Drew McCoy, *The Elusive Republic: Political Economy in Jeffersonian America* (Chapel Hill: University of North Carolina Press, 1980).

3. See Jefferson to Major John Cartright, June 5, 1824, in *Thomas Jefferson: Writings*, 1490–96.

4. For a detailed analysis of these state names, as well as the publication and circulation of the maps related to the Ordinance, see Julian Boyd's Editorial Note on "Plan for Government of the Western Territory" in *Papers of Thomas Jefferson.* https://founders.archives.gov.

5. James Madison, "The Federalist No. 10" (1787), in *The Federalist with Letters of "Brutus,"* ed. Terence Ball (Cambridge: Cambridge University Press, 2003).

6. See Rosemarie Zagarri, *The Politics of Size: Representation and the United States, 1776–1850* (Ithaca, NY: Cornell University Press, 1987) and Bill Hubbard, *American Boundaries: The Nation, the States, the Rectangular Survey* (Chicago: University of Chicago Press, 2009), 120–21.

7. Thomas Jefferson to James Madison, January 30, 1787. *Papers of Thomas Jefferson.*

8. Thomas Jefferson to John Jay, August 23, 1785. *Papers of Thomas Jefferson.* Classic "radical" interpretations of Jefferson can be found in Richard K. Matthews, *The Radical Politics of Thomas Jefferson* (Lawrence: University of Kansas Press, 1984) and Staughton Lynd, *Intellectual Origins of American Radicalism*, rev. ed. (Cambridge: Cambridge University Press, 2009).

9. Philip Fisher, "Democratic Social Space: Whitman, Melville, and the Promise of American Transparency," *Representations* 24 (1988): 64.

10. Thomas Jefferson to James Monroe, November 24, 1801. *Papers of Thomas Jefferson.*

11. Anthony F. C. Wallace, *Jefferson and the Indians: The Tragic Fate of the First Americans* (Cambridge, MA: Harvard University Press, 1999), 17.

12. For previous explanations for Jefferson's love of octagons, see C. Allan Brown, "Thomas Jefferson's Poplar Forest: The Mathematics of an Ideal Villa," *Journal of Garden History* 10, no. 2 (1990): 129; Jack McLaughlin, *Jefferson and Monticello: The Biography of a Builder* (New York: H. Holt, 1988), 254; and Roger Kennedy, "Jefferson and the Indians," *Winterthur Portfolio* 27, no. 2/3 (1992): 120.

13. Thomas Jefferson, Design of a chapel, c. 1770–78 (Huntington Library HM9387, N419r).

14. On the history of architectural analogies between bodies and buildings, see Rudolf Wittkower, *Architectural Principles in the Age of Humanism* (New York: W. W. Norton, 1971) and Joseph Rykwert, *The Dancing Column: On Order in Architecture* (Cambridge, MA: MIT Press, 1998).

15. Jefferson, "Notes on the State of Virginia," in *Writings*, 265.

16. Thomas Jefferson, Sketch labeled "To draw 3 sides of an Octagon . . .," c. 1771 (Massachusetts Historical Society N123, K94).

17. John Locke, "Of the Conduct of the Understanding," in *Some Thoughts Concerning Education; and, of the Conduct of the Understanding*, ed. Ruth Weissbourd Grant and Nathan Tarcov (Indianapolis, IN: Hackett, 1996), 181.

18. Thomas Jefferson to Thomas Mann Randolph, August 27, 1786. *Papers of Thomas Jefferson.*
Because mathematics was a tool for training individuals to think rationally, Jefferson related it to the cultivation of a rational and virtuous body of citizens. In his "Report of the Commissioners for the University of Virginia" (1818), he wrote that Americans should be taught reading, writing, arithmetic, and "the elements of mensuration" in order to know "their rights, interest, and duties, as men and citizens." Higher levels of education, including more advanced training in "the mathematical and physical sciences" would "develop the reasoning faculties of our youth, enlarge their minds, cultivate their morals, and instill into them the precepts of virtue and order." In *Papers of Thomas Jefferson.*

19. Jefferson, "Notes," 266.

20. Elizabeth Dillon, *The Gender of Freedom: Fictions of Liberalism and the Literary Public Sphere* (Standford, CA: Stanford University Press, 2004), 16.

21. Robert Morris, *Select Architecture*, 2nd ed. (London: Robert Sayer, 1757), 8.

22. This sentiment is clearly expressed by the English author Henry Wotton in a dictum concerning the selection of a site with a good view. Wotton refers to something he calls a "royalty of Sight": "For as there is a Lordship (as it were) of the Feet, wherein a Man walketh with much Pleasure about the Limits of his own Possessions, so there is a Lordship likewise of the Eye, which being a Ranging, and Imperious (I had almost said) Usurping Sense, cannot indure to be Circumscribed within a small Space, but must be satisfied both with Extent, and variety." Wotton's evocation of a "lordship of the eye" makes clear the link between picturesque perception and the power of ownership over a piece of land. Wotton, quoted in Richard Neve, *The City and Countrey Purchaser, and Builder's Dictionary: or, the Compleat Builder's Guide. . . . By T. N. Philomath* (London: printed for J. Sprint, G. Conyers, and T. Ballard, 1703), 59.

23. Isaac Coles to John Hartwell Cocke, February 23, 1816. In *Papers of Thomas Jefferson.*

24. Hugh Howard, *Thomas Jefferson, Architect: The Built Legacy of Our Third President* (New York: Rizzoli, 2015), 112.

25. John Adams, *A Defence of the Constitutions of Government of the United States of America* (London, 1787).

26. Jürgen Habermas, *The Structural Transformation of the Public Sphere: An Inquiry into a Category of Bourgeois Society* (Cambridge, MA: MIT Press, 1989), 28.

27. Jefferson to John Randolph, August 25, 1775. *The Papers of Thomas Jefferson.*

28. Joyce Appleby, *Inheriting the Revolution: The First Generation of Americans* (Cambridge, MA: Harvard University Press, 2000).

BIBLIOGRAPHY

Ackerman, James S. *The Villa: Form and Ideology of Country Houses*. Princeton, NJ: Princeton University Press, 1990.

Adams, John. *A Defence of the Constitutions of Government of the United States of America*. London, 1787.

Adams, William Howard, ed. *Jefferson and the Arts: An Extended View*. Washington, DC: National Gallery of Art, 1976.

———. *The Eye of Thomas Jefferson*. Charlottesville, VA: Thomas Jefferson Memorial Foundation and University of Missouri Press, 1992.

Appleby, Joyce. *Inheriting the Revolution: The First Generation of Americans*. Cambridge, MA: Harvard University Press, 2000.

Brown, C. Allan. "Thomas Jefferson's Poplar Forest: The Mathematics of an Ideal Villa." *Journal of Garden History* 10, no. 2 (1990): 117–39.

Dillon, Elizabeth Maddock. *The Gender of Freedom: Fictions of Liberalism and the Literary Public Sphere*. Stanford, CA: Stanford University Press, 2004.

Fisher, Philip. "Democratic Social Space: Whitman, Melville, and the Promise of American Transparency." *Representations*, no. 24 (1988): 60–101.

Habermas, Jürgen. *The Structural Transformation of the Public Sphere: An Inquiry into a Category of Bourgeois Society*. Cambridge, MA: MIT Press, 1989.

Hamilton, Alexander, James Madison, and John Jay. *The Federalist with Letters of "Brutus."* Ed. Terence Ball. Cambridge, UK, and New York: Cambridge University Press, 2003.

Howard, Hugh. *Thomas Jefferson, Architect: The Built Legacy of Our Third President*. New York: Rizzoli, 2015.

Hubbard, Bill. *American Boundaries: The Nation, the States, the Rectangular Survey*. Chicago: University of Chicago Press, 2009.

Jefferson, Thomas. *The Papers of Thomas Jefferson*. Princeton, NJ: Princeton University Press, 1958. http://founders.archives.gov.

———. *Thomas Jefferson: Writings*. New York: Library of America, 1984.

Johnson, Hildegard Binder. *Order Upon the Land: The U.S. Rectangular Land Survey and the Upper Mississippi Country*. New York: Oxford University Press, 1976.

Kennedy, Roger. "Jefferson and the Indians." *Winterthur Portfolio* 27, no. 2/3 (1992): 105–21.

Locke, John. *Some Thoughts Concerning Education; and, of the Conduct of the Understanding*. Edited by Ruth W. Grant and Nathan Tarcov. Indianapolis: Hackett Publishing Company, Inc., 1996.

Lynd, Staughton. *Intellectual Origins of American Radicalism*. Rev. ed. Cambridge and New York: Cambridge University Press, 2009.

Matthews, Richard K. *The Radical Politics of Thomas Jefferson*. Lawrence, KS: University of Kansas Press, 1984.

McCoy, Drew. *The Elusive Republic: Political Economy in Jeffersonian America*. Chapel Hill, NC: University of North Carolina Press, 1980.

McLaughlin, Jack. *Jefferson and Monticello: The Biography of a Builder*. New York: H. Holt, 1988.

Morris, Robert. *Select Architecture*. 2nd ed. London: Robert Sayer, 1757.

Neve, Richard. *The City and Countrey Purchaser, and Builder's Dictionary, or, The Compleat Builder's Guide*. London: 1703.

Jefferson, Thomas. *The Papers of Thomas Jefferson*. Princeton, NJ: Princeton University Press, 1958. http://founders.archives.gov.

Jefferson, Thomas. *Thomas Jefferson: Writings*. New York: Library of America, 1984.

Pattison, William David. *Beginnings of the American Rectangular Land Survey System, 1784–1800*. Chicago: University of Chicago, 1964.

Rykwert, Joseph. *The Dancing Column: On Order in Architecture*. Cambridge, MA, and London: MIT Press, 1998.

Wallace, Anthony F. C. *Jefferson and the Indians: The Tragic Fate of the First Americans*. Cambridge, MA: Harvard University Press, 1999.

Wittkower, Rudolf. *Architectural Principles in the Age of Humanism*. New York: W. W. Norton, 1971.

Zagarri, Rosemarie. *The Politics of Size: Representation in the United States, 1776–1850*. Ithaca, NY: Cornell University Press, 1987.

Chapter Two

Arctic Whiteness

William Bradford, Herman Melville, and the Invisible Spheres of Fright

Wyn Kelley

If, as a number of essays in this volume suggest, nineteenth-century photography made whiteness visible to U.S. culture in unprecedented ways, the Arctic photographs of William Bradford (1823–1892), landscape painter and author of *The Arctic Regions*: *Illustrated with Photographs Taken on an Art Expedition to Greenland* (1873), provide a striking example of how racial consciousness might manifest itself in different visual media.[1] In *The Arctic Regions*, Bradford's photographs and text emphasize the presence, and indeed inferiority of dark-complexioned "Esquimaux."[2] But his expansive landscape paintings, like those of other artists of the sublime, based on these photographs contain few human figures and certainly no Inuit ones. Nevertheless, he appears to have used animal surrogates—polar bears, seals—to suggest native, if nonhuman, resistance to "Arctic Intruders" (the title of one landscape) associated with white civilization, technological might, and moral progress—forces that François Specq speaks of as steeped in a "rhetoric of empire."[3] The ambivalence of Bradford's treatment of racial subjects draws attention even to works where race does not appear on the surface.

Surprisingly, traces of racial subjects, or at least of the racialized "native," may also appear in late poems of Herman Melville (1819–1891), in particular "The Berg: A Dream" from *John Marr, and Other Sailors* (1888).[4] Even if the poem does not speak directly to Bradford's art, the example of Bradford makes it possible to consider heretofore unnoticed racial coding in "The Berg." This connection is not as farfetched as it sounds. Bradford and Melville may or may not have met, but they resonate with one other as artists-turned-critics of the Arctic sublime. Close contemporaries with New England maritime roots and New York social circles, both showed early fascination with the world of Arctic exploration. By the end of the nineteenth century,

both also registered unease about new technologies threatening the natural world, as well as colonialist incursions into indigenous cultures. In relation to the emerging medium of photography or other visual technologies, both also speak to a foreboding sense of nature's indifference to human life that could be attributed to the harshness of the polar landscape or, alternatively, to the blindness of a white Euro-American gaze that cannot see itself—a blindness that photography may make starkly perceptible.

Could these two artists of polar regions have known each other's work? In an intriguing coincidence of dates, Melville was writing or returning to "The Berg" at around the time (1885) that Bradford toured New York and other cities with his popular "Bradford Recitals," exhibitions of his Arctic landscapes and the photographs that inspired them. In the mid-1880's, both men responded strongly and imaginatively to the spectacle of an artist confronting what Melville had called in *Moby-Dick* "a wide landscape of snows." Melville may further have seen photography as a medium that makes visible or palpable what he had once spoken of as "invisible spheres . . . formed in fright."[5]

We might hesitate to associate Melville too closely with the Arctic subject. There is little evidence of his having sought out or studied Arctic landscape painters; he never visited polar regions himself; and he is more commonly associated with literature of the sea, and particularly the South Seas, than with an icebound North. Yet Melville read about polar expeditions long before he began writing, and he invested in popular romantic images of the Arctic from early in his career, as any reader of *Moby-Dick* will recognize. His uncle Captain John D'Wolf, mentioned in *Moby-Dick*, voyaged in northern seas and wrote of his adventures. William Scoresby (1789–1857), whose *An Account of the Arctic Regions* was first published in 1820, is Melville's known source for many passages in *Moby-Dick*, including the famous descriptions of Lapland and the North in "The Whiteness of the Whale."[6] Greenland, where much of Bradford's narrative takes place, appears often in *Moby-Dick* as the epicenter of Northern whaling. Elsewhere in *Moby-Dick* Ishmael associates Queequeg's embrace with "one warm spark in the heart of an arctic crystal," and Ahab's determination with "the unsetting polar star, which through the livelong, arctic, six months' night sustains its piercing, steady, central gaze."[7] These references suggest the influence of a Romantic aesthetic of the sublime mingled with Arctic fever, inspired in part by Sir John Franklin's voyages and the rescue attempts that followed, starting in 1845.[8] "The Berg," with its evocation of "dense stolidity of walls" of ice,[9] returns to Melville's earlier Arctic visions with little of their youthful romanticism. But it seems that Melville never lost his fixation on polar ice and its forbidding majesty.

Bradford may have been swept up in a youthful Arctic mania of his own but he was not trained as a photographer or ethnographer, had no early con-

tact with Arctic lands or cultures, and indeed for the first part of his life did not paint either.[10] He began as an unsuccessful farmer and merchant of clothing in New Bedford, Massachusetts, then produced portraits of ships, used at first for advertising to maritime investors. In time, he established a modestly successful career painting New England seascapes. Hoping to achieve more prestige as a landscape artist in the grand manner, he moved to New York and embarked on a number of voyages to Labrador and then Greenland in the 1860s, commissioning photographs from professional assistants, John L. Dunmore and George P. Critcherson, which he used to remind himself of what he had seen. When he returned from Greenland in 1869 he wrote *The Arctic Regions* to help him sell his paintings, primarily to admirers in England. A dramatically embellished volume bound in Morocco and illustrated with 145 of Dunmore and Critcherson's wet-plate collodion photographs, the book was probably more expensive than Melville could afford.[11]

Did Melville know of it in some other way? During his final months as Inspector at the New York Customs House, he might have noted with interest a headline in the *New-York Tribune* of November 14, 1885: "Life and Scenery in the North. Wm Bradford on His Explorations. His Address Before the Geographical Society—Some of the Illustrations."[12] The *Tribune* article reports a meeting the evening before of the American Geographical Society of New York, gathered in Chickering Hall to hear William Bradford talk about his 1869 voyage to Greenland.

Although the journey took place 16 years earlier, Bradford had recently garnered considerable success through the Bradford Recitals, popular multimedia spectacles that drew on his book and presented it to a wider audience. The beautiful photographs produced by Dunmore and Critcherson were made into lantern-slides. Bradford also displayed his own paintings of Arctic scenery on easels around the hall and gave a lively lecture. Miss Ruby Sinclair sang haunting "Esquimaux" songs of welcome from behind a curtain at an appropriate moment in the talk.[13]

Of this dazzling performance, the American Geographical Society could reproduce only the verbal text of Bradford's lecture in its 1885 volume of the Society's *Journal*.[14] Still, it is tantalizing to consider whether, while he worked on the poems that later appeared in *John Marr*, Melville might have heard of or seen Bradford's paintings or the photographs on which they were based. We do know that the two men could have connected socially at any time over the previous two decades within the smallish elite that both knew in New York. In the 1860s Bradford shared studio space with painter Albert Bierstadt when, emulating the success of artists like Bierstadt and Frederic Church, Bradford was courting wealthy donors for funds to launch his expeditions to the far North.[15] During the same period, in 1865, author and traveler

Bayard Taylor invited Melville to a meeting of the newly formed Travellers' Club, noting off-handedly that Melville would know many of the other invitees: "Darley, Church, Bierstadt, Gottschalk, Cyrus Field," among others.[16] Church and Bierstadt, of course, provide an intriguing link between Bradford and Melville, although we have no evidence of a direct connection.

Melville might also have heard of Bradford's expeditions through other friends in the travel world. The American Geographical Society, where Bradford gave his 1885 lecture, had been in operation since 1854 and included among its founders Melville's old family friend and patron Alexander W. Bradford (no relation to the painter, as far as I know). The list of fellows past and present included Melville's brother-in-law John C. Hoadley and his brother Allan's brother-in-law, Richard Lathers, along with friends Cyrus Field (mentioned in Bayard Taylor's letter above), David Dudley Field (the Stockbridge friend who introduced Melville and Hawthorne), Henry Smythe (Melville's employer at the New York Customs House), and the aforementioned Alfred Bierstadt. The long roster also includes names from New York's oldest families, some of them familiar to Melville. The same American Geographical Society journal volume that included the full text of Bradford's lecture also featured David Dudley Field as the author of an article on the Indian names of American cities and towns.[17] It is not hard to imagine that Melville would have followed the Society's doings with considerable interest or read Bradford's lecture in its *Journal* volume of 1885.

If so, then Melville would have gathered stunning and graphic details of Inuit life, as well as a pretty fair picture of Bradford's racial bias. Much of the lecture, of course, concentrates on the rigors of travel via steamer in the Far North, thrilling landscapes of icebergs and northern lights, the "presence of a nature of such sublimity" that "surpasses the flights of imagination." As a painter, Bradford naturally stresses the remarkable effects of form, light, and color in polar landscapes. But some of the most sensational parts of his talk contain vivid descriptions of Inuits, and here Bradford speaks candidly of their (to him) distasteful appearance and practices. In spite of his admiration of their skills as kayakers, their friendly welcome of strangers, and their remarkable dancing, he cannot overcome his disgust at the odor of Inuit houses—an "ancient and fish-like smell" that he says was plainly "awful." He commiserates with Jensen, a Danish man living with his family in an isolation that he considers worse than loneliness, "for the few filthy Eskimos, with their packs of howling, vicious dogs, and their general wretchedness, cannot give companionship" to Europeans. Nor does Bradford conceal his preference for one girl's "almost pure Caucasian complexion with transparent skin and rosy cheeks," or the superiority of a certain "Miss Sophia," "the most intelligent young Eskimo woman in Greenland," over a "witch" of whom he remarks "a

more repulsive-looking being never walked in darkness and conspired with the evil one."[18] In *The Arctic Regions*, in fact, he places the image of a light-complexioned native woman in her festive costume directly over that of a darker-skinned woman, perhaps the "witch," and to the lower image appends this caption: "The ugliest-looking Esquimaux woman we found."[19] Granting that Melville probably did not see these images, either as lantern-slides or in *The Arctic Regions*, we might still conclude that if he read Bradford's lecture before the American Geographical Society he could not have missed its frank expressions of misogyny and racism.

Yet here it is important to distinguish between Bradford's different representations of the Arctic. In the New York lecture, in lantern-slides based on Dunmore and Critcherson's photographs, and in *The Arctic Regions*, where the same images had earlier appeared, Bradford records seemingly factual photographic evidence of Inuit people and culture, along with his judgments of their supposed thievery, lying, drunkenness, and torpor. His paintings tell a very different story. Here the only Arctic natives are polar bears and seals. As I have suggested elsewhere, these animal natives seem to stand in for humans, and Bradford represents them more sympathetically than he does the Inuits in his book.[20]

So, for example, in his painting "Arctic Intruders" (1882), he draws on an experience narrated in *The Arctic Regions*, where members of his expedition shoot a mother polar bear and her cubs. Dunmore and Critcherson's photographs show heaps of animal carcasses, but the painting humanizes the polar bear, emphasizing her heroism as she guards her dead cub and her forlornness and isolation in a vast landscape in which the white hunters appear as tiny figures with guns—ultimately insignificant in the face of sublime nature. Bradford's title further highlights the painting's ethical challenge: for "Arctic" does not modify or define "Intruders." Rather it identifies the ground being intruded upon. By extension, then, the polar bears appear to represent an Arctic way of life that white humans with weapons and steamships—Bradford's vessel, the *Panther*, appears as a dim presence in the background—seem determined to obliterate.

An earlier Bradford painting, "Ice Dwellers Watching the Invaders" (c. 1875) (see figure 2.1) makes the point even more explicitly. Although it seems to invoke standard features of the Arctic sublime in ways familiar to Bierstadt, Church, or other artists—towering forms of gigantic icebergs, glowing tints and pungent contrasts of lights, the brilliant reflective surfaces of water—Bradford also introduces disturbing elements that challenge romantic conventions. One is the presence of the ship with its blast of black smoke cutting horizontally across the spires of ice. This is no picturesque reminder of a distant, pastoralized civilization à la Leo Marx. Bradford's vessel,

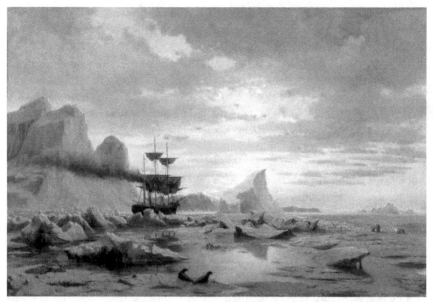

Figure 2.1. William Bradford, "Ice Dwellers Watching the Invaders" (c. 1875).
Courtesy of the New Bedford Whaling Museum, www.whalingmuseum.org.

the *Panther*, was a former sealer, built for cutting through polar ice. During the 1869 voyage it became trapped at one point in the fields and floes, but generally its considerable steam power cut a forceful swath through the ice islands. Here, although the ship lies at rest in a quiet cove, its infernal smoke and heavy hull dominate the scene and are reflected darkly in the calm, luminous water. Unlike a painting like Church's "Icebergs," where a fragment of a ship's mast refers subtly to the lost ship, Bradford's painting shows the indomitable vessel as an intrusive presence.

 In a further irony, the "Ice Dwellers" of the title are seals. Bradford's viewers might not have been aware that the vessel was once a sealer, now being used to convey wealthy New York adventurers to Greenland, but they could not have missed the dramatic contrast between looming ship and living animals poised at the lower edge of the canvas. The title reinforces the obvious imbalance of power, as nonhuman ice dwellers contemplate human invaders entering their domain. No amount of dramatic lighting and brilliant color can efface the violence of this uneven contest. Yet the ice holds both invading ship and ice dwellers in a moment of unnatural calm, similar to what Bradford produces in "Arctic Intruders," where the slaughter has already commenced but gets suspended for a brief instant as humans and animals contemplate each other. In such a moment, the human gaze dissolves. Differences of race and even species seem, for a brief spell, to disappear.

Bradford, then, seemed to achieve quite different effects in different works: the painterly (or imaginative or narrative) in his landscapes and the photographic (or realistic or more harshly critical) in the book he used to advertise and document his Arctic explorations. But Melville's "The Berg" seems to deploy both painterly and photographic strategies, if in puzzling ways. It is not difficult, perhaps, to detect in the poem what is imaginative or narrative. It may be harder to locate what might be thought of as photographic. Yet certain details suggest the focus of a new kind of lens for Melville, one that may owe its harsh clarity to emerging visual technologies.

The poem in any case is unsettling. Subtitled "A Dream," it proceeds through four stanzas that suggest the presence of a human observer but that in other ways undermine human consciousness—or what Ahab calls in Starbuck a "human eye."[21] The poem's challenge to human perception makes it difficult to detect a racial presence anywhere in its lines. But Bradford's paintings unexpectedly illuminate Melville's oblique evocation of racial themes.

As in Bradford's paintings, images associated with Arctic sublimity seem to offer a conventional vocabulary of visual signs. Melville's opening stanza draws on associations with shipwreck and desolation that artists like Caspar David Friedrich, Frederic Church, and Edwin Henry Landseer, as well as writers like William Cowper, Samuel Taylor Coleridge, Mary Shelley, Edgar Allan Poe, and Jules Verne had made popular.

> I saw a Ship of martial build
> (Her standards set, her brave apparel on)
> Directed as by madness mere
> Against a stolid Iceberg steer,
> Nor budge it, though the infatuate Ship went down.
> The impact made huge ice-cubes fall
> Sullen, in tons that crashed the deck;
> But that one avalanche was all—
> No other movement save the foundering wreck.[22]

Melville is clearly using aesthetic conventions in sly ways. In contrast with polar expedition narratives that stress human heroism, as in the first reports of Franklin's quest (to which, with the "brave apparel," he may be referring here), Melville's poem describes human aspiration as "madness mere," the vessel as an "infatuate Ship." And although with the opening first-person pronoun he posits a human witness, his subtitle undermines what that witness "saw" or could have seen in what is named "A Dream." Just as disconcertingly, Melville also strips the massive iceberg of any suggestions of sublimity. It is "stolid," not magnificent. It breaks into "huge ice-cubes," rather than offering a majestic spectacle of crags and jagged peaks. Its aspect is "sullen," not grand. As an added twist, the double meaning of "save"—meaning "except"

but also implying that nothing can save the ship—deprives the reader of the comforting lesson of the sublime: that its grandeur may in some way cure human ennui or elevate the human spirit.

From this opening, the poem departs further and more radically from what we might consider a human-centered perspective. The second stanza focuses instead on the iceberg's lack of response to the collision:

> Along the spurs of ridges pale,
> Not any slenderest shaft and frail,
> A prism over glass-green gorges lone,
> Toppled; nor lace of traceries fine,
> Nor pendant drops in grot or mine
> Were jarred, when the stunned Ship went down.[23]

These lines alone in the poem acknowledge any beauty in the berg, with its slender shafts, its "glass-green gorges," "traceries fine," and "pendant drops." Following on these mellifluous phrases, however, the forbidding beat of monosyllables—"in grot or mine / Were jarred, when the stunned ship went down"—implies the definite flight of any prettiness from the poem. Furthermore, it is clear that the only possible response would be physical, not emotional. The berg cannot feel anything for the ship; it might only "topple" or be "jarred."

Melville's third stanza seems to confirm the spatial patterns of the poem. As in the first two stanzas, this one is structured around a dramatic fall, moving from an image of height or distance to a crash: as, at first, from the "Ship of martial build" with her "brave apparel" to a "foundering wreck"; or from the "spurs of ridges pale" to where "the stunned Ship went down." In the third stanza too, after showing the gulls "circling one snow-flanked peak afar," it ends as "the Ship in bafflement went down."

> Nor sole the gulls in cloud that wheeled
> Circling one snow-flanked peak afar,
> But nearer fowl the floes that skimmed
> And crystal beaches, felt no jar.
> No thrill transmitted stirred the lock
> Of jack-straw needle-ice at base;
> Towers undermined by waves—the block
> Atilt impending—kept their place.
> Seals, dozing sleek on sliddery ledges
> Slipt never, when by loftier edges
> Through very inertia overthrown,
> The impetuous Ship in bafflement went down.[24]

The berg's towers and heights, with birds flying near and far, remain remote—"felt no jar," "kept their place"—while once again the ship hurtles "down" beneath the waves. But this time Melville's speaker imagines an intermediate space, the "crystal beaches" and "sliddery ledges" where the seals are "dozing sleek." The seals may feel the collision no more than "towers" do, but they offer a fleeting glimpse of animate life in a scene otherwise unpopulated except for alien birds. And they hold their own between the vast towers and the "impetuous Ship" in a space that is nonhuman but nevertheless alive in ways that the iceberg and the ship are not.

It might be a leap too far to imagine that the seals are also reminders of Bradford's nonhuman subjects—insistently Arctic and native, that is, if not racialized. But they are a puzzling presence nevertheless. The poem seems to leave them quickly, returning to the human observer ("methought"), who delivers a sarcastic diatribe at the iceberg itself:

> Hard Berg (methought), so cold, so vast,
> With mortal damps self-overcast;
> Exhaling still thy dankish breath—
> Adrift dissolving, bound for death;
> Though lumpish thou, a lumbering one—
> A lumbering lubbard loitering slow,
> Impingers rue thee and go down,
> Sounding thy precipice below,
> Nor stir the slimy slug that sprawls
> Along thy dense stolidity of walls.[25]

In this address to the berg, the speaker of the poem humanizes the ice itself, representing it less as a collection of shafts and towers—images at least of height, if not of moral or aesthetic superiority—than as a "lumbering lubbard," not unlike Melville's "Maldive Shark," a "dotard lethargic and dull."[26] For the fourth time, something goes "down," here the "Impingers" that "rue thee." But much less than in the other stanzas is the spectacle of what goes down at all terrifying, at least in the terms offered by the sublime. Instead the berg looks—human. Like humans it is "mortal." Like humans it respires, "Exhaling still thy dankish breath." Like humans it is "bound for death." And like many humans, it is unbeautiful: "a lumbering one— / A lumbering lubbard loitering slow."

Perhaps, then, as in some of Bradford's paintings, the presence of Arctic animals—reproachful polar bears or silent seals—casts shade on human intruders. Perhaps the presence of nature in frigid zones does not elevate human character as in the sublime but radically reduces human significance. But Melville's poem further undermines any conclusions about its meaning in

the final lines, where for the first time the speaker imaginatively dives under the berg—traveling below the surface to imagine the "Impingers," not just going "down" but also "Sounding thy precipice below"—taking the measure of vast depths as well as heights of the berg's "dense stolidity." Melville introduces a "slimy slug" as witness of this final degradation. Like the seals, the "slimy slug" rests on "sliddery ledges," but is even less picturesque, as it dully "sprawls," rather "dozing" on the berg's "crystal beach."

What, we might ask, is a slug doing on an iceberg? Or in a Melville text? In Melville's other works slugs occasionally appear, more often as part of the word "sluggard" (rhymes with "lubbard") that is almost always applied to humans. In *Clarel*, however, Melville memorably evokes sea slugs, as Clarel reflects that the monuments of Jerusalem on which faith relies will eventually erode, wash away, and fall into the sea:

> Its substance ebbs—see, day and night
> The sands subsiding from the height;
> In time, absorbed, these grains may help
> To form new sea-bed, slug and kelp.

At the beginning of the poem, Clarel associates the Jerusalem skyline with images of icebergs: "Like the ice bastions round the Pole, / Thy blank, blank towers, Jerusalem!"[27] But neither in *Clarel* or anywhere else does Melville directly juxtapose sea slugs with polar ice.

Yet here he does, and a logical conclusion might be that in "The Berg" the slug is a metaphor for a seal, if not an especially beautiful one. In her essay, "Reading Antarctica: How I Learned to Stop Worrying and Love 'Moby-Dick,'" Pakistani novelist Kamila Shamsie connects Melville, polar ice, seals, and slugs vividly: "how we gasped in amazement at the first Weddell seal moving across the snow like a slug."[28] Shamsie sees the resemblance between seals and slugs, but like Melville she does not invest them with the aura of wonder that Bradford gives seals in his paintings. Piling on even more insults, Melville writes that his "slug" is "slimy" and "sprawls." By the end of "The Berg," if the slug is actually a seal, it is no longer "dozing sleek" on a "sliddery ledge" but seems to have oozed out of some ancient and primal seabed to disgust the human observer.

For Shamsie, the seals not only challenge credulity and her powers of description but suggest as well the limits of cell phone photography. We have little evidence that Melville is thinking of cameras when he uses the image of the slug. But it might be a mistake to rule out the possibility that the speaker of "The Berg" could be viewing his subject through a photographic lens. By 1885 Melville had come a long way from the impetuous young writer who refused Duyckinck a daguerreotype.[29] Unlike Nathaniel Hawthorne, Freder-

ick Douglass, Oliver Wendell Holmes, or Walt Whitman, all fascinated by photography and especially portraits, Melville mentions photographs explicitly only in *Battle-Pieces: And Aspects of the War* (1866). Various poems in *Battle-Pieces* focus on painted images—"Formerly a Slave," or "The Coming Storm," for example,—but only "On the Photograph of a Corps Commander" refers to contemporary imaging technology. The poem, however, as "Formerly a Slave" does, offers an "idealised portrait" of its subject. In praising the Corps Commander—"Ay, man is manly. Here you see / The warrior-carriage of the head"—and reflecting on the power of courage to unite people in a great cause—"But manly greatness men can span, And feel the bonds that draw"—the speaker says almost nothing about the photograph itself, except to call it "A cheering picture."[30] Andrew Miller argues that Melville's one example of photographic ekphrasis treats the medium as a Platonic icon and sacred record of the spirit, "celebrating the camera's image as a radiant node of truth."[31] Perhaps, then, Melville's depiction of the Corps Commander draws on popular notions of the photograph as a medium of inner light or character as well as an external and artificial means of capturing the human spirit.

Another possibility might be that Melville views the photographic portrait in the more subversive way that John Stauffer, Zoe Trodd, Celeste-Marie Bernier, and Henry Louis Gates claim for Frederick Douglass. Their book *Picturing Frederick Douglass* presents the "idealised" and much photographed former slave, abolitionist, and friend of Lincoln as a canny user of visual media, a shape shifter whose images show the many ways to be a black man in America, and, in "Lecture on Pictures," "Age of Pictures," and "Pictures and Progress," a theorist of photography as well.[32] The example of Douglass shows, as Bradford's ethnographic images do as well, what Gates describes as a visual form of chiasmus—the "anti-slave" present in the image of the slave, the unacknowledged or nearly invisible antitype to what the photograph represents.[33] If Melville's berg is large, looming, and white, then the "slimy slug" is by definition not white. It is not the Arctic intruder. It is native and racialized, if, in this image, more disturbing than Bradford's seals.

Hence if "The Berg" is any evidence of Melville's evolving view of the photographic image, it shows him traveling a long way from the "idealised" portraiture of Civil War photographs.[34] But even earlier, in another context, Melville wrestled with visual technology and with images of color as possible racial antitypes. In "The Whiteness of the Whale," Ishmael struggles to represent un-representable color: "It was the whiteness of the whale that above all things appalled me. But how can I hope to explain myself here; and yet in some dim, random way, explain myself I must, else all these chapters might be naught." After exhausting the possibilities of encyclopedic analogy, listing every thinkable example of whiteness in human, animal, natural, and abstract

worlds, Ishmael concludes that what he seeks cannot be visualized. He knows that "the nameless things of which the mystic sign gives forth such hints . . . somewhere those things must exist." But they are hidden: "Though in many of its aspects this visible world seems formed in love, the invisible spheres were formed in fright." The ambiguity of the passive verb elides the question of *whose*. Whose are the spheres "formed in fright"? Are they formed by evil forces that conceal themselves out of nefarious motives or from fear of being exposed? Or have humans turned away their gaze from something they cannot bear to regard? Whatever the case, "invisible spheres," in being whatever is excluded by visible ones "formed in love," must belong to whatever is "most appalling to mankind."[35]

Ishmael then likens human vision to the wearing of "colored or coloring glasses" that make a "white or colorless" world visible to human eyes. Again, the seeing is ambiguous. Are colors "but subtle deceits, not actually inherent in substances, but only laid on from without; so that all deified Nature absolutely paints like the harlot"? Or are humans like "willful travellers in Lapland," who can choose whether to wear their "colored or coloring glasses" as they wish? Ishmael does not decide, leaving behind a trail of question marks: "Wonder ye then at the fiery hunt?"[36] But his inquiry raises pertinent questions about visual technology (the glasses) and whether it reveals or further obscures human perceptions of color.

Noting in passing that Inuits (and possibly Laplanders) used sun-blocking goggles long before Europeans discovered colored glasses, we may return to "The Berg" with a more refined notion of how the poem's speaker sees his subject—perhaps through a camera lens, or perhaps in a photograph like the ones Bradford published, where the icebergs drift so far in the distance that a seal might resemble a sea-slug. The caustic tone of Melville's poem, however, with its mockery of the berg's pallid sloth and lumbering gait, suggests that his target is racial ideology as well as a spectacle of Arctic whiteness. As Toni Morrison points out in "Unspeakable Things Unspoken," Melville had been racializing color at least since the writing of *Moby-Dick*. Ahab's pursuit of an "ideology of whiteness" becomes visible, Morrison suggests, when placed in the context of the Fugitive Slave Act of 1850 and Lemuel Shaw's ruling in the Sims case in 1851.[37] Shirley Samuels goes further in describing "such whiteness, the whiteness of the albino . . . as an unnaturally racialized category."[38] Might not the slug serve as a similar reminder of jarring and unnatural color contrasts that an eye could become trained not to see? Melville's slug is appalling, not so much because slugs are evil or repulsive but because they distract the eye away from the appalling whiteness of the berg, on which many an "infatuate Ship" might founder. Even the "dozing" seals begin to look menacing when it becomes clear that they sleep on the

"sliddery ledges" of a slippery whiteness. Indeed, what is "so cold, so vast," so "bound for death" as white ideology itself? When "Impingers" plunge into the depths, they see only more submarine vastness, the "precipice below" the towering surface, that like the Sermitsialik Glacier in Bradford's book seems an endless battery of ice, a "dense stolidity of walls."

What we may see in "The Berg," then, is an embrace of what photography can make visible—the stark reality of racialist ideology—and a recognition of what makes the spheres of fright invisible: not whiteness itself but the vision of whiteness as something naturally and morally superior. That vision—or blindness—Melville's poem seems to say, must itself go down into the sea with a resounding crash.

NOTES

1. William Bradford, *The Arctic Regions: Illustrated with Photographs Taken on an Art Expedition to Greenland*, ed. Michael Lapides (Boston: David R. Godine, 2013).

2. For a consideration of gender and racial hierarchies in Bradford's *Arctic Regions,* see Wyn Kelley, "Seeing Twice: William Bradford's *The Arctic Regions* in Print and Paint," *J19: The Journal of Nineteenth-Century Americanists* 3, no. 2 (Fall 2015): 429–36.

3. François Specq, "Quest for the Sublime and Rhetoric of Empire in Bradford's *The Arctic Regions*," in *Transcendence: Seekers and Seers in the Age of Thoreau* (Higganum, CT: Higganum Hill Books, 2006), 185–213.

4. Herman Melville, "The Berg," in *John Marr and Other Poems* (Princeton, NJ: Princeton University Press, 1922), 78–79.

5. Herman Melville, *Moby-Dick: Or the Whale*, eds. Harrison Hayford, Hershel Parker, G. Thomas Tanselle (Chicago and Evanston, IL: Northwestern University Press and the Newberry Library, 1988), 195.

6. For Arctic-related sources of *Moby-Dick*, see Merton M. Sealts, Jr., *Melville's Reading* (Columbia: University of South Carolina Press, 1988); and Mary K. Bercaw, *Melville's Sources* (Evanston, IL: Northwestern University Press, 1987).

7. Melville, *Moby-Dick*, 54, 536.

8. See Hester Blum, "Melville and Oceanic Studies," in *The New Cambridge Companion to Melville*, ed. Robert S. Levine (Cambridge: Cambridge University Press, 2013), 22–36; Russell Potter, *Arctic Spectacles: The Frozen North in Visual Culture, 1818–1875* (Seattle: University of Washington Press, 2007).

9. Melville, "The Berg," 79.

10. For biographies of William Bradford, see Richard C. Kugler, "William Bradford," in *William Bradford: Sailing Ships and Arctic Seas*, ed. Richard C. Kugler (Seattle: University of Washington Press, 2003), 1–42; Russell A. Potter, "Introduction," in William Bradford, *The Arctic Regions: Illustrated with Photographs Taken on an*

Art Expedition to Greenland (1873), ed. Michael Lapides (Boston: David R. Godine, 2013), xix–xxv; and John Wilmerding, *William Bradford: Artist of the Arctic*, exhibition catalog (Lincoln and New Bedford, MA: De Cordova Museum and New Bedford Whaling Museum, n.d.).

11. William Bradford, *The Arctic Regions: Illustrated with Photographs Taken on an Art Expedition to Greenland* (London: Samson Low, 1873). Samson Low was also the London publisher of Melville's novel *Pierre: or, The Ambiguities* (1852).

12. "Life and Scenery in the North. Wm Bradford on His Explorations. His Address Before the Geographical Society—Some of the Illustrations," *New-York Tribune*, November 14, 1885. N.p.

13. See Potter, *Arctic Spectacles,* 200–201; Potter, "Introduction," xxiii–xxv.

14. William Bradford, "Life and Scenery in the Far North," *Journal of the American Geographic Society of New York* 17 (1885): 79–124.

15. Kugler, "William Bradford," 22.

16. Herman Melville, *Correspondence*, eds. Lynn Horth, Harrison Hayford, Hershel Parker, G. Thomas Tanselle (Chicago and Evanston, IL: Northwestern University Press and Newberry Library, 1993), 696.

17. David Dudley Field, "On the Nomenclature of Cities and Towns in the United States," *Journal of the American Geographic Society of New York* 17 (1885): 1–16. For the list of founders, see "Charter of Incorporation," vii; for "Fellows," see xxi–xxxv.

18. Bradford, "Far North," 79, 90, 113, 91, 100, 111.

19. Bradford, *Arctic Regions* (1873), 33.

20. Kelley, "Seeing Twice."

21. Melville, *Moby-Dick*, 542.

22. Melville, "The Berg," 78.

23. Melville, "The Berg," 78.

24. Melville, "The Berg," 78–79.

25. Melville, "The Berg," 79.

26. Herman Melville, "The Maldive Shark," in *Published Poems*, 236.

27. Herman Melville, *Clarel: A Poem and A Pilgrimage in the Holy Land*. New York: G. P. Putnam & Co., 1876, 10.

28. Kamila Shamsie, "Reading Antarctica: How I Learned to Stop Worrying and Love 'Moby-Dick,'" *New York Times*, January 30, 2015.

29. Melville, *Correspondence*, 180.

30. Herman Melville, "On the Photograph of a Corps Commander," in *Published Poems*, 77.

31. Andrew Miller, "Favoring Nature: Herman Melville's 'On the Photograph of a Corps Commander,'" *Journal of American Studies* 46.3 (2012): 679.

32. John Stauffer, Zoe Trodd, Celeste-Marie Bernier, *Picturing Frederick Douglass* (New York: Liveright Publishing Corporation, 2015).

33. Henry Louis Gates, "Epilogue," in *Picturing Douglass*, 197–216.

34. Melville implicitly responds in *Battle-Pieces* to news and battlefield images as well. But he does not mention Matthew Brady's photography except in relation to

the portrait of General Hancock, the "Corps Commander" whom he never identifies by name in his poem.

35. Melville, *Moby-Dick*, 188, 194–95.

36. Melville, *Moby-Dick*, 195.

37. Toni Morrison, "Unspeakable Things Unspoken: The Afro-American Presence in American Literature," *Michigan Quarterly Review* 28.1 (1989), 1–34.

38. Shirley Samuels, *Reading the American Novel, 1780–1865* (Oxford and Malden: Wiley-Blackwell, 2012), 69.

BIBLIOGRAPHY

Bercaw, Mary K. *Melville's Sources*. Evanston, IL: Northwestern University Press, 1987.

Blum, Hester. "Melville and Oceanic Studies." In *The New Cambridge Companion to Melville*. Edited by Robert S. Levine. Cambridge: Cambridge University Press, 2013. 22–36.

Bradford, William. *The Arctic Regions: Illustrated with Photographs Taken on an Art Expedition to Greenland*. London: Samson Low, 1873.

Bradford, William. *The Arctic Regions: Illustrated with Photographs Taken on an Art Expedition to Greenland*. Edited by Michael Lapides. Boston: Godine Press, 2013.

———. "Life and Scenery in the Far North." *Journal of the American Geographic Society of New York* 17 (1885): 79–124.

Field, David Dudley. "On the Nomenclature of Cities and Towns in the United States." *Journal of the American Geographic Society of New York* 17 (1885): 1–16.

Kelley, Wyn. "Seeing Twice: William Bradford's *The Arctic Regions* in Print and Paint." *J19: The Journal of Nineteenth-Century Americanists* 3, no. 2 (Fall 2015): 429–36.

Kugler, Richard C. "William Bradford." In *William Bradford: Sailing Ships and Arctic Seas*. Edited by Richard C. Kugler. Seattle: University of Washington Press, 2003. 1–42.

"Life and Scenery in the North. Wm Bradford on His Explorations. His Address Before the Geographical Society—Some of the Illustrations." *New-York Tribune*. November 14, 1885. N.p.

Melville, Herman. *Moby-Dick: Or the Whale*. Edited by Harrison Hayford, Hershel Parker, G. Thomas Tanselle. Chicago and Evanston, IL: Northwestern University Press and Newberry Library, 1988.

———. *Clarel: A Poem and A Pilgrimage in the Holy Land*. New York: G. P. Putnam & Co., 1876.

———. *Correspondence*. Edited by Lynn Horth, Harrison Hayford, Hershel Parker, G. Thomas Tanselle. Chicago and Evanston, IL: Northwestern University Press and Newberry Library, 1993.

———. *John Marr and Other Poems*. Princeton, NJ: Princeton University Press, 1922.

————. *Published Poems*. Evanston, IL: Northwestern University Press, 2009.
Miller, Andrew. "Favoring Nature: Herman Melville's 'On the Photograph of a Corps Commander.'" *Journal of American Studies* 46.3 (2012): 663–79.
Morrison, Toni. "Unspeakable Things Unspoken: The Afro-American Presence in American Literature." *Michigan Quarterly Review* 28.1 (1989), 1–34.
Potter, Russell. *Arctic Spectacles: The Frozen North in Visual Culture, 1818–1875.* Seattle: University of Washington Press, 2007.
————. "Introduction." In William Bradford, *The Arctic Regions: Illustrated with Photographs Taken on an Art Expedition to Greenland.* Edited by Michael Lapides. Boston: David R. Godine, 2013. xix–xxv.
Samuels, Shirley. *Reading the American Novel, 1780–1865.* Oxford and Malden: Wiley-Blackwell, 2012.
Sealts, Merton M., Jr. *Melville's Reading.* Columbia: University of South Carolina Press, 1988.
Shamsie, Kamila. "Reading Antarctica: How I Learned to Stop Worrying and Love 'Moby-Dick.'" *New York Times*, January 30, 2015.
Specq, François. "Quest for the Sublime and Rhetoric of Empire in Bradford's *The Arctic Regions*." In *Transcendence: Seekers and Seers in the Age of Thoreau.* Higganum, CT: Higganum Hill Books, 2006, 185–213.
Stauffer, John, and Zoe Trodd, Celeste-Marie Bernier. *Picturing Frederick Douglass.* New York: Liveright Publishing Corporation, 2015.
Wilmerding, John. *William Bradford: Artist of the Arctic.* Exhibition catalog. Lincoln and New Bedford, MA: De Cordova Museum and New Bedford Whaling Museum, n.d.

Chapter Three

Music and Military Movement

Racial Representation

Brigitte Fielder

In his popular 1852 novel, *Clotel; or, the President's Daughter*, William Wells Brown writes about the integrated balls at which mixed-race women enact their tragic relationships with wealthy white men through dance. Brown describes the phenomenon of the "negro ball" attended by "quadroon and mulatto girls, and white men" as "democratic gatherings where gentlemen, shopkeepers, and their clerks, all appear upon terms of perfect equality."[1] These "negro balls" were racially integrated public dances at which cross-racial romantic connections were supposed to be made, also called "quadroon balls" after the mixed-race women with whom they were often associated. For Brown and many others, the dance floor became an important scene upon which the dynamics of race and sex could be thought in antebellum culture. While the locations, occurrence, and frequency of such dances are not known definitively, the "quadroon ball" became an event of mythic significance by the antebellum period, evoking either shock or titillation at the alleged impropriety of racial mixing to the majority of white Americans. The image of differently racialized bodies moving and relating to one another in dance became a visual metaphor of sorts for racial integration within other national contexts and at various scales. Racially integrated dances therefore represented potential spaces of social and political equality with which white supremacists would continue to voice (and legislate) their discomfort until well into the twentieth century.

 The archive of nineteenth-century visual culture abounds with descriptive and visual illustrations of racial integration, which reflect popular white anxieties about racial mixture and movement. In the context of "amalgamation" or racial mixture, depicting race—which is not always visible or discernable—translates well to the practice of depicting sound and movement—that which it is also difficult to represent visually. The illustration of race hereby also

illustrates the nature of race, itself, as constructed through the various media that purport to merely represent race. Racial representation has often been confined by the mediums used to depict its complexity—from language that describes race via metaphors of color to the technology of racial representation in black-and-white that obscures non-dualistic racial gradation.[2] Written music, like the written word, is a technology of representation. The visual representation of music and the visual representation of race are similar in that they are not mimetic but symbolic. Just as quarter and half notes stand in for certain pitches and durations that might be interpreted through variations such as instrumentations and style, the presence and absence of black ink represents racial difference that in reality is nuanced by gradations in complexion, historical contexts, and cultural resonances of racialization.

I begin my discussion with a single sheet of illustrated music, "Amalgamation Waltz and African's [*sic*] March in Turkey"—which adds to the depiction of racial difference, movement and mixture conveyed through the representation of sound in written music.[3] Layering illustrations of figures in movement atop the symbolic notation of the aural, the music conveys its narrative of race via musical, rather than literary genres: the waltz and the march. Both the waltz and the march produce bodies in motion. I situate these pieces in a broader U.S. context of depictions of racially integrated dance and military movement. The movement of racialized bodies through geopolitical spaces and with relation to one another hints at race's fluidity.

MUSICAL MOVEMENT AND RACIAL REPRESENTATION

"Amalgamation Waltz and African's [*sic*] March in Turkey" was a single sheet of music distributed by George P. Reed, a Boston music store owner and a seller of musical instruments, instruction books, and sheet music during the 1830s and 1840s.[4]

In the two musical genres on this music sheet, we see what might be understood as different methodological frames for understanding their respective narratives of race. The waltz's male and female pairing of partners suggests heterosexuality. The march denotes a different kind of movement, not simply interpersonal, but movement through geopolitical spaces and in militaristic endeavors. Both pieces' representation in not only music, but illustration, speak to other visual representations of racialized bodies from the time period. The simplicity of these stick-figure characters differs from more common, caricatured, illustration and this juxtaposition with musical form suggests movement that gestures toward—but which must not be simply equated with—musical and bodily performance.

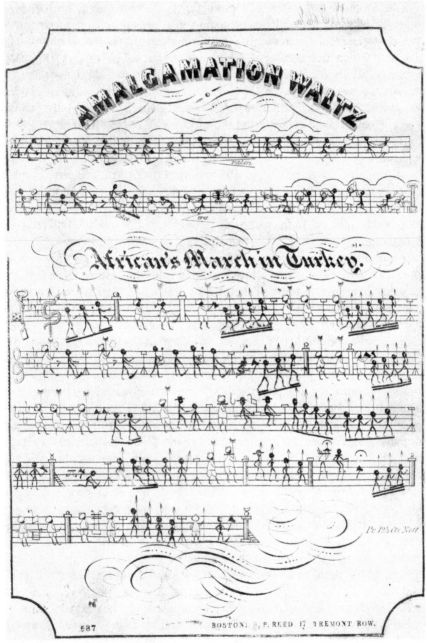

Figure 3.1. "Amalgamation Waltz" and "African's March in Turkey," sheet music, published by George P. Reed, Boston.

Courtesy of the American Antiquarian Society, Worcester, Massachusetts.

The limitations of the musical form for representing race corresponds to other limitations of racial representation in metaphors of color, racialized value, and racial distinctions that forego complexity in favor of legibility. The extent to which race becomes legible through musical notation is admittedly limited. This sheet music is, in many ways, difficult to read. The stick-figure drawings crowd the notes, making one wonder at the practicality of playing the musical notation. The parlor was a domestic space in which music would be both played and displayed, and this piece seems to lend itself more clearly to the latter. The sheet is poised to function less as legible musical notation and more as a visual showpiece. Notwithstanding its visuality, the flatness of stick-figure characters obscures the political import that is clearer in other racial/racist caricatures. Nevertheless, these juxtapositions of the movement of black and white bodies and the movement of music thematize relations of race within musical form, marking race as always in motion, unfixed, and progressing through a specific, readable generic narrative.

According to *George P. Reed's Catalogue of Select Publications* (a broadside advertisement on which the piece I discuss here is not listed), the establishment sold a variety of sheet music, instrument, and other musical accoutrements. Reed lists musical pieces in categories relating to dance, such as "Marches and Quicksteps," "Waltzes," and "Quadrilles, Dances, &c." Much of this music was arranged for piano, and Reed also advertises "Piano Fortes tuned" as a service the shop provides.[5] The piano was a popular nineteenth-century instrument, the ownership of which indicated material wealth, leisure time, and education. The piano's place in the home was usually the parlor or a similar space for entertaining guests, suggesting its importance for not only performance but also sociality. The social space of the parlor was also a space of racial performance and construction. Jasmine Cobb characterizes what she calls the "transatlantic parlor" as "a place for dissimilar groups of people and cultural producers to convene around visions of Blackness separated from slavery."[6] As Cobb's work shows, depictions of free black people were not always produced in the spirit of antiracism, and racist caricatures illustrated white racist fears of black people's freedom, movement, and occupation of domestic spaces (like the home and the nation) that according to many were coded as white. To think about this representation of race as a "parlor piece" of sorts is also to think about how this inflects upon widespread notions of racial relations. Both the waltz and the march suggest possible interpretations of racial movements and relations, which I will discuss in the next two sections.

Still, the visual text we see here is difficult to relate to other genres of racial representation. This sheet is not itself the music it depicts or an event of dance performance, but an illustration suggesting the relationship between these. Reed also published texts such as "The Young Minstrel: A Collection

of Music for the Use of Schools," a series of songs, with lyrics, arranged in three-part harmony. While here referring to song more generally, the term "minstrel" was most commonly associated with the racialized performance of song and dance, either by African American people, or white people in blackface makeup. Even off the stage, minstrel songs circulated as sheet music, bringing this into homes and evoking ideas of caricatured blackness. This sheet music seems to do work similar to sheet music for minstrel songs, even while its simplicity differentiates it from the visual representations of race associated with the blackface minstrel stage.

The nondescript stick-figure characters are not embodied blackface performers, nor are they detailed enough to constitute what we might call illustrated racial caricature, even as they allude to other popular caricatured depictions of black people. While minstrel sheet music might include a cover sheet illustration of caricatured black or blackface performers, the illustration of this sheet is contained not as a cover image, but in the music itself. These simple figures are not simply ambivalent about race and racial difference, however. While very little information about this particular sheet of music—who composed/illustrated it, what their connection to George P. Reed might have been, how many of these sheets were distributed, and where and how they might have been used—is available, putting this sheet into conversation with a larger context of representing racialized bodies, music, dance, and movement can help us to understand some of the cultural work such a piece must have done in the early nineteenth century.

Not simply a sheet of music, this piece is inherently difficult to categorize. By embedding the illustration within the music itself, the sheet demands that we read it within different genres—sheet music and illustration—simultaneously. The music itself is represented, but not necessarily played or heard. Still, this piece "works" even as it remains silent and calls to mind the other related genres—music, dance, and other forms of embodied performance, as well as political caricature and political action. Still, this visual representation should not be conflated with any of the various things it might represent. The illustrated sheet is not itself music, dance, or performance, even as it represents these. To read this music then, is to acknowledge these overlapping areas of categorization, but also to note the various genres to which the sheet alludes and how. Both the representation of racialized figures as part of a musical waltz and march and the juxtaposition of these two musical forms work within a larger visual context for representing race. My reading will take an oddly amalgamated march through these related and overlapping textual genres and forms of representation in an attempt to situate this piece, despite this difficulty of categorization, within the larger context available for understanding it.

AMALGAMATION DANCES

In nineteenth-century America, the image of a racially integrated dance was a popular site for American anxieties about race relations. Illustrations of integrated dances appeared throughout the antebellum period, in *Amalgamation Waltz* from Edward Williams Clay's 1839 "Practical Amalgamation" series of lithographs, his 1845 *Amalgamation Polka* (see fig. 3.2), and the 1864 political caricature *The Miscegenation Ball*.[7]

The underlying movement of music in such images composes a compelling backdrop for understanding popular depictions of and reactions to racial mixture in nineteenth-century America. Illustrations of dance, movement, and music signal the similarly fluid notions of race that permeated antebellum discourse. While Clay's *Amalgamation Waltz* is emphatic in its illustrated pairings of only black men and white women, Clay's later *Amalgamation Polka* and the *Miscegenation Ball* political caricature also depicted pairs of white men with black women. While imagery of interracial sex was at the center of such illustrations, sexuality was inextricably linked with imaginings of national belonging and reproduction. These illustrations spoke to concerns over interracial mixture more broadly, particularly as it suggested social and political racial equality.

The musical notation of Reed's music literalizes these juxtapositions of racial integration within the music itself. The three-beat measure of the waltz is comprised of stick-figure illustrations, mostly of pairings of black men and white women, drawn as quarter and half notes with the sartorial gendering of tuxedo tails or billowing skirts, respectively. The illustrated notes play upon sexual-racial anxieties by placing these figures in close proximity, implying more than the social scene of integrated dance—interracial romance, and by implication, interracial sex. Anxieties about what is now more familiarly termed "integration"—the mixing of races within United States populations—were, in the nineteenth century, inextricable from anxieties about interracial sex. While integrated dances were only one site for racial mixing, the association of interracial sexual relations and dance was a perfect pairing for inciting racist controversy. Partnered dance had already been associated with impropriety, particularly with regard to the waltz, which was scandalous when first introduced in the eighteenth century, but by the nineteenth had become more popularly accepted and lacked much of its earlier scandal. Elizabeth Aldrich writes that "The ballroom was a microcosm of the society at large" in which social interactions were "governed by specific protocols" for "proper conduct."[8] If the ballroom was, indeed, a "mirror of a changing society in nineteenth-century America," the racially integrated ballroom was an apt location for white supremacist anxieties.[9] As social perceptions of

dance could evolve, so might popular regard for racial mixing. Therein lies the real danger of the "Amalgamation Waltz"—in the possibility of images of amalgamation becoming mundane, rather than shocking.

Overwhelmingly, the waltz's pairing of partners continued to signify heterosexual romance. In 1855, *The Illustrated Manners Book* warned that "Doubtless it [the waltz] should be engaged in with caution by all sensitive organizations. A woman especially, ought to be very sure that the man she waltzes with is one worthy of so close an intimacy; and one who understands her nature and relations well, will not waltz with any other."[10] Even later, in 1892, T. A. Faulkner, the former Proprietor of the Los Angeles Dancing Academy and ex-president of the Dancing Masters' Association of the Pacific Coast, referred to the waltz as "one long, sweet and purely sensual pleasure."[11] Depicting interracial couples in positions of partnered dance added another layer of scandal to the waltz by rendering a scene that was already associated with sexuality even more shocking when coupled with the taboo of racial mixing. Many of these images' viewers would not have found black men "worthy of so close an intimacy" with white women. The implication of anything resembling shared "sensual pleasure" was more than enough to provoke racist reactions.

The event of the integrated ball suggests associations of music with culture and taste; the larger implication is that racial difference ought to prevent differently raced people from sharing affinities and social space. Nineteenth-century caricatures of integration expect viewers to find something off-putting about scenes of black and white people sharing in musical gathering. The implication is usually that these "amalgamated" groups must be subsuming something of their inherent natures, being inappropriately raised or lowered by racial integration. The social mixing of the races also implies the possibility of social movement, bringing black and white people together as possible equals in shared, intimate social spaces—an idea that enraged or frightened people committed to maintaining American white supremacy.

Another space where such integration was suggested was the blackface minstrel stage. While the work of white performers in blackface makeup adds complexity to these racial representations, one place where "amalgamation" was illustrated was in blackface productions of Shakespeare's *Othello*. Traditional theatrical versions of the play were not integrated during the nineteenth-century United States, which would have Othello played by a white actor in blackface until well into the twentieth century. But the suggestion of amalgamation was a central part of this play as Desdemona and Othello became iconic—and tragic—figures connected to conversations about racial mixture. Blackface minstrel versions of the play were also produced throughout the century, and on the minstrel stage, we often see

these figures joined in dance. T. D. Rice's *Otello*, first produced in 1844, for example, ends as Desdemona comes to life again and the couple dances and sings along with other characters.[12] Unlike the classic tragedy—which was often read as a warning against interracial marriage—this play provides a number of titillating suggestions of interracial sex.

The waltz was not simply sensual dance, however, but also a genteel one, connected to middle-class leisure. Reed lists 39 waltzes in his 1843 catalogue, the second most expansive category, after "Songs." The waltz's reach extended beyond the ballroom, then, and into the domestic space of the home, where dancing may also have occurred, but where waltzes might also have been played without an accompanying movement of bodies. Oddly, this music makes the connection between music and dance even without playing the piece as the bodies in motion and the beats of the waltz are inextricable from one another. Even without the presence of dancers, dance is suggested here. Moreover, even without actually racially integrating the domestic space of the parlor, that integration is here suggested, bringing something of the titillating suggestion of interracial romance into the white home.

The movement of partnered embrace provided a dangerous context for racial mixing in popular antebellum illustrations, with this musical movement playing upon the sexual connotations of "amalgamation." Depictions of dance suggest relations of heterosexual intimacy, and as interracial couples were imagined in dance's movement and embraces, they sparked popular anxieties about interracial sex and its inevitable result—mixed-race people. Thinking about music can therefore help us to understand notions of race that were not firmly fixed, but which flowed in and around one another like the figures of an "amalgamation waltz." In its allusion to sexuality, the waltz also suggests the imagined movement of race via genealogical transfer from parents to children. Movement signifies the fluidity of race in its instability and its inability to be indubitably determined—frightening prospects for a society committed to practices of racial definition and taxonomy.

The waltz was not the sole form of dance in which interracial relations were depicted, as Clay's later 1845 print, "Amalgamation Polka," continued this theme of racial mixing and dance. Showing pairs of white women and black men as well as pairs of white men and black women, "Amalgamation Polka" depicts dancing couples as its focus, embracing ones on the sidelines, and even a black man and a white man conversing in the background, presumably as equals. Below its title, the illustration is "Respectfully dedicated to Miss Abby Kelley," a radical abolitionist, known for delivering anti-slavery speeches to "promiscuous" (i.e., mixed-gender) as well as integrated

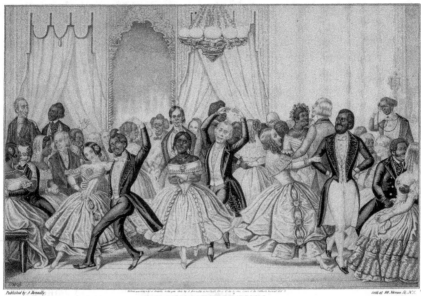

AN AMALGAMATION POLKA.
Respectfully dedicated to Miss ABBY KELLY.

Figure 3.2. Edward Williams Clay, "An Amalgamation Polka," respectfully dedicated to Miss Abby Kelley. Lithograph, black-and-white (28.5 x 45.5 cm, on sheet 33.5 x 48 cm), published by A. Donnelly, New York (1845).
Courtesy of the American Antiquarian Society, Worcester, Massachusetts.

audiences like the one Clay depicts, suggesting a connection between abolition and this scene.

In the nineteenth century, the polka spread throughout Europe and became particularly popular in England and then America in the 1840s. While neither as popular nor as contentious as the waltz when it was first introduced, the dance was viewed by some, as an April 1844 letter in *The Illustrated London News* indicates, as "ridiculous" and "ungraceful."[13] Allen Dodworth, a New York dancing school instructor, was reportedly horrified at the vulgarity of the polka when it was first introduced, and later worked to refine the dance through standardization. Dodworth published *Dancing and its Relation to Education and Social Life* in 1885, in which he characterized un-taught social dancing as "grotesque" and wrote that the introduction of the polka "had a serious effect in lowering the respect formerly given to motions and manner."[14] What this "lowering" might really suggest, though, is the accessibility of the polka—its popularity lying in the ability to perform the dance without formal instruction. In this accessibility,

the polka signifies different connotations of class and culture than the waltz, but also the threat of a trend in racial mixing that, like the waltz and the polka, might become commonplace.

The "Amalgamation Waltz" stops short of fully depicting race's fluidity in its black (filled) and white (open) notes, the discernment between which is essential for reading the music. The quarter- and half-note couples are illustrated in a dance of their own throughout the piece, the movement of their figures through the staves of music notating the musical form, itself. The "amalgamation" narrative is here embedded in the very music that comprises the waltz. The figures' movement throughout the piece is dependent upon the racial metaphors of "black" and "white" and notions of racial dualism and distinction. In this musical form, amalgamation can never progress beyond the movement of the waltz. Only able to notate distinctly racialized black and white bodies, the piece is unable to illustrate mixed-race people as an implied result of interracial couplings.[15] Dependent upon the figures of filled and open musical notes, Western musical notation has no symbols that could combine these black and white bodies. In this form, Reed's musical rendition limits what the waltz is able to depict. The black and white quarter and half notes remain separate, individual, and distinctly valued parts of each measure, with no possibility of their melding together to comprise a new, amalgamated, musical notation.

In keeping with the most popularly represented site of anxiety about racial mixture, Clay's *Amalgamation Waltz* exclusively pairs white women with black men. *Amalgamation Polka* and *The Miscegenation Ball* both include couples of white men with black women. Reed's sheet music, however, contains a few quarter-note variations, which seem to appear as black women. While the quarter and half note (black man—white woman) pairing predominates the piece, in the seventh and eighth, and then the eleventh and twelfth measures, we see multiple quarter notes in a row (some wearing tails and some skirts). These few instances of what seem to be black women figures dancing with black men, sets the piece apart from other popular nineteenth-century illustrations of integrated dance. As Cobb notes, visual representations brought depictions of black women into domestic spaces in which they were assumed not to belong, other than as servants (16). Here, black women join the dance enacted on the page, adding another dimension to notions of racial inclusion in middle-class spaces. By including pairs of black partners, the piece seems more radically inclusive than others in its depiction of integrated space and dance. An image of "amalgamation" that also acknowledges black men's and women's relationships to one another is a rarely illustrated example of racialized social relations from the period.

MILITARY MOVEMENT AND
"AFRICAN'S MARCH IN TURKEY"

"The Miscegenation Ball" directly connects the social to the political. The political cartoon frames its scene as directly following a political meeting at the Lincoln Central Campaign Club. The caption reads, in part:

> No sooner were the formal proceedings and speeches hurried through with, than the room was cleared for a "negro ball," which then and there took place! . . . This fact We Certify, "that on the floor during the progress of the ball were many of the accredited leaders of the Black Republican party, thus testifying their faith by works in the hall and headquarters of their political gathering.

Playing on accusations that Republicans (including Lincoln) were not only abolitionists, but also integrationists and amalgamationists, images of interracial dance argued that social integration posed a threat to the white supremacist nation by broaching racial equality. This framing shows how musical movement could be inherently political. This single sheet of music also illustrates the segue from racialized movement at these different scales and from the social to the imperial. The bottom two-thirds of this single sheet show a second musical piece, "African's [*sic*] March in Turkey." The odd pairing of "Amalgamation Waltz" and "African's March in Turkey" juxtaposes the politicized movement of interracial dance and racialized military movement. The pairing also presents alternate musical genres—the waltz and the march—for notating race, movement, and racial contention. The latter piece projects a different coupling of race and social movement onto the site of musical annotation. Using similar anthropomorphized notation to depict a series of black men, some with bare heads and some turbaned, this "march" contrasts with the waltz above it. As we follow these figures across the staff, we see that the march indicates a different kind of "movement," opposed to the movement of dance. Not a dance in itself, the march is a musical form associated with the act of marching, a movement associated most closely with military endeavors.

Following "Waltzes," "Marches and Quicksteps" is the third largest category in Reed's catalogue. With titles suggesting military action, such as "Beverly Light Infantry Quickstep," "La Fayette's Welcome March," and "Grand Military March" these pieces bring a different kind of movement into the domestic space of the parlor. Although a wedding march might use its two-beat rhythm to note steps down a church aisle, the majority of Reed's titles suggest the movement of soldiers rather than brides. Locating the action of this march in Turkey, the piece also brings a representation of the foreign

into this domestic space, as imagined military action elsewhere poses a point of interest but no immediate threat to the safety of the home.

Unlike the varied movement of the waltz's box-like dance steps, the march is unidirectional, moving only forward, and suggesting progress. As a musical form, the march is meant to mark time. Written in cut time or march time, the music mimics and regulates forward steps. The figures in the bottom musical piece all face to the right of the page, the direction toward which the music is read, indicating their progression from the beginning to the end of the piece. The march presents yet another way of understanding racial mixture, through the geographic movement of racialized bodies, suggesting projects of colonialism, imperialism, and, of course, the transatlantic slave trade. The particular pairing of amalgamation and the march also suggests interracial conflict.

Interpreting the "African's March in Turkey" music proves a bit harder than connecting the "Amalgamation Waltz" to popular caricatures of racially integrated dance. This form of racial representation differs significantly from the more prominent racist caricatures of nineteenth-century illustrations of African people and Orientalist imaginings of Turkey as a geopolitical space. If we read the piece's notation as marking racial differentiation, as in "Amalgamation Waltz," the locus of race is differently placed here. The quarter-note figures still seem to denote blackness, but whiteness appears not in the racially "blank" faces of half-note figures, but in the sartorial differences between the bodies depicted. The open half notes are represented by Turkish turbans rather than white faces as in the "Amalgamation Waltz." It is unclear whether this corresponding notation signals a similar racialization, but it bears noting that, as in the piece above, the figures bear different weight in their musical duration. Put simply, the quarter-note figures are valued differently—less by half—than their half-note counterparts, a difference that seems significant in light of the kinds of value (monetary, political, human) that has been historically attached to black bodies.

The difference between these two types of figures is difficult to describe. While the figures with turbans are also drawn with black faces, they signify as half notes in the musical score, linking them to the white women depicted above. The racial ambiguity of these figures is interesting in a nineteenth-century context of racial demarcation via racial sciences that laid claims to biology and geography to categorize a variety of possible races and their historical relations to one another. The cultural and geographical signification of the turban stands in for an Orientalist imagining of "Turkey," here juxtaposed with the vague but meaning-laden representation of the black notes as "African" figures. In the various scientific taxonomies of race operating throughout the nineteenth century, the Caucasus region of Eurasia often figured as a

site of racial whiteness that nevertheless contrasted with conventional associations of white Anglo-Saxon supremacy. Just as some races were difficult to fit into racial taxonomies without admitting a history of racial mixture, the predominant black–white dualism of American racialization could not contain the nation's racial complexity.

Moreover, the bottom piece may indicate a contemporaneous nineteenth-century site of African enslavement.[16] "African's March in Turkey" could allude to an event such as Mehmet Ali Pasha's enslavement and conscription of Sudanese men into the Ottoman army during its 1820s military campaign in Egypt.[17] If the black figures in the lower piece are enslaved Africans, one wonders at its relevance to the American context of integration suggested above, and the relation of the United States to other nations and geographic spaces relevant to the global economy of slavery. Conflict between black and white races was an important counter-frame to amalgamation discourse in the nineteenth-century popular imagination. When interracial relations are framed as war, the possibility of egalitarian integrated society and the reality of interracial mixing and amalgamated bodies could be more easily denied.

An alternate reading of "African's March in Turkey" to this one might note the black quarter-note figures as equals to the turbaned ones. Armed with spears, the black figures might register as a threat to white supremacist endeavors to subjugate black people in the United States or elsewhere. This military framing for black figures might suggest a larger danger for white supremacy. Contrasting with my earlier reading of these figures' enslavement or unwilling military conscription by the turbaned figures, then, is the possibility of these figures' political military alignment in a common cause. By locating these black figures abroad, rather than in the domestic space of the U.S. nation, this music distances these figures from local political concerns, while still suggesting the possibility of black militarization. Arguments that racially integrated spaces might lead to larger political shifts of power were not uncommon in antebellum visual imagery, and this piece's juxtaposition of the waltz and the march suggest similar connections. The idea of racialized warfare is not a long leap from most nineteenth-century U.S. discourses of racial relations, which were steeped in the violence of racial oppression and resistance to it. From the kidnapping of people in the transatlantic slave trade, the successful Haitian Revolution, the threat of slave insurrection, the state-sanctioned violence of domestic slavery, and the unpunished extralegal violence of lynching, examples reached well beyond the U.S. Civil War.

A similar vision of amalgamation-as-conflict appears in Jerome Holgate's 1835 novel, *A Sojourn in the City of Amalgamation, in the Year of our Lord 19—*. Written under the pseudonym "Oliver Bolokitten," the novel presents a dystopian, "amalgamated" city whose inhabitants enter into interracial

marriages not because of interracial love or romance (which Holgate cannot conceive), but because of a shared societal duty to uphold abstract philosophical principles of amalgamation. During his sojourn, Holgate's narrator attends an exhibition of "a man half black, half white; the lower half being black, the upper half white; the line dividing the two colours being clear and distinct."[18] This description of racial demarcation on the body is similar to at least one other nineteenth-century U.S. representation. In an 1846 playbill for T. D. Rice's 1844 minstrel play *Otello, A Burlesque Opera*, Othello and Desdemona's child is described as "Master Lorenzo Otello (eldest son of Otello and that there may be no partiality, nature has colored him half and half)."[19] Illustrating the amalgamated body as inherently unmixable, these depictions of race imagine whiteness and blackness as always and inherently in conflict. Holgate reproduces, in full, this phenomenal person's memoir, *The Memoirs of Boge Bogun, with an Account of the War which took place in His Own Body between the Differently Colored Particles of Flesh, and the Consequent Result.*[20] The *Memoirs* represent racial mixture as an internal war between the "white" and "black" "particles" of Bogun's genealogy, which are vying for his various body parts. Most of Bogun's story reads as a war narrative of the various battles in which the problem of a racially mixed nation is translated to a bodily scale. In the midst of his account, the white and black "particles of flesh" become, alternately "Whites" and "Blacks," and occasionally, "English" and "Africans."

Similarly to the separated white and black notes of the sheet music's waltz and march, this story refrains from illustrating the mixture of amalgamation, representing the mixed-race body not as thoroughly mixed, but as internally conflicted. This necessitates a bizarre parsing of "white" and "black" elements, imagining these parts as beyond any capacity to be melded indistinguishably within a single body. The upper and lower halves of Bogun's body house loci for attributes such as intellect and sexuality, literalizing their habitual racialization. The "Differently Colored Particles of Flesh" remain separate, the battle between which signifies not so much the blending of races but the triumph of one and the erasure of the other. Bogun's bodily war results in racial victory. The movement of "white" and "black" particles in battle implies one's eventual destruction or subjugation just as the movement of coupled dance suggests an intimate encounter that may result in amalgamated offspring or even an amalgamated nation. Depicting a site of possible interracial conflict, the progression of the march does not allow racialized bodies to remain fixed on the page, but implies both their constant movement and the ensuing results of interracial interaction in this scene of militarism and enslavement.

The pairing of the waltz and the march on this single sheet of music might be best understood as illustrating the tension between interracial sociality and interracial conflict in the United States. The paired pieces present a contrast

between an enslaved African population and an integrated (or integrating) African American one, perhaps hinting at global experiences and representations of blackness and their relationship within a complex geopolitical context of race-making. The intertwined bodies of coupled dance show not only anti-amalgamation fears, but also illustrate the already-existing state of the nation—as an amalgamated dance, the steps of which would have to be negotiated as the country moved toward racial equality. Moreover, the "Amalgamation Waltz" is not divorced from the global slave trade or the militarism of racialized movement, past or present, that is implied by "African's March in Turkey."

As our unknown composer presents a foreign march that follows a seemingly domestic scene of dance, the possibility of a similar domestic, racialized military conflict does not seem too far afield. The racial conflict Holgate describes is a precursor to the American Civil War. The ultimate arming of black troops produced a similar scene of racial relations in the establishment of the United States Colored Troops. In this 1863 Currier and Ives image, "The Gallant Charge of the Fifty Fourth Massachusetts" we see armed black soldiers fighting against the white Confederate Army (see figure 3.3). Not fully

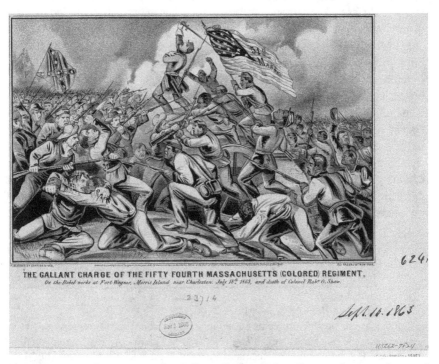

THE GALLANT CHARGE OF THE FIFTY FOURTH MASSACHUSETTS (COLORED) REGIMENT,
On the Rebel works at Fort Wagner, Morris Island near Charleston. July 18th 1863, and death of Colonel Robt G. Shaw.

Figure 3.3. Currier & Ives, "The Gallant Charge of the Fifty Fourth Massachusetts," lithograph, hand-colored (34 x 41 cm), published by Currier & Ives, New York (c. 1863).
Courtesy of the Library Company of Philadelphia.

integrated, but comprised of black soldiers led by white officers, these regiments formed a vision of racialized military movement not entirely unlike the relations in "African's March in Turkey." In this racialized conflict between the 54th Regiment's "Colored Troops," and the white Confederate troops, we see, primarily, an image of black and white soldiers in movement. Race seems to be clearly marked on the bodies we see here, but racialized bodies do not determine the political positions of these players. "The Gallant Charge" also depicts the death of Colonel Robert Shaw, who would be buried alongside the black men he fought alongside. Charging rather than dancing and locked in the throes of battle rather than in the embrace of a waltz or polka, these figures form a scene of violent racial conflict. However, this masculinized depiction of political movement only reveals bodies in battle. Figures of black and white women who also fought, in various ways—for abolition, women's rights, and other social justice causes—are absented from the picture.

W. E. B. Du Bois' often-cited statement that "the problem of the Twentieth Century is the problem of the color-line" points not only to an imagined American racial dualism but to ideas about racial movement and racial trajectories.[21] The image of free black soldiers fighting for the Union asks us to imagine different movements of race than either the racially coupled dancers of the "Amalgamation Waltz" or the possibly enslaved black army of "African's March in Turkey." Each of these, however, presents race not as static, but as always in motion. This illustrated motion speaks to race's trajectories, in temporal imaginings that suggest not only images of racial past or present, but also racial futures, whether projecting what interracial sociality or racialized militarism might portend. One could say that these depictions merely "dance around" larger national problems of racial oppression and separatism in their simplistic and ambiguous depictions of racial mixing. But in the musical and visual forms of this notation, we see both the sexual underpinnings of amalgamation and the geographical movement of races in this illustrated narrative, as well as a theoretical framing that suggests complex relations of racialized embodiment, representation, and movement.

NOTES

1. William Wells Brown, *Clotel; or, The President's Daughter* [1853], ed. Robert S. Levine (Boston: Bedford/St. Martin's, 2000), 86.

2. On these respective problems of metaphor and technology for representing race, see, for example, Richard Dyer, *White* (New York: Routledge, 1997), and Jonathan Senchyne, "Bottles of Ink and Reams of Paper: *Clotel*, Racialization, and the Material Culture of Print," *Early African American Print Culture*, eds. Lara Langer Cohen and Jordan Alexander Stein (Philadelphia: University of Pennsylvania Press, 2012), 140–158.

3. I am extremely grateful to Elizabeth Pope at the American Antiquarian Society, who first showed me this remarkable piece.

4. This piece was also published by J. G. Osbourn, 112 So. 3rd Street, Philadelphia. Osbourn was a music arranger and publisher who sold an array of popular songs and other music for piano that was not dissimilar to Reed's. A copy of this music with Osbourn's imprint is held by the Levy Sheet Music Collection at the Johns Hopkins University Sheridan Libraries Special Collections. Because, like Reed's, Osbourn's copy also reads "2nd Edition" across the top, it is unclear which publisher produced this first. WorldCat dates Osbourn's imprint in the 1850s, while Reed's may have been produced earlier, as he was located at the Tremont Row address between 1839 and 1856. See https://www.worldcat.org/title/amalgamation-waltz-africans-march-in-turkey/oclc/52588734. I have not located a "1st Edition" of this item anywhere.

5. See *George P. Reed's Catalogue of Select Publications* (Boston: Kidder & Wright, 1843).

6. Jasmine Nichole Cobb, *Picture Freedom: Remaking Black Visuality in the Early Nineteenth Century* (New York: New York University Press, 2015), 13.

7. Elise Lemire discusses these images in *Miscegenation: Making Race in America* (Philadelphia: University of Pennsylvania Press, 2002), 64–66, 121–124. Tavia Nyong'o does, as well, in *The Amalgamation Waltz: Race, Performance, and the Ruses of Memory* (Minneapolis: University of Minnesota Press, 2009), 29–30, 81–83.

8. Elizabeth Aldrich, *From the Ballroom to Hell: Grace and Folly in Nineteenth-Century Dance* (Evanston, IL: Northwestern University Press, 1991), xvii.

9. Aldrich, *From the Ballroom to Hell*, 3.

10. Robert De Valcourt, *The Illustrated Manners Book: A Manual of Good Behavior and Polite Accomplishments* (New York: Leland, Clay, & Company, 1855), 398.

11. T. A. Faulkner, *From the Ballroom to Hell* (Chicago: Henry Publishing Company, 1892), 11.

12. I further discuss the implications of blackface makeup's transferability from Othello to Desdemona in these productions' representations of race in "Blackface Desdemona: Theorizing Race on the Nineteenth-Century American Stage," *Theatre Annual* 70 (2017): 39–59.

13. Cited in Frances Rust, *Dance in Society: An Analysis of the Relationship Between the Social Dance and Society in England from the Middle Ages to the Present Day*. Volume 2 (London: Taylor & Francis, 1998), 74.

14. Allen Dodworth, *Dancing and its Relation to Education and Social Life* [1885] (New York: Harper and Brothers, 1913), 15, 17.

15. Mixed-race people did figure in other illustrations, such as Clay's *Fruits of Amalgamation* in the "Practical Amalgamation" series.

16. I owe thanks to Jameel Haque for helping me to make this connection.

17. See Khaled Fahmy, *All the Pasha's Men: Mehmed Ali, his Army and the Making of Modern Egypt* (Cairo, Egypt: American University in Cairo Press, 2002), 86–89.

18. Jerome Holgate, *A Sojourn in the City of Amalgamation in the Year of our Lord 19—* (New York, 1835), 69.

19. T. D. Rice, "*Otello, A Burlesque Opera* [1853]," in *Jim Crow, American. Selected Songs and Plays*, ed. W. T. Lhamon Jr. (Cambridge, MA: Harvard University Press, 2009), 176, n. 37, and Lhamon, "Introduction," xxi, note to Figure 1.

20. Holgate, 70.
21. W. E. B. Du Bois, *The Souls of Black Folk* [1903] (New York: Modern Library, 2003), vi.

BIBLIOGRAPHY

Aldrich, Elizabeth. *From the Ballroom to Hell: Grace and Folly in Nineteenth-Century Dance.* Evanston, IL: Northwestern University Press, 1991.
"Amalgamation Waltz and African's [*sic*] March in Turkey." Boston: George P. Reed, n.d.
Brown, William Wells. *Clotel; Or, The President's Daughter* [1853], ed. Robert S. Levine. Boston: Bedford/St. Martin's, 2000.
Cobb, Jasmine Nichole. *Picture Freedom: Remaking Black Visuality in the Early Nineteenth Century.* New York: New York University Press, 2015.
De Valcourt, Robert. *The Illustrated Manners Book: A Manual of Good Behavior and Polite Accomplishments.* New York: Leland, Clay, & Company, 1855.
Dodworth, Allen. *Dancing and its Relation to Education and Social Life* [1885]. New York: Harper and Brothers, 1913.
Du Bois, W. E. B. *The Souls of Black Folk* [1903]. New York: Modern Library, 2003.
Dyer, Richard. *White: Essays on Race and Culture.* New York: Routledge, 1997.
Fahmy, Khaled. *All the Pasha's Men: Mehmed Ali, his Army and the Making of Modern Egypt.* Cairo, Egypt: American University in Cairo Press, 2002.
Faulkner, T. A. *From the Ballroom to Hell.* Chicago: Henry Publishing Company, 1892.
Fielder, Brigitte. "Blackface Desdemona: Theorizing Race on the Nineteenth-Century American Stage." *Theatre Annual* 70 (2017): 39–59.
Holgate, Jerome. *A Sojourn in the City of Amalgamation in the Year of our Lord 19—.* New York, 1835.
Lemire, Elise. *Miscegenation: Making Race in America.* Philadelphia: University of Pennsylvania Press, 2002.
Nyong'o, Tavia. *The Amalgamation Waltz: Race, Performance, and the Ruses of Memory.* Minneapolis: University of Minnesota Press, 2009.
Rice, T. D. *"Otello, A Burlesque Opera* [1853]." In *Jim Crow, American. Selected Songs and Plays,* edited by W. T. Lhamon Jr. Cambridge, MA: Harvard University Press, 2009.
Rust, Frances. *Dance in Society: An Analysis of the Relationship Between the Social Dance and Society in England from the Middle Ages to the Present Day.* Volume 2. London: Taylor & Francis, 1998.
Senchyne, Jonathan. "Bottles of Ink and Reams of Paper: *Clotel*, Racialization, and the Material Culture of Print." In *Early African American Print Culture,* edited by Lara Langer Cohen and Jordan Alexander Stein, 140–158. Philadelphia: University of Pennsylvania Press, 2012.

Chapter Four

Black Faces Etched in White Stone

Black Feminist Visuality in Edmonia Lewis's Sculpture

Kelli Morgan

It is well known that the theoretical basis of Black feminism emphasizes the multilayered dynamic unique to Black women's material reality and oppression. Throughout the nineteenth century, Black women employed the novel, essay, short story, poem, quilt, podium, photograph and the bright hue of white marble to stress that Black women have always " . . . shared [an] awareness of how their sexual identity combined with their racial identity to make their whole life situation and the focus of their political struggles unique."[1] Examining the various ways American artist Edmonia Lewis visually asserted her authenticity and multiplicity during the nineteenth century, this chapter utilizes a concept that I term *Black feminist visuality*—a creative imaging of Black women's self-making, autonomy, subjectivity, and personal empowerment that allows them to transcend the distorted, mythological constructions of Black female identity concretized within Western visual culture as it reveals the functions of Western culture's racist visuality and rejects its subjugation of Black women's identity formation—to analyze both her cartes-de-visite and neoclassical sculpture *Forever Free* (1867). Specifically, I illustrate Lewis's application of *visible-aggregation*—the ways in which African American women artists express *Black feminist visuality* through visual representations that expose a collection of particulars that constitute Black female identity—to demarcate specific moments where she intentionally employs the photograph and the sculptural figure to express Black feminist visuality. Additionally, I posit *Forever Free* as a figurative challenge to the tragic mulatta trope, contending that Lewis's work makes use of the cultural and material heft of white marble to critique the presumption that mixed-raced African American women were destined for catastrophic demise because of their liminal existence between Blackness and whiteness.

71

THE PORTRAIT OF AN ARTIST
AS A YOUNG BLACK WOMAN

Circa 1870, Edmonia Lewis sat for a series of portraits that layer the typi-
cal feminine markers of the bohemian artist lifestyle within a tousled guise
and preoccupied gaze to image the laboring Black female subject as profes-
sional artist. As women of color were rarely afforded access to training in
the fine arts, Lewis's physical presence as a working artist in Rome com-
pletely troubled the Western visual field. *The Revolution* proclaimed, "one
of the first studios which we visited in Rome was that of Edmonia Lewis,

**Figure 4.1. Henry Rocher, Edmonia Lewis,
carte-de-visite, c. 1870.**
Courtesy of Harvard Art Museums/Fogg Museum, Trans-
fer from Special Collections, Fine Arts Library, Harvard
College Library, Bequest of Evert Jansen Wendell.

**Figure 4.2. Henry Rocher, Edmonia Lewis,
carte-de-visite, c. 1870.**

Courtesy of Harvard Art Museums/Fogg Museum, Trans-
fer from Special Collections, Fine Arts Library, Harvard
College Library, Bequest of Evert Jansen Wendell.

the colored sculptor. *We were interested in her even before we saw her,
or any of her works; not only because of her sex, but of her race,* and our
acquaintance with her and her works has only heightened the interest which
we felt in her" (emphasis mine).[2] Lewis's sheer existence frequently baffled
audiences to the point of pronounced fascination. However, audiences con-
sidered Lewis's autonomy and subjectivity to be so uniquely exotic that in
this instance she troubles the writer's vision without actually being seen. The
simple mention of her race, gender, and occupation altogether was enough to
"heighten the [writer's] interest" because it disrupts popular understandings
of Black womanhood.

A female artist of both Native American and African American heritage,[3] Edmonia Lewis was habitually perceived by whites to be the anomaly of all anomalies. Newspaper editors and art critics often relied upon the pseudo-scientific language of the day, using adjectives like "wild" and "natural" to describe Lewis's physicality and her neoclassical works in efforts to under-stand her existence as a professional sculptor who was at once Chippewa, Black and female.[4] In 1865, she expatriated to Rome to perfect her skills, and remained abroad for the duration of her career. Thus, her material reality as an American sculptor is central to her photographic employment of visible-aggregation. Her self-portraits convey her occupation, underscoring her unconventionality through a visual layering that combines themes of labor, femininity, respectability, and womanhood within artist dress—her clothing, short curls, recalcitrant gaze, and accessories—to confirm her authenticity as an internationally renowned American artist. Art historian Gwendolyn DuBois Shaw explains:

> From her cropped hair, cut short to stay out of her way while at work as well as in the style of a fellow American sculptor Harriet Hosmer, to the exquisitely trimmed jacket and the unrestrictive cut of her clothes, all serve to identify her as a bohemian and an artist. At the same time they indicate that this was not the average image of a woman of color in the 1870's. Her clothing depicts the dominant and the avant-garde cultural ideologies of feminine and artistic dress as well as the artist's own relationship to these discourses.[5]

The more essential aspect of Lewis's Black feminist visuality, however, is that she employs visible-aggregation to center the Black female as an active, autonomous subject fully engaged in producing neoclassical sculpture.

Known for singularly performing all tasks required to complete her works, notions of Black women's industry are central to Lewis's professional image. Laura Bullard, editor of *The Revolution* reported:

> Miss Lewis is one of the few sculptors whom no one charges with having assis-tance in her work. Every one admits that whether good or bad, her marbles are all her own. So determined is she to avoid all occasion for detraction, that she even "puts up" her clay; a work purely mechanical, and one of great drudgery, which scarcely any *male* sculptor does for himself. It is a very hard and very fatiguing process, for it consists in the piling up masses of wet clay into a vague outline of a human figure, out of which the sculptor brings the model into form and beauty. If Miss Lewis were not very strong, she could not do this, and it seems to us an unnecessary expenditure of her physical powers.[6]

Bullard provides fundamental insight into Lewis's passion for neoclassical sculpture as she outlines the arduous physical labor the medium demands

from its practitioners and confirms that Lewis accomplishes this work "all [on] her own."

It hardly needs to be stated that Black women were excluded from Victorian concepts of true womanhood because slavery forced them into permanent conditions of strenuous physical labor and relentless sexual abuse. However, this exclusion was also rooted in the romanticisms of Trans-Atlantic travel narratives penned by Europeans, whose imaginative tales depicted Black women as "natural born" laborers, while visually establishing the iconography that identified the African "Hottentot" as the authentic Black woman. Given that racist societal conditions continued to perpetuate analogous circumstances for emancipated women, sentiments denying Black women's subjectivity and womanliness were also prominent throughout the post-bellum period.

Considering the dominant culture's belief that Black women were "natural laborers," Bullard's comments racialize the processes of neoclassical sculpture through a phraseology of exceptionalism, describing Lewis's corporal labor as a "physical power," which sets her apart from her colleagues in Rome. To be sure, Bullard's intent is to celebrate Lewis and her artistic achievements. However, by describing Lewis as a herculean individual with the innate ability to labor strenuously, Bullard's review dehumanizes Lewis in the tradition of racist mythologies that legitimized Black women as natural physical laborers. For instance, Bullard confirms that Lewis built all her own models. Yet, in Bullard's opinion, it is precisely this ability that differentiates Lewis from white neoclassical artists as no "male" sculptor performs this chore. Unquestionably, white women sculptors working in the nineteenth century experienced great scrutiny when it came to the labor of modeling and carving their sculptures, as their abilities to perform or abstain from this work spoke to the authenticity of their artistry. As art historian Kirsten Buick explains:

> Women were automatically done when they hired studio help. The workshop method was something we are familiar with from the Renaissance and Andy Warhol—you hire people more skilled than you to realize your conceptions. In the 19th century, it was as though women couldn't do the conceptual work. The Italian carvers that they had in their studios were credited with everything.[7]

Lewis's colleagues, Harriet Hosmer and Anne Whitney, were often subjected to such discrimination. Sexism within neoclassical sculpture was so blatant in Whitney's case that she was denied the first-place honor her anonymous submission won in the competition for a commissioned memorial of U.S. senator and abolitionist Charles Sumner. Tenets of true womanhood were at work against Whitney as the judges sought "to avoid the indelicate

associations of a woman knowledgeable of the male body, particularly the modeling of a man's legs."[8]

As Lewis worked very closely with Hosmer and Whitney throughout her time in Rome, Bullard's failure to mention either woman in her review also racializes Lewis's preparatory work through notions of true womanhood, insinuating that, as white "ladies," Hosmer and Whitney did not execute the "mechanical" "drudgery" putting up clay required. At the very beginning of her editorial, Bullard claims that Lewis possesses "an untiring patience to conquer all difficulties"[9] simply because she is Black, Chippewa, and female. Hence, Bullard establishes a double binary based on race and gender that separates Lewis from her white constituents because she literally performs what they do not—the work itself. Bullard's use of descriptive phrases such as, "physical powers" and "very strong," then links Lewis to colonial and antebellum ideologies of Black women's "supposed" innate ability to endure grueling circumstances, and post-bellum narratives that used this mythology to deny Black women's freedom and womanhood. Surely, principles of true womanhood relegated physical labor to the man's realm, but reading Bullard's review within the contexts of slavery and Reconstruction reveals how her narrative of Lewis's exceptionalism draws upon both racist and sexist Victorian ideologies in order to differentiate her position as an internationally renowned fine artist from the professional realities of her white contemporaries.

This tone persists as Bullard asserts that "Miss Lewis is one of the few sculptors whom no one charges with having assistance in her work."[10] Though Bullard is specifically referencing the absence of studio assistants from Lewis's practice, her review couples Lewis's biography—her rise from the "wilds" of a primitive Native American lifestyle and fledgling African American culture, to the sophistication of neoclassical sculpture and prestige of Rome—with her physical prowess, to convince readers that Lewis is so extraordinary she needs no help at all. But in fact Lewis desperately needed assistance. Contrary to what Bullard assumes, Lewis could not sustain a living on her "physical powers" alone. In 1868, she appeals to her patron Maria Weston Chapman for help securing funds for her livelihood and now famous sculpture *Forever Free*. Lewis wrote:

> I am in great need of money. What little money I had I put all in that work with my heart. And I truly hope that the work of two long years has not been lost. Dear Mrs. Chapman I been thinking that it may be that you have meat [*sic*] with some who think that it will ruin me to help me—but you may tell them that in giving a little something towards that group—that will not only aid me but will show their good feeling for one who has given all for poor humanity...Will you dear Mrs. Chapman be so kind as to see Mr. Sewall and if he has been paid the

Eaight [*sic*] hundred dollars ($800.) will he be so kind as to send to me the same as I am in need of it very mutch [*sic*]—I have done very little this winter and unless I receive this money from home—I will not be able to get on this year.[11]

Though Bullard's perception falsely conceives Lewis as the typical Black woman who could singularly transcend enormous adversity, Lewis's letter to Chapman indicates that she was not an exception who could accomplish everything alone. Bullard's exceptionalization of Lewis's laboring ability becomes an overall interrogation of her status as a neoclassical sculptor because she suggests that without such "physical powers," Lewis could never conceptualize, model, or even carve her works "into form and beauty," let alone become a famous international visual artist. Bullard deems Lewis's physical labor "an unnecessary expenditure" as neoclassicism was not a modern industry that required Black women's work. Nevertheless, Lewis deliberately emphasizes that it was precisely her labor that authenticated her work and sustained her position as an American artist, stressing to Chapman that with every bit of her heart, she put all her work and capital into *Forever Free*. The juxtaposition of Bullard's review and Lewis's letter then demonstrates how visual interpretations of Black womanhood, particularly Black women's work, often fragmented along racial lines, registering inversely within the Western visual field depending on the viewer.

Like most Black women working during the Civil War and Reconstruction, Lewis wanted to be fully compensated for the work she performed, and needed a supportive community of friends and patrons. Just as much as she depended upon her own labor, she was reliant upon the financial patronage of abolitionists and their networks of northern art collectors. In the photos above, she employs visible-aggregation to create imagery that centralizes her physical labor as an essential component of her artist practice, which constitutes her living, expresses Black feminist visuality, and grounds her authenticity as a neoclassical sculptor. For example, in figure 4.1 Lewis's slightly disheveled appearance implies interruption, as if she'd recently paused and rushed from another activity to sit for the portrait. Her frazzled hair, loosened necktie, and the crumpled textile thrown loosely over her left shoulder give a sense of action and hasty preparation. Although she is seated, the undulating folds of her apparel evoke feelings of movement as they echo both the sway and twists of the tassels on the chair's armrest. The strategic wrinkling of her skirt and the textile, coupled with the untidiness of her curls, signify a body that may have been performing the laborious tasks Bullard describes. In this manner, Lewis's long, full skirt is not the Victorian marker of domesticity; rather, it is the feminine dress of the sculptor. By constructing an image that implies physical activity, Lewis exhibits her determination "to avoid all occasion for detraction,"[12] photographically representing her position as a maker

of Western art. Concepts of Black women's work then move between the layers of the feminine artist's uniform to link Black women's physical labor to the cultural prestige of artistic genius.

Lewis's gaze also communicates her passion for sculpture and authenticity as an artist. Fixated on something off-camera, her eyes indicate that her attention is elsewhere—possibly on her work in Rome. Though she fabricates figure 4.1 to look as if she may have been in the middle of sculpting, in reality, she sat for her portraits in Henry Rocher's Chicago studio. This informs Lewis's Black feminist visuality given that after her apprenticeship with American sculptor Edward A. Brackett, she sailed for Italy and never maintained a studio space in the United States. Instead, she worked independently in Europe and employed various abolitionist networks and publications to solicit American interest in her work. Her pert expression, which disregards the photographer in each portrait, then signifies her position as an internationally renowned artist. Her look encourages the viewer to contemplate what she may be looking at, drawing attention away from her corporeal reality to encourage consideration of the circumstances under which her status arose. Her gaze reinforces her apparel, suggesting that Black women's industriousness operates concurrently with abolitionist support to stabilize her position. Like Sojourner Truth, she circulated her portraits as cartes-de-visite.[13] Moreover, Lewis's photographic use of visible-aggregation here visualizes her individual autonomy. Thus, she layers her gaze and clothing to express hints of physical labor, which articulate the Black woman as an artistic operative.

In figure 4.2, Lewis drastically tidies her layered appearance, stating her claims to womanhood and femininity. The large, velvet textile is wrapped loosely but elegantly around her torso, reinforcing perceptions of refinement, while providing additional layers of material coverage to express morality. Her cap is placed carefully atop her head and not a single strand of hair is out of place. Though her presence is firm, her appearance is softened and stilled by the careful unfolding and smoothing of her skirt, hair, and the textile. In this manner, Lewis's neatened representation suggests sophistication and Black women's respectability. Additionally, her left hand figures prominently to emphasize the band on her ring finger. The ring figures considerably to add social worth to her person, as married women often garnered more protection and safety from the ills of society; however, Lewis never married. The ring then demonstrates, as Buick argues, that "African Americans were forced to deploy the ideology of the dominant culture to protest their treatment under the system; [and] their use of sentimentality formed an effective social critique."[14] Here, Lewis's clothing and accessories speak to her understanding of Western cultural mores.

Reading both images together illuminates Lewis's complex arrangement of material, design, theme, construction, and space, and how essential visible-aggregation is to her photographic self-making. Explaining how Lewis's highly stylized self-imagery offered her a type of fluidity with which to move through various notions of her identity, Buick argues:

> Accordingly, Lewis's carte-de-visite is no more "true" or "real" than the myriad of representations of the artist. It, too, is a construction, strategically inserted into the field of representations of Lewis and thus holding no absolute authority over her. Even so, the photograph does constitute a conscious choice on the part of Lewis, perhaps to construct an image that denies the exotic interpretations favored by the biases of the time.[15]

As critics, reviewers, and patrons alike frequently read Lewis's work as autobiographical, and her physical presence through the popular racist mythologies of her contemporary moment, it is not hard to conceive why she would commission her own portraits. Maintaining her autonomy and subjectivity were critical. Lewis remained abroad to maintain the distance she needed to enact her selfhood and her artistic interests away from myopic understandings that stereotyped both her background and material reality. Her international presence as an American artist then grants her the opportunity to literally shape her sculptures and her identity as she sees fit. Thus, she conquers the metaphysical dilemma through a material articulation of both physical labor and cultural refinement that constitute a photographic design, layering fabric, dress, accessories, gaze, allusions of physical movement, and themes of Black women's labor and sentimentality to demonstrate the multidimensionality of her identity as well as the multiplicities of her life experiences. Her deft employment of visible-aggregation then expresses Black feminist visuality to envisage a self-employed Black woman artist contributing to both her material well-being and the advancement of American art.

NEOCLASSICAL MUSINGS IN BLACK AND WHITE

Appearing as early as 1842 in Lydia Maria Child's short story *The Quadroons*, the tragic mulatta and her catastrophic demise quickly became a fundamental trope of abolitionist sentimental fiction.[16] She was a stock character, designed to evoke sympathy from northern audiences simply because her enslaved body looked very much like the white women reading her story. Often rendered as a dejected damsel trapped within the biological admixture of Blackness and whiteness, the image of the tragic mulatta was a calamitous woman doomed to disastrous ends because her racial composition was

perceived as a life-threatening social and political consequence. Though the trope figured prominently in American literature throughout the Civil War, when considering how it informed nineteenth-century perceptions of neoclassical sculpture and the Black female body, it functions as a valuable critical lens through which to understand how Lewis asserted Black feminist visuality as a means to dismantle literary and visual narratives that defined both mixed-race and non-mixed-race Black women as "tragic."

From the Revolutionary War and subsequent development of the Republic, Americans adapted neoclassicism as a visual marker of the nation's connection to ancient Greece. Colonial Americans imbibed Enlightenment ideals, "point[ing] to classical antiquity as proof of man's capacity to create an ideal social and political society," which they too believed they could implement in their contemporary moment.[17] Hence, neoclassicism became the popular style of American painting, architecture, sculpture, and decorative arts from the mid-eighteenth century to the early nineteenth century. The style waned in American painting at the turn of the nineteenth century but remained prevalent in American architecture and sculpture through the post-bellum era. Although neoclassicism represented the perceived greatness of American society, both Black and white anti-slavery advocates emphasized that the presence of slavery severely contradicted America's identity as a free democracy. Naturally, this fundamental conflict operated within American neoclassical sculpture. Though marble generally served to elevate its subject matter, it often reinforced or complicated common nineteenth-century racial prejudices when Black subjects, particularly the Black female, were represented in the medium. As art historian Charmaine A. Nelson explains:

> the whiteness of the marble medium was not of arbitrary significance but functioned to mediate the representation of the racialized body in ways that preserved a moral imperative essential to the ideals of nineteenth-century neoclassicism. Unlike other forms of sculpture or types of art, the medium of marble was inherent to the practice of nineteen-century neoclassical sculpture.[18]

Therefore, culturally, the sculptural style worked alongside stereotypical literary constructs of Black women to produce a type of visual fiction that defined both mixed-race and non-mixed-raced African American women as naïve and inferior.

Edmonia Lewis's self-portraits and subsequent Black female figures challenged the fictions white writers and artists produced about Black women, including those of Lydia Maria Child. One of Lewis's most avid patrons, Child was a notable figure among nineteenth-century feminist writers and abolitionists. The editor of Harriet Jacob's 1861 narrative *Incidents in the Life of a Slave Girl*, Child was well known throughout the anti-slavery community

for her support of Black women and Native Americans and Lewis benefitted handsomely from Child's patronage. Yet, Child held very problematic views of women of color. As her *Quadroons* introduced the tragic mulatta trope to American sentimental fiction, Child's personal views often stereotyped Black women as undeveloped. For instance, to stress her dissatisfaction with Lewis's decision to sculpt a bust of the fallen commander of the 54th Massachusetts, Colonel Robert Gould Shaw, in 1866 Child wrote to Shaw's mother, Sarah Blake Sturgis Shaw, exclaiming:

> I do not think she has any genius, but I think she has a good deal of imitative talent, which, combined with her indomitable perseverance, I have hoped might make her something above mediocrity, if she took *time* enough. But she does *not* take time; she is in too much of a hurry to get up to a conspicuous place, without taking the necessary intermediate steps. I do not think this is so much "self-conceit," as it is an uneasy feeling of the necessity of making things to sell, in order to pay for her daily bread. Then you must remember that *youth*, in its fresh strength and inexperience, naturally thinks itself capable of doing anything . . . and it should not be forgotten that Edmonia is younger than young—brought up, as she was among the Chippewas and negroes without any education. I think it is a pity that she has undertaken to be a sculptor; . . . Brought up among the Chippewas, how *can* she know anything of the delicate properties of refined life.[19]

A pejorative description meant to discredit Lewis's subjectivity as a Black woman with mixed ancestry and her autonomy as an artist, Child's statement represented the common belief that a Black woman's heritage somehow made her naïve and incapable of self-sufficiency. Child cannot see Lewis's determination to build a successful artistic career as a healthy or positive form of autonomy; rather, she interprets Lewis's independence as a childish defiance strictly because Lewis disregards the contemporaneous narratives that marked her unqualified by her African and Chippewa heritage. Lewis obviously did not submit to many of Child's recommendations, which of course reinforced tensions between the two. Art historian Kirsten Buick explains:

> Publicly, Child was a proponent of the idea that Lewis was a "representative Negro." Privately, however, Child's patronage was more conflicted. As part of her "duty" as Lewis's patron, Child felt bound to provide both aesthetic advice and advice on how the artist should conduct her career. As an independent creative spirit, Lewis naturally had her own ideas about both. The misunderstandings that arose between them concerning the bust of Robert Gould Shaw illustrate well the difficulties in reconciling their two positions . . . Child's objection is to the reversal of the formula—in this instance a black knowing *subject* and a white known *object*.[20]

As a result, Lewis's expressions of Black feminist visuality in both her cartes-de-visite and neoclassical sculpture become a recourse through which she demonstrates her commitment to a self-sufficient life. However, it is precisely Lewis's close proximity to Child that made her undoubtedly aware of her patron's problematic conceptualizations of Black women. For that reason, Lewis frequently ignored advice from one of her most important patrons in order to assert a Black feminist visuality that shaped her career in ways that interested her.

Lewis debuted *Forever Free* (1867) as an aggressive articulation of race and emancipation. A sculpture that elevates artistic perceptions of Black bodies through neoclassical renderings, *Forever Free* directly references the Emancipation Proclamation in both its title and its depiction of African Americans. Her implementation of the medium as well as her portrayal of a semi-nude figure postured in the classic contrapposto pose firmly places *Forever Free* within the neoclassical style. In terms of physiognomy, most scholars have read the female character's obvious European features as Lewis's way of disconnecting herself from the subject matter. By examining *Forever Free* as well as Lewis herself within the intersections of slavery, Black women's reproductive labor, and the antebellum rhetoric of "blackness," Buick presents a compelling argument that "because she has shed all markers that would identify her as chattel, Lewis's freedwoman in *Forever Free* can no longer be a carrier of property or even racialist stereotypes. [Thus], she is indeed "free."[21] Buick argues that much like anti-slavery writers, Lewis purges any obvious visual marker of Blackness from her female protagonist's physiognomy to "neutralize" the figure as a more appealing and sympathetic character for dominant audiences, while simultaneously removing herself from the work as subject.[22] Lewis's depiction of the freedwoman thankfully celebrating her freedom very deliberately signifies that she is in fact not white; rather, she is a representation of a mixed-raced Black woman who, along with her partner, has gained freedom, and is now in control of her own life.

Lewis was very much concerned with her own economic freedom. Well known for designing, pricing, and selling her own works, her sculptural application of visible-aggregation in *Forever Free* begins with a layering of gestures that at first glance appear to reify the popular gendered notions of the nineteenth century. Yet, closer examination suggests that Lewis utilized neoclassicism to re-visualize the tenets of true womanhood in advocacy for Black women's autonomy and subjectivity. For example, the freedman gently and protectively rests his right hand on the freedwoman's right shoulder, supporting her as she kneels thankfully to the heavens. With both his head and left arm lifted in praise, the chain of his broken manacles dangle around his wrist as he gives thanks to God, and *not* Lincoln, for their freedom.[23] Though

Lewis's design renders him higher than the freedwoman, he is a strong and stabilizing equal, which suggests a family unit and certain roles within the spousal relationship. Where many scholars have interpreted this figuration to represent the inequity in traditional Victorian gender roles—male agency, female passivity—Buick clarifies that, "[i]n order to participate fully in the culture of the United States, [newly emancipated] African American men and women had to adhere to the dominant gender conventions, and thus submission by black women was a necessity."[24] Claudia Tate also points out that African Americans in the nineteenth century were well aware of the social mores of the time period, and staunchly approved of marriage as an indication of respectability, family stability, and social progress and the appearance of Black female submission was crucial to those gains.[25] Lewis's commitment to Black feminist visuality appears in how her female figure, though kneeling, is an autonomous Black woman. She is an active agent of political change, ready for the opportunity to live as she sees herself. Lewis is sure to center the Black female at the very moment of emancipation, visualizing the solidarity needed between Black men and women if they are to succeed in freedom. This neoclassical expression of Black feminist visuality then foregrounds how important both images and acts of Black women's autonomy are to the future of African American communities.

Subtler design elements of *Forever Free* reveal how Lewis employs visible-aggregation to express Black women's personal empowerment. For instance, she carefully positions the freedman next to yet slightly behind the freedwoman, suggesting that even though his foot breaks her chain, her freedom comes first. Though she is kneeling, it is not a position of submission or defeat in that she is only on one knee. Lewis positions the freedwoman's left leg sturdily under her frame, implying that when she rises she will do so completely, free and able to pursue her aspirations.[26] Accordingly, Lewis confronts not only post-bellum images of Black women as mammy or jezebel but more importantly she and her freedwoman stand together in direct opposition to Child's conceptualization of the tragic mulatta—catastrophic women who can only gain freedom through death. With *Forever Free*, Lewis frankly rejects the tragic mulatta trope, showing Child visually through her subject matter that Black women of mixed ancestry were not only wise beyond their so-called "cultural age," but more than capable of securing their freedom in life.

Though the characters in *Forever Free* are posed as grateful, simply representing African Americans in neoclassical sculpture signified a boisterous defiance to the visual status quo. As stated earlier, the color of white marble innately informed the elevating principle of neoclassical sculpture and was reserved for the representation of whites only. Lewis deliberately ignores this rule in efforts to comment upon the lack of accurate representations of Black

people in Western art. Her Black feminist visuality aggressively converts neoclassical styles to confront her audiences' prejudice, particularly Child's, while simultaneously articulating more complex depictions of African American women's identity. These neoclassical expressions of Black feminist visuality then envisage Black bodies to Euro-American viewers typically blinded by racist visuality. This is most staunchly affirmed in Child's reaction to *Forever Free*. Upon viewing the piece, Child writes again to Sarah Blake Sturgis Shaw explaining that she would not review the sculpture simply because she did not think Lewis had created a superior work. She states, "I should praise a really good work all the more gladly because it was done by a colored artist; but to my mind, Art is sacred, as well as Philanthropy; and I do not think it either wise or kind to encourage a girl, merely because she is colored, to spoil good marble by making poor statues."[27] In response to Lewis's making of *Hagar in the Wilderness* (1875), Child remarks, "I think it is better that the Freedman & his Wife [*sic*], but I do not think it is worth putting in marble."[28] Hagar, Abraham's slave mistress who Sarah condemns to wander the desert after she becomes pregnant with Isaac, was a frequent allegorical figure for the plight of enslaved Black women. Thus, Child's commentary about *Hagar*, *Forever Free*, and the sacredness of art illuminates the nineteenth-century understanding that the appropriate execution of neoclassical sculpture was never to represent the Black subject in the medium, revealing the amaurosis of not only a racist, patriarchal society, but more pointedly the racist visuality of the one person celebrated as the most sympathetic to African American women's experiences.

In 1940 the philosopher Alain Locke attributed the "advent of Negro art" to *Forever Free* and a portrait of Daniel Payne and his family painted by African American landscape artist Robert S. Duncanson.[29] Locke's praise for *Forever Free* is essential in that he basically credits Lewis as one of the originators of Black aesthetics in American fine art. In this regard it is apparent that Lewis's confrontational, visual expressions of African American women's identity grounded the beginning of Black visual aesthetics in a solid Black feminist visuality.

NOTES

1. Combahee River Collective, *The Combahee River Collective Statement: Black Feminist Organizing in the Seventies and Eighties*, with a foreword by Barbara Smith, (New York: Kitchen Table, Women of Color Press, 1986), 10.
2. Laura Curtis Bullard, "Edmonia Lewis," *The Revolution* 7, no. 16 (April 20, 1871).

3. Lewis's mother Catherine Lewis was born in Canada to an African American father named John Mike, who was an escaped slave, and a mother of mixed Ojibwa and African American heritage. Later, once the Mike family settled in Albany, New York, Catherine married a West Indian man with the surname Lewis, who Edmonia describes as "a negro and a gentleman's servant" in an 1866 interview with Henry Wreford of the London Athenæum. Kirsten Pai Buick, *Child of the Fire: Mary Edmonia Lewis and the Problem of Art History's Black and Indian Subject* (Durham, NC: Duke University Press, 2010), 4; Henry Wreford, "A Negro Sculptress," in *Frank Leslie's Weekly*, April 7, 1866. For more on Lewis's biography see also Harry Henderson and Albert Henderson, *The Indomitable Spirit of Edmonia Lewis: A Narrative Biography* (Milford, CT: Esquiline Hill Press, 2014).

4. Buick dedicates an entire chapter to the ways in which Lewis's heritage frequently informed readings of her artworks by reviewers, critics, and art historians from the nineteenth century to the present. So much so, that an art historical binary emerges that traps Lewis and her works between two analytical paradigms: "that of the exotic on the one hand and, on the other, the wily subversive feminist who manipulated her white audience through the use of her white marble sculpture." Buick, 133–143.

5. Shaw, 170.

6. Bullard, "Edmonia Lewis."

7. Stephanie Cash and Carl Rojas, "Q & A: Q& A with Kirsten Pai Buick," *Burnaway*, March 18, 2016, www.burnaway.org.

8. Charmaine A. Nelson, *The Color of Stone: Sculpting the Black Female Subject in Nineteenth-Century America* (Minneapolis: University of Minnesota Press, 2007), 23.

9. Bullard, "Edmonia Lewis."

10. Bullard, "Edmonia Lewis."

11. Edmonia Lewis to Maria Weston Chapman, May 3, 1868, Boston Public Library, Anti-Slavery Collection, Rare Books and Manuscripts Department.

12. Bullard, "Edmonia Lewis."

13. Shaw, 170. Though it is known that Lewis circulated her cartes-de-visite to potential buyers, a large visual archive of Lewis does not exist. The images included here are only two of a set of six cartes-de-visite commissioned by Lewis. See also Buick, 137.

14. Buick, 56–57.

15. Buick, 56–57.

16. Though the tragic mulatta is writ large in American literature and literary criticism, for key texts that examine the trope in both antebellum and postbellum works by white and black writers, see Judith R. Berzon, *Neither White nor Black: the Mulatto Character in American Fiction* (New York: New York University Press, 1978); Hazel Carby, *Reconstructing Womanhood: The Emergence of the Afro-American Woman Novelist* (New York: Oxford University Press, 1987); Werner Sollors, *Neither Black nor White Yet Both: Thematic Explorations of Interracial Literature* (New York: Oxford University Press, 1997); Teresa C. Zackodnik, *The Mulatta and the Politics of Race* (Jackson: University of Mississippi Press, 2004). For notable literary

works that employ the trope during the antebellum period, see Lydia Maria Child, *The Quadroons*; William Wells Brown *Clotel or The President's Daughter*, and Harriet Beecher Stowe, *Uncle Tom's Cabin*.

17. Jules Prown, "Style As Evidence," *Winterthur Portfolio* 15, no. 3 (Autumn 1980): 205.

18. Nelson, 57.

19. Benjamin Quarles, "A Sidelight on Edmonia Lewis," *The Journal of Negro History* 30, no. 1 (January 1945): 82–84.

20. Buick, 14–15.

21. Buick, 67.

22. Buick, 66.

23. The gracious slave genuflecting to Lincoln was a very common image in visual representations of Emancipation, particularly American public sculpture. See Thomas Ball's *Freedmen's Memorial to Lincoln*, 1876, Lincoln Park, Washington, D.C.

24. Buick, 55.

25. Claudia Tate, *Domestic Allegories of Political Desire: The Black Heroine's Text at the Turn of the Century* (New York: Oxford University Press, 1992), 90–93.

26. Both the 13th amendment and the Freedman's Bureau were established in 1865.

27. Lydia Maria Child to Sarah Blake Sturgis Shaw, August 1870, Harvard University, Houghton Library, MS Am 1417 (105). Date is obscured.

28. Lydia Maria Child to Sarah Blake Sturgis Shaw, August 1870.

29. Alain Locke, *The Negro in Art: A Pictorial Record of the Negro Artist and of the Negro Theme in Art* (New York: Hacker Art Books, 1968), 9.

BIBLIOGRAPHY

Berzon, Judith R. *Neither White nor Black: the Mulatto Character in American Fiction*. New York: New York University Press, 1978.

Buick, Kirsten Pai. *Child of the Fire: Mary Edmonia Lewis and the Problem of Art History's Black and Indian Subject*. Durham, NC: Duke University Press, 2010.

Bullard, Laura Curtis. "Edmonia Lewis." *The Revolution* 7, no. 16 (April 20, 1871).

Carby, Hazel. *Reconstructing Womanhood: The Emergence of the Afro-American Woman Novelist*. New York: Oxford University Press, 1987.

Cash, Stephanie, and Carl Rojas. "Q & A: Q & A with Kirsten Pai Buick," *Burnaway*, March 18, 2016. www.burnaway.org.

Child, Lydia Maria, to Sarah Blake Sturgis Shaw, August 1870, Harvard University, Houghton Library, MS Am 1417 (105). Date is obscured.

Combahee River Collective. *The Combahee River Collective Statement: Black Feminist Organizing in the Seventies and Eighties*. Foreword by Barbara Smith. New York: Kitchen Table, Women of Color Press, 1986.

Henderson, Albert, and Harry Henderson. *The Indomitable Spirit of Edmonia Lewis: A Narrative Biography*. Milford, CT: Esquiline Hill Press, 2014.

Lewis, Edmonia, to Maria Weston Chapman, May 3, 1868, Boston Public Library, Anti-Slavery Collection, Rare Books and Manuscripts Department.

Locke, Alain. *The Negro in Art: A Pictorial Record of the Negro Artist and of the Negro Theme in Art*. New York: Hacker Art Books, 1968.

Nelson, Charmaine A. *The Color of Stone: Sculpting the Black Female Subject in Nineteenth-Century America*. Minneapolis: University of Minnesota Press, 2007.

Quarles, Benjamin. "A Sidelight on Edmonia Lewis," *Journal of Negro History* 30, no. 1 (January 1945).

Shaw, Gwendolyn DuBois, and Emily K. Shubert. *Portraits of a People: Picturing African Americans in the Nineteenth Century*. Seattle: University of Washington Press, 2006.

Sollors, Werner. *Neither Black nor White Yet Both: Thematic Explorations of Inter-racial Literature*. New York: Oxford University Press, 1997.

Tate, Claudia. *Domestic Allegories of Political Desire: The Black Heroine's Text at the Turn of the Century*. New York: Oxford University Press, 1992.

Wreford, Henry. "A Negro Sculptress," in *Frank Leslie's Weekly* (April 7, 1866).

Zackodnik, Teresa C. *The Mulatta and the Politics of Race*. Jackson: University of Mississippi Press, 2004.

Chapter Five

Enchanted Optics

Excavating the Magical Empiricism of Holmesian Stereoscopic Sight

Cheryl Spinner

The history of photography has been characterized by disenchanted interests. Any photography that touches the supernatural, such as spirit photographs or nineteenth-century 3D photography, appears as an outlier. Mass consumer culture, as exemplified by still and motion pictures, was diagnosed by Marxist critics such as Guy Debord, Theodor Adorno, and Max Horkheimer as media that mystified the masses.[1] The early appearance of 3D visual culture might thus appear to be the ultimate mystifier: it lulls passive viewers into trances as 3D glasses construct illusory realities before their eyes.[2] Building on the concept of 3D visual culture as an instantiation of such mystification, my work proceeds from the assumption that excavating a history of stereoscopic sight can help re-train the way we think, see, and read in both the humanities and the sciences. In particular, as scholars such as Jane Bennett question Max Weber's story of modernity, which pivots on the progressive disenchantment of the world,[3] the mesmerizing power of the stereograph's ocular illusions actually enables attentive modes of analysis.

The eye has long been understood as *the* sensory organ of realism: seeing is, after all, believing. But the eye has also been entangled with the perception of a supernatural or supranatural (that which is beyond the natural) world. Throughout this chapter, I unpack the history of the empirical eye to investigate what happens with such supernatural associations. The shift in literary studies might be called an enchanted turn as scholars seek to recuperate magic as a valid mode of reading. Rita Felski, for example, articulates how "contemporary critics . . . mercilessly direct laser-sharp beams of critique at every imaginable object"; she observes that in literary studies "enchantment is bad magic," such that "the role of criticism is to break its spell by providing rational explanations for seemingly rational phenomena."[4] With

"laser-sharp beams," Felski evokes the sterile scientism of surgical precision that appears to be incompatible with enchanted, spellbound modes of reading. By this view, the spell and the scalpel cannot coexist. I argue otherwise: enchantment does not preclude precision or critical reading practices; rather, enchanted modes of seeing can enable sustained critical attention. Indeed, enchanted sight can actually sustain an intimate and nuanced relationship with the object.

As a counterexample, I offer a largely overlooked history of supernatural sight. To do so, I turn to the essays and fiction of Oliver Wendell Holmes, who, as the inventor of the Holmesian stereoscope, exemplifies the union of the visual and the literary that concerns me here. Nineteenth-century stereograph enthusiasts literally saw through Holmes' eyes via the most popular handheld stereoscope apparatus. Holmes' essays on stereography archive enchanted histories of photography that imagine three-dimensional images as both hypnotically enchanted and microscopically attentive. In so doing, Holmes offers a model that allows us to rethink the role of enchantment in contemporary scientific and humanistic analysis.

But while Holmes' essays exemplify a compatibility between science and enchantment, his literary works manifest the kind of tension between them that is more characteristic of contemporary thinking. Unlike his essays, his novel, *Elsie Venner: A Romance of Destiny* (1861), genders and racializes enchanted modes of looking through a hetero-normative plot device. Holmes hyper-feminizes and racializes stereographic sight in the serpentine protagonist, causing scientific and supernatural sight to unravel into separate and competing strains. The distinction, in turn, genders divisions of knowledge, aligning mystical reading practices with the racially, or rather serpentinely, ambiguous feminine and precise scientism with the masculine.

A great deal of this essay is devoted to accessing the scientific and enchanted aspects of the history of 3D photography that have been forgotten over the centuries. If we allow scientific and supernatural histories to exist alongside and with each other we access forgotten methodologies and histories, much like the stereoscope that synthesizes slightly different twin images to produce phantom three-dimensionality. We might call this scholarly move a stereoscopic method.

ENCHANTED MICROSCOPIC SIGHT IN HOLMES' ESSAYS ON THE STEREOGRAPH

Three-dimensional phantom images inhabit the ocular field of nineteenth-century visual technologies. Visual landscapes of this kind were made pos-

sible by the theoretical work of inventor and scientist Charles Wheatstone.[5] In his experiments with two-dimensional geometric shapes, Wheatstone successfully simulated three-dimensionality by inventing the stereoscope, a device that artificially merged twin two-dimensional line drawings into one three-dimensional geometric shape. In doing so, Wheatstone discovered this "binocular trick"—that the mind could be deceived into believing it is receiving a fictive three-dimensional image. Wheatstone published his discovery in 1838, one year before Daguerre revealed his method for fixing images on mirror plates. By the mid-century, stereoscopy would enter the realm of the photographic with the emergence of stereographs that could temporarily bring twin pictures, not simply line drawings, into the third dimension.

In his *Letters on Natural Magic* (1835), written four years before the invention of photography, Sir David Brewster, inventor of the Brewster stereoscope, describes the eye as "the most important and most remarkable" of the sensory organs and the one that provides the most information regarding the external world.[6] But the eye sees more than that; it acts as a gatekeeper between the sphere of the mystical and the mundane. The primary organ of the supernatural, it is the sensory organ most attuned to deciding whether exterior stimuli are mere matter or supernatural occurrences:

> When the indications of the marvellous are addressed to us through the ear, the mind may be startled without being deceived, and the reason may succeed in suggesting some probable source of the illusion by which we have been alarmed: but when the eye in solitude sees before it the forms of life, fresh in their colours and vivid in their outline; when distant or departed friends are suddenly presented to its view; when visible bodies disappear and reappear without intelligible cause; and when it beholds objects, whether real or imaginary, for whose presence no cause can be assigned, the conviction of supernatural agency becomes under ordinary circumstances unavoidable.[7]

While curious sounds may be easily explained away, visual perceptions are evidently harder to refute. The eye, for Brewster, is "the sentinel which guards the pass between the worlds of matter and of spirit, and through which all their communications are interchanged . . . *The eye is consequently the principal seat of the supernatural*" [italics mine].[8]

In *Techniques of the Observer*, visual cultural theorist Jonathan Crary calls stereoscopes "the most significant form of visual imagery in the nineteenth century, with the exception of photographs."[9] Stereographs of the century varied in subject, ranging from the 3D photographs of Alexander Gardner's and Matthew Brady's famed images of Civil War corpses to images of famous sights around the world. These images enabled a kind of virtual tourism, extending even to the moon. In addition to these realist

brands of stereography, photographers produced more fanciful images that included staged supernatural scenarios of ghosts and ghouls, or trick photographs such as "Heart and Hand" (see figure 5.1). "Heart and Hand" evokes the cuff-linked wrist of the magician displaying his trick, in this case the sleight of hand that is visualized by the image of a woman's head floating in the presumably masculine hand of the prestidigitator. Particularly when viewed through a stereoscope, the tilt of the hand appears more pronounced, showcasing her upper body in such a way that she is both a camera trick and a kind of miniaturized scientific specimen.

Brewster foresaw the supernatural potential of stereoscopic photography as a form of entertainment. As he notes in his 1854 work, *The Stereoscope: Its History, Theory, and Construction,*

> For the purpose of amusement, the [stereograph] photographer might carry us even into the regions of the supernatural. His art, as I have elsewhere shewn, enables him to give a spiritual appearance of one or more of his figures, and to exhibit them as "thin air" amid the solid realities of the stereoscopic picture. While a party is engaged, a female figure appears in the midst of them with all the attributes of the supernatural. Her form is transparent, every object or person beyond her being seen in shadowy but distinct outline. She may occupy more than one place in the scene, and different portions of the group might be made to gaze upon one or other of the visions before them.[10]

Hence, while hyper-real stereographic imaging was being used to carve out a fictional image of the moon, the very same technology was also turning ghosts into spectacles for public view.

Holmes coined the word "Stereograph" in his *Atlantic Monthly* article, "The Stereograph and the Stereoscope" (1859). The term is derived from

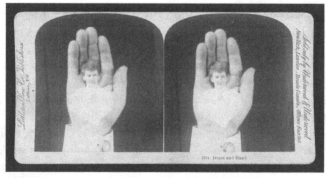

Figure 5.1. Heart and Hand. 1896. Stereograph.
Courtesy of the Library of Congress, Washington, D.C.

the Greek words *stereo* (solid) and *graph* (writing), the same suffix used to describe photography as writing (graph) with light (photo). Holmes' term understood stereographs as solid photographs, able to produce the illusion of three-dimensional matter and depth. He also distinguished stereography from photography by calling stereographs "sun-sculptures" and photographs "sun-paintings."[11] He continually extolled the unique nature of stereography's ability to mimic the real. "*All* pictures," he maintained, "in which perspective and light and shade are properly managed, have more or less of the effect of solidity; but by *this* instrument that effect is so heightened as to produce an appearance of reality which cheats the senses with its seeming truth."[12]

Photography's illusions are most realized, for him, in the technology of the stereoscope, in which we "*feel around objects*"; the technology allows the viewer to clasp objects "with our eyes, as with our arms, or with our hands, or with our thumb and finger, and then we know it to be something more than a surface" (75). Unlike the photograph, often dubbed the "pencil of nature," the stereograph, for Holmes, was more like the sculptor's chisel. Fittingly, a popular subgenre of stereographic pictures included images of famed statues. The numerous stereographic allusions in Nathaniel Hawthorne's book about a sculpture, *The Marble Faun: or, the Romance of Monte Beni*, published the year after Holmes' essay, testifies to the rapidity with which the technology was becoming a staple of the broader culture.

At the same time, Holmes believed in the technology's remarkable ability to mimic the real in those marble-like pictures, he also described its effects as otherworldly:

> Perhaps there is also some half-magnetic effect in the fixing of the eye on twin pictures,—something like . . . *hypnotism* . . . At least the shutting out of objects, and the concentration of the whole attention, which is a consequence of this, produce a dream-like exaltation of the faculties, a kind of clairvoyance, in which we seem to leave the body behind us and sail away into one strange scene after another, like disembodied spirits. ("Sun-Painting and Sun-Sculpture," 172)

This kind of looking is "magnetic"; one is hypnotized by the three-dimensional image and floats away into it like a "disembodied spirit." Stereovision is clairvoyant vision.

In Holmes' essays the stereoscopic image also enables microscopic forms of looking. He conceptualized the experience of viewing a stereoscopic image as singular, evoking a different kind of reading practice from that enabled by 2D images:

> The first effect of looking at a good photograph through the stereoscope is a surprise such as no painting ever produced. The mind feels its way into the very

depths of the picture. The scraggy branches of a tree in the foreground run out at
us as if they would scratch our eyes. [. . .] Then there is such a frightful amount
of detail, that we have the same sense of infinite complexity which Nature gives
us. A painter shows us masses; the stereoscope figure spares us nothing—all
must be there, every stick, straw, scratch. . . . This distinctness of the lesser
details of a building or landscape often gives us incidental truths which inter-
est us more than the central object of the picture. ("The Stereograph and the
Stereoscope," 148, 151)

Like the photomicrograph that replicated every cell, every hair on a flea, the
stereoscope recorded all details that the painter simply could not. In doing
so, stereographs illuminated the world, on the macro scale, by recording the
"lesser details" of objects. 3D images do not merely enchant, they also illu-
minate and bring forth what the eye could not see.

The stereograph's attention to the lesser details of the image echoes what
Roland Barthes would call in the twentieth century the *punctum* of the photo-
graph. For Barthes, the *punctum* is a "detail" or "partial object" that "pricks"
the viewer."[13] The *punctum,* "lightning-like," provokes a "tiny shock" that
arrests the looker quite suddenly and unexpectedly, but that momentary punc-
ture gives way to a "power of expansion," in which the whole image is read
via the lens of startling details.[14] Unlike Barthes' *punctum*, which is localized
as a specific aspect of the image that pierces the viewer, the stereographic im-
age is all *punctum*. The more one looks, the more details hook the eye into the
depths of the image. Holmes praised photography as a medium which made it
so that "one may creep over the surface of the picture with his microscope and
find every leaf perfect, or read the letters of distant signs" ("The Stereoscope
and the Stereograph," 128).[15]

Stereographs only heightened such microscopic attention. Holmes' ste-
reograph straddled the line between science and the supernatural, solid and
transient images, realism and fantasy, embodiment and disembodiment.
Intriguingly, Holmesian three-dimensional sight resonates with Rita Felski's
description of contemporary enchanted reading practices. "Enchantment,"
she explains, "is characterized by a state of intense involvement, a sense of
being so entirely caught up in an aesthetic object that nothing else seems to
matter."[16] Elaborating on Stephen Greenblatt's claim that "looking may be
called enchanted when the act of attention draws a circle around itself from
which everything but the object is excluded," Felski writes that viewers
"wrapped up in the details of a novel, a film, a painting," might feel "enclosed
in a bubble of absorbed attention."[17] For Felski, such "immersion seems
self-enclosed and self-sustaining, demarcated by a distinct boundary."[18] The
bubble-like experience of enchanted perception—one that is predicated on
boundaries—describes an aesthetics of the cellular. To take Felski one step

further, the point of view of the microscope is one that operates on the level of the bubble—the circular view that isolates the slide beneath the lens's stem.

The experience of shutting out an outside to better attend to an inside is characteristic of scientific looking. The enclosure that aesthetic objects enact—whether in the form of a novel, a visual image, a microscopic slide, or the interior of a human organism—is the condition that enables sustained close reading. This same enclosure provides the necessary condition for enchanted modes of seeing. A precursor to modern virtual-reality goggles such as Oculus Rift, the Holmesian stereograph brought this kind of scientific enclosure into the parlor room. "The Stereograph as an Educator," for instance, depicts a lady looking into her stereoviewer, entranced by the phantom images she sees, unaware of her surroundings. The device is both a learning tool that exposes the viewer to intricacies of images on all sorts of topics and a technology of entertainment. The image of ladies looking into stereoscopes was a popular subgenre of stereography, allowing viewers to re-embody themselves in the image of the looking ladies, who are also engrossed in this technology of enclosure at the moment they are looking through the device.

Arden Reed explains that the goggle-like perspective of the stereoscope creates new forms of perception because, with stereographs, the eye "moves, as it were, forward and back, in and out. Add to which, unlike photographs, which blur beyond their range of focus, stereo views offer sharp images at whatever distance—all of which creates more to engage the eye."[19] The eye scans stereoscopic images differently from two-dimensional photographs because all aspects of the image remain in focus. The stereoscope brackets offer external visual stimuli to apprehend an image that requires close and slow looking to make sense of optical information. As Reed explains, "However 'rapidly' the mind synthesizes images, stereoviewing still unfolds in time . . . Stereo views appear to stack one flat image behind another at indeterminable distances. . . . Stereos thereby bring into relief the relationship between flatness and depth. More importantly, because optical motion occurs in time, *the perception of depth produces duration*."[20] Stereovision slows time down as we linger on the images, allowing our eyes to adjust, process, and move across the variegated layers of simulated three-dimensionality.

Throughout his articles, Holmes close-reads specific stereographs. In a glass stereograph of the Lake of Brienz, for example, he ruminates on the particular duration of the stereoscopic camera with its two lenses that could catch moving subjects across each lens:

It is common to find an object in one of the twin pictures which we miss in the other; the person or vehicle having moved in the interval of taking the two photographs. In the lovely glass stereograph of the Lake of Brienz, on the left–hand side, a vaguely hinted female figure stands by the margin of the fair water;

on the other side of the picture she is not seen. This is life; we seem to see her come and go. All the longings, passions, experiences, possibilities of woman-hood animate that gliding shadow which has flitted through our consciousness, nameless, dateless, featureless, yet profoundly more real than the sharpest of portraits traced by a human hand. ("The Stereoscope and the Stereograph," 153)

Shooting these twin images in camera creates the possibility of capturing bodies in motion. A figure that had been static on one end of the lens may move to the next in the course of a few seconds, thereby creating an unex-pected phantom in the background. Viewing items under the stereograph is incredibly important, and yet these images are not supplied in his *Atlantic Monthly* article, nor are their actual titles and makers referenced so that the reader might track them down. Words replace viewing. To a certain extent, knowing which stereograph Holmes is analyzing is unnecessary. One gets the idea, the theoretical feeling, from his words. But perhaps in light of the digital humanities, we could do a little better. This essay lends itself to reimagining how we might present scholarly material on the subject, wherein the experi-ence of *seeing* is important, especially for a technology that hinges on the tension between solidity and ether, embodiment and disembodiment.

STEREOGRAPHY'S NEW POWERS OF PERCEPTION: ENCHANTMENT AND THREE-DIMENSIONAL SCIENCE PHOTOGRAPHS, FROM THE NINETEENTH TO THE TWENTY-FIRST CENTURIES

The phenomenologist Maurice Merleau-Ponty described all binocular vision, the default state of natural vision in humans, as the stuff of phantoms because perception itself can only give an approximation of the material world. For Merleau-Ponty, binocular perception is more than

> two monocular perceptions surmounted; it is of another order. The monocular images *are* not in the same sense that the thing perceived with both eyes *is*. They are phantoms and it is the real; they are pre-things and it is the thing: they vanish when we pass to normal vision and re-enter into the thing as into their daylight truth. . . . The monocular images cannot be *compared* with the synergic perception: one cannot put them side by side; it is necessary to choose between the thing and the floating pre-things.[21]

The binocular state of natural vision exists beyond the third dimension: twin images from each eye are not merely merged on the retina to produce a third dimension. Natural vision is, rather, beyond sight, much like artificial binocu-lar vision that produces temporary phantom images.

The virtual realities of artificial binocular vision invite hypnotic close-reading: a slow and sustained attention to the nuances of the image, which is the result in part of their planar composition. Crary teases out how the planar effect of stereographs produces strange visual landscapes:

> We are given an insistent sense of "in front of" and "in back of" that seems to organize the image as a sequence of receding planes. And in fact the fundamental organization of the stereoscopic image is *planar*. We perceive individual elements as flat, cutout forms arrayed either nearer or further from us. But the experience of space between these objects (planes) is not one of gradual and predictable recession; rather, there is a vertiginous uncertainty about the distance separating forms. Compared to the strange insubstantiality of objects and figures located in the middle ground, the absolutely airless space surrounding them has a disturbing palpability.[22]

Crary articulates the paradox of these images: while they round out the two-dimensional images, they can also have the effect of looking like flat cutouts in a sequence of planes. The distance between such planes is unclear to the viewer, and as a result the objects in the image create the effect of "absolutely airless space" between each other that produces a "disturbing palpability" to all components of the image.[23] The airlessness of these intervening spaces does not follow the rules of natural depth perception where the length of space in between objects is generally discerned. The fact that Crary fixates on the disturbing nature of this "airless space" gets at the discomfort these images create. Their hyper reality is embedded in an airless space where no living organism could actually survive. Arden Reed adds to the peculiar reality of stereographs by stating they do not simply reinstate a third-dimension to flattened two-dimensional photographs.[24] Instead, as the standard human eye blurs distant objects in its depth of field, and a single lens camera does the same; all objects in stereographic images are in focus regardless of their distance because this mode of photography does not mimic natural human vision.[25]

The lack of depth of field in stereographs allows for a different kind of perception that is slow, localized, and attentive. Crary attributes this new kind of looking to the fact that "stereoscopic relief or depth has no unifying order" and as such one's eyes "never traverse the image in a full apprehension of the three-dimensionality of the entire field, but in terms of localized experience of separate areas."[26] When we encounter a photograph or painting, the images retain an "optical unity" because "our eyes remain at a single angle of convergence."[27] The stereograph, however, is never processed in its totality by the optical field, rather:

> The reading or scanning of a stereo image . . . is an accumulation of differences in the degree of optical convergence, thereby producing a perceptual effect of a

patchwork of different intensities of relief within a single image. Our eyes follow a choppy and erratic path into its depth: it is an assemblage of local zones of three-dimensionality, zones imbued with a hallucinatory clarity, but which when taken together never coalesce into a homogenous field.[28]

In understanding stereoscopic vision as a form of "reading" or "scanning," Crary distinguishes the medium from the more recognizable idea of "looking" at photographs or paintings. In the cases of photographs and paintings spectators first encounter the totality of the image and then hone in on the details. Conversely, the eye darts across the stereographs, processing its pieces, which never achieve any kind of optical unity. Crary explains that the "realism" of stereographic images is a result of the eye's ability to reconcile the slight differences between the twin images, which leads him to conclude that "there never really is a stereoscopic image, that it is a conjuration, an effect of the observer's experience of the differential between two other images."[29]

By producing these realist conjurations, nineteenth-century stereograph technologies enabled enchanted ways of seeing. Unlike the single lens camera, the stereoscopic camera mimicked natural vision more closely with its two "eyes." While the stereoscope was a technology of illusion, it was also argued by many to be the most accurate and natural of all photographic technologies. The stereoscopic camera, in particular, was often compared to an actual human head. An essay in *Harper's* described the stereoscopic camera, with its twin lenses, as having a "forehead with two eyes," the brass lens covers "eyelids" that open and close when the plate is exposed and the aperture mechanism that controls the size of the lens opening is "the pupil of the eye that contracts and expands according to the degree of light."[30]

Robert J. Silverman notes how the arrangement of the stereoscopic camera became a topic of great debate among photographers of the nineteenth century: "one side maintained that the separation of the human eyes should be duplicated unwaveringly by the photographer. Appeals to nature, as one might gather, provided the most potent rhetorical device for those who maintained this stance." Those in support of stereographs that mimicked natural human vision "often warned that widely separated cameras would make objects appear like 'models'" or would "seem 'distorted' or even 'monstrous' if the exaggeration became extreme."[31] Other photographers "enjoyed the enhanced perspective and model-like effect" that came with more experimental stereoscopic cameras. Landscape stereographers often separated the lenses by several feet so that the stereograph purchaser could enjoy the effect of what we would now call "hyper-space" to "observe deeper valleys and more dramatic cascades than existed in reality."[32]

Warren De La Rue's first stereograph of the moon in 1848, taken at the Cranford Conservatory, generated controversy over the distinction between

fact and fiction in scientific photography precisely because De La Rue extensively manipulated the interocular distance of the stereoscopic camera even more drastically than the practices used by landscape stereographers. In order to create these three-dimensional images, two telescopic photographs were taken months apart to produce the optimal stereograph. The successful lunar stereographs brought out previously invisible details of the moon's surface and provided important information for astronomers. Stereography produced new ways of perceiving the world. It augmented natural vision, but it often did so with the help of unnatural camera manipulations. The scientific community was bothered precisely because the most accurate images of the material world required a fair dose of camera magic to produce them.

The celestial photographs of the nineteenth to the twenty-first centuries produce phantom images of what we perceive as "Pluto" or the "Moon," but the fictive—and, perhaps, enchanted—component of these images is overlooked particularly in our contemporary moment in the name of scientific fact. Holmes' own struggle with how enchanted and scientific sight could remain compatible is most evident in the first of what he described as his "medicated novels," *Elsie Venner: A Romance of Destiny* (1861), wherein he struggles with the dilemma of the supernatural eye. Holmes' essays on stereography present an enchanted eye that is tethered to a microscopic way of seeing. Three-dimensional vision affords close and meticulous readings that "give not only every letter of the old inscriptions" on the arches of Constantine, but "render the grain of the stone itself" ("The Stereoscope and the Stereograph," 148). Here, enchanted looking cannot be distinguished from microscopic sight; the stereoscope and the microscope are intimately related. Holmes explores the connection in *Elsie Venner*, but when the enchanted eye becomes embodied in Elsie—a human stereograph—the two forms of looking doubly split gendering and racializing sight: enchantment is feminized and racially othered, and scientific looking is masculinized and predicated on unambiguous origins of whiteness. This splitting turns the supernatural eye into a conceptual dilemma disruptive to the scientific reading practices of men of medicine, which perhaps shows Holmes' discomfort with the more integrative theorizations of stereography evident in his essays.

Notably, it is the snake bite her mother receives while pregnant, that raises the question of blood. Undoubtedly invoking the one drop of blood rule, the novel fixates on whether Elsie is actually a woman anymore. The mixing of interspecies blood here is where enchantment comes in—there is no method for proving empirically that Elsie is a snake or a woman. While blood may be of biological matter, its composition could never be proven empirically. It is the enchanted stuff of life that makes up the unreadable body of the snake woman. The novel evokes this pressing question by positing that perhaps Elsie is part reptilian.

HOLMESIAN STEREOSCOPIC LITERATURE AND
THE FEMINIZATION OF ENCHANTED SIGHT

The eponymous character of Holmes' novel acquires her unique optical powers while still in the womb when her pregnant mother is bitten by a snake. The venom may have altered her biochemical constitution, which raises the question of whether or not she is biologically a woman anymore. One of the most discernible symptoms of her condition is Elsie's "diamond eyes," which transfix the viewer into a hypnotic trance, much like the magnetic qualities of the stereograph that Holmes articulates in his photographic writings. She is even said to enjoy "studying the stereoscopic Laocoön," a three-dimensional photograph of a statue "representing an old man with his two sons in the embraces of two monstrous serpents."[33] Elsie manifests the hypnotically clairvoyant relationship between image and viewer that Holmes describes in his writings on photography when she studies the Laocoön. But she does not simply encounter the stereograph for her own entertainment; with eyes that entrance, she is a walking stereograph herself, creating hypnotic circuits between her and those who look at her.

We realize the full extent of Elsie's powers when Bernard Langdon, love interest, teacher, and part-time medical student, finds himself ensnared in a magnetic eye loop with a snake. In the important scene, his eyes meet the "two diamond eyes" of the serpent shining out of the darkness, and he stands "fixed, struck dumb, staring back into them with dilating pupils and sudden numbness of fear that cannot move" (173). The diamond eyes begin to morph and become "two sparks of light," much like Barthes' *punctum*, that "move forward" and grow into "circles of flame" (173). The description corresponds to Greenblatt's articulation of enchanted looking as the moment "when the act of attention draws a circle around itself from which everything but the object is excluded" (quoted from Felski, 55). Langdon is transfixed by the orbs, as "magnets toward the circles of flame" in a kind of horrific analog to the more hypnotic gaze stereographic sight enables (*Elsie Venner*, 173). The serpentine eyes similarly move forward as the statue of the Laocoön would when Elsie views it in a stereoscope. Langdon only emerges from the trance when he senses that Elsie is behind him, "looking motionless into the reptile's eyes, which had shrunk and faded under the stronger enchantment of her own" (173). The medical student's powers of scientific sight—his rationality, methodological reasoning—are stupefied in the face of the snake eye. Elsie's enchanted eye, not Langdon's scientific acumen, is the only antidote to the hypnotic snake stare. Langdon finds himself pierced frozen before mystical serpentine eyes much like Barthes' *punctum*, which produces "an *intense immobility:* linked to a detail (to a detonator), an explosion" that "makes a little star on the pane of the . . . photograph."[34]

That the novel itself is preoccupied with the dilemma of Elsie's powers of stereographic sight, the physiological basis of her strange supernatural eye, is in part a function of its narrator: a professor of medicine. The Professor, as he is called, recounts the romantic entanglements of his own medical student, Bernard Langdon, with Elsie Venner. But the novel is not simply a love story; it is a case study of a woman who is stricken with an unusual malady, and the Professor continually hypothesizes explanations for Elsie's peculiar symptoms. Like the snake, Elsie's "diamond eyes" spill outward, and the Professor attempts to attribute them to discoveries in phosphorescence by Henri Becquerel, the husband and collaborator of Marie Curie, who is tellingly not cited with him. The narrator describes Mr. Langdon's sensation at looking into these very eyes:

> He [Langdon] had just been looking at the young girl next to him, so that his eyes were brimful of beauty, and may have spilled some of it on the first comer: for you know M. Becquerel has been showing us lately how everything is phosphorescent; that it soaks itself with light in an instant's exposure, so that it is wet with liquid sunbeams, or, if you will, tremulous with luminous vibrations, when first plunged into the negative bath of darkness, and betrays itself by the light which escapes from the surface. (*Elsie Venner*, 272)

Elsie's eyes luminesce, like light that exists on the invisible spectrum and can only be seen when exposed to a light-sensitive photographic plate. Elsie's magical eye is tied to the invisible forces—magnetism, phosphorescence—the forces that *produce* light on the invisible spectrum.[35] Mr. Langdon's professor makes a rhetorical nod to the possible magical applications of luminescence: "whether a woman is ever phosphorescent with the luminous vapour of life that she exhales,—these and other questions which relate to occult influences by certain women we will not now discuss" (98–99). Margaret Fuller describes a similarly electric feminism in her work *Woman in the Nineteenth Century* when she praises women for their "superior susceptibility to magnetic or electric influence."[36] Like Holmes, Fuller similarly genders the occult when she describes the womanly body as gifted with exceptional chemical qualities that give her special powers.

While Holmes' phosphorescent woman registers an anxiety over the special influence of women, Fuller celebrates it, but both are gendered. Ironically, Elsie's serpentine constitution makes her an "almost over-womanized woman" with eyes that bewitch all who see her, men and women alike (*Elsie Venner*, 99). Yet, it is those very powers of enchantment that make her an entirely different creature. Intriguingly though, when Holmes aligns enchanted, stereoscopic sight with the hyper-feminized body and mysterious blood of Elsie, the magic eye splinters off from scientific modes of looking and enters the realm of aberrant dangerous vision, which must be solved by the eye of

the masculine man of science. Here Holmes manifests a troubling sense of the occult in relation to science that is not evident in his essays. *Elsie Venner,* moreover, illustrates the gendering of knowledge that accompanies the split between the microscopic and the magical: the medical student possesses the eye of rationality, the snake-woman possesses the eye of magic. Contemporary reading practices in both the sciences and humanities similarly split the enchanted eye from the microscopic eye, aligning themselves with the rigor of the scalpel, but I trouble this distinction by arguing that the humanities and the sciences can learn quite a lot from the enchanted viewing practices of stereographic images that sustain slow and meticulous reading, for a magical eye does not preclude a methodological one.[37]

NOTES

1. See Debord's *Society of the Spectacle* (Detroit: Black and Red, 1983) and Adorno and Horkheimer's *Dialectic of Enlightenment* (Stanford, CA: Stanford University Press, 2002).

2. Several editions of Debord's *Society of the Spectacle* display photographs of 1950s moviegoers watching a 3D film on the front cover. See Jens Schröter, *3D: History, Theory, and Aesthetics of the Transplane Image* (New York: Bloomsbury Academic, 2014).

3. See Max Weber's "Science as Vocation" (1919); Jane Bennett's *The Enchantment of Modern Life: Attachments, Crossings, and Ethics* (Princeton, NJ: Princeton University Press, 2001).

4. Rita Felski, *Uses of Literature* (Malden, MA: Blackwell Publishing, 2008), 54, 57.

5. See *The Scientific Papers of Sir Charles Wheatstone* (London: Taylor and Francis, 1879).

6. Sir David Brewster, *Letters on Natural Magic* (London: John Murray, Albermale-Street, 1835), 10.

7. Brewster, 10, 11.

8. Brewster, 10, 11.

9. Jonathan Crary, *Techniques of the Observer: On Vision and Modernity in the Nineteenth Century* (Cambridge, MA: MIT Press, 1993), 116.

10. Brewster, *The Stereoscope: Its History, Theory, and Construction* (London: John Murray, Albermale-Street, 1856), 205–206.

11. Oliver Wendell Holmes, "The Stereoscope and the Stereograph," *Soundings from the Atlantic* (Boston: Ticknor and Fields, 1864), 167, 171. All further quotations will be cited parenthetically.

12. Holmes, "The Stereoscope and the Stereograph," 124–165. See also "Sun-Painting and Sun-Sculpture; With A Stereoscopic Trip Across The Atlantic." *Soundings from the Atlantic* (Boston: Ticknor and Fields, 1864), 166–227. Holmes wrote

two more articles on photography and stereography in *The Atlantic Monthly*: "Sun-Painting and Sun-Sculpture" (1861), and "Doings of the Sun-Beam" (1863).

13. Roland Barthes, *Camera Lucida: Reflections on Photography* (New York: Hill and Wang, 2010), 45, 49, 47.

14. Barthes, 45.

15. Cynthia Davis has charted Holmes' appreciation of microscopic reading practices in both his anatomy and physiology lectures at Harvard and in his fiction, what she calls the "microscopic insight" that allowed doctors to "see through" the body's layers, gifting the physician with X-ray sight 40 years before the X-ray technology was even discovered. In *Bodily and Narrative Forms: The Influence of Medicine on American Literature, 1845–1915* (Stanford, CA: Stanford University Press, 2000), 13.

16. Felski, 55.

17. Felski, 55.

18. Felski, 55.

19. Arden Reed, *Slow Art: The Experience of Looking, Sacred Images to James Turrell* (Oakland: University of California Press, 2007), 75.

20. Reed, 75.

21. Maurice Merleau-Ponty, *The Visible and Invisible* (Evanston, IL: Northwestern University Press, 1968), 7–8.

22. Crary, 125.

23. Crary, 125.

24. Reed, 75.

25. Reed, 76, 77.

26. Crary, 125, 126.

27. Crary, 126.

28. Crary, 125, 126.

29. Crary, 122.

30. Quoted in Robert J. Silverman, "The Stereograph and Photographic Depiction in the 19th Century," *Technology and Culture* 34.4 (1993): 741.

31. Silverman, 729–756.

32. Silverman, 748–749.

33. Oliver Wendell Holmes, *Elsie Venner: A Romance of Destiny* (London: Routledge, Warne, and Routledge, 1861), 278, 266. Further references will be parenthetical.

34. Barthes, 49.

35. As Laura Saltz notes, "By the mid-1840s, scientists began to believe that to speak of light acting photographically in darkness was inexact and 'unscientific.' Instead, light ought to be considered as a variation of such other forces as electricity and magnetism, which were also attributed to ethereal vibrations" (112). "The Magnetism of a Photograph: Daguerreotypy and Margaret Fuller's Conceptions of Gender and Sexuality." *ESQ: A Journal of the American Renaissance* 56.2 (2010): 106–134.

36. Margaret Fuller, *The Portable Margaret Fuller* (New York: Penguin Books, 1994), 74.

37. In our contemporary moment, the *da Vinci* surgical system, complete with robotic scalpels and a stereoscopic viewing apparatus, embodies within its system the coexistence of the spellbound eye of three-dimensional sight with the precision of the surgical knife.

BIBLIOGRAPHY

Barthes, Roland. *Camera Lucida: Reflections on Photography.* New York: Hill and Wang, 2010.

Bennett, Jane. *The Enchantment of Modern Life: Attachments, Crossings, and Ethics.* Princeton, NJ: Princeton University Press, 2001.

Bentley, Nancy. "Introduction." *J19: The Journal of Nineteenth-Century Americanists* 1.1 (2013): 147–153.

Brewster, Sir David. *Letters on Natural Magic.* London: John Murray, Albermale-Street, 1835.

———. *The Stereoscope: Its History, Theory, and Construction.* London: John Murray, Albermale-Street, 1856.

Crary, Jonathan. *Techniques of the Observer: On Vision and Modernity in the Nineteenth Century.* Cambridge, MA: MIT Press, 1992.

Davis, Cynthia. *Bodily and Narrative Forms: The Influence of Medicine on American Literature, 1845–1915.* Stanford, CA: Stanford University Press, 2000.

Debord, Guy. *Society of the Spectacle.* Detroit: Black and Red, 1983.

Felski, Rita. *Uses of Literature.* Malden, MA: Blackwell Publishing, 2008.

Fuller, Margaret. *The Portable Margaret Fuller.* New York: Penguin Books, 1994.

Heart and Hand. 1896. Stereograph. Library of Congress, Washington, D.C.

Holmes, Oliver Wendell. *Elsie Venner: A Romance of Destiny.* London: Routledge, Warne, and Routledge, 1861.

———. "The Stereoscope and the Stereograph." *Soundings from the Atlantic.* Boston: Ticknor and Fields, 1864. 124–165.

———. "Sun-Painting and Sun-Sculpture; With A Stereoscopic Trip Across The Atlantic." *Soundings from the Atlantic.* Boston: Ticknor and Fields, 1864. 166–227.

Merleau-Ponty, Maurice. *The Visible and Invisible.* Evanston, IL: Northwestern University Press, 1968.

Reed, Arden. *Slow Art: The Experience of Looking, Sacred Images to James Turrell.* Oakland: University of California Press, 2017.

Saltz, Laura. "The Magnetism of a Photograph: Daguerreotypy and Margaret Fuller's Conceptions of Gender and Sexuality." *ESQ: A Journal of the American Renaissance* 56.2 (2010): 106–134.

Schröter, Jens. *3D: History, Theory, and Aesthetics of the Transplane Image.* New York: Bloomsbury Academic, 2014.

Silverman, Robert J. "The Stereograph and Photographic Depiction in the 19th Century," *Technology and Culture* 34. 4 (1993): 729–756.

Wheatstone, Charles. *The Scientific Papers of Sir Charles Wheatstone.* London: Taylor and Francis, 1879.

Chapter Six

Between Word and Image

The Use of Humor, Satire, and Caricature in Early Abolitionist Political Cartoons

Martha J. Cutter

On May 9, 1754, Benjamin Franklin's *Pennsylvania Gazette* included what was probably the first political cartoon ever published in America—a vivid depiction of the embattled American colonies as a snake that had been broken into eight pieces, with the glaring motto, "Join, or Die."[1] Believed to have been drawn by Franklin to accompany an editorial about how the colonies (labeled as parts of the snake) needed to band together (and with the British) in order to fight the French and the Indians, the image was popular and widely used as a header for newspapers in its own time. It was even more extensively employed during the American Revolutionary War, as well as (much later) in the Civil War era. As such, this cartoon inaugurated a tradition of deploying popular cartons for political purposes.[2]

Yet it was not until the 1830s, when abolition debates became entrenched in US politics, that the full power of political cartoons was apprehended. As lines were drawn politically, they were also drawn visually. Illustrators on both sides of the slavery debate waged war on each other, using realistic prints as well as caricature, satire, and humor in political cartoons. Abolitionists greatly esteemed the power of images and pictures, and used them to great benefit in their print publications.[3] In assessing the deployment of satirical political cartoons, however, abolitionists had to consider the genre's racist underpinnings. Satirical cartoons tended to work against abolition by exaggerating its proposed reforms,[4] while more naturalistic and realistic modes of illustration tended to appear in antislavery rhetoric. At times abolitionists appear to distrust satire, perhaps because satirical humor can convey ambiguous messages that might miss their intended goal and offend sympathetic readers or viewers.[5]

The abolitionists therefore approached satirical political cartoons with caution, but they did approach them. This essay examines a series of antislavery political cartoons published in the 1830s–1860s to understand how they attempt to shift viewers into a particular ideological standpoint through the use of caricature, humor, and satire.[6] There has been little interpretive scholarship on satirical antislavery political cartoons.[7] They are complicated, often wordy documents that engage storytelling modes, satire, caricature, chronological and spatial shifting, and a form of virtual (unseen) guttering[8] that asks the viewer to collaborate in the making of meaning and complete the antislavery argument being forwarded. Charles Hatfield notes that in comics "words can be visually inflected, reading as pictures, while pictures can become as abstract and symbolic as words."[9] Therefore, comics can demand a different order of reading by generating tension among formal elements. As they move between word and images, these nineteenth-century illustrations demand a different mode of reading, one that asks the reader to grapple with complex visual-verbal systems surrounding both slavery and rhetoric. These images interpellate viewing readers, prodding them to enter the diegetic universe of the cartoon and become part of an evolving abolitionist story.

A PUBLIC, SATIRIC BLACKNESS

To understand how antislavery groups used satirical political cartoons, we must first consider that as a group such cartoons had a long history of containing caricatures of blackness and of spoofing freed or free African Americans. In an essay on comic modes, Joseph Witek contends that cartoons are rooted stylistically in two distinct traditions of visual representation: caricature, which employs simplification or exaggeration, and realistic illustration, which relies on verisimilitude and the re-creation of accurate physical appearances.[10] Many early antislavery political cartoons contain what Corey Capers has called a satirical and public blackness that mocked the desire for freedom.[11] Such prints became popular both in the United States and abroad. Beginning with the "Bobalition" series of broadsides produced from 1819–1832 and continuing into the "Life in Philadelphia Series" of cartoon prints created by Edward Williams Clay, these illustrations mocked blacks as unfit subjects of freedom.

Since Clay was the leading practitioner of this satirical comic mode, his works are worth examining in detail. Clay's *Grand Celebration Ob de Bobalition of African Slavery* (1833) was created in response to the 1833 British abolition of slavery, but the print was popular in the United States as well.[12] It satirically instills fear of the social disorder that might result from abolition,

as African Americans in fancy clothing carouse and drink. A key feature of indirect satire is "a series of extended dialogues and debates (often conducted at a banquet or party) in which a group of loquacious eccentrics, pedants, literary people, and representatives of various professions or philosophical points of view serve to make ludicrous the attitudes and viewpoints they typify by the arguments they urge in their support."[13] Clay's 1833 lithograph clearly relies on this methodology. The individuals in the illustration—all at a banquet—say things such as, "White man—mighty anxious to send niggers to de place dey stole him from, now he got no further use for him." This reference to colonization plans in which freed African Americans would be sent back to Africa appears to be directed more to a US audience than a British one, as debates about colonization intensified in the United States after the American Colonization Society was formed in 1816 and the colony of Liberia was established in 1821–1822. The verbal satire is clear—some abolitionists who argued for the freedom of slaves only wanted them to be free outside of the United States or Europe. Visual caricature is similarly deployed as the black individuals in the print, although elegantly dressed, have grotesque features—large lips and noses. They speak in a dialect that would sound uncouth and comic to a white viewer. The print is a wordy document, yet its biting caricature gives it a strong visual appeal and saves it from didacticism.

More darkly, some of Clay's cartoons promoted fears of what would happen if African Americans achieved freedom and remained in the United States. A number of them feature lurid scenes of miscegenation, such as the 1839 series of prints, *Practical Amalgamation*. This series first shows several mixed-race couples engaged in frantic foreplay (see figure 6.1). Like the *Life in Philadelphia* series, the *Amalgamation* lithographs use visual caricature as well as verbal satire. Visually they depict blacks as grotesque and stereotyped: the man on the left has the big lips thought to be physically characteristic of African Americans, while the woman on the right has broad hips and bosom borrowed from the "mammy" stereotype. Whites, on the other hand, are depicted as slender and elegant—even the white dog in the corner is tall and graceful, while being wooed by a squat, ungainly black dog with bowed legs. Verbal satire is evident in the framed pictures of noted abolitionists on the wall: A. Tappan (Arthur Tappan, co-founder of the American Anti-Slavery Society in 1833), D. O'Connell (Daniel O'Connell, Irish Emancipation leader who befriended Frederick Douglass and spoke out against US slavery), and J. Q. Adams (John Quincy Adams, who as a Congressman in 1837 controversially argued against gag rules banning antislavery petitions and against the slave states' control of the US Congress). By interpolating figures from the transatlantic abolition movement who look down approvingly on these scenes, the print implies that those who support

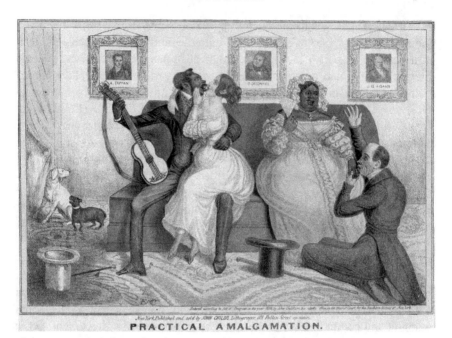

Figure 6.1. Edward W. Clay, from *Practical Amalgamation* series (1839). Lithograph.
Courtesy of the Library Company of Philadelphia.

the end of slavery endorse what Clay sees as its dark underbelly—a misce-
genated nation.

The next few prints in Clay's "Amalgamation" series portray the result
of such activities—marriage and the birth of mixed-race children. Taken
together such prints tend to imply that African Americans are not fitting
subjects for freedom, and they warn society of the dire results of too much
liberty for African Americans. In other prints from this series, Clay took even
more direct aim at abolition in the United States. For example, in *The Fruits
of Amalgamation* (1839), a white woman nurses her African American child,
while her African American husband rests his feet in her lap and reads the
Emancipator; a white and black dog cuddle together while reading Paine's
The Age of Reason.[14] Garrison enters from the back with an African American
woman who appears to be his date. As Jasmine Cobb notes, this image sug-
gests that the world of abolition is "host to a number of inappropriate interac-
tions."[15] Quite literally, mixed-race children will be the "fruit" of abolition,
but more symbolically abolition will bear a "fruit" of social disorder and
chaos, a world turned topsy-turvy.

A number of other prints implied that abolition would only hurt African
Americans. Such is the implication of *Immediate Emancipation*, a print with

the message that abolition will cause the enslaved to starve and lead to great social unrest and even violence.[16] In this drawing, an emaciated slave chases the word *food* while members of an antislavery society prepare to write a pamphlet calling for immediate abolition. Members of the antislavery society ignore the plight of the enslaved while engaging in their esoteric debate. The sculpture of a leopard on the right is meant to prompt viewers of the print to recall the biblical passage, "Can the Ethiopian change his skin, or the leopard his spots?" (*King James Version*, Jer. 13.23); it appears to imply that African Americans' debased and servile status is established by their essential character. On the left the print contains a drawing of slaves massacring a white family meant to remind readers of the Haitian revolution (1791–1804). The print as a whole satirically signifies horrific events that will transpire should emancipation occur: revolution, murder, and starvation.

Many of these illustrations were extremely popular in the United States and abroad, as Cobb has documented.[17] In response, abolitionists began to deploy satirical cartoons for a progressive, antislavery agenda. Satire can have reconstructive pro-social aims as well as deconstructive, anti-social ones, and the abolitionists' struggle was to use satire not to mock the enslaved, but to make fun of those who promote slavery or impede abolition. Abolitionist satire walked a fine line between didacticism and ridicule, between progressive and destructive impulses.

ABOLITIONIST USE OF HUMOR, SATIRE, AND STORYTELLING MODES IN POLITICAL CARTOONS

An early abolitionist political cartoon that employs satire and caricature to make meaning is *Southern Ideas of Liberty* (1835).[18] According to Bernard Reilly, *Southern Ideas of Liberty* is "an imaginative portrayal of the violent suppression of abolitionist propagandizing and insurrectionism in the South. The print may have been stimulated by several instances during the early 1830s of hanging, tarring and feathering of anti-slavery activists in Georgia, Louisiana and Mississippi."[19] What is most interesting is that the artist is using print to satirize and caricature not only the South, but also the South's suppression of print. Indeed, *Southern Ideas of Liberty* was often printed with a second lithograph that made this suppression clear: *New method of assorting the mail, as practised by Southern slave-holders, or attack on the Post Office, Charleston, S.C.* (1833), which shows slaveholders looting a post office and burning mail.[20] These cartoons clearly play on linkages in the 1830s between freedom of speech and abolition.[21] The very title of this illustration—*Southern Ideas of Liberty*—satirically implies that the South

does not see liberty as involving freedom of speech or even the freedom to get one's mail.

There are other modes of satire and caricature at work in *Southern Ideas of Liberty*. For example, a judge with ass's ears and whip is seated on bales of cotton and tobacco while he tramples the Constitution; he condemns a white man (an abolitionist) to hanging, and we watch this man being dragged toward his death. The caption reads ironically: "Sentence passed upon one for supporting that clause of our Declaration viz. All men are born free & equal. 'Strip him to the skin! give him a coat of Tar & Feathers!! Hang him by the neck, between the Heavens and the Earth!!! as a beacon to warn the Northern Fanatics of their danger!!!!'" The print sides with abolitionists who want to market antislavery print materials and it satirizes those who would suppress such materials both visually (the ass's ears) and lexically (through multiple exclamation marks, which suggest the hysteria of southerners in the face of this abolitionist onslaught).

Judge Linch—a man in ass's ears who condemns antislavery individuals to death—is featured again in the satirically named and closely associated work, *Fourth of July Celebration, or Southern Ideas of Liberty* (1840). Here an enslaved man in chains reads the Declaration of Independence while Judge Linch in the background oversees the hanging of three abolitionists. The banner at the bottom of the picture reads:

> Behold! The degraded son of Africa, reading the Declaration of Independence, handcuffed as he is; and stared at with astonishment the Husband and Wife, in front of him, who are also chained; and whose appearance seems to say, "are these things so."

The Musicians, no doubt, perform better, at least with some ease themselves, if they had the use of both hands. In the back ground is to be seen, the notorious Judge Linch, with whip in hand, and his foot on the Constitution—bolstered up with bales of Cotton and hogshead of Tobacco—surrounded by his Court, condemning the friends of humanity, and executing them upon the spot, merely for supporting the clause of the Declarations, viz. "All men are created free and equal," and acting in conformity with the 192 passages of Holy writ, which are either directly or indirectly against the system of slavery.

In juxtaposing the Holy Bible and the US Constitution with the slaveholder's and Judge Linch's nefarious actions, the cartoon again uses print to satirize the actions of the South. Southern "ideas of liberty" are shown to be anti-United States and anti-Christian. The print engages visual caricature (again in the ears on Judge Linch), and the linguistic satire is forceful. The movement between words and images is dynamic, as words become integrated into the text via the document the enslaved man reads, the song the enslaved men play (the title

"Hail Columbia Happy Land" is legible), the word "COTTON" embossed on the throne that Judge Linch sits on, and the banner at the print's bottom. Words become part of the fabric of the visual content, and as a viewer moves between text and image he or she may be moved toward an antislavery ideology by virtue of the metalinguistic demands being made and the active reading practices required to connect all the disparate visual-verbal elements.

Sometimes, political satire appears to become unruly in cartoons, and too many stories seem to be in the process of being told. A fascinating political cartoon appeared in 1852 titled *A Grand Slave Hunt, or Trial of Speed for the Presidency, between the celebrated nags Black Dan, Lewis Cass, and Haynau*. It critiques the Fugitive Slave Law and the Compromise of 1850 and comments on the upcoming political election; Lewis Cass and Daniel Webster, both of whom ran for president in 1852, are featured prominently.[22] The cartoon contains thirteen separate speech balloons, each of which conveys a different facet of the debate about the law and a different view of it, and each of which vie for the reader's attention. In it, Daniel Webster (who spoke in favor of the fugitive slave law even though he was an abolitionist) leads Lewis Cass and Julius Jacob von Haynau, an Austrian general noted for cruelty in his pursuit of slaves. The men are loosely connected by a ribbon that reads "Similis simili gaudet," Latin for "Like takes pleasure in like," implying that abolitionists such as Webster are no better than proslavery forces. A dog with a man's head runs along with them, barking, "Bow wow! Whose dog art thou? I am Daniel Webster's dog. Whose dog are you"; this phrase implies that everyone in the illustration has sold their soul for political favor. The fugitive slave mother, with her two children, is one of the few individuals in the print who does not speak, and her silence, isolation, and placement in the left foreground seems to make her status stand out all the more in the busy cartoon.

An elaborate reference to *Macbeth* and more specifically to Macbeth's obsession with the blood crime that he has committed is woven into the print. Lines about how dead men "rise again with twenty mortal murders on their crowns and push us from our stools" and about how there is a "spot upon the hem of New England's garment which must be washed out though it should be 'multitudinous seas incarnadine'" are knitted into the speeches of various men. The crime referenced here is not only slavery, but the passing of the fugitive slave law by the North. In the background, another group of white men listen intently to a black man speaking of racial and constitutional justice and on the horizon we see the Capitol building with an American flag at its top, an ironic symbol in that slavery still existed in the nation's capital. In addition to the three individuals who are directly mentioned in the title, the illustration references Henry Clay, Millard Fillmore, and Horace Mann. Fillmore holds the Fugitive Slave Bill and says: "I do not blight beneficent legislation by vetoes." Clay remarks: "We southern gentlemen leave the details of this

business to our Haynau's and northern apostates." Mann laments losing the 8th Congressional district race for Congress. Webster says: "This is slightly inconvenient, but it is the best run I ever made for the Presidency."

The irony is thick in all these bits of dialogue, the visual caricature of the man/dog is novel, and the interlacing of *Macbeth* is complex. Yet would a reader enter the world of the cartoon? Thierry Groensteen contends that the content of captions is more than informational; it often functions as a type of "voiceover" that "encloses a form of speech, that of the explicit narrator (who can be the principal narrator or the delegated narrator)."[23] Yet the caption at the bottom of this print does little to guide the reader's understanding. What would a reader make of a cartoon with so many narrators articulating so many divergent and complex points of view? Such a print fails to visually rival something like Clay's grotesque (yet extremely funny) satire and caricature in *Grand celebration ob de bobalition ob African slavery*. In Clay's print, although there are many narrators, they are all making similar points, so they provide a narrative path through the cartoon, whereas *A Grand Slave Hunt* is quite chaotic in its layout and in its presentation of its ideas and narrative voices.

Less chaotic is *Secession Exploded* (1861), an anti-Confederate satire concerning a fantastical prophecy of the Union defeat of the secessionist movement.[24] In this print, a monster representing secession emerges from the water. He is struck by a blow from a cannon labeled "Death to Traitors!" and operated by Uncle Sam (on the right). A two-faced figure represents Baltimore, whose allegiance to the Union was ambiguous; this figure tugs at Uncle Sam's coat. The detonation drives several small demons, symbolizing the secessionist states, through the air (South Carolina, in a coffin; Tennessee and Kentucky, represented by a two-headed monster due to their internal divisions over secession). Although part of the Confederacy, Virginia is shown riven—perhaps because its Appalachian and eastern regions were affiliated with the Union. Among the monsters is a small figure of the 1860 presidential contender John Bell (with a bell-shaped body). The foreground of the print holds an American flag.[25]

The verbal satire is somewhat heavy handed, but what seems most crucial in analyzing this print is its use of visual caricature. Various states are represented as animals or monsters, and there is a ludic quality to the print which gives it energy and makes it compelling; the figures charge across the page and across the visual field of the cartoon. Furthermore, the print ingeniously compresses both space and time. Beginning with South Carolina's secession in 1860, eleven states across the United States left the Union in a process that lasted for over a year. The cartoon condenses disparate historical moments and geographical locations, and predicts something that would not happen until 1865—the defeat of the Confederacy by the Union. In so doing, it asks the viewer to project him/herself into an abolitionist future, in which the

hypocritical southern states have been decimated by the forces of Uncle Sam. But it additionally predicts the continuing violence and animosity between North and South that would be the legacy of the Civil War. It asks its viewing reader to enter into the chaotic whirlwind of succession, and to understand the lasting social disorder unleashed by the South's failure to end slavery in a democratic fashion.

CARTOONS, SATIRE, AND POLITICAL LEADERS, NORTH AND SOUTH

These cartoons from 1830–1861 ask the reader to be afraid of the results of either abolition (in the antislavery satires) or continuance of slavery (in the abolitionist works). As the country entered into Civil War in 1861, the debate became even more strident. Leaders of each political faction were attacked with caricature and satire. Lincoln was frequently an object of satire, both in single panel prints and in four-panel newspaper comics available after 1861. One famous cartoon published in *Harper's Weekly* in 1861 uses satire to make fun of president-elect Lincoln. After one attempt on his life, Lincoln purportedly fled in a disguise composed of a Scottish bonnet and cape. John McLenan created a four-panel satirical cartoon showing this event which was titled *The Flight of Abraham*.[26] For the rest of Lincoln's presidency, the story of his sneaking like a coward through Baltimore would be told and retold by his enemies, and was particularly dwelled on by cartoonists of the day.

Abolitionists responded in kind, once again utilizing the tools that pro-slavery forces had employed. A twelve-panel broadside cartoon by David Claypoole Johnston called *The House that Jeff Built* (1863) counteracts this image of a cowardly Lincoln by satirizing Jefferson Davis, two years after the Lincoln cartoon and two years after Davis had assumed the presidency of the Confederacy (see figure 6.3). Wood argues that this print's satirical sources are "English social print satire of the late eighteenth century."[27] Yet I would argue that it is more closely allied (and responsive to) the satirical images present in pro-slavery satires created by Clay, McLenan, and others.

The cartoon is an extended and bitter indictment of Jefferson Davis and the Southern slave system. It contains twelve verses that follow the scheme of the nursery rhyme "The House That Jack Built." The verses of the twelve panels tell an evolving story about the harm that slavery does:

1. This is the house that Jeff built.
2. This is the cotton, by rebels, called king (Tho' call'd by Loyalists no such thing) that lay in the house that Jeff built.

3. These are the field chattels that made cotton king, (tho' call'd by Loyalists no such thing), that lay in the house that Jeff built.
4. These are the chattels babes, mothers, and men, to be sold by the head, in the slave pen;— A part of the house that Jeff built.
5. This is the thing, by some call'd a man, Whose trade is to sell all the chattels he can, From yearlings to adults of life's longest span; In and out of the house that Jeff built.
6. These are the shackles, for those who suppose their limbs are their own from fingers to toes; And are prone to believe say all that you can, that they shouldn't be sold by that thing call'd a man; Whose trade is to sell all the chattels he can from yearlings to adults of life's longest span, in and out of the house that Jeff built.
7. These buy the slaves, both male and female, and sell their own souls to a boss with a tail, who owns the small soul of that thing call'd a man, whose trade is to sell all the chattels he can, from yearlings to adults of life's longest span, in and out of the house that Jeff built.
8. Here the slave breeder parts with his own flesh to a trader down south, in the heart of secesh, thus trader and breeder secure without fail, the lasting attachment of him with a tail, who owns the small soul of that thing

Figure 6.2. *The House that Jeff Built* (1863), David Claypoole Johnston. Etching.
Courtesy of the Library of Congress, Washington D.C.

call'd a man, whose trade is to sell all the chattels he can, from yearlings to adults of life's longest span, in and out of the house that Jeff built.

9. This is the scourge by some call'd the cat, Stout in the handle, and nine tails to that, t'is joyous to think that the time's drawing near when the cat will no longer cause chattels to fear, nor the going, going, gone of that thing call'd a man, whose trade is to sell all the chattels he can, from yearlings to adults of life's longest span, in and out of the house that Jeff built.

10. Here the slave driver in transport applies, nine tails to his victim, nor heeds her shrill cries, Alas! that a driver with nine tails his own, should be slave to a driver who owns only one, albeit he owns that thing call'd a man, whose trade is to sell all the chattels he can, from yearlings to adults of life's longest span, in and out of the house that Jeff built.

11. Here's the arch rebel Jeff whose infamous course, has bro't rest to the plow and made active the hearse, and invoked on his head every patriots' curse, spread ruin and famine to stock the slave pen, and furnish employment to that thing among men, whose trade is to sell all the chattels he can, from yearlings to adults of life's longest span, in and out of the house that Jeff built.

12. But Jeff's infamous house is doom'd to come down, so says Uncle Sam and so said John Brown.—With slave pen and auction shackles, driver and cat, together with buyer and seller and breeder and that, most loathsome of bipeds by some call'd a man, whose trade is to sell all the chattels he can, from yearlings to adults of life's longest span, in and out of the house that Jeff built.

Satire as a mode is foremost here in the nursery rhyme harnessed to a story of horrific violence and hypocrisy. Yet this cartoon differs from many political satires of this time period in that it goes beyond a single issue to create a "broad historical narrative" about slavery and a "graphic satiric summary of the origins of the Civil War."[28] A storytelling mode is employed, connected to an intricate set of meanings that a reading viewer must hold in his or her mind. To understand these meanings, readers have to cross frames, suspend meaning, and collaborate in the making of the antislavery message. Comics, notes Scott McCloud, present a "kind of call and response in which the artist gives you something to see within the panels, and then gives you something to imagine between the panels."[29] The call-and-response of the nursery rhyme ("The House that Jack Built") is linked to something the reader must piece together between the panels—the story of slavery as it is enacted politically and personally.

To take just one example of the type of call-and-response reading practice required here: the cartoon as a whole has a strong narrative thread in which

the traditional association of the enslaved with a subhuman entity is cunningly reversed. First, in stanza five, it is the slave owner who is called a thing, in contrast to the slave, who is called (in the same stanza) a man with a soul. Then, in stanza seven, slave owners are equated with subhuman devils through the specific symbolism of the tail. In stanza nine, the whip used to slash slaves (the cat o' nine tails) transforms itself into the nine tails that slave owners/drivers wear, as emblems of their association with the devil. Within the format of the poem and the political cartoon, the print plays with the symbolism surrounding the idea of the slave owner/seller/buyer/trader as a subhuman devil, turning it around in various visual and verbal directions, citing it and reciting it in a complex process. As Wood notes, it leaves interpretive space for the viewer/reader to fill.[30] A reader must hold a multifaceted pattern of symbolism in his or her mind and pay careful heed to its twists and turns. In so doing, the cartoon pushes the viewer toward readerly activity in the construction of the unfolding story and its meaning—that slavery is an utter wrong that must be ended.

The evocative images within the cartoon similarly create a tale for the audience to piece together. The first panel has in fact only a short caption ("This is the house that Jeff built") but in it we see an ominous dark door with crude lettering atop of it ("SLAVE PEN") and an evocative sign: "Slave Pen—Auction—Prime Lot." It is a gripping visual-verbal image, and in conjunction with the verse added as the print moves forward, it combines the documentary realism characteristic of much abolitionist cartoon work with the satire that is often more pronounced in antislavery work. The image of the woman chained to a post while she is whipped in panel ten would, no doubt, echo in abolitionist viewers' mind with the many graphic and realistic images of the beating of women that both British and US antislavery forces circulated in the early part of the nineteenth century. And the images of enslaved families being separated from each other in panels four and six would evoke a long British and US broadside tradition depicting such partings and sales.[31] Yet visual satire is clear in (for example) panel four, where the features of the auctioneer are exaggerated and he is given an evil and smug expression. Ironic humor is similarly evident in the phrase, "This is the thing by some call'd a man" which again refers not to the slaves but to the auctioneer. Johnston's biting satire and caricature is cleverly woven with dark humor, as he illustrates both the horror of slavery and satirizes the men who allow it to continue.

Charles Hatfield notes that although we generally tend to separate word and image, in comics words and image can approach each other and become hybrid textual formations.[32] In Johnston's illustration as a whole, we can see hybrid formations of text-image. For example, in panel one we have a picture of words (on the auction notice) as well as a mode of language that

is itself a visual feature of the text (the careful, neat cursive writing seems to function as a contrast that enhances the horror of the story being told). Words become symbolic elements in the cartoon's design, as they are carefully braided into many of the panels. In addition to the sign for a "SLAVE PEN" in panel one, we see signs for auction notices (panel four) and posters for the auction itself (panel seven). Most telling, in panel twelve, all these signs come together within the cartoon design and sit atop a table, crushed by the symbolic and actual weight of unlocked fetters, broken pens, and smashed gavels (see figure 6.3).

The picture graphically and linguistically depicts the caption and predicts the Northern victory in the Civil War: "But Jeff's famous house is doom'd to come down / So says Uncle Sam and so said John Brown." Quite literally,

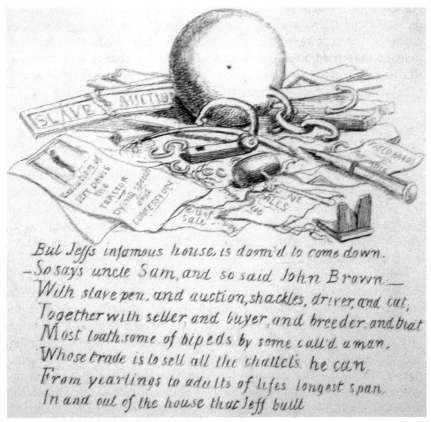

Figure 6.3. Panel 12 of *The House that Jeff Built* (1863), David Claypoole Johnston. Etching.

Courtesy of the Library of Congress, Washington D.C.

Johnston's etching manipulates iconic signs, such as the sign for a "Slave Auction," which is broken in half. But to a larger degree it plays with symbolic signs, creating wholly new ones such as a fictive written document that is called "Constitution of Jeff Davis, the traitor, dying speech and confession" and appears to have an image of Davis hung on a gallows (bottom left corner). This symbolic sign (meant to be prophetic) is a hybrid visual-verbal text within the larger comic matrix (so a metacomic); as such it asks a reader to meditate not only on enslavement, but on how systems of rhetoric are themselves implicated in systems of oppression.

Ultimately, Johnston suggests that the discursive/linguistic and visual/pictorial elements that have kept the slave enchained need to be broken. In so doing, he creates a cartoon that interpellates the reader and encourages him or her to comprehend and even enter the visual-verbal world of enslavement. Some of the cartoons discussed in this essay rely very heavily on words, and often the images are not compelling; or, they rely almost exclusively on the power of the image itself, with few words. But *The House that Jeff Built* is an inventive visual-verbal text that relies not on one mode (the linguistic or the pictorial) but on the interplay between them to push its viewers toward antislavery activity.

CONCLUSION: READERLY CLOSURE

On both sides of the slavery debate, satirical political cartoons were employed in sophisticated and provocative ways, with the goal of moving an individual into a particular political stance. These cartoons festooned shop windows, taverns, and stores with their competing messages,[33] and were bought as sets to be shown to visitors and friends, circulating across "a wide and diverse swath of viewers."[34]

Pro-slavery cartoonists created strong forms of political satire, but it is evident that abolitionists likewise utilized this mode. The most innovative antislavery political cartoons use storytelling modes, satire, caricature, humor, and a complex metalinguistic and metapictorial relationship between image and text to interpellate a viewer. "Comics panels fracture both time and space, offering a jagged staccato rhythm of unconnected moments," writes McCloud. "But closure allows us to connect these moments and mentally construct a continuous, unified reality."[35] We see this propulsion toward a continuous abolitionistic reality in some of the political cartoons created by antislavery writers, artists, and designers. The best of these cartoons exploit innovative metalinguistic features, creating hybrid works that move between word and image. In so doing these cartoons propel viewers

into the diegetic universe of an unfolding antislavery story—one that readers actively create through careful attention to the intricate rhetorical and visual designs of the satire itself.

NOTES

1. My thanks to Chris Gonzalez, Peter Baldwin, Christopher Clark, Clare Eby, Cornelia (Nina) Dayton, Nancy Shoemaker, Kathy Knapp, and most especially Shirley Samuels for feedback on this essay. "Join, or Die." *The Pennsylvania Gazette*, 9 May 1754, https://www.newspapers.com/clip/1607106/join_or_die/.

2. See Victor Margolin, "Rebellion, Reform, and Revolution: American Graphic Design for Social Change," *Design Issues* 5.1 (1988): 59–70.

3. See Martha J. Cutter, *The Illustrated Slave: Empathy, Graphic Narrative, and the Visual Culture of the Transatlantic Abolition Movement, 1800–1852* (Athens: University of Georgia Press, 2017), 1–13.

4. As Frank Weitenkampf writes: "Some phases of the slavery controversy had been touched upon by the satirist's pencil. . . . In most cases the pictures showed proslavery leanings. Abolitionism was repeatedly attacked, with especial emphasis on the dire effects of miscegenation," *American Graphic Art* (New York: Holt, 1912), http://hdl.handle.net/2027/hvd.fl2ehq, 256; also see 257–260.

5. For example, in 1792 the Scottish radical James Tytler published a satire titled, "The Petition of the Sharks of Africa," addressed to the British Parliament, in which the sharks kindly ask the legislator not to abolish the slave trade and deprive them of "large quantities of their most favourite food—human flesh" (35); James Tytler, "The Petition of the Sharks of Africa," reprinted in *The Bee: Or Literary Weekly Intelligencer*, July 11, 1792: 34–36. However, according to Marcus Wood, the satire forced Tytler into exile: "Further research revealed that it had been republished widely, in Edinburgh, Philadelphia, New York, and Salem . . . For his radicalism, [Tytler] was eventually arrested and charged with sedition, only to flee into exile in 1793, first to Ireland, then to Salem." See Wood, "Slavery: A Shark's Perspective," *Boston Globe*, 23 Sept. 2007, http://archive.boston.com/news/globe/ideas/articles/2007/09/23/slavery_a_sharks_perspective/.

6. Satire is defined as "the literary art of diminishing or derogating a subject by making it ridiculous and evoking toward it attitudes of amusement, contempt, scorn, or indignation," while caricature (either in graphic art or verbal texts) is an exaggeration or distortion of a person's distinctive physical features or personality traits for comic effect. See M. H. Abrams and Geoffrey Harpham, *A Glossary of Literary Terms* (Stanford, CT: Cengage Learning, 2014), 352, 42.

7. Wood analyzes *The House that Jeff Built* in "The Influence of English Radical Satire on Nineteenth-Century American Print Satire: David Claypoole Johnston's 'The House that Jeff Built,'" *Harvard Library Bulletin* 10.1 (1999): 43–67 and Weitenkampf has a brief overview of the caricature tradition in chapter 12 of *American Graphic Art.*

8. The gutter is the space between comics panels. In comics theory, a reader must fill in information not supplied in the panels proper to create meaning or what has been termed closure.

9. Charles Hatfield, *Alternative Comics: An Emerging Literature* (Jackson: University Press of Mississippi, 2005), 36.

10. Joseph Witek, "Comics Modes: Caricature and Illustration in the Crumb Family's *Dirty Laundry*," in *Critical Approaches to Comics: Theories and Methods*, edited by Matthew J. Smith and Randy Duncan (New York: Routledge, 2012), 28.

11. Corey Capers, "Black Voices, White Print: Racial Practice, Print Publicity, and Order in the Early American Republic," in *Early African American Print Culture*, ed. Lara Langer and Jordan Alexander Stein (Philadelphia: University of Pennsylvania Press, 2012), 108–26.

12. See Edward Williams Clay, *Grand Celebration Ob de Bobalition of African Slavery* (1833), lithograph, http://www.abolitionseminar.org/wp-content/uploads/2013/12/Life.jpg.

13. Abrams and Harpham, *A Glossary*, 277.

14. Edward Williams Clay, *The Fruits of Amalgamation* (1839), American Antiquarian Society, http://www.americanantiquarian.org/Exhibitions/Reading/5/5point20L.jpg.

15. Jasmine Nichole Cobb, *Picture Freedom: Remaking Black Visuality in the Early Nineteenth Century* (New York: New York University Press, 2015), 175.

16. See *Immediate Emancipation* (1833), Library Company of Philadelphia, https://digital.librarycompany.org/islandora/object/digitool%3A130181.

17. Cobb, *Picture Freedom*, 145.

18. *Southern Ideas of Liberty* (1835), Library of Congress, http://www.loc.gov/pictures/resource/cph.3b38594/.

19. Bernard Reilly, *American Political Prints, 1766–1876: A Catalog of the Collections in the Library of Congress* (New York: G. K. Hall, 1991), 72.

20. *New method of assorting the mail, as practised by Southern slave-holders, or attack on the Post Office, Charleston, S.C.* (1833), Library of Congress, http://www.loc.gov/pictures/resource/cph.3b38593/.

21. Louis Ruchames, *The Abolitionists: A Collection of Their Writings* (New York: Putnam, 1963), 20.

22. See *A Grand Slave Hunt, or Trial of Speed for the Presidency, between the celebrated nags Black Dan, Lewis Cass, and Haynau* (1852), lithograph, Lincoln Financial Foundation Collection, Indiana State Museum, https://www.lincolncollection.org/collection/categories/item/?cat=14&item=22173.

23. Thierry Groensteen, *The System of Comics*, translated by Bart Beaty and Nick Nguyen (Jackson: University of Mississippi Press, 2007), 128.

24. *Succession Exploded* (1861), Library of Congress, https://www.loc.gov/pictures/item/2008661629/.

25. I am indebted to Reilly's description of this print for many of the facts in this paragraph. See *American Political Prints*, 475.

26. See *The Flight of Abraham*, February 23, 1861, Library of Congress, https://www.loc.gov/exhibits/lincoln/interactives/journey-of-the-president-elect/feb_23/artifact_2_509f.html.

27. Wood, "Influence," 44.

28. Wood, "Influence," 45.

29. Scott McCloud, "The Visual Magic of Comics," https://www.ted.com/talks/scott_mccloud_on_comics/transcript?language=en, 2.

30. Wood, "Influence," 66.

31. Cutter, *Illustrated Slave*, 47–58.

32. Hatfield, *Alternative Comics*, 36–37.

33. Harold Holzer, "With Malice Towards None: Abraham Lincoln and Jefferson Davis in Caricature," in *Wars within a War: Controversy and Conflict over the American Civil War*, edited by Joan Waugh and Gary W. Gallagher (Chapel Hill: University of North Carolina Press, 2009), 115.

34. Cobb, *Picture Freedom*, 144.

35. Scott McCloud, *Understanding Comics: The Invisible Art*, reprint edition (New York: Morrow, 1994), 67.

BIBLIOGRAPHY

Abrams, M. H. and Geoffrey Harpham. *A Glossary of Literary Terms*. Stamford: Cengage Learning, 2014.

Capers, Corey. "Black Voices, White Print: Racial Practice, Print Publicity, and Order in the Early American Republic." In *Early African American Print Culture*, edited by Lara Langer and Jordan Alexander Stein, 108–26. Philadelphia: University of Pennsylvania Press, 2012.

Clay, Edward Williams. *The Fruits of Amalgamation*. 1839. American Antiquarian Society. Accessed January 21, 2019. http://www.americanantiquarian.org/Exhibitions/Reading/5/5point20L.jpg.

———. *Grand Celebration Ob de Bobalition of African Slavery*. 1833. *The Abolition Seminar*. Accessed January 21, 2019. http://www.abolitionseminar.org/wp-content/uploads/2013/12/Life.jpg.

Cobb, Jasmine Nichole. *Picture Freedom: Remaking Black Visuality in the Early Nineteenth Century*. New York: New York University Press, 2015.

Cutter, Martha J. *The Illustrated Slave: Empathy, Graphic Narrative, and the Visual Culture of the Transatlantic Abolition Movement, 1800–1852*. Athens: University of Georgia Press, 2017.

The Flight of Abraham. February 23, 1861. Library of Congress. Accessed January 21, 2019. https://www.loc.gov/exhibits/lincoln/interactives/journey-of-the-president-elect/feb_23/artifact_2_509f.html.

Franklin, Benjamin. "Join, or Die." *The Pennsylvania Gazette*, May 9, 1754. Accessed January 21, 2019. https://www.newspapers.com/clip/1607106/join_or_die/.

A Grand Slave Hunt, or Trial of Speed for the Presidency, between the celebrated nags Black Dan, Lewis Cass, and Haynau (1852). Lincoln Financial Foundation Collection, Indiana State Museum. Accessed January 21, 2019. https://www.lincoln collection.org/collection/categories/item/?cat=14&item=22173.

Groensteen, Thierry. *The System of Comics*, translated by Bart Beaty and Nick Nguyen. Jackson: University Press of Mississippi, 2007.

Hatfield, Charles. *Alternative Comics: An Emerging Literature*. Jackson: University Press of Mississippi, 2005.

Holzer, Harold. "With Malice Towards None: Abraham Lincoln and Jefferson Davis in Caricature." In *Wars within a War: Controversy and Conflict over the American Civil War*, edited by Joan Waugh and Gary W. Gallagher, 109–136. Chapel Hill: University of North Carolina Press, 2009.

Immediate Emancipation. 1833. Library Company of Philadelphia. Accessed January 21, 2019. https://digital.librarycompany.org/islandora/object/digitool%3A130181.

Johnston, David Claypoole. *The House that Jeff Built*. 1863. Library of Congress. Accessed January 21, 2019. https://www.loc.gov/pictures/item/2008661652/.

Margolin, Victor. "Rebellion, Reform, and Revolution: American Graphic Design for Social Change." *Design Issues* 5, no. 1 (1988): 59–70.

McCloud, Scott. *Understanding Comics: The Invisible Art*, reprint edition. New York: Morrow, 1994.

———. "The Visual Magic of Comics." *Ted Talks*. Accessed January 21, 2019. https://www.ted.com/talks/scott_mccloud_on_comics/transcript?language=en.

New method of assorting the mail, as practised by Southern slave-holders, or attack on the Post Office, Charleston, S.C. 1833. Library of Congress. Accessed January 21, 2019. http://www.loc.gov/pictures/resource/cph.3b38593/.

Reilly, Bernard. *American Political Prints, 1766–1876: A Catalog of the Collections in the Library of Congress*. New York: G. K. Hall, 1991.

Ruchames, Louis. *The Abolitionists: A Collection of Their Writings*. New York: Putnam, 1963.

Southern Ideas of Liberty. 1835. Library of Congress. Accessed January 21, 2019. http://www.loc.gov/pictures/resource/cph.3b38594/.

Tytler, James. "The Petition of the Sharks of Africa." Reprinted in *The Bee: Or Literary Weekly Intelligencer* (July 11, 1792): 34–36.

Weitenkampf, Frank. *American Graphic Art*. New York: Holt, 1912. Accessed January 21, 2019. http://hdl.handle.net/2027/hvd.fl2ehq.

Witek, Joseph. "Comics Modes: Caricature and Illustration in the Crumb Family's *Dirty Laundry*." In *Critical Approaches to Comics: Theories and Methods*, edited by Matthew J. Smith and Randy Duncan, 27–42. New York: Routledge, 2012.

Wood, Marcus. "The Influence of English Radical Satire on Nineteenth-Century American Print Satire: David Claypoole Johnston's 'The House that Jeff Built.'" *Harvard Library Bulletin* 10, no. 1 (1999): 43–67.

———. "Slavery: A Shark's Perspective." *Boston Globe*. September 23, 2007. Accessed January 21, 2019. http://archive.boston.com/news/globe/ideas/articles/2007/09/23/slavery_a_sharks_perspective/.

Part 2

DEMOCRATIC VISIONS

Chapter Seven

Seeing Irony in Barnum's America

Anti-Slavery Humor in Uncle Tom's Cabin

Adena Spingarn

At P. T. Barnum's American Museum in 1850s New York City, the path to moral drama was lined with bearded ladies and spotted men. Before visitors could see a moral drama like *The Drunkard* or *Uncle Tom's Cabin*, they first made their way through "salons" packed with unusual objects and atypical bodies that Barnum advertised with characteristic hyperbole. For a single 25-cent ticket, patrons gained access not only to five stories of what Barnum called "curiosities" but also to a gloriously appointed "Lecture Room" recently refurbished into a 3,000-seat theater, where performances alternated between variety acts popular with the Bowery's working classes and moral dramas intended to draw a higher class of patrons.[1]

In December of 1853, as H. J. Conway's dramatic adaptation of Harriet Beecher Stowe's novel, *Uncle Tom's Cabin*, wound down its run, a visitor would have encountered Madame Josephine Fortune Clofullia, the Swiss bearded lady ("That Unparalleled Curiosity"); a couple of live giraffes ("The Only Giraffes in America. And the only ones of their gigantic size ever exhibited in any country"); and the "Largest Living Serpents in the world."[2] After walking through rooms in which the human body was so spectacularly commodified, how could a viewer of Barnum's production of *Uncle Tom's Cabin* possibly come to the conclusion that the buying and selling of human beings should end?

In the 1850s, the growing controversy over slavery and new ethnological work codifying human difference complicated the question of who was truly human. As scholars including Rosemarie Thomson, Benjamin Reiss, and Les Harrison have suggested, nineteenth-century displays of eccentric bodies allowed Americans living in an increasingly heterogeneous society to explore the allure of difference while confirming their own normative status.[3] Barnum's

American Museum exhibited human beings alongside living animals, often de-scribing them in animalistic terms. Visitors could be titillated by the potential relationship between man and beast and yet ultimately reassured that they—unlike the "Leopard Child," a black man with vitiligo, and "What Is It?," a man billed as a potential "missing link" between human beings and their simian ancestors just three months after the publication of Darwin's *On the Origin of Species*—were squarely in the category of the human.

What made Barnum the most successful showman of the nineteenth century was his recognition that the most profitable relationship between patron and exhibit was a dynamic one. Whatever was on display needed to be impressive, of course, but the conversations surrounding the exhibit were what made the difference between a modest draw and a big hit. Barnum un-derstood the surprising pleasure of uncertainty, and he selected and framed his exhibits to capitalize on this feeling. His boundary-blurring "living curi-osities" were liminal figures who "disrupted normative boundaries between black and white (albino Negroes), male and female (bearded ladies), young and old (General Tom Thumb), man and animal (dog-faced boys), one self or two (Siamese twins)," and as such, they intrinsically invited interrogation by the viewer.[4] Realizing that visitors would be more attracted to a spectacle if it demanded their active engagement in determining the truth about what they saw, Barnum encouraged audiences to question the authenticity of his displays. Extraordinarily canny about "the great power of the public press," he used printed notices and planted newspaper stories to call into question the true nature of his "curiosities."[5] His characteristic approach to exhibiting "living curiosities" began with the first major exhibition of his career: Joice Heth, an elderly woman Barnum claimed had raised George Washington from infancy. As part of the spectacle, Barnum and his business partner ques-tioned Heth about her memories of Washington and then encouraged visitors to do the same.[6] When the exhibit moved to Boston, he planted newspaper stories that Heth was in fact an automaton, a tactic that helped lure crowds away from a nearby exhibit of an "automaton chess-player."[7] As Barnum realized, it was far less exciting to see a guaranteed automaton than it was to puzzle over whether Joice Heth was a woman or a machine. When Heth died, Barnum staged a public autopsy, once again encouraging Americans to question the elusive "truth" about the exhibited body. As Benjamin Reiss observes, the autopsy "dramatized some of the new meanings of racial iden-tity and provided an opportunity for whites to debate them (in a displaced register) as they gazed upon or read about her corpse."[8] By encouraging the pleasures associated with blurring and interrogating categories, Barnum turned nineteenth-century anxieties about the nature of the human into a per-sonal fortune.

Drawn by the showman's provocations, visitors came to Barnum's American Museum eager to confront sights that demanded their careful visual inspection and questioning. They took pleasure in the process of trying to figure out whether and how the displayed bodies fit into their existing categories of people, animals, and objects. Moving through this atmosphere of curiosity, visitors who entered the Lecture Room for a performance of Conway's *Uncle Tom's Cabin* were already primed for a drama that used ironic humor about the categories of humans, animals, and machines to advance an anti-slavery critique. Conway's adaptation has developed what I have elsewhere argued is an inaccurate reputation as the pro-slavery or "compromise" alternative to the more enduring and authentic adaptation written by George L. Aiken.[9] In this reading, Conway's script, even more than Aiken's, relies on blackface minstrelsy for its humor, "leaving . . . minstrelsy's harsh stereotypes intact."[10] The fact that this drama was staged within Barnum's American Museum, a space in which atypical and racially othered bodies were spectacularly displayed, might seem to drain the script's potential anti-slavery energy even further. However, I'd like to suggest that the curious spirit of Barnum's American Museum worked in concert with the anti-slavery argument of Conway's *Uncle Tom's Cabin*, a script that both attends to the ironic verbal humor within Stowe's anti-slavery critique and visualizes it by applying a Barnumian curiosity about the physical body to the question of slavery. In offering a model of an embodied anti-slavery that works through humor rather than sentiment or rigorous philosophical argument, this adaptation and its staging in Barnum's entertainment complex expands our understanding of how anti-slavery could and did work in the nineteenth century.

Recent scholarship on the humor of *Uncle Tom's Cabin* has focused largely on its incorporation of blackface minstrelsy, showing how Stowe's novel draws on minstrel conventions in ways that both challenge slavery and reinforce unfavorable racial stereotypes.[11] In her insightful reading of blackface minstrelsy as the essence of the humor of *Uncle Tom's Cabin*, Sarah Meer suggests that, while the novel sometimes uses comedy for serious purposes, the stage adaptations fail to do the same. Yet the novel's humor goes beyond blackface minstrelsy. Through humorously ironic commentary on the difference between perceptions and truth, Stowe's narrator plays a crucial role in advancing the novel's anti-slavery argument. This aspect of Stowe's novel disappears in Aiken's adaptation but is key to Conway's, which incorporates Stowe's ironic anti-slavery humor through the introduction of an original Yankee character, the delightfully named Penetrate Partyside. In Conway's adaptation, Penetrate repeatedly misidentifies unseen human bodies as animals or things based on the language he hears describing them. At first these blunders are the result of honest confusion,

but as the play continues, Penetrate strategically deploys this confusion of categories in a sharp critique of the morality of slavery. Through his ironic engagement with the absent slave body and his miscategorization of visible bodies, Penetrate dramatizes the disjunction between the dehumanizing language of slavery and the clear visual evidence of slaves' humanity. Drawing on a Barnumian spirit of curiosity about the physical body, Conway's *Uncle Tom's Cabin* stages the ironic anti-slavery humor of Stowe's narrator as a visual spectacle.

STOWE'S IRONIC NARRATOR

When nineteenth-century dramatists such as Aiken and Conway adapted *Uncle Tom's Cabin* for the stage, they confronted the usual practical and formal challenges inherent in transferring a long, written text into an evening's dramatic performance, including paring down the cast of characters, consolidating the plot, and using visual and aural devices to communicate what previously existed only in words on a page. In many ways, *Uncle Tom's Cabin* lends itself quite naturally to staging. Stowe famously described her approach to composing this novel in visual terms, writing to Gamaliel Bailey, "My vocation is simply that of a *painter*. . . . There is no arguing with *pictures*, and everybody is impressed by them, whether they mean to be or not."[12] The novel is highly detailed in its visual descriptions, particularly of people and interiors; sometimes the text enacts a proto-cinematic approach to scene-setting, its prose guiding the eye of the reader's imagination like a camera panning across a scene. Some of the novel's visual descriptions are already theatrical, from the melodramatic poses of its characters (Eliza and Tom both respond to the shocking news that Tom and Harry have been sold with raised hands, a typical physical posture of the stage melodrama[13]) to the ready-made tableau.

Stowe's narrator does not let these pictures speak for themselves. Often, the narrator implores imagined readers to imagine themselves in the place of the novel's enslaved characters and thus to connect what they read to their own lives. This imperative to identify with the novel's characters is reinforced in the many times that these characters ask the same of each other. In the narrator's direct address of the reader, *Uncle Tom's Cabin* relies on what Robyn Warhol calls an "engaging narrator," one who "addresses a 'you' that is intended to evoke recognition and identification in the person who holds the book and reads."[14] In Stowe's novel, the narrator's earnest, sentimental interjections demand an empathetic link between the reader, the author, and the novel's characters, encouraging the reader to connect her experiences to

the action of the text.[15] By directing readers to feel for characters as representatives of real people in the world, the narrator becomes a key activator of its anti-slavery message.

Sometimes, however, the narrator's commentary works less directly. While many of the narrator's interjections are earnestly imploring, *Uncle Tom's Cabin* works in a multitude of narrative modes. In addition to the sentimental mode that has rightly received much attention from the novel's critics, *Uncle Tom's Cabin* also relies upon the narrator's ironic commentary for its anti-slavery message.[16] One way this irony works is through the novel's plot reversals.[17] What has received less attention, however, is the way that the novel's ironic humor serves its anti-slavery message. Where direct address in the novel demands the reader's identification with the characters, irony aligns the reader primarily with the narrator's perspective on the characters. Beginning at the same moment that the novel does, in its ironic first chapter title: "In Which the Reader Is Introduced to a Man of Humanity," ironic humor provides a crucial means of calling out the deformed logic of slavery, which exceeds any particular tragedy or villain. Appearing most often in the first third of the novel, this anti-slavery humor prepares the way for the narrator's angrier and more exhortative critique of slavery in the second half.

Operating primarily through hyperbole, understatement, and juxtaposition, ironic humor is fundamental to the novel's anti-slavery project. Stowe's irony is, in Wayne Booth's terms, "stable," its target and meaning clear once the irony is recognized.[18] Encompassing a variety of strategies and targets, Stowe's ironic humor is verbal rather than situational, developed through the narrator's comments on the novel's characters and plot. At times, the narrator of *Uncle Tom's Cabin* pokes fun at the foibles and pretensions of the characters with an ironic wit that bears comparison to Jane Austen and her "truth universally acknowledged": hats, for example, are the "characteristic emblem of man's sovereignty."[19] Most prominently, the novel's treatment of Miss Ophelia uses affectionate mock heroism to send up the character's grim fastidiousness.

The novel's ironic anti-slavery humor is often deployed through the narrator's seemingly innocent comments about slavery rather than the situations encountered in the plot. This occurs most fully in the transitional moment of Tom's travel from Kentucky to Louisiana in the twelfth chapter, with its characteristically deadpan title "Select Incident of Lawful Trade." The chapter begins as the slave trader Haley, having just taken ownership of Tom from Shelby, travels by wagon with his newly acquired "property." As Haley and Tom sit side by side in the wagon, the narration pauses to compare the physical body and thoughts of each man. The tone is curious and full of wonder, as if the narrator is simply marveling at the scene:

Now, the reflections of two men sitting side by side are a curious thing,—seated on the same seat, having the same eyes, ears, hands and organs of all sorts, and having pass before their eyes the same objects,—it is wonderful what a variety we shall find in these same reflections!

As, for example, Mr. Haley: he thought first of Tom's length, and breadth, and height, and what he would sell for, if he was kept fat and in good case till he got him into market. He thought of how he should make out his gang; he thought of the respective market value of certain supposititious men and women and children who were to compose it, and other kindred topics of the business; then he thought of himself, and how humane he was, that whereas other men chained their "niggers" hand and foot both, he only put fetters on the feet, and left Tom the use of his hands, as long as he behaved well; and he sighed to think how ungrateful human nature was, so that there was even room to doubt whether Tom appreciated his mercies. He had been taken in so by "niggers" whom he had favored; but still he was astonished to consider how good-natured he yet remained! (105)

Beginning with an objectifying catalogue of the body parts Haley and Tom share and what they, with their "same eyes," can see, the narrator proceeds with a seemingly innocent interest in the "wonderful" variety of their curiously different thoughts. Given that racial categories were thought to be visually discernible, starting by asserting how much Tom and Haley look alike is a risky move. But the narrator's tone of wonder distracts the reader from a likening that might otherwise raise alarm. We begin with Haley, whose mental measurement of another man's worth by the dollar amount attached to his physical measurements mirrors the list of body parts the narrator has just invoked. While this view is outrageous according to the values of the novel, the narrator makes no comment, instead proceeding to Haley's hyperbolically congratulating self-assessment. The signals of irony in this passage are graphic (exclamation points in sentences that don't need them; the placement of "nigger" in quotes, so that the narrator's disapproval of the term is visually marked without interrupting the flow of Haley's thoughts) as well as structural and stylistic (the repetition of "he thought," the hyperbolic language of words like "mercies" and "astonished," and the echoic mention of humanity).[20] As Haley continues to marvel at his own humanity, Stowe's dark irony deepens.

Against the exaggerated language of Haley's commodifying conception of Tom's body, the chapter then juxtaposes an ironically understated account of Tom's thoughts:

As to Tom, he was thinking over some words of an unfashionable old book, which kept running through his head, again and again, as follows: "We have here no continuing city, but we seek one to come; wherefore God himself is not

ashamed to be called our God; for he hath prepared for us a city." These words of an ancient volume, got up principally by "ignorant and unlearned men," have, through all time, kept up, somehow, a strange sort of power over the minds of poor, simple fellows, like Tom. (106)

With ironic understatement, the narrator casually dismisses the Bible as "an unfashionable old book" and "ancient volume, got up principally by 'ignorant and unlearned men,'" and facetiously marvels that the book "somehow" holds "a strange sort of power" over the mind of the purportedly inferior Tom. This understatement sets up an opposition between the narrator's words and their real implication. Again, the use of quotation marks is a visual cue that helps turn the passage against itself: whoever might think that Old Testament's origin is "ignorant and unlearned men," this is clearly not the narrator's assessment. The lines that repeat in Tom's mind bring together two passages from the New Testament's book of Hebrews (13:14 and 11:16) and suggest Tom's focus on the heavenly city over earthly concerns.[21] Coming after Haley's self-congratulating thoughts, the allusion indirectly suggests that Haley is one of those of whom God is ashamed. By juxtaposing this ironic assessment of Tom's thoughts with Haley's, the passage shows Tom's humanity and moral superiority to Haley, essentially giving Haley a rope and letting him hang himself with it. The "man of humanity" isn't the one marveling at his own humanity; it's Tom. Stowe's use of ironic humor allows the novel to advance a philosophical critique of slavery's undemocratic, unchristian logic.

Ironic humor continues to do anti-slavery work in the rest of the chapter, as Tom, Haley, St. Clare, and Eva travel down the Mississippi River to Louisiana. Stowe's representation of the thoughts and feelings of other slaves on the boat, where "the stripes and stars of free America waving and fluttering over head," is notably understated: everyone is in a celebratory mood—"all but Haley's gang, who were stored, with other freight, on the lower decks, and who, somehow, did not appreciate their various privileges" (110); these folks, Stowe writes, "had their various little prejudices in favor of wives, mothers, sisters, and children, seen for the last time" (111). By scoffing first at Tom's commitment to the Bible and then at the yearning for family evinced by other slaves, the novel uses humor to upset the popular notion that black people do not have the same moral and emotional capabilities as white people do. These moments work in concert with the sentimental scenes in which Stowe more directly portrays black morality and feeling, and they are crucial preparation for the reader to understand the way that slavery fundamentally violates the principles of Christianity and American democracy. Legree's violence, then, is not an aberration of a generally benevolent system, but in fact part and parcel of its inherent deformities.

THE CURIOSITY OF SLAVERY

For the antebellum dramatist, there was a special challenge in turning a written text with such a prominent narrator into an embodied performance in which the characters, scenes, and visual and auditory effects functioned on their own. Given that Stowe's irony is largely concentrated in the voice of her narrator, translating the text into an embodied performance risked losing this crucial element. Yet the importance of the novel's ironic anti-slavery humor was not lost on Henry J. Conway, whose 1853 adaptation of *Uncle Tom's Cabin* lingers on Tom's passage from Kentucky to Louisiana aboard a steamboat. Produced with great success first at the Boston Museum and next at P. T. Barnum's American Museum in New York, Conway's adaptation follows Stowe in concentrating anti-slavery humor in the transitional moment of Tom's travel from Kentucky to Louisiana. (This event happens between acts in Aiken's adaptation.) Using the ironic techniques of hyperbole, understatement, and juxtaposition, Conway's script uses Penetrate Partyside's appearance on the steamboat trip to translate the anti-slavery humor of Stowe's narrator into a visual gag.

Although he hails from Connecticut and employs the Yankee's "trademark dry humor," Penetrate is not the typical stage Yankee often seen on American stages from the Revolutionary Era to the mid-nineteenth century.[22] By the 1850s, this stage type was characterized by his duplicitous, if comical, attempts to get rich. As Jeffrey Richards, William J. Mahar, and others have shown, the stage Yankee often ridiculed a drama's black characters, in the process reinforcing racial stereotypes.[23] In Aiken's adaptation of *Uncle Tom's Cabin*, which like Conway's adds a Yankee character, Gumption Cute fits this stage Yankee type to a T, trying to lure Topsy away from Miss Ophelia for a speculation and deriding her in the process. Yet as Heather Nathans suggests, sometimes the stage Yankee's ignorance became a means of exposing the flaws of an impersonal market system that included slavery.[24] Conway's Penetrate begins the play interested in getting rich—to "collect suthin' out south particlarly, besides material for my book of observations on human nature ginerally"—but unlike the typical stage Yankee, he rapidly abandons any such plan when it interferes with his desire to speak out against the inhumanity of slavery.[25] Even so, he remains a humorous character to the last, turning his comic ignorance into a powerful indictment of the institution of slavery.

Humor and slavery are, of course, odd bedfellows, especially within the conventions of the stage. For Meer, Penetrate Partyside's comic blundering "blunts the impact of his strike against slavery."[26] Yet I'd like to suggest that Penetrate's blundering presence allows Conway to make the ironic commentary of Stowe's narrator visible to a theater audience, extending

the curiosity of the Museum environment to the serious issue of slavery. As such, Conway's play shows how the environment of curious spectatorship at Barnum's American Museum could and did serve the anti-slavery cause. Conway's transformation of Stowe's verbal irony into an embodied visual irony begins during the second act, as the steamer upon which St. Clare and Eva will soon meet and purchase Uncle Tom heads south. Having stumbled through a dark gangway to board the ship, Penetrate's first lines of dialogue recount his bewilderment at the squirming "live things" that he felt underfoot in the darkness. Unable to see what they were, Penetrate now asks the Waiter, "What on airth was them live things I sot my foot on tu? They squirmed like eels—they warn't alligators was they?" (61). Combining his non-visual senses and his prior knowledge to develop a hypothesis, he guesses that he must have stepped on some sort of sea creature; he does not consider that the unseen "things" would be human. But the waiter tells him otherwise: "Oh no, Sir, only niggers, Sir" (61), he responds, explaining that the boat is so crowded they had to be chained to the gangway. Surprised to learn that the "live things" were people, Penetrate assumes that they must have committed crimes, but the waiter informs him that they've done nothing: "They're only to be sold" (62).

In the framework of the United States, Penetrate is shocked that the sensations he felt in the dark corridor of the gangway would indicate the presence of human beings. With his notebook at the ready, he instructs himself to "put that down in your remarks on the wisdom, mercy, and justice of the laws of the United States, the home of the free and the land of the brave! Mem. *(writes)* Niggers chained like dogs ginerally; because they are going to be sold according to law particlarly. Queer! Who deserves to be chained most: the niggers to be sold, or the owners who sell them?" (62). Penetrate's invocation of the principles that purportedly activate American law is ironic, as what he has just observed clearly violates these mainstays of American democracy. He points out the irony that slave traders, in treating slaves like dogs instead of human beings, prove their own inhumanity. Although his attitude is clearly critical here, his observation that the situation is "queer" aligns with the ironically curious tone of Stowe's description of the same moment in the novel. That Penetrate is more puzzled than incensed allows the scene to mimic the affect of the Museum setting, challenging the deformed logic of slavery through humor rather than sentiment or extensive intellectual argument.

This mode of curious questioning continues with a more prolonged misunderstanding by Penetrate, once again arising from a lack of visual evidence. Soon after settling into the steamer, Penetrate overhears Haley and Loker discussing some kind of trade. While the drama's audience knows from the first part of their conversation that the men are talking

about selling slaves, Penetrate, who enters in the middle of their verbal exchange, cannot see what they are discussing. With a mind to finding a potential financial speculation, he tries to figure out what it is based on their language, as if he's solving a riddle. Yet his guesses continually fail: when Haley says he's taking a lot down to New Orleans, Penetrate decides they must be referencing bales of cotton. But in the next moment, Haley reports that the object of trade is said to be "great at picking" because "she's got the right fingers for it"; "Can't be cotton," Penetrate mutters. "Some machine, I guess" (66). A moment later, Haley says something about flesh, and Penetrate realizes that, whatever the two men are talking about, it can't be a machine. As they discuss "raising" whatever they're trading, he decides they must be talking about cattle; then, when Haley says "they ain't a bit more trouble than pups" (67), hogs. Penetrate's confusion arises from the way that slavery challenges the categories of person, animal, and thing, a confusion that the audience likely notices as they laugh.

When Loker insists that Haley should not ask for "more than ten dollars for that chap!" Penetrate approaches Haley to inquire, "how much will the crittur heft alive" (68). The stated figure sounds low: "Ten months old and weighs only thirty five pounds, the runt o' the litter, and you refuse ten dollars for him?" (68). The cost of pork and beans must be rising, he concludes. Finally, Haley and Loker settle on $45 for the trade, an impressive price for what Penetrate assumes is a hog. (Considering that the being in question weighs as much as a three-year-old boy, it's a fair assumption.) The unfolding of this irony relies on the prolonged absence of the slave's body. After asking several more questions, Penetrate finally realizes that all along they've been talking about the infant child of an enslaved mother. Hardly able to believe it, he records the transaction in his notebook: "Nigger babby ten months old, lifting thirty-five pounds—sold on the waters of the wide and free Mississippi for forty-five dollars by one cussed hog and bought by another darned brute" (71). While he casually uses the term "nigger," his response highlights the irony of such an inhuman practice occurring in a space that is supposed to be free. In the ironic reversal of this transaction, Haley has not *sold* a hog—he *is* one.

Taking up more than half of the long second scene of Act II, this exchange is too involved to be a simple joke on Penetrate's deductive skills. As he repeatedly guesses incorrectly, his failure to realize that Haley and Loker are discussing the sale of a human being becomes an indictment of the dehumanizing language of slavery. The scene shows how slavery not only violates fundamental American principles, but also deforms humanity and human bodies in mutually constituted ways: by treating and describing people like animals, slave traders themselves become "cussed hogs" and

"darned brutes." Certainly, it should be noted that Conway's anti-slavery humor, like Stowe's, is part of an inconsistent rhetoric of racial equality. Penetrate's insistence that slaves are human beings does not stop him from seeing St. Clare's slaves primarily as entertainment, and his descriptions and imitations of them suggest that his argument for their humanity does not extend to equality. Yet Penetrate's pattern of misunderstanding uses humor to call attention to the disconnect between American principles and the language of slavery.

Ironic reversal of the language of slavery continues in Conway's fourth act, when the now-coupled Penetrate and Aunty Vermont attend a slave auction hoping to use all of their money to buy and free Tom, a decision that Penetrate describes as "our duty as human beings." Recognizing his former misapprehension as an indictment of slavery, Penetrate now uses animal terminology with ironic purpose, forcing the slave traders to confront the implications of their buying and selling human beings. "Which be the drover of your two?" he inquires of Legree and Loker as he enters the scene. The term surprises Loker, whose confusion continues as Penetrate speaks of "cattle" and "crittures" despite a clear absence of farm animals in the vicinity. Finally, Penetrate explains that in fact he is talking about "niggers," but then quickly returns to animal terminology to describe Tom: "The crittures name is Tom. He's a black gentle critture, but powerful strong. Trot him out" (133). Penetrate's parodic use of these terms emphasizes the fact that Tom is *not* an animal, creating, in Bakhtin's formulation of parody, a "second voice" that clearly repugns the slaveholders' intentions, "forc[ing] it to serve directly opposite aims."[27] Suspicious of Penetrate's motives, Legree asks what is going on with "all this gibberish," and Penetrate retorts that he's simply using the usual language of slave traders: "Guess it's natral [*sic*] talk in these warehouses ginerally. Don't you understand it? It's suited to all brutes particlarly" (133). With the buying and selling of human beings, Penetrate suggests, the slave auction does involve beasts: the traders themselves. Insulted, Legree threatens Penetrate with a Bowie knife, but the Yankee stands his ground, asking whether Legree "stick[s] hogs with it . . . black uns on two legs?" (134). Recalling his earlier interaction with Loker and Haley, Penetrate's ironic question once again calls attention to the inhumanity of slavery. Drawing on Barnum's favored mode of curiosity and interrogation, Penetrate's comedy highlights the disconnect between the inhuman language of slavery and the clear visual evidence of the humanity of the enslaved. His pointed questions penetrate the walls of the Museum, becoming a challenge to the very legitimacy of slavery. Conway's play thus makes the American Museum a space in which the interrogation of difference between human beings, animals, and objects cannot be contained.

NOTES

1. Les Harrison, *The Temple and the Forum: The American Museum and Cultural Authority in Hawthorne, Melville, Stowe, and Whitman* (Tuscaloosa: University of Alabama Press, 2007), 131; Andrea Stulman Dennett, *Weird and Wonderful: The Dime Museum in America* (New York and London: New York University Press, 1997), 34–35.

2. Barnum's American Museum broadside (New York: s.n. 1853), *American Broadsides and Ephemera*, Series 1, no. 14475.

3. Harrison, *The Temple and the Forum* (Tuscaloosa: University of Alabama Press, 2007); Rosemarie Thomson, *Extraordinary Bodies: Figuring Physical Disability in American Literature and Culture* (New York: Columbia University Press, 1997); Benjamin Reiss, *The Showman and the Slave: Race, Death, and Memory in Barnum's America* (Cambridge, MA: Harvard University Press, 2010).

4. James F. Cook, *The Arts of Deception: Playing with Fraud in the Age of Barnum* (Cambridge, MA: Harvard University Press, 2001), 121.

5. Cook, *The Arts of Deception*, 57.

6. Phineas Taylor Barnum, *The Life of P. T. Barnum* (London: Sampson Low, 1855), 58. For a superb cultural history of Barnum's display of Joice Heth, see Benjamin Reiss, *The Showman and the Slave*.

7. Barnum, 58–59.

8. Reiss, 128.

9. Bruce McConachie, the first scholar to publish on the recovered 1876 Conway-Aiken script, compared it to the 1852 playbills and concluded that the 1876 version seemed to match the original Conway play (except, of course, where it is replaced by the Aiken text). Prior to the script's recovery, Robert Toll's description of the play as "pro-Southern," a judgment largely based on Birdoff's assessment, was generally accepted. With the discovery of the 1876 script, this understanding of Conway's play was somewhat amended to, as McConachie described it, "mildly anti-slavery," or, according to Eric Lott, a work of "relatively complacent politics." Recent scholarship has complicated this reading of Conway: Sarah Meer describes the Conway *Uncle Tom's Cabin* as "more muddled in its politics than calculating," and Les Harrison, contesting the notion of Aiken's play as authentic to Stowe's novel and Conway's as inauthentic, notes the preponderance of debate in Conway's play, a dramatic strategy that embraces a part of Stowe's novel that Aiken's script largely ignores. While David Reynolds highlights the play's "biting comments on slavery and the institutions that support it," John Frick argues that each of these "supposedly subversive examples . . . was, in some way, compromised and hence rendered ambiguous" and that theater managers Kimball and Barnum tried to "mut[e] or even eliminat[e] totally [Stowe's] anti-slavery sentiments by incorporating "minstrel themes, characterizations and conventions" and "romanticizing the plantation." See Bruce McConachie, "Out of the Kitchen and into the Marketplace: Normalizing *Uncle Tom's Cabin* for the Antebellum Stage," *Journal of American Drama and Theatre* 3, no. 1 (1991), 5–28; Robert Toll, *Blacking Up: The Minstrel Show in Nineteenth Century America* (Ox-

ford: Oxford University Press, 1974); Eric Lott, *Love & Theft: Blackface Minstrelsy and the American Working Class* (Oxford: Oxford University Press, 2013); Sarah Meer, *Uncle Tom Mania: Slavery, Minstrelsy and Transatlantic Culture in the 1850s* (Athens: University of Georgia Press, 2005); Harrison, *The Temple and the Forum*; David S. Reynolds, *Mightier Than the Sword: Uncle Tom's Cabin and the Battle for America* (New York: W. W. Norton & Co., 2011), 143; John Frick, *Uncle Tom's Cabin on the American Stage and Screen* (New York: Palgrave Macmillan, 2012), 89.

10. Harrison, 147.

11. See Harrison, *The Temple and the Forum*, and Meer, *Uncle Tom Mania*.

12. Harriet Beecher Stowe to Gamaliel Bailey, March 9, 1851. *Uncle Tom's Cabin and American Culture: A Multimedia Archive*. http://utc.iath.virginia.edu/uncletom/ utlthbsht.html. (Accessed October 1, 2015.)

13. Eliza "raised her hands in mute appeal to Heaven" (32); "Tom had stood, with his hands, raised, and his eye dilated, like a man in a dream" (34).

14. Robyn R. Warhol, "Towards a Theory of the Engaging Narrator: Earnest Interventions in Gaskell, Stowe, and Eliot," *PMLA* 101.5 (October 1986): 811.

15. Warhol, 815.

16. Jane Tompkins, "Sentimental Power: *Uncle Tom's Cabin* and the Politics of Literary History," *Glyph* 2 (1978).

17. For example, Robin Bernstein notes the irony of the novel's title. See Robin Bernstein, *Racial Innocence: Performing American Childhood From Slavery to Civil Rights* (New York: New York University Press, 2011), 134–138.

18. See Wayne C. Booth, *A Rhetoric of Irony* (Chicago: University of Chicago Press, 1974).

19. Harriet Beecher Stowe, *Uncle Tom's Cabin* (1852 New York and London: Norton, 2010), 93. All further quotations will be cited parenthetically.

20. For a discussion of the "echoic mention," see Deirdre Wilson and Dan Sperber, "On Verbal Irony," *Lingua* 87 (1992): 57–62.

21. William B. Allen, *Rethinking Uncle Tom: The Political Thought of Harriet Beecher Stowe* (Lanham, MD: Lexington Books, 2009), 113–118.

22. See Constance Rourke, *American Humor: A Study of the National Character* (1931).

23. Francis Hodge, *Yankee Theatre: The Image of America on the Stage, 1825–1850* (Austin: University of Texas Press, 1964); Jeffery H. Richards, "Race and the Yankee: Woodworth's The Forest Rose," *Comparative Drama* 34.1 (Spring 2000): 33–51.

24. Heather Nathans, *Slavery and Sentiment on the American Stage, 1787–1861* (Cambridge: Cambridge University Press, 2009), 153.

25. H. J. Conway, "Uncle Tom's Cabin: A Drama in Five Parts," 2.2, unpublished MS, Boston, 1852, 64. The Conway script has not been published in print, but it is available with page numbers added through *Uncle Tom's Cabin and American Culture: A Multimedia Archive*, http://utc.iath.virginia.edu/onstage/scripts/conwayhp .html. (Accessed October 1, 2015.) This transcription of the play was extracted from a manuscript version of the promptbook that was used in an 1876 production at the

Boston Museum. The promptbook is housed at The Howard Collection, Performing Arts Collection, Harry Ransom Center, University of Texas at Austin. Subsequent citations of Conway's version will be cited parenthetically in the text.

26. Meer, 120.

27. Mikhail Bakhtin [here spelled Mixail Baxtin], "Discourse Typology in Prose." In *Readings in Russian Poetics: Formalist and Structuralist Views*, ed. Ladislav Matejka and Krystyna Pomorska, 1971 (Chicago: Dalkey Archive Press, 2002), 185.

BIBLIOGRAPHY

Allen, William B. *Rethinking Uncle Tom: The Political Thought of Harriet Beecher Stowe*. Lanham, MD: Lexington Books, 2009.

American Broadsides and Ephemera: Series 1. Chester: Readex, 2000.

Barnum, Phineas Taylor. *The Life of P. T. Barnum*. London: Sampson Low, 1855.

Bernstein, Robin. *Racial Innocence: Performing American Childhood From Slavery to Civil Rights*. New York: New York University Press, 2011.

Booth, Wayne C. *A Rhetoric of Irony*. Chicago: University of Chicago Press, 1974.

Cook, James F. *The Arts of Deception: Playing with Fraud in the Age of Barnum*. Cambridge, MA: Harvard University Press, 2001.

Frick, John. *Uncle Tom's Cabin on the American Stage and Screen*. New York: Palgrave Macmillan, 2012.

Harrison, Les. *The Temple and the Forum: The American Museum and Cultural Authority in Hawthorne, Melville, Stowe, and Whitman*. Tuscaloosa: University of Alabama Press, 2007.

Hodge, Francis. *Yankee Theatre: The Image of America on the Stage, 1825–1850*. Austin: University of Texas Press, 1964.

Lott, Eric. *Love & Theft: Blackface Minstrelsy and the American Working Class*. Oxford: Oxford University Press, 2013.

McConachie, Bruce. "Out of the Kitchen and into the Marketplace: Normalizing *Uncle Tom's Cabin* for the Antebellum Stage." *Journal of American Drama and Theatre* 3, no. 1 (1991): 5–28.

Matejka, Ladislav, and Krystyna Pomorska, eds. *Readings in Russian Poetics: Formalist and Structuralist Views*. Chicago: Dalkey Archive Press, 2002.

Meer, Sarah. *Uncle Tom Mania: Slavery, Minstrelsy, and Transatlantic Culture in the 1850s*. Athens: University of Georgia Press, 2005.

Nathans, Heather. *Slavery and Sentiment on the American Stage, 1787–1861*. Cambridge: Cambridge University Press, 2009.

Reiss, Benjamin. *The Showman and the Slave: Race, Death, and Memory in Barnum's America*. Cambridge, MA: Harvard University Press, 2010.

Reynolds, David S. *Mightier Than the Sword: Uncle Tom's Cabin and the Battle for America*. New York: W. W. Norton & Co., 2011.

Richards, Jeffery H. "Race and the Yankee: Woodworth's The Forest Rose," *Comparative Drama* 34.1 (Spring 2000): 33–51.

Stowe, Harriet B., and Elizabeth Ammons. *Uncle Tom's Cabin: Authoritative Text, Backgrounds and Contexts, Criticism*. New York: W. W. Norton & Co., 2010.

Stulman Dennett, Andrea. *Weird and Wonderful: The Dime Museum in America*. New York and London: New York University Press, 1997.

Thomson, Rosemarie. *Extraordinary Bodies: Figuring Physical Disability in American Literature and Culture*. New York: Columbia University Press, 1997.

Toll, Robert C. *Blacking Up: The Minstrel Show in Nineteenth Century America*. Oxford: Oxford University Press, 1974.

Tompkins, Jane. "Sentimental Power: *Uncle Tom's Cabin* and the Politics of Literary History," *Glyph* 2 (1978): 79–102.

Uncle Tom's Cabin and American Culture: A Multimedia Archive. http://www.iath.virginia.edu/utc.

Warhol, Robyn R. "Toward a Theory of the Engaging Narrator: Earnest Interventions in Gaskell, Stowe, and Eliot." *Publications of the Modern Language Association of America* (1986): 811–818.

Wilson, Deirdre, and Dan Sperber. "On Verbal Irony." *Lingua* 87, no. 1 (1992): 53–76.

Chapter Eight

Babo's Skull, Aranda's Skeleton

Visualizing the Sentimentality of Race Science in Benito Cereno

Christine Yao

To see the corpse of Alexandro Aranda displayed as the ersatz figurehead of the *San Dominick* and to finish with Babo's head impaled on a pole in the Plaza become the marks of overturning and then restoring expected visions in Herman Melville's *Benito Cereno*. The deliberate public exhibition of bodily remnants from the Spanish enslaver and the Senegalese rebel mastermind are central to the turn and resolution of Melville's novella. These scenes of visual display stand out as significant deviations from Melville's source, an episode from the real-life Amasa Delano's memoir *Narrative of Voyages and Travels* in which the American captain thwarts a revolt on board a Spanish slave ship. The gruesome spectacle made from the corpses of Aranda and Babo points to the novella's exploration of how visual culture intersects with race science as part of the nineteenth-century emergence of modern forms of scientific objectivity dependent upon the making and reading of images.[1] Melville's text makes visible what objectivity cannot fully erase: the racialized violences behind that image-making and the influence of sentimental reading on objectivity's optics. Through its attention to Captain Amasa Delano's affective response as an observer to the public spectacles of Aranda's skeleton and Babo's head, *Benito Cereno* ties together the visualization of race science with the moral authority of sentimentalism.

At the beginning of *Benito Cereno*, the narrative establishes ironic distance from its focalizing character whose sight is emphasized in conjunction with his heart in the apparent right place. From his perspective, "viewed through the glass," the *San Dominick* becomes an object of intrigue as the captain "continued to watch her" for the ship appears stranger "the longer the stranger was watched."[2] Despite possible suspicions that might arise from these observations, with his "singularly undistrustful good-nature" he does not fear evil

141

from the Spanish ship (55). The opening challenge for the reader is to determine whether the American's "benevolent heart" might affect his "quickness and accuracy of intellectual perception"—and to question both (56). Delano's way of seeing, his literal point-of-view, draws upon the authority of popular scientific discourse that justifies his sympathies toward those he observes with obsessive attention to faces and heads. This attention varies based on the racial hierarchies of the "head sciences" of physiognomy, phrenology, and craniology—purported "scientific" fields of study whose legitimacy would wax and wane over the century. The scholarly conversation on Melville's portrayal of Delano's hermeneutics and racism has overlapped with ongoing academic work on the politics of American sentimentalism: following Peter Coviello's claim that Delano is a sentimental reader,[3] I ask how that mode might be influenced by the rise of scientific observation in American visual culture. Delano embodies Harriet Beecher Stowe's famous injunction from the end of *Uncle Tom's Cabin*, published three years prior to *Benito Cereno*'s serialization in 1855: "There is one thing that every individual can do,—they can see to it that *they feel right*. An atmosphere of sympathetic influence encircles every human being; and the man or woman who *feels* strongly, healthily and justly, on the great interests of humanity, is a constant benefactor to the human race."[4] While for Stowe to "feel right" leads to the right kind of politics, according to Coviello and others, Melville indicts Stowe's sentimentalism by tying the captain's "good nature" to a deeply violent ideology. Delano's perspective allows us to track how the everyday optics of race science were naturalized through sentimentalism, a justificatory schema that transforms scientific rationalizations for racial prejudice into the affective certainty of what feels like the natural order. His gaze directed by his heart, Delano reproduces the sentimental rhetoric and brutal violences of American race science onto the events off the coast of Chile. The subversive display of Aranda's skeleton is replaced by the closing spectacle of Babo's head as a symbol of order restored in the world: the rebel leader dehumanized into a craniological specimen suitable for race science's appropriation as evidence, reaffirming what the American felt was right all along.

In *The American Phrenological Journal* (1846) Orson Squire Fowler announces the visual impact of the popular science: "Its observations so thoroughly interest as to create a *seeing mania* which scrutinizes everybody and every thing. And the more you learn of it, the more it will promote still further observation."[5] The phrenologist's phrase "seeing mania" articulates a manifestation of what Jonathan Crary has more broadly argued is the rise of the modern techniques of the observer.[6] Through the influence of science on nineteenth-century American visual culture, faces, heads, and skulls acted as the visible material signifiers not just of character and ability, but of dif-

ferences within the hierarchy of the human. The overlapping disciplines of physiognomy, phrenology, and craniology affirmed vision as a technology of scientific judgment. Despite their present-day disavowal as pseudosciences due to association with scientific racism, these fields once enjoyed varying degrees of professional respectability and institutional credibility; their research and paradigms laid the groundwork for the development of the disciplines of anatomy, psychology, and neuroscience. The late eighteenth-century field of physiognomy, based on the work of the Swiss writer Johann Kaspar Lavater, promoted the observation of faces and other outward physical traits as an objective means for judging the inner self and revealing the soul. For Lavater, this also meant the visible differences between peoples, for "that there is national physiognomy, as well as national character, is undeniable," although he admits "it will, sometimes, be very difficult to describe scientifically.[7] Phrenology would give physiognomy the more rigorous and scientific description the latter lacked: stemming from the work of German physicians Franz Josef Gall and his disciple Johann Gasper Spurzheim, phrenology adapted the principles of physiognomy into a more materialist critique of the head whose external bumps reflected and quantified the inherent faculties of the brain, presumed to be the seat of human ability. Their analyses combined physiognomy's privileging of the critical eye with the authenticating tangibility of haptic evidence. The wide-spread acceptance of phrenology in nineteenth-century America stemmed from the work of phrenology's proselytizers such as the Scottish lawyer George Combe, whose 1823 *The Constitution of Man* was one of the bestsellers of the era with 200,000 copies sold before the Civil War,[8] and the aforementioned Fowler family who printed numerous pamphlets on practical phrenology and gave many lecture tours and public demonstrations. The promise of access to scientific knowledge that would train the individual in the ability to interpret everyday life and enable self-knowledge and, therefore, self-improvement, was crucial to the successful dissemination of phrenology's precepts. Coeval to phrenology's life as a popular science, the study of skulls was practiced by esteemed craniologists like Ivy League–educated scientist Samuel George Morton, expanding the visual analysis of individual heads and faces to the mass collection of data about comparative anatomy in relation to the differences between civilizations and peoples. Such research provided the phenotypical evidence for the ethnological theory of polygenesis, also known as the "American School," which boasted Harvard scientist Louis Agassiz as its most prestigious advocate: one of the most notorious examples of scientific racism, its central claim was the separate origins of each "race." These interlocking discourses helped to train the average American eye in the techniques of scientific visual evaluation, combining the expertise of the Foucauldian clinical gaze with a culture

of everyday panoptic scrutiny, thereby providing widespread justification for racial prejudices naturalized to be as evident as sight itself.

The scientific dependence on the visual as a primary tool of analysis meant the proliferation of images of faces, heads, and skulls, in order to illustrate theory.[9] One edition of Lavater's *Essays on Physiognomy* boasts three hundred and sixty engravings on its title page, while practitioners of popular phrenology used its iconic diagrams of the head's faculties and organs for advertising their services. While physiognomic and phrenological texts were generally small for the sake of facilitating easier distribution and greater affordability, *Crania Americana*'s expensive folio format imbued Morton's ethnological findings with gravitas and delivered the impact of John Collins's striking seventy-eight lithographs depicting the scientist's extensive skull collection. Similarly, the scholarly *Types of Mankind* by Josiah Clark Nott and George R. Gliddon, boasting selections from Samuel Morton and Louis Agassiz among other scientific authorities, includes several foldout color prints that display schematic renditions of the faces, skulls, and characteristic fauna associated with each race's place of origin. The titular "types" are meant to be instantly recognizable by their displays of distinctive anatomy: "how indelible is the image of a type impressed on a mind's eye!" proclaims the tome.[10] Incongruous to modern standards of evidence, the title page of *Types* declares that its research is drawn from "ancient monuments, sculptures, and paintings" as well as the expected crania, but the dependence upon art, under the presumption of mimetic representation, recurs throughout the head sciences. Phrenologists regularly used busts and paintings at their demonstrations in order to affirm the timelessness of their principles and to use the visages of deceased famous individuals as examples.

Art in this period, however, was shifting in response to phrenological principles. Hiram Powers was inspired by phrenology in his sculpting and even distributed the movement's pamphlets, while the popularity of the science meant that artists were pressured, in the case of Augustus Saint-Gaudens, or, like Henry Inman, savvy about altering their busts and paintings, in order to give their sitters flattering phrenological portrayals.[11] These aspirational representations indicate the bias of science's reliance on the visual: the faces of white, moneyed subjects have the privilege of signifying an idealized individuality, while racialized faces are reducible to types. In his approach to ethics, Lévinas unintentionally channels the head sciences' fixation with their preferred object of study: according to the philosopher, "the face is meaning all by itself" and its epiphanic alterity demands an ethical relation.[12] But this assumption about the irreducible alterity runs into the unexamined problem of universality that Deleuze and Guattari critique in their discussion of faciality: although the face acts as a way of tying meaning to a subject, the assumed

face is "your average ordinary White Man": "Racism operates by the determination of degrees of deviance in relation to the White-Man face.[13] Tellingly, in one comparative diagram *Types* presents the contrast between racial norms and deviations by placing the caricatured faces of black men beside those of primates, while the representative face of whiteness is the classical bust of Apollo Belvedere.[14] The chosen faces and heads of physiognomic and phrenological texts and demonstrations are of idealized white men reaffirmed as normative ideals by science.

Sentimentalism legitimized the scientific thought, practice, and methodology of this period.[15] As scholarship by Lauren Berlant, Lisa Lowe, Laura Wexler, and many others has shown us, feeling is never simply the private affective capacity of the individual but constitutive of public national sentiments and their political projects of belonging, interlocked with colonial and imperialist transnational intimacies of labor and domination. In this light, Kyla Schuller argues for our attention to the overarching biopolitics of feeling: "Sentimentalism," she states, "in the midst of its feminized ethic of emotional identification, operates as a fundamental mechanism of biopower."[16] Science produced hierarchies of racial and gendered differences based on the capacity for feeling with civilized agency versus unsophisticated reaction. Sentimentalism was then and is now more than a moral or aesthetic or rhetorical mode: feeling is a technology of domination, molding bodies and populations as part of political projects. If we look to the writings of the scientists themselves we can see how they understood their racism through the rhetoric of sentimentalism and the concept of sympathy. Returning to Lavater, his take on national physiognomy sowed the seeds of race science combined with the title page proclaiming that his writing was intended "to promote the knowledge and the love of mankind."[17] Phrenology helped to systematize the connection between science and emotion: the major classes of the phrenological organs include those called the "sentiments" by Combe, and the "affective faculties, or feelings" by the Fowlers. *Crania Americana* features an essay by George Combe that speaks to sympathy as the principle behind phrenology: "Sympathy is not a faculty, nor is it synonymous with moral approbation. The same notes sounded by ten instruments of the same kind, harmonise, blend softly together, and form one peal of melody."[18] In *Types of Mankind*, race science and slavery justify one another through a compassionate appeal to greater good: "the Negro thrives under the shadow of his white master, falls readily into the position assigned him, and exists and multiplies in increased physical well-being."[19] Dedicated to Morton, *Types* opens with a memoir of the founding skull collector as a sensitive soul: he had "nervous temperament, delicate fibre, acute feelings, and ardent sympathies."[20] Much like Delano guided by his

benevolent heart in his racism, these proponents of race science believed themselves as motivated by the finest feelings for good.

By shifting the original account of Captain Delano's encounter with the Spanish slave ship *Tryal* from 1805 to the fictionalized 1799, the temporal scope of the novella published in 1855 captures these developments in visual culture and race science. Melville himself can be counted among those interested in both science and art: his reading included many works on art history by luminaries such as John Ruskin and Giorgio Vasari alongside scientific texts like Darwin's journal and a volume of Cuvier's *The Animal Kingdom*.[21] Melville himself owned about four hundred individual prints and his final published work *Timoleon* explores his love of art in poetry.[22] As for Melville's knowledge of these sciences in particular, during his trip to England in 1849 he purchased a copy of Lavater's *Essays* for 10 shillings and an 1854 letter to Richard Lathers indicates the return of Lathers' copy of Combe's bestselling *Constitution*.[23] In an August 16, 1850, letter to publisher and editor Evert A. Duyckinck, he jokes to his friend about the pandering of phrenologists: "A horrible something in me tells me that you are about dipping your head in plaster at Fowler's for your bust."[24] Lynn Horth speculates that Melville's knowledge of the phrenological Fowlers may have been as early as 1835 due to the active practices of the brothers and their students in Albany and Lansingburgh; for instance, John C. Hoadley, Melville's brother-in-law, had his head examined by Lorenzo Fowler.[25] Both science and art are woven into the foreground and background of Melville's life and work.

Benito Cereno was published serially in a literary periodical dedicated to both subjects: *Putnam's Monthly Magazine of American Literature, Science, and Art*, in which Melville debuted numerous other works such as "Bartleby the Scrivener" and *Israel Potter*, included regular updates about the fine arts and discussions of science. When *Types of Mankind* appeared in 1854 as a salvo for polygenesis's proponents, the July edition of *Putnam's* engaged in an extensive discussion of the book that ends up in agreement with its claims. The review "Is Man One or Many?" ends up on the side of polygenesis, accepting the use of art as evidence for the unchanging and separate nature of the races based on "different physiognomies" that "enable us, for the most part, to distinguish them at a glance."[26] In January 1855, however, the essay "Are All Men Descended From Adam?" returns to the debate and argues for monogenesis in part on the basis of the "mysterious sympathy which inspires whole nations with the emotions of a single man," while still maintaining physiognomy as the distinctive characteristic of racial difference.[27] *Benito Cereno* would be published in the last three issues of that year to a readership conversant in contemporary visual culture as well as antebellum debates about scientific racism.

Captain Delano is introduced as a clear participant in the race science's popular *"seeing mania"* as a biopolitical technology of sentimental recognition. Once aboard the *San Dominick*, Delano's "one eager glance took in all faces, with every other object about him," and when he first looks specifically at the people who are the ship's cargo, the old Africans picking oakum are described as having "heads like black, doddered willow tops."[28] Throughout his guided tour of the ship, the captain's gaze is drawn to faces and heads as organized receptacles of legible meaning, but he parses them unevenly according to race: white faces are continually recognized and privileged with gazes that can be returned, while black faces are continually erased, ignored, or downplayed, and often rendered simply as heads with the status of objects. While the physiognomic face holds the holistic representation of individual humanity, the head in phrenology, if one is not in the position to be pandered to by its practitioners as a subject of admiration, quantifies one's abilities as an object of study. During one of many instances when Delano is on the verge of revelation about the clever racial masquerade, he with "eye directed forward" believes the Spanish sailors "returned the glance and with a sort of meaning. He rubbed his eyes and looked again; but again seemed to see the same thing" (83–84). When he then enters the scene, he only looks to white faces for answers, with "his eye curiously surveying the white faces, here and there sparsely mixed in with the blacks," and, after failing to get answers from a Spanish sailor, he looks "round for a more promising countenance but seeing none, spoke pleasantly to the blacks to make way for him" (84–85). By affectively prioritizing white faces, black faces barely register for him as subjects.

The visual evidence of race science gives reassuring authority to Delano's racist sympathies and directs his interactions, but in turn, sentiment is the tool that naturalizes science by allowing its ideological influence almost invisibly to shape Delano's sentimental way of seeing through "the blunt-thinking American's eyes" (68). His recognition of black people is contingent upon them as affectable and animated projections of his own feelings. After noting the oakum pickers, with a "first comprehensive glance" that "rested but an instant upon them," he sees the hatchet-polishers as "unsophisticated Africans," and frames their labors as "the peculiar love in negroes of uniting industry with pastime" (60). The same snap judgment of Delano's first glance on board the *San Dominick* combines race science's evaluation of black inferiority with sentimentality's euphemizing of enslaved labor. Rather than viewing blackness as evil, Delano's condescending stance instead renders blackness as a benign childlikeness that justifies their subordination into subservient roles. He takes as proof the phrenological and craniological "evidences" of racial mental ability. These peoples are suited for servitude due to that "unaspiring

contentment of a limited mind, and that susceptibility of bland attachment sometimes inhering in indisputable inferiors" and accordingly sympathetic whites only "took to their hearts" by graciously preferring them as servants "almost to the exclusion of the entire white race" (98).

For the American, his reading of the flat visual signification of black bodies acts as a comforting reminder of the fixed hierarchization of nature according to science whenever he becomes suspicious about any strangeness around him. In one such moment of anxiety, Delano's observation of a nameless black woman and her child cheer him by playing to his sympathies about the proper roles allotted by gender and race. Viewing them as "a pleasant sort of sunny sight," he at once dehumanizes and sentimentalizes both bodies through the language of nature: she is "like a doe," while her child is a "wide-awake fawn" trying to nurse like a piglet, "giving a vexatious half-grunt" (86). Even though a strange man is gawking at her breasts, the woman "started up, at a distance facing Captain Delano" (86), and pretends not to see him, reinforcing his sense of voyeurism and confidence as the observer rather than the observed. The scene recalls for us Saidiya Hartman's insight into the paradox of the legibility of black humanity predicated upon enslavement and subjugation: to him, Black women "seemed at once tender of heart and tough of constitution; equally ready to die for their infants or fight for them. Unsophisticated as leopardesses; loving as doves" (86).[29] Coviello claims that Delano "cannot but read this scene as a kind of sentimental apotheosis, an image of human benignity at its most naked and pure, and carried, appropriately, by the transports of the 'maternal.'"[30] Justifications for slavery like George Fitzhugh's *Sociology of the South* used the oppressive construction of the domestic sphere to argue for the validation of slavery through the naturalness of familial affection: slaves "are part of the family, and self-interest and domestic affection combine to shelter, shield and foster them," and Fitzhugh later clarifies his stance against women's rights through recourse to the same truth that "the family government, from its nature, has ever been despotic."[31] The final touch is Delano's citation of observations about Black women by white explorers of Africa like Mungo Park and John Ledyard, bringing together sentimentalism and ethnographic knowledge through reminders of the transnational scope of systemic antiblackness.[32]

The captain's rationalizations about black bodies are justified through sentimentality, not just participating in the cultural discourse of paternalism expressed by the sciences, but also personalized by his own nostalgia. The contrast in racial physiognomic worthiness is most apparent in how Delano sees Babo's black face only in relation to Benito Cereno's white face. Initially, Babo's visage is rendered as a "rude face, as occasionally, like a

shepherd's dog, he mutely turned it up into the Spaniard's" and later, when Delano questions the relationship between Spaniard and African, "Babo, changing his previous grin of mere animal humor into an intelligent smile, not ungratefully eyed his master" who affirms the man's value to him.[33] The American repeatedly notices Babo's preoccupation with Cereno's face, reading this attention as a slavish attentiveness to Cereno as a worthy subject like a dog to his owner; the canine comparison serves to sentimentalize his servitude in relation to Delano's boyhood New England memories. He later associates the incoming boat *Rover* with recollections of his younger self and describes the boat like "a Newfoundland dog" docked by his Duxbury, Massachusetts home, with its loyalty and promise of support like "a good dog; a white bone in her mouth" (91). Only good things happen to good people, Delano reassures himself, and soon after he views Babo's presence as external confirmation mirroring his internal affective affirmation: Babo's "pleasing expression, [was] responsive to his own present feelings" (91). This fond childhood memory based upon disavowed Northern racism comes back to reinforce Delano's nostalgic associations of faithful support as he watches Babo shave Cereno: "In fact, like most men of a good, blithe heart, Captain Delano took to negroes, not philanthropically, but genially, just as other men to Newfoundland dogs (99). Fitzhugh, in his sociological defense of slavery as "healthy, beautiful, and natural," declares, "A man loves not only his horses and his cattle, which are useful to him, but he loves his dog, which is of no use. He loves them because they are his."[34] To the nostalgic American, Babo's solicitous care of Cereno can only be a reflection of loving loyalty like that of a dog's; during dinner Delano repeatedly views Babo's attention to Cereno in canine terms, "the black was still true to his master, since by facing him he could the more readily anticipate his slightest want" and "He only rested his eye on his master's."[35] The atavism of blackness in the schema of racial science becomes parsed as fond nostalgia for racial and natural order as well as for his bucolic New England past; it is little wonder that at one point Captain Delano tries to purchase Babo for fifty doubloons to fulfill this fantasy of being pandered to by black emotional labor.

By contrast, Delano continually scrutinizes the subtleties of Cereno's face for deeper meaning because he does not question the validity of the man's affective interiority. During their interactions Delano is attuned to numerous shifts and tics of Cereno's physiognomy such as when his "face lighted up" for "the honest glance of his visitor" or when "his pale face [appeared] twitching and overcast" (69, 77). After entertaining the elaborate possibility that Cereno might be an imposter, Delano turns to a physiognomic reading of his fellow captain for reassurance:

> He was struck by the profile, whose clearness of cut was refined by the thinness
> incident to ill-health, as well as ennobled about the chin by the beard. Away
> with suspicion. He was a true offshoot of a true hidalgo Cereno. (76)

For Delano, Don Benito's face reads as testimony of his superior breeding as
a hidalgo, a member of Spanish nobility: racial notions of inheritance come
into play as biology and exterior physical traits become synonymous with
character, ability, and morality. Rather than viewing whiteness as imperiled,
the visual authority of race science assuages Delano's anxieties by familiar-
izing the dangerously uncanny sights of the slave ship through the comfort
of racial nostalgia.

The narrative takes a turn when it is revealed that the Africans are no lon-
ger cargo, but actually the masters of the slave ship. The reveal of Aranda's
skeleton bookmarks this section much as Babo's execution closes the novella.
Yet Delano's sentimentality and dependence on race science are not so eas-
ily overcome: the battle does not break his ideology so much as display the
persistence of structures of power. Before setting back to his ship, he casts a
glance over the slave ship and smiles: he "saw the benign aspect of nature" in
the aesthetic charm of the setting sun framing the tableaux of enslavement an-
chored by the images of enslaved blacks (113). Pleased by this sight, Captain
Delano reacts to Cereno's farewell with "instinctive good feeling" (113, 114).
With Cereno's frantic escape onto his boat and Babo close behind, the "scales
dropped from [Delano's] eyes" (116). His recognition of Babo as leader of
the revolt rather than loyal slave, however, does not constitute a break from
the American's way of looking and thinking: he views Babo's "countenance
lividly vindictive, expressing the centered purpose of his soul" (116), the
Senegalese man's face finally acknowledged but still read as a transparently
legible sign according to the standards of race science. When Babo leaps onto
the boat with dagger in hand, he seems to aim "at Captain Delano's heart,"
and in retaliation Delano "smote Babo's hand down, but his own heart smote
him harder" (116). Babo's true intentions would appear to attempt to literally
skewer Delano's sentimental heart and the heart of his sentimentalism, but
the disappointment only reaffirms the power of the American's sympathies
as Delano acts on behalf of Cereno's safety (116).

The potency of visual signifiers informed by scientific racism endures with
the public presentation of the dead. When the conflict between the Africans
and the combined forces of the Americans and Spanish begins, Aranda's
skeletal remains are discovered lashed onto the *San Dominick* as a morbid
figurehead, a "chalky comment on the chalked words below, FOLLOW
YOUR LEADER" (117). Aranda's bones are not a mere death's head, but an
entire skeleton instead of a skull: even in death, the former enslaver has the

privilege of not being reduced to the singular scientific object of Melville's day, instead remaining intact. When Cereno cries out at the sight, "'Tis he, Aranda! My murdered, unburied friend!" he both identifies and identifies *with* the man's bones (117). The skeleton both retains Aranda's individuality and signifies *memento mori*, an unacknowledged racialized universality that privileges white bones. Babo's treatment of Aranda's bones subverts race science's relationship to visual signification and racial identification: according to the accounts codified by the later deposition, Babo took each member of the crew to the remains and asking "whose skeleton that was, and whether, from its whiteness, he should think it a white's," threatening that unless the Spaniards help the Africans, they "shall in spirit, as now in body, follow [their] leader" (126). In response, each covers his face, a gesture of racial physiognomic recognition (126). During the subsequent battle Don Alexandro Aranda's skeleton becomes a symbol for rallying the Spanish and Americans alike, "beckoning the whites to avenge it" (119). Their victory proves to themselves that the natural order was duly maintained.

Babo's beheading functions as the abjected racial reversal of Aranda's death: the lawful execution versus the obscene murder. While both remains are publicly displayed in order to terrorize their respective racial communities with the consequences of following their leader, one can compare the divergences between white and racialized bodies in their post-mortem treatment and attendant visual signification: Babo's body is burned leaving only his head, while Aranda's intact "recovered bones" rest in peace (137). Placing Babo's head on a pole, "that hive of subtlety," in part reflects the phrenological fetishization of the head as the material object of visual analysis; as the narrative emphasizes, the African's "brain, not body" was responsible for the uprising (137).

Babo's severed head returns the reader to the multivalent violence of race science; one can trace the shift from living face to mute head to eventual skull specimen. Ann Fabian points out the contemporaneous correlation between Nat Turner's rebellion, during which "slaveholders executed suspected plotters and stuck their heads on stakes" as warnings, and Morton's skull collection for *Crania Americana*, which included "heads of African tribal leaders who led a bloody resistance to settlement on their lands by former American slaves" plucked from their stakes in Liberia for scientific research.[36] The authoritative science that informs Delano's gaze and confirms his racial prejudices is based on empirical data wrested from exhumed bodies of peoples of color and a product of national and colonial projects. Among Morton's careful description of each skull's origins, one "remarkably characteristic Indian head" belonged to a Seminole warrior killed during the Second Seminole War that was still ongoing during and after the publication of *Crania Americana*.[37]

The purported objectivity of science attempts to sanitize the means of its own production and its resulting effects, but Melville's *Benito Cereno* returns context to the effects of race science on the American way of looking, reminding us that representative violence is inevitably linked to other forms of national and transnational brutality. Against abolitionist arguments for feeling as a weapon against unfeeling institutional oppressions, Melville reveals that such institutions were imbricated within the nineteenth-century culture of sentiment. This American scopophilia is both scientific and sentimental: Delano's racism is justified by contemporary science but naturalized by love, not hate. Representative weight is literally on Babo's head alone; as a man who fought to escape the violence of being rendered property, in death his remains are held up as a legal example that may also eventually find use as a scientific example, trapped in the self-serving tautologies of righteous feeling. Although silenced, his head's accusing gaze "met, unabashed, the gazes of the whites,"[38] glaring up toward the vaults where slave-owning Aranda's body rests, as a reminder of this injustice.

NOTES

1. Lorraine Daston and Peter Galison, *Objectivity* (New York: Zone Books, 2007).

2. Herman Melville, *Billy Budd, Bartleby, and Other Stories*, ed. Peter Coviello (New York: Penguin Books, 2016), 55. All further quotations will be cited parenthetically.

3. Peter Coviello, "The American in Charity: 'Benito Cereno' and Gothic Anti-Sentimentality," *Studies in American Fiction* 30, no. 2 (2002): 155–80.

4. Harriet Beecher Stowe, *Uncle Tom's Cabin*, ed. Jean Fagan Yellin (New York: Oxford University Press, 2008), 452.

5. Orson Squire Fowler, "Analysis, Adaptation, Location, and Cultivation of Individuality," *The American Phrenological Journal* 8, no. 11 (1846): 331.

6. Jonathan Crary, *Techniques of the Observer: On Vision and Modernity in the Nineteenth Century* (London: MIT Press, 1990).

7. Johann Caspar Lavater, *Essays on Physiognomy*, trans. Thomas Holcroft (London: G.G.J. and J. Robinson, 1789), 85.

8. Charles Colbert, *A Measure of Perfection: Phrenology and the Fine Arts in America* (Chapel Hill: University of North Carolina Press, 1997), 23.

9. Many thanks to the Center for Historic American Visual Culture 2014 summer seminar for giving me the opportunity to research this section at the American Antiquarian Society.

10. Josiah Clark Nott and George Robbins Gliddon, *Types of Mankind* (Philadelphia: J. B. Lippincott, 1854), 412.

11. Colbert, *A Measure of Perfection: Phrenology and the Fine Arts in America*, 41, 152.

12. Emmanuel Lévinas, *Ethics and Infinity: Conversations with Philippe Nemo* (Pittsburgh: Duquesne University Press, 1985), 86.

13. Gilles Deleuze and Félix Guattari, *A Thousand Plateaus: Capitalism and Schizophrenia*, trans. Brian Massumi (Minneapolis: University of Minnesota Press, 1987), 178.

14. Nott and Gliddon, *Types of Mankind*, 458.

15. Jessica Riskin, *Science in the Age of Sensibility: The Sentimental Empiricists of the French Enlightenment* (Chicago: University of Chicago Press, 2002). George M. Fredrickson, *The Black Image in the White Mind: the Debate on Afro-American Character and Destiny, 1817–1914* (New York: Harper and Row, 1971).

16. Kyla Schuller, *The Biopolitics of Feeling* (Durham, NC: Duke University Press, 2017), 2.

17. Lavater, *Essays on Physiognomy*, title page.

18. George Combe, "Phrenological Remarks on the Relation between the Natural Talents and Dispositions of Nations, and the Developments of Their Brains," in *Crania Americana*, ed. Samuel George Morton (Philadelphia: Dobson, 1839), 290.

19. Nott and Gliddon, *Types of Mankind*, xxxiii.

20. Nott and Gliddon, xxi.

21. Merton M. Sealts, *Melville's Reading* (Columbia: University of South Carolina Press, 1988), 89, 102, 55, 54.

22. Douglas Robillard, *Melville and the Visual Arts: Ionian Form, Venetian Tint* (Kent, OH: Kent State University Press, 1997), x.

23. Herman Melville, *Journals*, ed. Lynn Horth and Howard C. Horsford (Evanston, IL: Northwestern University Press, 1989), 24; Melville, *Correspondence*, ed. Lynn Horth (Evanston, IL: Northwestern University Press, 1993), 260.

24. Melville, *Journals*, 167–68.

25. Melville, *Correspondence*, 169.

26. "Is Man One or Many?," *Putnam's Monthly Magazine of American Literature, Science, and Art* 4, no. 19 (1854): 9.

27. "Are All Men Descended From Adam?," *Putnam's Monthly Magazine of American Literature, Science, and Art* 5, no. 25 (1855): 88.

28. Melville, *Billy Budd, Bartleby, and Other Stories*, 59.

29. Melville, *Billy Budd, Bartleby, and Other Stories*, 59. See Saidiya Hartman, *Scenes of Subjection: Terror, Slavery, and Self-Making in Nineteenth-Century America* (New York: Oxford University Press, 1997).

30. Coviello, "The American in Charity: 'Benito Cereno' and Gothic Anti-Sentimentality," 164.

31. George Fitzhugh, *Sociology for the South, or the Failure of Free Society* (New York: Burt Franklin, 1854), 46, 96.

32. In the original *Putnam's* publication the reference is to the Scottish Mungo Park. In Melville's revisions for *The Piazza Tales*, however, he changes the reference to the American explorer John Ledyard.

33. Melville, *Billy Budd, Bartleby, and Other Stories*, 60, 79.

34. Fitzhugh, *Sociology for the South, or the Failure of Free Society*, 81, 46.

35. Melville, *Billy Budd, Bartleby, and Other Stories*, 105, 107.

36. Ann Fabian, *The Skull Collectors: Race, Science, and America's Unburied Dead* (Chicago: University of Chicago Press, 2010), 4.

37. Samuel George Morton, *Crania Americana* (Philadelphia: Dobson, 1839), 166.

38. Melville, *Billy Budd, Bartleby, and Other Stories*, 137.

BIBLIOGRAPHY

"Are All Men Descended From Adam?" *Putnam's Monthly Magazine of American Literature, Science, and Art* 5, no. 25 (1855): 79–88.

Colbert, Charles. *A Measure of Perfection: Phrenology and the Fine Arts in America.* Chapel Hill: University of North Carolina Press, 1997.

Coviello, Peter. "The American in Charity: 'Benito Cereno' and Gothic Anti-Sentimentality." *Studies in American Fiction* 30, no. 2 (2002): 155–80.

Crary, Jonathan. *Techniques of the Observer: On Vision and Modernity in the Nineteenth Century.* London: MIT Press, 1990.

Daston, Lorraine, and Peter Galison. *Objectivity.* New York: Zone Books, 2007.

Deleuze, Gilles, and Félix Guattari. *A Thousand Plateaus: Capitalism and Schizophrenia.* Translated by Brian Massumi. Minneapolis: University of Minnesota Press, 1987.

Fabian, Ann. *The Skull Collectors: Race, Science, and America's Unburied Dead.* Chicago: University of Chicago Press, 2010.

Fitzhugh, George. *Sociology for the South, or the Failure of Free Society.* New York: Burt Franklin, 1854.

Fowler, Orson Squire. "Analysis, Adaptation, Location, and Cultivation of Individuality." *The American Phrenological Journal* 8, no. 11 (1846): 327–34.

Fredrickson, George M. *The Black Image in the White Mind: the Debate on Afro-American Character and Destiny, 1817–1914.* New York: Harper and Row, 1971.

Hartman, Saidiya. *Scenes of Subjection: Terror, Slavery, and Self-Making in Nineteenth-Century America.* New York: Oxford University Press, 1997.

"Is Man One or Many?" *Putnam's Monthly Magazine of American Literature, Science, and Art* 4, no. 19 (1854): 1–14.

Lavater, Johann Caspar. *Essays on Physiognomy.* Translated by Thomas Holcroft. London: G.G.J. and J. Robinson, 1789.

Lévinas, Emmanuel. *Ethics and Infinity: Conversations with Philippe Nemo.* Pittsburgh: Duquesne University Press, 1985.

Melville, Herman. *Billy Budd, Bartleby, and Other Stories.* Edited by Peter Coviello. New York: Penguin Books, 2016.

———. *Correspondence.* Edited by Lynn Horth. Evanston, IL: Northwestern University Press, 1993.

———. *Journals.* Edited by Lynn Horth and Howard C. Horsford. Evanston, IL: Northwestern University Press, 1989.

Morton, Samuel George. *Crania Americana*. Philadelphia: Dobson, 1839.

Nott, Josiah Clark, and George Robbins Gliddon. *Types of Mankind*. Philadelphia: J. B. Lippincott, 1854.

Riskin, Jessica. *Science in the Age of Sensibility: The Sentimental Empiricists of the French Enlightenment*. Chicago: University of Chicago Press, 2002.

Robillard, Douglas. *Melville and the Visual Arts: Ionian Form, Venetian Tint*. Kent, OH: Kent State University Press, 1997.

Sealts. Merton M. *Melville's Reading*. Columbia: University of South Carolina Press, 1988.

Schuller, Kyla. *The Biopolitics of Feeling*. Durham, NC: Duke University Press, 2017.

Stowe, Harriet Beecher. *Uncle Tom's Cabin*. Edited by Jean Fagan Yellin. New York: Oxford University Press, 2008.

Chapter Nine

Melville's Greens

Color Theory and Democracy

Jennifer Greiman

Alexis de Tocqueville closes the second chapter of *Democracy in America* with the image of American society as a painting coated with a layer of democracy underneath which one can still perceive the colors of an aristocratic social order: "*Le tableau que présente la société américaine est, si je puis m'exprimer ainsi, couvert d'une couche démocratique, sous laquelle on voit de temps en temps percer les anciennes couleurs de l'aristocratie.*"[1] In his 2003 translation, Gerald Bevan renders this "*couche démocratique*" as "a democratic patina beneath which we see from time to time the former colors of the aristocracy showing through."[2] In translating "*couche*" as "patina," Bevan proposes a fairly strong reading of the layering through which Tocqueville claims aristocracy reveals itself under democracy. A patina is neither a varnish nor a paint overlaid on a canvas, but a coat of bluish-green that forms on the surface of oxidized copper or bronze. In his translation, Bevan gives democracy a specific color with a specific history, and he changes both the aesthetic and political implications of Tocqueville's visual metaphor. Where Tocqueville's image hints at the paradox of color's double meaning as concealment and truth—a thin layer of democracy cannot hide the true colors of aristocracy—Bevan's patina evokes the complex process through which these two senses of "color" produce and support each other. Bevan's translation thus suggests how coloring democracy with a green patina can transform it because, as Michael Taussig argues, "color is not secondary to form . . . it is not an overlay draped like a skin over a shape," but a primary form in itself.[3]

If Bevan's "patina" rather over-reads Tocqueville's "*couche*," his translation is nonetheless true to a specific history of democracy, aristocracy, and imperialism that Herman Melville tells through the color green. Indeed, Bevan's patina is precisely the color that Melville chooses in the first book

of *Pierre; or, The Ambiguities* to describe the process by which democratic and aristocratic social relations produce and preserve each other. "For," Melville writes, "the democratic element operates as a subtle acid among us, forever producing new things by corroding the old, as in the south of France, verdigris, the primitive material of one kind of green paint, is produced by grape-vinegar poured upon copper plates."[4] In Melville's 1852 elaboration of America's "democratic patina," green is no simple metaphor for democracy, no figurative paint that can be scraped away to reveal some old aristocratic portrait beneath. Instead, it is a material by-product of the process out of which democracy manufactures its difference from other political traditions and social relations. As such, green is for Melville the color that links revolution to its repetitions and reversals—and not only in *Pierre*. In what follows, I trace Melville's association of the color green with democracy, revolution, and imperialism through the 1840s and 1850s in order to show how tightly bound his aesthetic and political thinking really are. Melville engaged seriously in his work with theories of color—primarily, Johann Wolfgang von Goethe's *Farbenlehre*—to tell a history of democracy as one of vibrant and violent paradoxes.

LIVING COLOR

Even as the historian Michel Pastoureau has sought to document the history of color in each lavish volume of his ongoing five-book project on the social functions of blue, black, green, red, and yellow over two thousand years of European culture, he also confirms the lessons of Ishmael's own frustrated attempt at art history.[5] Just as Ishmael can only compile monstrous and less erroneous pictures of a creature "which must remain unpainted to the last,"[6] so not even the most comprehensive of catalogs by the most erudite of Sub-Subs can give more than "a glancing bird's-eye view" of a quality whose defining characteristic is, as Goethe claimed, its capacity for alteration to the point of total inversion.[7] Pastoureau's *Green: The History of a Color* is exemplary of the problem: the trouble with green is that it is always bound up with paradox. At once ubiquitous in the chloroform of plant life, green was, until the 19th-century, difficult, expensive, and toxic for artists and dyers to manufacture. Used by 14th-century scribes to soothe their eyes between pages, green was at the same time the color of Judas, witches, dragons, demons, and even whales. If green became the signal color of nature, new life, and hope for Romantics like Goethe, Pastoureau argues that it never lost its associations with decay, poison, and disorder.[8] And so, from the anarchic green knights of chivalric romance to the green cockade that was, briefly, the first emblem of the French

Revolution, the long history of green that Pastoureau tells is one of a quality whose only consistent function is transformation, instability, and reversal.

In this, green would seem to epitomize the general claim for color that Goethe makes in his 1810 rejoinder to Sir Isaac Newton. In *Zur Farbenlehere* (*Theory of Colours*), Goethe undertakes a self-consciously revolutionary project. Against what he calls the "aristocratic presumption" of Newton's prismatic theory of color (which Goethe compares to a decaying castle that must be dismantled, stone by stone, like the Bastille), Goethe sets out to show that color is not a secondary property of light but "an elementary phenomenon in nature."[9] Asserting the triple materiality of color—as a physiological property of the eye, as a physical act of light, and as chemical substance—Goethe seeks to restore to color both a body and a capacity for action. "Yet we hope," Goethe says, "to bring color once again into credit, and to awaken the conviction that a progressive, augmenting, mutable quality, a quality that admits of alteration even to inversion, is not fallacious, but rather calculated to bring to light the most delicate operations of nature."[10] In asserting color's ontological primacy, Goethe insists that its radical mutability is neither fallacious nor artificial, but the mark of nature itself in its most "delicate operations."

Writing his own rejoinder to Goethe roughly two hundred years after *Theory of Colours*, Michael Taussig further complicates the work of chromatic history. Taussig argues that color evokes both fallacy and truth, both artifice and nature because it stands at the distinction between nature and second nature, and in this, it poses even thornier ontological problems.[11] Color is not a symbol for something else, Taussig argues; it doesn't *mean* anything, and it is nothing so simple as a surface layered onto a form. Color is form and referent. It has a body, it acts, and indeed, it's "something alive." But what kind of life form is it? For Taussig, color is best understood as "a polymorphous magic substance" that moves like an animal, makes connections like a language, and alters the atmosphere like a change in the weather. In this sense, color is not simply a highly mutable quality whose own history is difficult to tell but a register of history in itself. According to Taussig's theory of colors, that is, Goethe may have been right to restore color to its body and find in its radical mutations the "most delicate operations of nature," but he fails to recognize its function in world history—its relation to industrialization, to the colonial trade in the raw materials of pigment (indigo, lapis lazuli), and to what Taussig calls the "Western experience of colonization as colored otherness."[12]

In short, to follow the methodological cues of Goethe, Taussig, and Pastoureau, any theory of color must account for a quality that transforms to the point of inversion, for a body that moves like an animal, for an atmosphere that feels like the weather, for a word that reveals connections like a lost language, and for a property both ubiquitous and rare that registers itself

in and on history. What I will argue in what follows is that this is precisely what Melville does with color across the body of his work. As Robert Wallace, Christopher Sten, Elisa Tamarkin, Samuel Otter, and many others have shown, Melville engaged seriously with painting and other visual arts from the 1840s on, and he likely encountered Charles Locke Eastlake's 1842 English translation of Goethe's *Theory of Colours* before completing *Moby-Dick*. Scholars often cite Chapter 42, the "The Whiteness of the Whale," as the first evidence of Melville's serious, philosophical engagement with color theory.[13] (Even Taussig concedes that Melville asked and answered his own titular question 160 years earlier: the color of the sacred is the whiteness of the whale.) But rather than the sum total of Melville's thinking through and with color theory, "The Whiteness of the Whale" is better read as a climactic chapter in four decades of such thinking, which begins in *Typee* with a craving hunger for some "green thing" and culminates with the rainbow that spreads over the opening of *Billy Budd*'s pivotal twenty-first chapter as an image of the ineffable made visible: "Who in the rainbow can draw the line where the violet tint ends and the orange tint begins? Distinctly we see the difference of the colors, but where exactly does the one first blendingly enter into the other?"[14] Color is more than a figure for something else, more than a shade or tint laid onto a form in Melville's work, and to read Melville for his colors involves attending to more than his visual registers alone. My point is that Melville, too, has his theory of colors, and it is one that joins ontology and phenomenology to history and political philosophy through a vibrant and varied aesthetic idiom that extends across his forty-year career.

To read Melville specifically for his greens is to trace ways in which his writing contends with particular modes of mutation, opposition, inversion, and transformation. True to the history of green that Pastoureau tells as one of the paradoxes made visible and values reversed, green is the color through which Melville performs one of his most recognizable aesthetic gestures, a gesture that Colin Dayan has recently described as his constant "translation between ontologically disparate points of view" and one that Melville himself calls simply "Art" in the poem of that title: "But form to lend, pulsed life create, / What unlike things must meet and mate."[15] Indeed, Melville's entire corpus opens with a color of green whose tone, shade, and function inverts completely over the course of two sentences. "Oh!" Tommo cries out, in the opening pages of Melville's first novel:

> For a refreshing glimpse of one blade of grass—for a snuff at the fragrance of a handful of the loamy earth! Is there nothing fresh around us? Is there no green thing to be seen? Yes, the inside of our bulwarks is painted green; but what a vile and sickly hue it is, as if nothing bearing even the semblance of verdure could flourish this weary way from land.[16]

Throughout *Typee*, Melville's greens are, at once, lush, living, and vegetal and vile, sickly, and painted. Verdure and green paint "meet and mate" once again when the narrator of *Pierre* invokes the manufacture of that especially toxic chemical green as an "apt analogy" for the way in which American democracy transmutes nature into artifice and death into life. Melville's greens are always more than visual phenomena: they are bodies that mutate between living form and chemical substance, as they straddle the tenuous distinction between nature and second nature. In this, they tell the history of other bodies, too, as in "The 'Gee's'" where green is the color through which an absurdist racial science punningly converts the Cape Verdean into the ideal and yet much-maligned sea-laborer, "a green 'Gee being of all green things the greenest."[17] With such consistent attention to the mutations of green, then, it is no idle detail that this is also the color of the screen with which Melville's attorney divides his office in two, separating his desk from Bartleby's so that "privacy and society were conjoined." As the attorney well knows, green does more than mark a boundary; it also mediates a process through which privacy and society—along with persons and objects, nature and artifice, life and death, and so on—separate, blur, combine, mutate, and change places.

If green is the color through which Melville translates between what Dayan describes as two "ontologically disparate" things, then it is also one of the ways that Melville's writing reveals and preserves the co-presence of distinct and even radically opposed things at once. Nature / artifice, life / death, privacy / society: all of these may meet and mate in the tonal shifts of Melville's greens, but green is also the color of Melville's writing when it discloses what Jacques Rancière describes as "the construction of a paradoxical world that puts together two separate worlds."[18] For this, in particular, green is essentially bound to Melville's thinking about that mutable form of politics that goes by the name of "democracy"—the political form that Bonnie Honig argues is best defined by the constitutional paradoxes that it never fully resolves.[19] Most vividly in *Typee* and *Pierre*, I will argue in the next section, Melville theorizes green as the color of democracy in its most liberating and most repressive forms at once, partly because he follows Goethe in thinking of color as a material substance "that admits of alteration even to inversion," and partly because he leads Taussig in thinking of color as a lived boundary between nature and history. Melville's greens thus enable ways of narrating the histories of post-revolutionary empires that operate under the name of "democracy" by translating between liberation and domination, converting one into the other and back again. At the same time, though, Melville's greens also open glimpses onto those whose perspectives on democracy's more dubious history cannot be reconciled to it. In the view of the Typees as Captain David Porter's men lay waste to their valley, or that of the tenant farmers in

the Hudson Valley as hereditary landowners lay perpetual claim to theirs, Melville ultimately reveals two green worlds where only one appeared to be.

GREEN VALLEYS

Tommo's hunger for some "green thing" is, first and foremost, a craving for what Ishmael calls "the green, gentle, and most docile earth"[20] after six months at sea. But it is also a craving that is so fully somatic—something to be glimpsed, grasped, tasted, and sniffed all at once—that it is not Tommo's alone, but one that it is shared by every living thing on the ship, and even by the ship herself: "Poor old ship! Her very looks denote her desires . . . [for] didn't every one of her stout timbers grow on shore, and hasn't she sensibilities as well as we?" Green becomes, in the opening pages of *Typee*, the color of the fellow-feeling of life for life and bodies for bodies, the color of the force that draws the splintered timbers of a manufactured ship to the living trees of a verdant island, just as it draws the bodies of the men to the fruits of the loamy earth. As the color that defines the body's need for fresh food and living land, green also becomes the color of the ground on which Tommo stakes a claim of his political right to void the contract between himself and the captain, for "the usage on board the ship had been tyrannical . . . the provisions had been doled out in scanty allowance . . . her cruises were unreasonably protracted . . . and the captain was the author of these abuses." Tommo, in short, determines to desert his ship, articulating that claim in a mock-revolutionary declaration that precisely captures the paradox of democratic origins: describing his appetite while enumerating his grievances, he yokes an assertion of natural right to the captain's broken promises and claims a double foundation for his own political agency.[21]

But within moments of Tommo's double declaration of natural right and historic wrong, the craving for green that has drawn him out of tyrannical usage carries him face-to-face with another color scheme entirely: "the tri-colored flag of France trailing over the stern of six vessels, whose black hulls and bristling broadsides . . . [were] floating in that lovely bay, the green eminences of the shore looking down so tranquilly upon them."[22] Tricolor displaces green in 1842 Nukuheva as it did in 1789 Paris: Pastoureau describes how Camille Desmoulins replaced the green revolutionary cockade with a tricolor one when he learned that green was the livery color of the Compte d'Artois.[23] The revolutionary history on which Tommo models his own liberation is also the history of an island over which two nominal democratic republics have been contending for decades, a history that Tommo narrates in full color as the chromatics of revolution cede to those of colonization.

Declarations of political independence are thus succeeded and displaced by claims of imperial possession in Tommo's narrative, just as they are in one of Melville's main source texts for *Typee*—David Porter's *Journal of a Voyage Made to the Pacific Ocean*. Captain of the USS *Essex*, Porter landed on Nukuheva in 1813, and issued his own "Declaration" of right to the island, claiming both total possession of the land and a political alliance between the peoples of America and Nukuheva, "whose pure republican policy approaches so near their own." Calling the bluff of Porter's "pure republican policy," the Typees refused to sign onto their own dispossession, so Porter and his men attempted to take the valley by force. As Tommo tells it the Typees "valiantly . . . disputed every inch of ground" before being forced to retreat. Incensed at the Typees' resistance, Tommo continues, the American "invaders . . . consoled themselves by setting fire to every house and temple in their route."[24] For the most part, Tommo follows Porter's account very closely—disarmingly so—but he omits one of Porter's most perverse narrative tics: the deep appreciation he repeatedly voices for the people and the valley that he is about to annihilate.

> Never in my life did I witness a more delightful scene, or experience more repugnancy than I now felt, for the necessity, which compelled me to make war against this happy and heroic people.[25]

As the language of Porter's "Declaration" yokes alliance to dispossession, so the language of his narrative slides seamlessly between delight and desolation. "Who can wonder at the deadly hatred of the Typees at all foreigners after such unprovoked atrocities?" Tommo asks. Certainly not Tommo.

> By many a legendary tale of violence and wrong, as well as by events which have passed before their own eyes, these people have been taught to look upon white men with abhorrence. The cruel invasion of their country by Porter has alone furnished them with ample provocation; and I can sympathize in the spirit which prompts the Typee warrior to guard all the passes to his valley with the point of his leveled spear, and standing upon the beach with his back turned upon his green home, to hold at bay the intruding European.[26]

To understand the history of democracy in the Marquesas, Tommo suggests, is to see the valley as a verdant space of freedom and appropriation, one of sensational pleasures and annihilating warfare. For Tommo as for Porter, that is, the island is a space of paradox, of constant inversion between vibrant, but irreconcilable, sensations and conditions, all of which democracy can contain but not resolve. But for the Typee warrior on the beach, the island is simply "his green home" on which he must turn his back in order to save it. The green that yokes

all of the unlike things through which democratic revolutions yield global empires is also the color of another world in total revolt against that history.

Like *Typee*, *Pierre* opens in a flood of green, as its eponymous hero emerges from his ancestral manor into the verdure of a summer morning, "wonder-smitten with the trancelike aspect of the green and golden world." But unlike Tommo's Nukuheva, which gurgles and vibrates with verdant life, Pierre's Saddle Meadows is utterly still, more painted landscape than living land, for "not a flower stirs, the trees forget to wave, the grass itself seems to have ceased to grow."[27] Time, it seems, moves very slowly in these Meadows, and even Pierre, though only twenty, is himself something of an antiquity. Pierre Glendinning, the narrator tells us, is the scion of one of the last families whose vast holdings in upstate New York date to the earliest colonial era. To explain the anomaly of such a family "imposingly perpetuating itself" through the revolution and flourishing in a republic, the narrator offers an extended analogy that reads like a primer on Goethe's chemical colors:

> For indeed the democratic element operates as a subtle acid among us, forever producing new things by corroding the old, as in the south of France, verdigris, the primitive material of one kind of green paint, is produced by grape-vinegar poured upon copper plates. Now in general, nothing can be more significant of decay than the idea of corrosion, yet on the other hand, nothing can more vividly suggest the luxuriance of life than the idea of green, as a color, for green is the peculiar signet of all-fertile Nature herself. Herein, by apt analogy, we behold the marked anomalousness of America . . . that out of death, she brings life.[28]

In the transition from verdure to verdigris, Melville's green tells yet another history. No longer the verdant ground of bodily need that carries Tommo into colonial history, green is in *Pierre* the result of a process of corrosion and decay that is itself a philosophy of democratic history. In a passage that asserts the "marked anomalousness" of American democracy, the narrator instead achieves an erosion of all the distinction that America seeks to produce between nature and artifice, the old and the new, death and life—and even, I would add, between America's history at home and abroad.

If the narrator of *Pierre* turns Tommo's verdure into the "sickly hue" of green paint, he also collapses the distance between the valleys of Typee and Hudson with a reminder of more recent, more local history. Melville's narrator culminates his long illustration of democracy's remarkable powers of productive corrosion with an allusion to the suppression of anti-rent strikes by tenant farmers in the Hudson Valley in 1845:

> Consider those most ancient and magnificent Dutch manors at the North, whose perches are miles—whose meadows overspread adjacent counties—and whose

haughty rent-deeds are held by their thousand farmer tenants, so long as grass grows and water runs, which hints at a surprising eternity for a deed, and seems to make lawyer's ink unobliterable as the sea.[29]

The corrosion of copper into verdigris is less an analogy for the feudal social relations that "defy time's tooth" to flourish in nineteenth-century New York, than a description of the process by which that social order always makes itself new again. It is, in other words, a philosophy of democracy's history of joining unlike things. But if the descendants of the Patroons seek to lay claim to the valley "as long as grass grows and water runs," the tenant farmers see another world entirely in that green grass. As "regular armies" were sent by the landowners to quell the thousands of striking tenants, the anti-renters quoted Fitz-Greene Halleck's famous poem, "Marco Bozzaris," in their broadsides as a call to "the opponents of Patroonery" to "Arouse!" and:

> Strike 'till the last armed foe expires
> Strike for your alters and your fires—
> Strike for the green graves of your sires,
> God and your happy homes![30]

Like the Typee warrior with his hand on his spear and his back to "his green home," the anti-renters seek another history for democracy in the "green graves of [their] sires," one that cannot be eroded, transmuted, or altered to the point of inversion. True to the full force of the political paradox that Melville conveys in his palette of mutable greens from verdure to verdigris, the green valleys of the Typee and the Anti-Renters are exemplary of what Rancière calls "*dissensus*"; they "make visible that which had no reason to be seen" because they redefine the worlds in which they appear.[31] The Typee Valley is a green home, unconquered by American interests, just as the green graves of the Hudson Valley's tenant farmers exempt themselves from the landlords' claims and deeds. In this, these green spaces become otherworldly in the strongest sense: they stand as evidence not just of the existence of other worlds, with other versions of history and other visions of the people and their claims, but of the power, persistence, and vibrancy of those worlds.

NOTES

1. Alexis de Tocqueville, *De la démocratie en Amérique,* première partie (Édition électronique réalisée par Jean-Marie Tremblay, 2002), 48.
2. Alexis de Tocqueville, *Democracy in America*, trans. Gerard Bevan (New York: Penguin, 2003), 58.

3. Michael Taussig, *What Color Is the Sacred?* (Chicago: University of Chicago Press, 2009), 9.

4. Herman Melville, *Pierre; or, the Ambiguities*, ed. Harrison Hayford, Hershel Parker, G. Thomas Tanselle (Evanston, IL and Chicago: Northwestern University Press/Newberry Library, 1971), 9.

5. Michel Pastoureau, *Green: The History of a Color* (Princeton, NJ: Princeton University Press, 2014), 7.

6. Herman Melville, *Moby-Dick* (New York: W. W. Norton, 2002), 218.

7. Johann Wolfgang von Goethe, *Theory of Colours*, trans. Charles Locke Eastlake (New York: Dover, 2006), xxx.

8. Pastoreau, 57, 95, 121, 137.

9. Goethe, xxx.

10. Goethe, xxx.

11. Taussig, 18.

12. Taussig, 9.

13. See in particular Micheala Giesenkirchen, "'Still Half Blending with the Blue of the Sea': Goethe's Theory of Colors in *Moby-Dick*," *Leviathan* 7, no. 1 (2005): 3–18; and Robert Wallace, *Melville and Turner: Spheres of Love and Fright* (Athens: University of Georgia Press, 1992).

14. Herman Melville, *Billy Budd, Sailor* (Chicago: University of Chicago Press, 1962), 102.

15. Colin Dayan, "Melville's Creatures," *American Impersonal*, ed. Branka Arsic (New York and London: Bloomsbury, 2014), 54. Herman Melville, "Art," *The Poems of Herman Melville*, ed. Douglas Robillard (Kent, OH: Kent State University Press, 2000), 322.

16. Herman Melville, *Typee; or, a Peep at Polynesian Life* (New York: Penguin, 1996), 12.

17. Herman Melville, "The 'Gees," in *Pierre, Israel Potter, The Piazza Tales, The Confidence-Man, Uncollected Prose, and Billy Budd* (New York: Library of America, 1984), 1293.

18. Jacques Rancière, *Dissensus: On Politics and Poetics*, trans. Steven Corcoran (New York and London: Continuum, 2009), 39.

19. Bonnie Honig, *Emergency Politics: Paradox, Law, Democracy* (Princeton, NJ: Princeton University Press, 2009), xvii–xviii.

20. *Moby-Dick*, 225.

21. *Typee*, 13, 20–21.

22. *Typee*, 18.

23. Pastoureau, 175.

24. *Typee*, 26.

25. David Porter, *Journal of a Cruise Made to the Pacific Volume II* (New York: Wiley and Halstead, 1822), 98–99.

26. *Typee*, 205.

27. *Pierre*, 3.

28. *Pierre*, 9.

29. *Typee*, 205.

30. Fitz-Greene Halleck, "Marco Bozzaris," *The Poetical Works of Fitz-Greene Halleck* (New ed., New York: Appleton and Company, 1859); Melville certainly knew this poem: Hershel Parker describes it as among the first poems Melville "was known to have heard, and heard repeatedly." *Herman Melville: A Biography Volume One* (Baltimore: Johns Hopkins University Press, 1997), 37.

31. Rancière, 38.

BIBLIOGRAPHY

Dayan, Colin. "Melville's Creatures." *American Impersonal: Essays with Sharon Cameron.* Ed. Branka Arsic. New York and London: Bloomsbury, 2014.

Giesenkirchen, Micheala. "'Still Half Blending with the Blue of the Sea': Goethe's Theory of Colors in *Moby-Dick.*" *Leviathan* 7.1 (2005): 3–18.

von Goethe, Johann Wolfgang. *Theory of Colours.* Trans. Charles Locke Eastlake. New York: Dover, 2006.

Honig, Bonnie. *Emergency Politics: Paradox, Law, Democracy.* Princeton, NJ: Princeton University Press, 2009.

Melville, Herman. *Billy Budd, Sailor.* Chicago: University of Chicago Press, 1962.

———. "The 'Gees." In *Pierre, Israel Potter, The Piazza Tales, The Confidence-Man, Uncollected Prose, and Billy Budd.* New York: Library of America, 1984.

———. *Moby-Dick.* New York: W. W. Norton, 2002.

———. *Pierre; or, the Ambiguities.* Ed. Harrison Hayford, Hershel Parker, G. Thomas Tanselle. Evanston, IL and Chicago: Northwestern University Press/Newberry Library, 1971.

———. *The Poems of Herman Melville.* Ed. Douglas Robillard. Kent, OH: Kent State University Press, 2000.

———. *Typee; or, a Peep at Polynesian Life.* New York: Penguin, 1996.

Parker, Hershel. *Herman Melville: A Biography Volume One.* Baltimore: Johns Hopkins University Press, 1997.

Pastoureau, Michel. *Green: The History of a Color.* Princeton, NJ: Princeton University Press, 2014.

Porter, David. *Journal of a Cruise Made to the Pacific Volume II.* New York: Wiley and Halstead, 1822.

Rancière, Jacques. *Dissensus: On Politics and Poetics.* Trans. Steven Corcoran. New York and London: Continuum, 2009.

Taussig, Michael. *What Color Is the Sacred?* Chicago: University of Chicago Press, 2009.

de Tocqueville, Alexis. *De la démocratie en Amérique,* première partie. Édition électronique réalisée par Jean-Marie Tremblay, 2002.

———. *Democracy in America.* Trans. Gerard Bevan. New York: Penguin, 2003.

Wallace, Robert. *Melville and Turner: Spheres of Love and Fright.* Athens: University of Georgia Press, 1992.

Chapter Ten

Narrative Structure as Secular Judgment in Thomas Crawford's *Progress of Civilization*

Kirsten Pai Buick

Assigned to supervise the extension of the United States Capitol in 1853, Montgomery Meigs decided with the American sculptor, Thomas Crawford, to develop the theme of racial conflict between Whites and Native Americans as the subject for the decoration of the pediment over the entrance to the new Senate building. Conceptualized to juxtapose the "Progress of the White Race" to the "Degradation of the Indian," with "America" personified in the center of Crawford's composition, careful examination shows us that America stands on a rock, against which the waves of the ocean are beating. She is flanked by the rising sun on her right and by a bald eagle on her left. She holds in her right hand a laurel and an oak wreath, which signify the rewards of civic and military duty, and holds them in such a way that each will be placed on the respective heads of the pioneer and the soldier who ensure the march of civilization. Even as she represents the focus of their energies, it is the actions of the men who flank her who must fulfill her purpose—thus the soldier, acting in her defense, appears to either draw or sheathe his sword while the pioneer is caught mid-swing wielding his ax. With her beseeching left arm and her heavenward gaze, she asks the protection and blessing of God. The drama unfolds from there.

At least two lines of thinking appear with regard to interpreting the sculpture. The first is ostensibly a simple one—that how we read determines how we see and therefore what we see. In viewing such images, we have narrative expectations of a beginning, middle, and end. In this first instance, interpretation can also be bound to rhetorical ideologies that had been developed in Europe since the late sixteenth century, ideologies which found fertile ground in the early American Republic. In either instance, visual logic is subsumed by or recognized as the equivalent of language. Two of the most thorough

discussions of Crawford's sculpture were written in the 1990s: Vivian Green
Fryd's book, *Art and Empire: The Politics of Ethnicity in the U.S. Capitol,
1815–1860*, and Klaus Lubbers' article, "Strategies of Appropriating the
West: The Evidence of Indian Peace Medals."[1] Using a combination of the
visual evidence and the history of "nineteenth-century American events and
beliefs," Fryd offers up a longer treatment of the work and maps the narra-
tive geographically.[2] According to Fryd, "Symbolically, then, the tightly ar-
rayed figures in the right side of the pediment spread across half a continent.
America stands at the Atlantic shore looking westward as the sun rises be-
hind her. The backwoodsman inhabits the eastern woodlands, and the Plains
Indians reside in the continent's interior. But Crawford failed to follow the
geographical and temporal continuity on the left half of the pediment, which
should feature people of the Far West."[3]

In contrast, Lubbers interprets the organizing principle of Crawford's
sculpture as a reliance on the "specious symmetry" found in Indian peace
medals that successfully mask the cost of colonization for indigenous peoples
with the illusion of reciprocity and "enduring mutual concord."[4] Lubbers con-
tends further that, "The three terms denoting versions of the official mythol-
ogy found in American political rhetoric, literature, and art were *syndeton*,
asyndeton, and *polysyndeton*. The ideology of syndeton, the rhetorical equiv-
alent to the dominant myth of ethnic unification, pervaded the compositions
of peace medals. Asyndeton was the tacit admission that ethnic fusion was
a pretense, while polysyndeton was the forerunner of today's multicultural-
ism."[5] In Crawford's composition specifically, Lubbers notes that symmetry
functions as both an element of stabilization and justification for an "asyn-
detic antithesis camouflaged with the help of a device suggesting two halves"
that "suggested the semblance of fair dealing."[6] Even as Fryd and Lubbers
offer very different "readings" of the pediment, each scholar opens up inter-
pretive possibilities with regard to the sculpture that cannot be dismissed. In
advancing their assumptions, I would like to offer up another possibility that
will complement their work while taking its implications further.

The second line of thinking has to do with the discipline of art history itself
and how, rather than opening up possibilities, it sometimes functions as more
of an impediment to interpretation. Working from the traditional art histori-
cal model, critical attention locates the Senate (when mentioned at all) in a
role as "patron" in relation to Crawford as "artist," with no mention of the
political function of the Senate. Moreover, the Senate building is emptied of
any content-specific meaning or function that could inform either the signifi-
cance or the signification of the pediment. Instead, art history, acting as both
social drama and thematized space, fills the void with what I call "textual
spaces" for Crawford's sculpture. With regard to social drama, Art History
certainly belongs. As cultural anthropologist Victor Turner suggests, "social

dramas occur within groups of persons who share values and interests and who have real or alleged common history." Social dramas are a "processual unit" and have four phases: "breach, crisis, redress, and *either* reintegration *or* recognition of schism"[7] (emphasis his). Even as art historians attempt to work out how objects participate in social dramas, we are implicated in the very processes that we seek to illuminate. And so, we must approach with caution what I term the "Descriptive Function" in Art History, in which the description of objects reenacts a particular and identifiable social drama by narrativizing the function of objects through the four phases. The "Descriptive Function" is further exacerbated by Art History's self-referentiality, which is the repetition and refinement of objects through the various texts— surveys, journal articles, papers given at conferences, etc.—that can displace objects from the meaningful spaces to which they belong. Art historical texts perforce become the staging ground, subsuming the objects under the narrative of textual space.

It might be helpful to look at how Mieke Bal, author of *Narratology*, distinguishes between "frame-space"—a "place of action" and "thematized space." As Bal argues, when "space is 'thematized' . . . it becomes an object of presentation itself, for its own sake. Space thus becomes an 'acting place' rather than a place of action."[8] The consequences are cumulative as discussions of objects (and perhaps even performances) are taken up by other scholars who remove the work from its context so that the *text itself* assumes the role of "thematized space" where either reintegration or recognition of schism is theorized. The result is that meaning is now staged in the text, especially when controversial works like Crawford's "Progress" are not even discussed on site, since the piece tends to be ritually ignored by tour guides at the U.S. Capitol.[9] My purpose is to reframe the pediment so that we look at the ritual interaction of art, architectural function, thematized space, and audience. To that end, I will examine the duties of the Senate leading up to the 1853 meeting; how those duties reaffirmed and reinforced the shared vision of Meigs and Crawford; and finally, how the pediment participates in the political social process.

I began my description of the sculpture in the middle. I began with the "Scene" of Crawford's "Progress," because, as Bal identifies it, "a scene is often a central moment, from which the narrative can proceed in any direction. In such cases, the scene is actually anti-linear."[10] Mindful of my previous caveats about the pitfalls of description, I would like to invoke Crawford's own description of the work. Significantly, he begins his account in the center:

The central figure of the composition represents America standing upon a rock against which the waves of the ocean are beating. She is attended by the Eagle of our country, while the sun rising at her feet indicates the light accompanying

the march of liberty. In one hand she holds the rewards of civic and military merit—the laurel and oak wreath. The left hand is held out towards the pioneers for whom she asks the protection of the Almighty.

The pioneer I have rendered by the athletic figure of a backwoodsman clearing the forest.

The Indian race and its extinction is explained by the group of the Indian chief and his family. Connecting this group with the backwoodsman are a few stumps of trees in which is seen retreating a rattlesnake. The son of the chief appears next returning from the hunt with a [col]lection of game slung upon a spear over his shoulder. His looks are directed to the pioneer whose advance he regards with surprise. In the statue of the Indian chief I have endeavored to concentrate all the despair and profound grief resulting from the conviction of the white man's triumph.

The wife and infant of the chief complete this group of figures, while the grave, being emblematic of the extinction of the Indian race, terminates and fills up [this] portion of the tympanum. . . .

The opposite half of the pediment is devote[d] to the efforts of civilization and liberty. The first figure represents the soldier. I have given him this important position, as [our] freedom was obtained by the sword and must be preserved by it. I have clothed this statue with the military costume of our revolution as being suggestive of our country's struggle f[or] independence. . . . His hand in the act of drawing the sword indicates the readiness [and] determination of our army to protect America from insul[t].

Adjoining the soldier I have placed the merch[ant] sitting upon the emblems of commerce. His right ha[nd] rests upon the globe to indicate the extent of our trade. The anchor connects his figure with thos[e] of two boys, who are advancing cheerfully forward to devote themselves to the service of their country. The anchor at their feet is an easily understood emblem of hope for them in the future. Behind them si[ts] the teacher, emblematic of scholarship. He is instructing a child, whose career is shown by the advance of the boys his school mates. The mechanic completes this group. He rests upon the cogwheel, without which machinery is useless. In his hands are the implements of his profession, the hammer and compass; at his feet are seen [?] sheaves of wheat, expressive of fertility, activity, and abundance, in contradistinction to the emblem of Indian extinction—the grave—at the corresponding angle of the tympanum.[11]

As Crawford's own description demonstrates, this is indeed a "scene" in which a central moment marks its origin; and, as I will show, the narrative is anti-linear and does not "read" from left to right or from right to left. And while Lubbers' interpretation of the sculpture borrowed from rhetoric and noted its indebtedness to the symmetry of Indian peace medals, peace played no part in what Crawford and Meigs developed as the theme for the tympanum. Nevertheless, Lubbers' interpretation gets us closest to what I believe is the actual prototype for the sculpture.

Crawford modeled the figures in Rome during the year 1854. With frequent consultations with and input from Meigs, who rejected the idea of making the soldier in the likeness of George Washington, Crawford set up a studio near the Capitol and actually carved the figures from 1855 until 1859, using marble from Lee, Massachusetts. The sculpture was erected in 1863 and in its entirety measures about 80 feet long; with a height in the center of about 12 feet; and the length of the sculptures themselves about 60 feet. Despite its theme, despite its American marble, despite its homegrown carvers, the key to understanding the work is the time that Crawford spent in Italy, specifically Rome.[12] Surrounded as he was by Catholic iconography, the structural model for Crawford's "Progress" is visual rather than textual. It is, in fact, Michelangelo's "Last Judgment" (1512).[13] Where the newly risen Christ would normally be located, the personification of America is placed; and like Christ, she stands in judgment so that all who occupy her proper left represent "the damned" while all to her proper right represent "the saved."

Crawford indicates the relative trajectories of damned and saved in his language and in his imagery. On the side of the damned, we note that time is bifold—it exists as both pre-history in which a prelapsarian Eden is signified by the rattlesnake/serpent and by the indigenous peoples who exist in various stages of nakedness, and whose place is a wilderness/garden. But time also exists as end-time, the time of Revelations, as the eagle, representative of St. John of Patmos who wrote the book of Revelations, watches over the extinction (to use Crawford's word) of the wilderness and its indigenous inhabitants. Existing as they do in simultaneous pre- and post-history, significant human action is rendered irrelevant because they are symbolically "out of time." These "bifold end times" are also marked by the preparation of the wilderness to receive civilization in the form of the white pioneer who takes an axe to the tree.

On the side of the saved, the sun rises; here the empty hand of America, which is all that was offered to indigenous people, is replaced by a hand offering the rewards of significant human action—the oak and the laurel—which indicate recognition of military and civic merit, but rewards only made possible in the context of history. In this framework, Crawford's space/time binary is instructional. Indians occupy space while Whites both master space and move through time. The globe, the history books, the objects that symbolize trade and commerce, all speak to postlapsarian knowledge of the world—an objectifying gaze and mastery compellingly evoked by the proprietary hand that the white male places upon the symbol of the world, ordered by science, exploration, trade, and imperialism. Writing about racism and the attempted impossibility of moving beyond the black/white binary/encounter, Sharon Holland queries, "what happens when someone who exists in time

meets someone who only occupies space?" She continues, "Those who order the world, who are world-making master time—those animals *and* humans who are perceived as having no world-making effects—merely occupy space . . . If the black [or Indian—my insertion] appears as the antithesis of history (occupies space), the white represents the industry of progressiveness (being in time)."[14] Her question is also my question.

What this particular binary/encounter tells us is that Indian degradation is constitutive of White progress and vice versa. Notably, an old Protestant belief in the spiritual meaning of "progress" undergirds the visual debt that the tympanum owes to Catholic iconography, while both Protestantism and Catholicism reinforce the religious undertones of the political mission of American world-building. Since the seventeenth-century, Progress had emerged as a Puritan idea that signified a spiritual journey from damnation to salvation, from sin to grace.[15] As Puritanism was gradually absorbed into Protestantism, the meaning of Progress was also retained. Hence, by the nineteenth-century, "American Progress" was largely understood as a civilizing project that was righteous, spiritual, and ordained by God. If we understand this sense of mission, and if we reconceptualize the Senate as thematized space, whose actors were charged with transforming the American landscape, we can then reconnect it as a governing body to the meaning of the sculpture relative to the Senate's power to advise and consent in treaty making with Native Americans.

Between 1778 when the first treaty was signed with the Delaware and 1868 when the final treaty was completed with the Nez Perce, there were 367 ratified Indian treaties and 6 more whose status was questionable, according to Francis Prucha. Moreover, there was nothing consistent about them. Prucha notes, "The general rule is that a treaty is a formal agreement between two or more fully sovereign and recognized states operating in an international forum, negotiated by officially designated commissioners and ratified by the governments of the signatory powers. But American Indian treaties have departed from that norm in numerous ways, as their history shows. They exhibited irregular, incongruous, or even contradictory elements and did not follow the general rule of international treaties."[16] The various treaties actually mark the shift for Native Americans who initially held international status within the borders of the United States as independent nations with the ability to make war and peace with the U.S. government. Through treaty making and breaking, the U.S. government (whose instrument was the Senate) redefined these independent sovereign nations with their distinct linguistic, governmental, and cultural practices as tribes and from tribes to domestic dependents who were neither alien nor citizen. And finally, attempts were made by the United States to detribalize the nations and assimilate indigenous

peoples as individuals with "a love of exclusive property."[17] Prucha studied American Indian treaties as what he calls "a history of political anomaly," and states, "much more powerful in contributing to the anomalous character of the Indian treaties was the persistent drive of white society and its government to change—indeed, to revolutionize—Indian societies by the promotion of white civilization. The treaties themselves, to a remarkable degree, were instruments intended to transform the cultures of the tribes."[18] Narratives of transformation and extinction were coterminous in the nineteenth century, and like the tympanum that ritually marked the procession of legislators, petitioners, the Vice President, and to a lesser extent the general public into the thematized space of the Senate, transformation of indigenous cultures was for the purpose of extinction.

To return the social drama of the pediment and its theme of degradation and progress to its rightful place as emblematic of the function of the U.S. Senate is to find that Victor Turner's elaboration of social dramas makes much more sense. Recall that "social dramas occur within groups of persons who share values and interests and who have real or alleged common history." As a body, the Senate of the nineteenth century was the elite branch of the legislative body; they were white men of standing whose interest was in property and in securing that property (land belonging to indigenous people) for ownership and use by the federal government. The social drama between Whites and Indians was realized in the function of the Senate and made emblematic by Crawford: the breach in his representation both recognized the significance of the encounter and fixed the relative racial categories of White and Indian. In his representation, crisis appears in the fatal conflict over land, between lifestyles, and the contest between civilization and savagery. Even as redress was ostensibly the function of the Senate through treaty making, in the larger society this meant redefinition and removal to reservations, boarding schools, etc. Finally, the impossibility of reintegration and in its stead the recognition of schism was set in stone, which the tympanum itself enshrines.

The myth of the Vanishing American that Crawford artfully describes and renders through his sculptures as an inevitable and natural "extinction," hides the real project of U.S. settler colonialism—that of "extermination" (an explicit policy brought about by direct human action).[19] In the nineteenth century, extinction was recognized as the softer term for extermination. Both were part of what Karl Jacoby understands as a "logic of elimination" that actually shaped interactions with Native Americans. In the same year that Crawford's pediment was installed, 1863, even as the Civil War raged in the east, a vicious war was being waged against the Apache in Arizona. One newspaper carried the following headline: "Arizona Settlers Preparing for the

Extermination of the Apache." These civilian campaigns were eagerly joined by settlers who conducted community hunts, the taking of scalps (modeled on their slaughter of wolves), and the rewarding of bounties.[20] Jacoby traces the etymology of the word "extermination" and reveals, "The term at the centre of so much nineteenth century thought about indigenous peoples can be traced to the Latin word *exterminates*, meaning beyond *(ex)* a boundary *(terminus)*." By the early 1800s, however, extermination had acquired in contemporary Anglo-American usage a far harsher edge. As Richard Trench observed in his 1873 work, *A Select Glossary of English Words Used Formerly in Senses Different from their Present*, "our fathers, more true to the etymology" understood *exterminate* to mean "to drive men out of and beyond their own borders." But, reported Trench, extermination "now signifies to destroy, to abolish."[21] Extermination was understood as synonymous with "eradication" and as the opposite of "colonization."

In fact, Crawford's soft language is belied by his composition. He renders extermination—the explicit policy brought about by direct human action—visible in the figures that flank America. The soldier with his sword and the pioneer with his axe (useful for clearing forests and for taking scalps) ensure the march of civilization; they ensure civilization through eradication and so the soldier appears to be either drawing his sword to complete an action or sheathing it at the end of such action while the pioneer is caught mid-swing. The soldier and the frontiersman are the male generative forces that make "America" possible. As Jacoby notes, the age of American Exceptionalism corresponded to the age of Imperialism that he more generally describes as an "era of global extermination," in which "the dominance of newly arriving settlers was predicated upon the disappearance of indigenous societies."[22] Inasmuch as Crawford gave us a sense of geography, it is a sacred geography built on Catholic iconography wedded to Protestant ideals of Progress and Extermination as coterminous rituals in securing the frontier, rather than axis points on a map. Even as the pediment posits a unitary existence or "being-ness" of whiteness, eliding the constant coming into being/contestation of it, it also acknowledges the contingent nature of whiteness. Neither time nor geography are present in the pediment in the way that a reliance on strict textual analysis would have it; rather there is a cosmic, eternal balance, a simultaneity that fixes the relative nature of difference between Whites and Indians *as always and already in conflict*. Even the title of the sculpture "Progress" reinforces the religious, rather than the temporal, undertones of the political mission. Racial conflict may have been the determining theme, but here it is resolved (even as it is forever) in America's final judgment and last word on the issue.

TERRA NULLIUS / EX TERMINUS

Sadly, the history of treaty making and breaking continues. In 1851, the U.S. government and the Sioux Nation signed the Treaty of Fort Laramie to allow safe passage for white settlers who flooded Sioux territory on their way to California during the Gold Rush. The second treaty of Fort Laramie in 1868 was the result of the U.S. government's continued violation of the first treaty and, to make amends, granted the tribes the right of regulating the entry of persons into their territory. In 1889, the Senate once again diminished the Great Sioux Reservation with the Dawes Act and Allotment Act, which partitioned the land into six sections, one of which was the Standing Rock Sioux Reservation. And it is on that land that the Dakota Access Pipeline is being built. We still treat Native American land as "terra nullius"—land belonging to nobody or as territories deemed void of civilized society. It is a concept invented in the seventeenth century by European powers who sought to systematically divest indigenous societies of their land. Even as we fulfill the horrendous conception of Crawford and Meigs, we expose the anomaly of U.S. treaty making as gestures of temporary pacification until our true motives are exposed. Such treaties continue to assume that land is held provisionally by indigenous sovereign nations until a corporation needs it or some other priority renders the land forfeit. The entreaty (pun intended) written by Kiana Herold over the threat posed by oil companies to Standing Rock Sioux Reservation is instructive:

> *Whether it is the gold rush or the oil rush, the U.S. government continues even now to invade native land and break treaties. The proposed DAPL would pass under Lake Oahe, the land that was openly, "legally" taken from the Sioux tribe in 1958 by Congress, despite the prior 1868 Treaty that had* legally *granted the Sioux rights to the land.*
>
> *Today's protests at Standing Rock today can only be fully understood in light of this colonial legacy, which from the beginning proclaimed that native lands were empty and that native people, were, in effect, nothing more than the rocks, the trees, the water that they now so valiantly strive to protect.*
>
> *Let us fight against this narrative, and show through Standing Rock that native tribes are sovereign nations that possess the inherent right to life on their territories. Let us show that Native American lands are not empty, but that proud sovereign peoples live there, alongside the earth, water, rocks and trees, wind and sky, encompassing a vibrant fullness in their long defense of life.*
>
> *There never was terra nullius. The only emptiness to be found exists in the hollow promises of the United States, in the historic lack of equitable substance in the U.S. legal system.*[23]

Corporations are not people, but they threaten us all (those who occupy space) in their quest for immortality (permanence and permanent relevance). They truly master time. Moreover, terra nullius isn't just a land that is empty; it is "Nowhere" in the sense articulated by Eric Purchase—i.e., land that has yet to be commodified.[24] And so, despite the solutions offered by clean energy, the oil and gas industry continues its program of ex terminus in order to eradicate terra nullius. These acts of extermination are performed with the full support of local and federal governments, thereby rendering and pushing to the forefront the truth of Crawford's vision. With its emphasis on commerce and technology, in opposition to basic requirements for life, it prefigured the long game that promises to transform our space (terra; planet Earth) into a grave.

NOTES

1. Two of the best and most thorough discussions of Crawford's sculpture were written in the 1990s: Vivian Green Fryd, *Art and Empire: The Politics of Ethnicity in the U.S. Capitol, 1815–1860* (New Haven, CT: Yale University Press, 1992); and Klaus Lubbers, "Strategies of Appropriating the West: The Evidence of Indian Peace Medals," *American Art*, Vol. 8, No. 3/4 (Summer–Autumn, 1994), 78–95. Both scholars are indebted, as am I, to the phenomenal work of Lillian B. Miller, *Patrons and Patriotism: The Encouragement of the Fine Arts in the United States, 1790–1860* (Chicago: University of Chicago Press, 1966), 70–75. See also Michele Cohen, "New Perspective, New Discoveries: A Close-up Look at Crawford's Progress of Civilization" (September 28, 2016), https://www.aoc.gov/blog/new-perspective-new-discoveries-close-look-crawfords-progress-civilization [accessed December 14, 2017].

Where appropriate, I use the terms "America" and "American" to reflect the terminology of citizens of the United States. I use "Indian" to reflect the process by which independent sovereign nations were gradually transformed over time into domestic dependents and whose distinct linguistic and cultural identities were simplified and generalized by various means so that they could be dealt with as a group by the federal government and by the culture as a whole—in literature, art, jurisprudence, essays, sermons, etc. Elsewhere, I refer to Indigenous, Indigenous Americans, and Native Americans. When white is an adjective, I leave it without capitalization, but when using it as a noun I capitalize it to reflect the process by which people of European descent created and re-created their realities as racialized beings. This essay is dedicated to water protectors everywhere and to my student Danielle Begay (Dinè) who was present at and for Standing Rock and who left us too soon.

2. Fryd, *Art and Empire*, 3.
3. Fryd, 119.
4. Lubbers, "Strategies of Appropriating the West," 87.

5. Lubbers, 87.

6. Lubbers, 94.

7. Victor Turner, "Social Dramas and Stories about Them," in *On Narrative*, ed. W.J.T. Mitchell (Chicago: University of Chicago Press, 1981), 145.

8. Mieke Bal, *Narratology: An Introduction to the Theory of Narrative*, 2nd edition (Toronto: University of Toronto Press, 1992), 119, 124. The first and second editions are highly recommended for scholars who work on visual culture. By the third edition, Bal eliminates all visual examples because she felt that visual studies scholars and art historians were not using her book.

9. Since as early as 1930, Crawford's sculpture for the U.S. Senate has been discussed within the textual spaces of art history. See Lorado Taft, *The History of American Sculpture* (New York: MacMillan Company, 1930), 80–85. Taft characterizes the theme as the "Past and Present of America." See also Robert L. Gale, *Thomas Crawford: American Sculptor* (Pittsburgh: University of Pittsburgh Press, 1964), 108–123; Sylvia E. Crane, *White Silence: Greenough, Powers, and Crawford, American Sculptors in Nineteenth-Century Italy* (Miami: University of Miami Press, 1972), 359–364; and see the most recent survey of U.S. art from the colonial period to the present by Angela Miller, Janet Berlo, Brian Wolf, and Jennifer Roberts, *American Encounters: Art, History, and Cultural Identity* (New York: Prentice Hall, 2008), 222–224.

10. Bal, *Narratology*, 106.

11. Gale, *Thomas Crawford: American Sculptor*, 111–112. I have transcribed the description exactly as it appears in Gale. When Crane wrote her text in 1972, she had cleaned up the errors and so had no use for brackets. Crane, *White Silence*, 360.

12. Thomas Crawford was the first American sculptor to take up permanent residence in Rome and his son, the famous author Francis Marion Crawford was born there. See William L. Vance, *America's Rome*, Volume One, *Classical Rome* (New Haven, CT and London: Yale University Press, 1989), 35.

13. It is an interesting coincidence that the Senate is oriented North like many European Last Judgments.

14. Sharon Patricia Holland, *The Erotic Life of Racism* (Durham, NC and London: Duke University Press, 2012), 10.

15. John Bunyan, *The Pilgrim's Progress (Part 1, 1678; Part 2, 1684)*, (Oxford: Oxford University Press, 2003); and Nathaniel Hawthorne, "The Celestial Railroad (1843)," in *Hawthorne's Short Stories*, ed. Newton Arvin (New York: Vintage Books, 1946), 210–228. Hawthorne spoofs Bunyan's fable, mocking the ease of the modern pilgrim's journey, now taken by railroad, as he travels, unbeknownst to himself in the company of the devil, from the City of Destruction to the Celestial City.

16. Frances Prucha, *American Indian Treaties: The History of a Political Anomaly* (Berkeley and London: University of California Press, 1994), 2.

17. Prucha, 3–5.

18. Prucha, 9.

19. On the inevitability of Native American extinction, see Brian W. Dippie, *The Vanishing American: White Attitudes and U.S. Indian Policy* (Middletown, CT: Wesleyan University Press, 1982). While Extermination was the policy and

practice, the ideology of "Vanishing" was what made policy and practice palatable. Karl Jacoby, "'The broad platform of extermination': Nature and Violence in the Nineteenth Century North American Borderlands," *Journal of Genocide Research*, Vol. 10, no. 2 (June 2008), 251.

20. Jacoby, "'The broad platform of extermination,'" 249–267.

21. Jacoby, 252.

22. Jacoby, 250–251, 263.

23. Kiana Herold, "Terra Nullius and the History of Broken Treaties at Standing Rock," *Intercontinental Cry* (November 14, 2016), https://intercontinentalcry.org/terra-nullius-history-broken-treaties-standing-rock/ [accessed December 15, 2017].

24. Eric Purchase, *Out of Nowhere: Disaster and Tourism in the White Mountains* (Baltimore and London: Johns Hopkins University Press, 1999).

BIBLIOGRAPHY

Arvin, Newton, ed. *Hawthorne's Short Stories*. New York: Vintage Books, 1946.

Bal, Mieke. *Narratology: Introduction to the Theory of Narrative.* 2nd ed. Toronto; Buffalo: University of Toronto Press, 1997.

Bunyan, John, and W. R. Owens. *The Pilgrim's Progress*. Oxford World's Classics. New ed., Oxford, England; New York: Oxford University Press, 2003.

Crane, Sylvia E. *White Silence; Greenough, Powers, and Crawford, American Sculptors in Nineteenth-Century Italy.* Coral Gables, FL: University of Miami Press, 1972.

Dippie, Brian W. *The Vanishing American: White Attitudes and U.S. Indian Policy.* 1st ed., Middletown, CT: Wesleyan University Press, 1982.

Fryd, Vivien Green. *Art & Empire: The Politics of Ethnicity in the United States Capitol, 1815–1860.* New Haven, CT: Yale University Press, 1992.

Gale, Robert L. *Thomas Crawford, American Sculptor.* Pittsburgh: University of Pittsburgh Press, 1964.

Harring, Sidney L. *Crow Dog's Case: American Indian Sovereignty, Tribal Law, and United States Law in the Nineteenth Century.* Cambridge Studies in North American Indian History. Cambridge; New York: Cambridge University Press, 1994.

Hawthorne, Nathaniel. *The Celestial Railroad and Other Stories.* New York: Signet Classics, 1963.

Herold, Kiana. "Terra Nullius and the History of Broken Treaties at Standing Rock." https://intercontinentalcry.org/terra-nullius-history-broken-treaties-standing- rock/.

Holland, Sharon Patricia. *The Erotic Life of Racism.* Durham, NC and London: Duke University Press, 2012.

Jacoby, Karl. "'The Broad Platform of Extermination': Nature and Violence in the Nineteenth Century North American Borderlands." *Journal of Genocide Research* 10, no. 2 (June 2008): 249–267.

Lifton, Robert Jay. "Interview: Art and the Imagery of Extinction." *Performing Arts Journal* 6, no. 3 (1982): 51–66.

Lubbers, Klaus. *Born for the Shade: Stereotypes of the Native American in United States Literature and the Visual Arts, 1776–1894.* Amsterdam: Rodopi, 1994.

———. "Strategies of Appropriating the West: The Evidence of Indian Peace Medals." *American Art* 8, no. 3/4 (Summer–Autumn 1994): 78–95.

Miller, Angela L., Margaretta M. Lovell, David M. Lubin, Jennifer L. Roberts, and Bryan Wolf. *American Encounters: Art, History, and Cultural Identity.* Upper Saddle River, NJ: Pearson/Prentice Hall, 2008.

Miller, Lillian B. *Patrons and Patriotism: The Encouragement of the Fine Arts in the United States, 1790–1860.* Chicago: University of Chicago Press, 1966.

Mitchell, W. J. T., ed. *On Narrative.* Chicago: University of Chicago Press, 1981.

Prucha, Francis Paul. *American Indian Treaties: The History of a Political Anomaly.* Berkeley: University of California Press, 1994.

Purchase, Eric, and Center for American Places. *Out of Nowhere: Disaster and Tourism in the White Mountains.* Baltimore, MD: Johns Hopkins University Press, 1999.

Taft, Lorado. *The History of American Sculpture.* New York: MacMillan Company, 1930.

Chapter Eleven

Beheld by the Eye of God

Photography and the Promise of Democracy in Frederick Douglass's The Heroic Slave

Kya Mangrum

A gift from Frederick Douglass to his close friend Susan B. Anthony, this rarely circulated 1848 portrait of the nineteenth-century writer-activist once sat on the mantel-piece of Anthony's parlor (see figure 11.1).[1] As a sign of both their friendship and mutual respect for one another, the daguerreotype offers not only a picture of how Douglass saw himself, but also how he desired to be seen by Anthony and her guests, many of whom were also activists in the anti-slavery and women's rights movements. Although the 1848 daguerreotype features the distinguished yet stylish attire typical of Douglass's early daguerreotypes—the smart black suit and starched white shirt—it also provides a stark contrast to both the fierce dignity of his other photographed portraits, as well as the cartoon-like illustrations drawn by white artists, illustrations that led Douglass to deride the limits of visual representation.[2]

Suggestive as it is of a robust and mysterious inner-life, this daguerreotype's visual departure mirrors a generic departure in Douglass's narrative representations of slavery.[3] In recent years, scholars have uncovered Douglass's specific interest in the representational possibilities of the daguerreotype.[4] My reading on Douglass and daguerreotypes differs from that of other studies in that I read Douglass as less an art object or artist, and more as a visual and narrative theorist. By focusing in on the material and cultural specificity of the daguerreotype as a visual technology, I demonstrate how Douglass creates a narrative of slavery and freedom that enacts a new kind of racialized seeing and imagines a radical form of inter-racial friendship. Boldly rejecting fellow abolitionist John Collins's admonition to "give [readers] the facts" and merely to "tell his simple story," Douglass ties the fugitive's emancipation together with the fugitive's evolution as philosopher. In this way, the materiality of the daguerreotype—its structural specificities

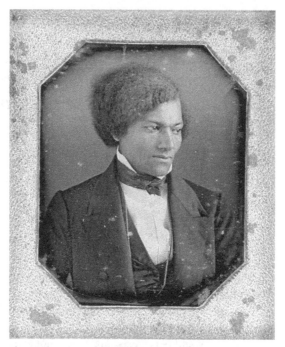

**Figure 11.1. Frederick Douglass. Daguerreotype 1848.
(Possibly taken by Edward White, NY, NY).**
Courtesy of the Format Photograph Collections, Chester County His-
torical Society, West Chester, PA.

and cultural meanings as a radically new technology of seeing—inspires, for
Douglass, a new imaginary for Black-White relations.

 As an innovative work of experimental fiction, Douglass's 1852 novella,
The Heroic Slave, uses the daguerreotype to model a theory of race and
nation capacious enough to embrace the former slave as friend and citizen.
Much like the 1848 daguerreotype in Anthony's parlor, Douglass's 1852
novella—his first and only foray into fiction-writing—captures a picture of
slavery marked by its focus not on the spectacle of the formerly enslaved
person's wounded body, but on his opaque and dynamic interior life. In a
narrative experiment designed to highlight the formerly enslaved person's
otherwise absent thoughts, feelings, interpretations, and analyses, Douglass
uses the daguerreotype as both a metaphor for deep interpersonal connec-
tion as well as a model for Black self-expression.[5] As Laura Wexler dem-
onstrates, Douglass's treatment of the daguerreotype in *The Heroic Slave*
was both an argument for abolition, and an argument for the former slave's
rights as citizen.[6] I push against constructs of Douglass and his fugitive

protagonists' rhetorical and political power as residing solely in their respective identities as artists and works of art. While scholars like Celeste-Marie Bernier and Fionnghuana Sweeney show us how Douglass refutes flat caricatures of former fugitives, they do so, in part, by arguing that Douglass's embrace of photography makes him both an artist and art object. I argue, however, that Douglass's vision of the fugitive hero, Madison Washington, neither objectifies nor aestheticizes him. Rather, Douglass exploits the daguerreotype's structural and cultural qualities—particularly the daguerreotype's power to close relational distance between seer and seen—to imagine an inter-racial friendship that transcends the boundaries of race and caste. Rejecting representations of the fugitive that direct the reader's attention to those indignities of bondage visible to the eye—e.g., chained hands and feet, branded flesh, or scarred backs—Douglass employs the processes, effects, and cultural meanings of the daguerreotype to not only picture the invisible, but also decrease the social and relational distance between the seen fugitive and the seeing Northern viewer.

THE EYE OF GOD

As "a mirror with a memory," "the pencil of nature," and "the eye of God," the daguerreotype was imagined not only to reveal a perfect copy of the visible world, but also to show the invisible world of the sitter's heart and mind.[7] A photo-mechanical process perfected by Louis Jacque Mandeé Daguerre, the daguerreotype became a viable method for picture-making when, in 1839, France offered the new technology as a gift "free to the world."[8] A one-of-a-kind positive print whose clarity inspired awe in its contemporary viewers, the daguerreotype offered a "perfect" reproduction of its sitter, an image that for some proved ". . . without the *possibility* of an incorrect likeness."[9]

The daguerreotype's presumably perfect reproduction of the physical world led some viewers to imagine that the daguerreotype's powers of revelation might extend to the hidden and interior worlds of a sitter's heart and mind. Beliefs about the new technology's revelatory powers were no doubt amplified by both its uncanny ability to mirror reality, and its eerie hyper-reflectivity, a mirroring that caused a viewer to see her own face superimposed upon that of her loved one's. The daguerreotype's flickering surface—made possible by the exposure of direct sunlight onto a silver-plated copper plate polished to a mirror finish—provided a photographic image that confounded the distance between seer and seen.[10] The result—both strange and beautiful—is that of "a flickering mirror . . . something alive,"[11] or someone rather, someone who demands the viewer's full attention.

Ensconced behind a protective layer of glass, the daguerreotyped image is a photographic object with both material and metaphorical heft. A viewer looking at the daguerreotype at a particular angle and in the appropriate light might view an image of ethereal clarity. However, depending on how the daguerreotype is tilted, and the play of light upon the protective layer of glass, one might encounter instead one's own mirrored reflection—or the commingling of one's own visage with that of the photographed sitter—or, in some instances, nothing at all. Its instability, its shifting balance between clarity and mystery, promised the viewer a sort of visual transcendence denied to the unaided human eye.

ON BEHOLDING THE FUGITIVE

In *The Heroic Slave*, Douglass adopts the daguerreotype's structural qualities and cultural meanings to craft the fictional biography of fugitive slave and rebel leader, Madison Washington. More than just a re-telling of his own life story, Douglass's *The Heroic Slave* allows him to experiment with a new kind of racialized seeing. Fascinated by the meanings of Washington's armed revolt aboard *The Creole*, Douglass—in speeches given both before and after the novella's publication—extolled the rebel leader as a luminary of his race and of the nation.[12] Although Douglass found himself with few facts with which to frame Washington's biography, he was also free to place the imagined facts of Washington's life narrative in service to his own philosophical treatise on race, vision, and nation.

Written as a contribution to the 1852 anthology *Autographs for Freedom*, and edited by abolitionist Julia Griffiths, *The Heroic Slave* presents a narrative structure that modeled for its 1852 audience how the fugitive slave's thoughts, feelings, and subsequent actions were analogous to those of the heroic rebels of 1776.[13] Douglass starts his novella, then, not with the "I was born" of the slave narrative, but with the narrating voice of an unnamed third-person speaker, a speaker who positions Washington as an equal to the most illustrious of Americans: "The State of Virginia is famous in American annals for the multitudinous array of her statesmen and heroes . . . Yet not all the great ones of the Old Dominion have . . . escaped undeserved obscurity. By some strange neglect, *one* of the truest, manliest, and bravest of her children—one who, in after years, will, I think, command the pen of genius to set his merits forth, holds now no higher place in the records of that grand old Commonwealth than is held by a horse or an ox."[14] Here the "I was born" of the slave narrative establishes Washington as the ideological kinsman of "statesmen and heroes" the likes of Thomas Jefferson and Patrick Henry, all

the "children" of a personified "Virginia" (175). In direct opposition with Southern law and custom that dictated that an enslaved child takes on the enslaved condition of his or her mother, the novella personifies the State of Virginia as Washington's "mother," and traces Washington's political gene-alogy back to the ideals of the nation.

In this way, Douglass places Washington's face and form alongside America's most lauded heroes. This move transforms the fugitive slave from a criminal on the margins of national life into a patriot at its center. Douglass's imaginative reconstruction of Washington's life story mirrors the multi-medial form of another kind of narrative—the patriotic mid-century portrait-biographies published during the 1840s and 1850s.[15] The best known of these portrait biographies was Mathew Brady's *The Gallery of Il-lustrious Americans, containing the Portraits and Biographical Sketches of Twenty-Four of the Most Eminent Citizens of the American Republic Since the Death of Washington*. Sub-titled "the gift book of the republic," *The Gallery* included engraved portraits drawn by artist Francis D'Avignon, and modeled after daguerreotypes taken in Brady's studio.[16] Each engraving was accompanied by a short biography intended to illustrate the representational qualities lost when artists translated a daguerreotyped portrait into a woodcut engraving. Portrait-biographies like Brady's relied upon the daguerreotype's presumed indexicality and powers of revelation to actualize *The Gallery*'s myriad purposes. Written by C. Edwards Lester, the volume's editor, each biography was intended to illustrate the character of the public figures pictured, as well as to construct a "national work," one intended to reflect back to the nation the visage and character of its most celebrated patriots.[17] Like later works that patterned themselves after it, *The Gallery of Illustrious Americans* urged viewers to "contemplat[e] the portrait of an eminent person . . . [to] conside[r] his actions . . . [and] behold his countenance."[18] Griffiths' gift book *Autographs for Freedom* does work similar to that done in Brady's gift book. The longest contribution in *Autographs*, Douglass's novella, like Brady's *Gallery*, connects word and image so as to render visible the hidden, interior life of "a great character" (Douglass, *The Heroic Slave*, 175). Doug-lass exploits the daguerreotype's reputation as both a faithful index into the natural world and a prescient window into the hearts and minds of men to demonstrate Washington's exceptional character. As a gift to the nation that modeled in its very structure the picture biographies of the nation's greatest men, *The Heroic Slave* offers an alternative means by which to picture the former slave's life narrative.

As a model for seeing, the daguerreotyped biography also permitted Doug-lass an opportunity to represent Washington's life story in ways that stressed the difficulty of representing slavery at all. Resembling slave narrators like

William Wells Brown, Harriet Jacobs, Lansford Lane, and Moses Roper, Douglass's fugitive protagonist speaks repeatedly of feelings that words cannot describe. In emphasizing the ways in which slavery and its effects defied representation, Douglass notes the gaps and silences of the slave record in order to construct what he believes to be a more apt likeness of slavery as it was. As such Douglass focuses not on Washington's transparency, but on his inscrutability: "Glimpses of this great character are all that can now be presented. . . . Like a guiding star on a stormy night, he is seen through the parted clouds and the howling tempests; or, like the gray peak of a menacing rock on a perilous coast, he is seen by the quivering flash of angry lightning, and he again disappears covered with mystery." Douglass frames Washington's fictional biography not with strongly worded assertions about who Washington is and why he can be trusted, or a frontispiece portrait that attests to his identity and respectability, but with similes that liken him to a "guiding star," or a "gray peak of a menacing rock." In comparing Washington to a force of nature, Douglass offers his reader "glimpses" of an epically heroic figure, one whose greatness seemingly escapes the power of full description. "Covered with mystery" and "enveloped in darkness," the novella's fugitive is only partly "revealed" by "the light of the northern skies." This insistence on partial revelation, on "marks, traces, possibles, and probabilities," challenges the notion that the reality of slavery's consequences could ever be represented without the unfettered expression of the fugitive's hidden thoughts and feelings (Douglass, *The Heroic Slave*, 175).

And yet, the possibility that the invisible might be made visible is suggested by the novella's opening epigraph. Taken from the first stanza of a popular song and poem that is variably titled "For I Know Their Sorrows," "Consolation," and "God is Love," the novella's first epigraph describes the "sorrow" of an unnamed "weeping pilgrim":

> Oh! child of grief, why weepest thou?
> Why droops they sad and mournful brow?
> Why is thy look so like despair?
> What deep, sad sorrow lingers there?

Composed of a series of questions, and set to iambic tetrameter, the epigraph speaks directly to an invisible interlocutor, a man of "sorrow" whose cries precede the action of Washington's heroic tale. A "child of grief," born into "deep, sad, sorrow," the poem's protagonist communicates his inner state on his "brow" and in his "look" (Quoted in Douglass, *The Heroic Slave*, 174). Yet, this physical manifestation of the protagonist's inner pain fails to offer the speaker a transparent picture of the protagonist's inner state; it prompts,

instead, a series of questions that reveal the speaker's inability to know the thoughts and feelings behind the pilgrim's brow.

Suggestive of an internal dialogue inaccessible to the viewer/speaker—a private debate of the pilgrim's heart and mind—the pilgrim's visibly "droop[ing] brow" hides more than it reveals. Although the poem's first stanza emphasizes the difficulty of translating his thoughts and feelings to the eye and ear, the pilgrim's "sad" state changes dramatically in the song's final quatrain. As a result of a perceptual apparatus "more perfect" than that of the speaker, the unnamed sojourner ends his "sorrow[ful]" journey by becoming a participant in a more perfect union:

> Then, weeping pilgrim, dry thy tears;
> Comfort on every side appears;
> An eye beholds thee from above,
> The eye of God, and "God is love"

In being "beheld from above" the sojourner is the recipient of an admiring gaze, and via the superior powers of perception attached to "the eye of God," is seen anew. The epigraph that Douglass chooses to frame his novella presents an exchange between seer and seen in which "God's [loving] eye" enacts a special kind of seeing and knowing, a mode of perception that closes distance and enacts relationship. Douglass's choice, then, to frame Washington's narrative with a poem that identifies "God's eye"—a term also used to describe the daguerreotype's powers of extrasensory revelation—as a healing extension of His love emphasizes the necessity of picturing the fugitive's thoughts and feelings through a medium capable of producing an "impartial" likeness.[19]

By going beyond the limits of human perception, the "eye of God" makes it possible to see the pilgrim's invisible inner world; this is the kind of exchange Douglass desires for Washington and Listwell, one in which the daguerreotype allows a kind of racialized seeing that permits the viewer to see Washington with the right-seeing "eye of God."[20] In a lyrical set of non-narrative soliloquies, Washington uses the secluded pine forest as material to theorize the nature of slavery and freedom. Looking at the birds flying "among the tall pines" at the edge of a secluded forest, Washington compares his fate to theirs: "Those birds . . . sounding forth their merry notes in seeming worship of the rising sun . . . are [my] superiors. They *live free*, though they may die slaves. . . . But what is freedom to me, or I to it? I am a *slave* . . . even before I made part of this breathing world, the scourge was platted for my back; the fetters were forged for my limbs." In naming the birds of the air as his "superiors," Washington unveils a key contradiction in the peculiar institution's logic. Asking broad existential questions such as "What is life?"

and "What is freedom?," Washington unveils a robust thought life (Douglass, *The Heroic Slave*, 177). When he poses existential questions about the meaning of life and liberty—questions that engender deep anguish—Washington undoes arguments about the slave's lackluster intellect and shallow emotional life. Indeed, Washington's angst is heightened, not by physical trauma of his enslavement—he was whipped by an overseer before retreating to the forest—but more so by his awareness of it. Similar, in this way, to the young Douglass of his 1845 *Narrative*, Washington's robust thought life leads him to question the meanings of slavery. He goes on to theorize his own enslavement by use of reasoned arguments and rhetorical craft. Using a distinctly literary diction, he engages in a dialogue with himself, a dialogue that rejects the most popular pro-slavery arguments.

When Washington delivers his soliloquy, he believes himself to be alone. His impassioned debate is, however, performed for an audience of two. Listwell, a Northern traveler, and Washington's hidden interlocutor, is initially attracted to the glen by the "sound of a human voice . . . engaged in earnest conversation" (Douglass, *The Heroic Slave*, 176). As a result, Washington's image and unfettered self-expression unfold before Listwell's eyes without the limiting effects of less "perfect" textual and visual forms. When Listwell hides behind a fallen tree so that he can both hear and see Washington—a hearing and seeing that reveal not only Washington's form, but his character—his active yet silent attendance mimics the interpersonal contact between a daguerreotyped sitter and his viewer.

As he gazes upon the living daguerreotype that Washington develops with his heart-felt words, Listwell beholds the future fugitive via the revelatory power of Washington's words and image. After hearing Washington's most private thoughts, Listwell looks up to see the eloquent bondsman in "full view." What Listwell sees becomes critical to his experience of what he hears. Long after Washington leaves the scene, Listwell "meditate[s] on the extraordinary revelation" enacted by Washington's embodied performance. In seeing and hearing Washington's uninterrupted "revelation," Listwell experiences a state of vision not possible with conventional ways of seeing, one which allows him "to sound the mysterious depths . . . of [Washington's] thoughts and feelings" (Douglass, *The Heroic Slave*, 178, 181, 179). What was at first a solitary address is, in fact, transformed into a conversation, in which a speaking Washington and a listening Listwell engage in an intimate act of exchange. This act, however, is as much a visual one as it is an aural one. Washington is transformed by speaking into being an idealized image of himself; Listwell is transformed by witnessing Washington's dynamic self-imaging. Within the quiet space of a pine wood clearing, Washington's words and image forge a bond between the two men.

Washington concludes his soliloquy with a firm resolution to flee. Echoing the language of Patrick Henry: Washington proclaims, "Liberty I will have or die in the attempt to gain it." At the end of his speech, Washington declares that his "resolution is fixed" upon freedom. The steadfastness of Washington's resolution, the fixedness of his gaze toward a free future brings to a close what seems to Washington's hidden interlocutor, Mr. Listwell, an almost supernatural transformation. After Washington speaks his final words of resolve, Listwell takes a second and "full view" of the man whose "earnest conversation" had, at first, sparked only curiosity: "Madison was of manly form. In his movements he seemed to combine, with the strength of the lion, a lion's elasticity. His torn sleeves disclosed arms like polished iron. His face was 'black, but comely.'" Indeed, Listwell continues, "His whole appearance betokened Herculean strength. . . . But his voice, that unfailing index of the soul, though full and melodious, had that in it which could terrify as well as charm." Here the novella continues the anthropomorphic comparisons begun with Washington's comparisons between himself and the small and vulnerable creatures of the forest. In stark contrast to the birds of the pine wood forest, Listwell imagines Washington as a powerful force of nature. Following Washington's resolution to live free or die trying, Listwell likens the fugitive to a lion "in his movements . . . and strength," suggesting a latent power and ferocity that frighten Listwell (Douglass, *The Heroic Slave*, 178, 179).

Mirroring the ferocity of Douglass's own early photographic portraits, Listwell's word-portrait communicates Listwell's awe after hearing and seeing Washington's soliloquy. What inspires Listwell to look upon Washington with awe, however, is not only the latter's physical prowess; it is also the power of his voice, "that unfailing index of the soul . . . which could terrify as well as charm" (179). In its dual ability to "charm" and "terrify," Washington's voice evokes what philosopher Immanuel Kant defines as the sublime, a greatness that inspires both wonder and awe, and exists outside the bounds of human perception.[21]

Although Listwell views Washington with a sense of awe, this awe works to re-frame Washington's African features into features that Listwell can view with appreciation. With Douglass's carefully constructed portrait, those physical features of African heritage so often derided in mid-nineteenth-century popular culture and race science—a "broad mouth and nose"—are re-framed as indicative of "Herculean strength," indomitable courage, and a kind and peaceful disposition.[22] In the context of nineteenth-century notions of the masculine ideal and the daguerreotyped portrait, we find that Washington's fine form and figure reflect an even more refined character. This character is offered to us in pieces, "brought to view only by a few transient incidents" that "afford but partial satisfaction." And yet the

import of Washington's text-based photograph lies in the decisive turn of the word "but." Although his visual appearance offers a dignified character, it is Washington's voice that proves "poignant" to Listwell and is what, in the end, provided a developed and complete image of Washington, the man, a man who Listwell imagines as a friend and an equal. It is this image, developed in a pine wood glen that prompts Listwell to declare himself an abolitionist and creates within his own memory a living daguerreotype of a man that he embraces as a friend (Douglass, *The Heroic Slave*, 175, 179, 182).

When he sees Washington in "full view," Listwell sees the former slave through the mediating effects of the daguerreotype. Far from either a repetition of racialized scripts in which Listwell's gaze assaults Washington's sub-altern body, or flat visual representations that imagine the fugitive as caricature, Listwell's observation impress upon his memory a sort of living daguerreotype, one animated by Washington's face and voice. Throughout the narrative, Douglass explicitly rejects visual images that treat the fugitive as a transparent figure of spectacle. With its lurid descriptions of scars, wounds, and brands, the runaway advertisement was one of the most common visual and written genres of fugitive representations, and by 1852, the woodcut stereotype that often accompanied it, was an iconic fixture of U.S. visual culture. As Marcus Wood notes in his seminal study, *Blind Memory: Visual Representations of Slavery in England and America 1780–1865*, the two-dimensional woodcut so popular in newspaper advertisements was "a negation of the slave's most radical anti-slavery gesture. . . . Comic, trivial, pathetic, and always the same, with his bundle of goods and one foot eternally raised, he proclaims his inadequacy for the task he has set himself. The very engraved lines which make up the slave are running around in circles, running everywhere and nowhere."[23]

The "eternally raised" foot of the stereotyped woodcut places the fugitive in a state of permanent captivity. "Running around in circles," the fugitive is frozen in a timeless moment of aimless wandering that he can neither alter nor comprehend. "A negation of the slave's most radical anti-slavery gesture," the woodcut runaway refutes the very notion of the fugitive's inner life, making still and one-dimensional the complex realities of the fugitive's dynamic interiority. In stark contrast, Douglass's daguerreotype of Washington features a thinking fugitive struggling in the throes of existential crisis. While the woodcut runaway's visual argument reduces the fugitive to a figure dead to thought and feeling, Douglass's protagonist embraces his decision to run away after a great deal of self-reflection, and despite much travail.[24]

Douglass explicitly contrasts his "living impression" of Listwell with the runaway woodcut at two different points: once after Washington decides to "pursue his journey" North, and once outside of the Listwells' Ohio cabin.

Indeed, Douglass stresses the image of a Washington on the move, developing his text-based daguerreotype in sharp contrast to the woodcut stereotype: "my last dollar was now gone, and you may well suppose I felt the loss of it; but the thought of being once again free to pursue my journey, prevented that depression which a sense of destitution causes; so swinging my little bundle on my back, I caught a glimpse of the *Great Bear* (which ever points the way to my beloved star,) and I started again on my journey." "Swinging his little bundle on [his] back," Douglass's hero speaks of himself as engaged in a journey, placing him in a long tradition of heroic wanderers. Like the wandering pilgrim in Part I, Washington travels with intention, if not without peril, and uses his wit to influence his destiny. Once he arrives at the Listwells' cabin, Washington is described as having "a stick in one hand" and a "small bundle in the other," breaking apart—literally—the iconic imagery of the "little bundle" hanging from the woodcut fugitive's back (Douglass, *The Heroic Slave*, 201). In both instances, Douglass self-consciously alludes to the most iconic visual imagery of the runaway only to refute its inherent meanings.

This desire for an improved perceptual apparatus (a technology of right-seeing) was, for Douglass, critical in providing a "deeper shade to [slavery's] picture" (Douglass, "Lecture on Slavery" 167). The daguerreotype's uncanny ability to picture the invisible—its perceived status as the unerring "eye of God"—allowed Douglass to craft a theory of visuality "adequate" to the task of representing "the unparalleled enormity of slavery."[25] For Douglass, the daguerreotype's power as a personal—and deeply intimate—technology of remembrance was integral to this project of making viewers' perceptions "adequate" to the task of seeing former slaves as fully sentient beings "endowed . . . with mysterious powers" not merely in hindsight, but during the moment of their enslavement.[26]

Douglass hints at the danger of racist vision re-imposing itself upon seer and seen. Five years after his resolution to flee, Washington walks up to a lone cabin in a forest in Ohio; this cabin belongs to Mr. and Mrs. Listwell. Sensing a presence outside of his cabin door, Listwell steps outside and sees Washington, but at first, does not recognize him. Glimpsing the heroic slave against the darkened backdrop of the night-time sky, Listwell at first views Washington via the inverted camera obscura of his well-lit cabin, and misidentifies the heroic slave as a generic and nameless wanderer. When Listwell describes Washington as "a tall man . . . with a stick in one hand and a small bundle in the other," he is calling to mind the runaway woodcut. This brief moment of misrecognition is broken, however, when Washington speaks. Then, "the Virginia forest scene flash[es] upon [Listwell]," and he instantly recalls the living daguerreotype impressed upon his memory by his experience in the glen. As

"that unfailing index of the soul," Washington's voice "made such an impression upon [Listwell] as can never be erased." This "impression" inspires Listwell to recognize the unknown traveler as a friend only after both voice and image are combined. As Listwell says when the two men meet face-to-face outside of his cabin, "Oh sir, I know not your name, but I have seen your face, and heard your voice" (Douglass, *The Heroic Slave*, 185, 17). In seeing and hearing Washington's face and voice, Listwell calls up the mental image that had so struck him five years before, a mental image that he had cherished as a token of friendship and interpersonal connection.

Listwell's appellation of respect and recognition surprises Washington, who knows nothing of the friend he had made on the day of his own internal transformation from slave to free man. After Washington expresses alarm at what seems an uncanny level of familiarity, Listwell reveals his identity as an unknown witness to the revolutionary events of Washington's pine wood soliloquy: "'Ever since that morning,' said Mr. Listwell, 'you have seldom been absent from my mind, and though now I did not dare to hope that I should ever see you again, I have often wished that such might be my fortune; for, from that hour, your face seemed to be daguerreotyped on my memory'" (Douglass, *The Heroic Slave*, 188). Here, Listwell describes the experience of seeing and hearing Washington's embodied free expression of his deepest thoughts and feelings as an act of daguerreotyping. In doing so, Listwell taps into a popular discourse in which the word "daguerreotype" was used as a verb, one that meant "telling the literal truth of things."[27] As a "daguerreotype" of the "mind," Listwell's remembrance of Washington once again closes the affective distance between the two men, allowing Listwell to see Douglass not in the faint outline of the woodcut runaway, but with the perceptual clarity of the daguerreotyped portrait.

This yoking of word and image not only reveals Washington to himself, and Washington to Listwell; it yokes the men's lives so that they mirror one another. This mirroring of identity is made explicit in the two men's final encounter. Listwell, while once again traveling through Virginia, runs into Washington after the fugitive has been captured, re-enslaved, and sold South. Here, Washington is for the first time featured in the company of fellow slaves. It is in this state that Listwell finds him. As the unnamed narrator relates, Listwell, "thoughtless of the consequences . . . ran up to his old friend, plac[ed] his hands upon his shoulders, and looked him in the face!" In this second moment of recognition, Washington's face is now the index by which Listwell recalls his dynamic character. Much like the "eye of God" that "beheld" the "weeping pilgrim" in the novella's first epigraph, Listwell is able to once again look upon Washington and know all (Douglass, *The Heroic Slave*, 216, 185). During the split second of the men's mirrored and

"speechless gaze," they look upon one another as equals. In this way, both Washington and Listwell are seer and seen, and Listwell is transformed from beholder to beheld.

NOTES

1. According to Pamela Powell, photo archivist at the Chester County Historical Society, "a note that was placed inside the case by the donor Albert Cook Myers [states that] the daguerreotype was a gift from Douglass to Susan B. Anthony." The note's authenticity is corroborated by the testimony of Miss Lucy Anthony (Susan Anthony's niece) who gave the daguerreotype to historian Albert Cook Myers, and noted that Douglass's daguerreotype used to sit on the mantelpiece of Anthony's parlor (e-mail, 1/17/2012). The inscription on the inside of the case "E. White maker, NY" leads me to believe that the daguerreotype was taken in the New York City studio of daguerreotypist Edward White, whose gallery featured "1, 000 Daguerreotype Miniatures from life, of nearly all our eminent men."

2. See Colin L. Westerbeck, "Frederick Douglass Chooses His Moment*,"* *Art Institute of Chicago Museum Studies* 24, issue 2 (1999).

3. A number of modern-day Douglass scholars read *The Heroic Slave* as structurally unremarkable. Douglass biographer William McFeely, for example, reads *The Heroic Slave* as "a way station on the road to [Douglass's] second telling of his own heroic life [in *My Bondage and My Freedom*]." In *Frederick Douglass* (New York: W. W. Norton, 1991), 174.

Against more canonical readings, my article demonstrates that rather than being a failed slave narrative or a detour on the road to his later work, *The Heroic Slave* is a formal experiment that influenced how Douglass imagined the representational possibilities of portrait photography.

4. Scholars like Laura Wexler, John Stauffer, Marcy Dinius, Julia Faisst, and Celeste Marie Bernier have all noted Douglass's profound interest in the representational possibilities of photography. I contend that Douglass's interest in photography was shaped and informed by the material and technological particularities of the earliest photographic form—the daguerreotype.

5. See Douglass, *Life and Times.*

6. Laura Wexler, "'A More Perfect Likeness': Frederick Douglass and the Image of the Nation," in *Pictures and Progress: Early Photography and the Making of African American Identity,* eds. Maurice O. Wallace and Shawn Michelle Smith (Durham, NC: Duke University Press, 2012), 18.

7. Oliver Wendell Holmes, "The Stereoscope and the Stereograph." *Soundings from the Atlantic* (Boston: Ticknor and Fields, 1864), 129.

8. Beaumont Newhall, *The History of Photography from 1839 to the Present Day* (New York: Museum of Modern Art, 1949), 17.

9. Lewis Gaylord Clark, "The Daguerreotype," *Knickerbocker, or New-York Monthly Magazine* 14, no. 6 (December 1839): 560.

10. The plate was polished to a mirror finish, sensitized with iodine and then placed into a camera. Once the image is exposed to light, the plate is developed, resulting in an image so diaphanous that the swipe of a single finger might destroy it.

11. Alan Trachtenberg, "Likeness as Identity: Reflections on the Daguerrean Mystique," in *The Portrait in Photography,* ed. Graham Clarke (London: Reaktion Books, 1992), 409.

12. Douglass refers to Washington in at least two different speeches.

13. McFeely, 174.

14. Frederick Douglass, *The Heroic Slave* in *From Autographs for Freedom*, ed. Julia Griffiths (Boston: John P. Jewett and Company. Cleveland, OH: Jewett, Proctor, and Worthington. London: Low and Company, 1853), 175. All further quotations will be cited parenthetically.

15. Examples include Charles Wilson Peale's *Gallery of Distinguished Person-ages*, Joseph Delephaine's "National Panzographia," and a printed collection of the *National Portrait Gallery of Distinguished Americans*. For more, see Susan S. Williams, *Confounding Images: Photography and Portraiture in Antebellum American Fiction* (Philadelphia: University of Pennsylvania Press, 1997), 19–24.

16. Alan Trachtenberg, *Reading American Photographs* (New York: Macmillan, 1990), 45.

17. Trachtenberg, *Reading American Photographs*, 48.

18. John Chester Buttre, in *The Gallery of Illustrious Americans, containing the Portraits and Biographical Sketches of Twenty-Four of the Most Eminent Citizens of the American Republic Since the Death of Washington* (New York: M. B. Brady, F. D'Avignon, C.E. Lester, 1850), ii.

19. Anonymous, "Consolation," in *The Young Gentleman's Book: Containing a Series of Choice Readings in Popular Science and Natural History, together with Retrospective Essays, Conversations, Literary Reminiscences, etc.* (London: Baldwin and Cradock, 1834), 208.

20. Anonymous, "Consolation," 208.

21. John Stauffer, "Interracial Friendship and the Aesthetics of Freedom," in *Frederick Douglass & Herman Melville: Essays in Relation,* eds. Robert S. Levine and Samuel Otter (Chapel Hill: University of North Carolina Press, 2008), 137.

22. Richard A. Yarborough, "Race, Violence, and Manhood: The Masculine Ideal in Frederick Douglass's 'The Heroic Slave,'" in *Frederick Douglass: New Literary and Historical Essays*, ed. Eric J. Sundquist (Cambridge: Cambridge University Press, 1991), 167.

23. Marcus Wood, *Blind Memory: Visual Representations of Slavery in England and America 1780–1865* (Manchester, UK: Manchester University Press, 2000), 93.

24. Wood, 93.

25. Anonymous, "Consolation," 208. Frederick Douglass delivered "A Lecture on Slavery" at Rochester, New York, on December 8, 1850. It was published as part of a pamphlet, *Lectures on American Slavery* (1853) and reproduced in *My Bondage and My Freedom* (1855).

26. Douglass, "A Lecture on Slavery."

27. Alan Trachtenberg, "The Emergence of a Keyword," in *Photography in Nineteenth-Century America,* ed. Martha Sandweiss (Fort Worth, TX: Amon Center Museum, 1991), 17.

BIBLIOGRAPHY

Batchen, Geoffrey. *Forget Me Not: Photography and Remembrance.* New York: Princeton Architectural Press, 2006.

Clark, Lewis Gaylord. "The Daguerreotype." In *Knickerbocker, or New-York Monthly Magazine* 14, no. 6 (December 1839): 560–561.

Douglass, Frederick. *My Bondage and My Freedom.* New York: Modern Library, 2007.

———. *The Heroic Slave.* In *From Autographs for Freedom*, ed. Julia Griffiths. Boston: John P. Jewett and Company. Cleveland, OH: Jewett, Proctor, and Worthington. London: Low and Company, 1853.

Holmes, Oliver Wendell. "The Stereoscope and the Stereograph." In *Soundings from the Atlantic.* Boston: Ticknor and Fields, 1864.

McFeely, William S. *Frederick Douglass.* W. W. Norton & Company, 1991.

Newhall, Beaumont. *The History of Photography from 1839 to the Present Day.* New York: Museum of Modern Art, 1949.

Sandweiss, Martha A. and Alan Trachtenberg, eds. *Photography in Nineteenth-Century America.* Fort Worth: Amon Carter Museum, 1991.

Stauffer, John. "Interracial Friendship and the Aesthetics of Freedom." In *Frederick Douglass & Herman Melville: Essays in Relation,* eds. Robert S. Levine and Samuel Otter, 134–158. Chapel Hill: University of North Carolina Press, 2008.

Trachtenberg, Alan. "Likeness as Identity: Reflections on the Daguerrean Mystique." In *The Portrait in Photography,* ed. Graham Clarke. London: Reaktion Books, 1992.

———. *Reading American Photographs.* New York: Macmillan, 1990.

Westerbeck, Colin L. "Frederick Douglass Chooses His Moment." *Art Institute of Chicago Museum Studies* 24, no. 2 (1999): 145–262.

Wexler, Laura. "'A More Perfect Likeness': Frederick Douglass and the Image of the Nation." In *Pictures and Progress: Early Photography and the Making of African American Identity*, eds. Maurice O. Wallace and Shawn Michelle Smith, 18–40. Durham, NC: Duke University Press, 2012.

Williams, Susan S. *Confounding Images: Photography and Portraiture in Antebellum American Fiction.* Philadelphia: University of Pennsylvania Press, 1997.

Wood, Marcus. *Blind Memory: Visual Representations of Slavery in England and America 1780–1865.* Manchester, UK: Manchester University Press, 2000.

Yarborough, Richard A. "Race, Violence, and Manhood: The Masculine Ideal in Frederick Douglass's 'The Heroic Slave,'" In *Frederick Douglass: New Literary and Historical Essays*, ed. Eric J. Sundquist. Cambridge: Cambridge University Press, 1991.

The Young Gentleman's Book: Containing a Series of Choice Readings in Popular Science and Natural History, together with Retrospective Essays, Conversations, Literary Reminiscences, etc. London: Baldwin and Cradock, 1834.

Chapter Twelve

Cotton Babies, Mama's Maybe

Kara Walker's Marvels of Invention in 8 Possible Beginnings

Janet Neary

In the mid-1990s Kara Walker shifted from working primarily in acrylic paint to the medium of silhouette, becoming, in the process, a lightning rod for debate. Fashioning "black" and "white" figures out of monochromatic paper pasted against white gallery walls, Walker draws on a visual lexicon mined from nineteenth-century postcards, romance novels, and minstrel fliers to construct elaborate tableaux of Southern plantation slavery. In conjunction with anachronistic titles such as *Gone: An Historical Romance of a Civil War as It Occurred b'tween the Dusky Thighs of One Young Negress and Her Heart* (1994), Walker deploys stock figures such as the "mammy," the "pickaninny," the "soldier," and the "lady," with narrative priority given to the "Negress," who often functions as a cipher for Walker herself, to construct scenes of racialized violence and desire. Scaled two-thirds life size, Walker's figures populate a landscape extending just beyond our own immediate ground, situating our perspective as that of witness and voyeur hovering just outside the tableau's frame.[1] The narrative aspect of Walker's tableaux is dependent on her mobilization of viewers' familiarity with racist iconography, recognition that is key to her formal insistence on our complicity with what Christina Sharpe calls a past that is not past.[2] To read the scenes narratively is to admit one's fluency in the visual grammar of racial stereotype, exposing racial mythology not as a curiosity of the past, but as a structuring principle of the present.

Given that Walker's intervention into debates over racial representation relies heavily on recognition, identification, and classification, I was interested to discover her creation, in 2005, of a creature that resists a metonymic relationship to the raced and gendered body in her short film *8 Possible Beginnings; Or the Creation of African America. A Moving Picture by the*

Young, Self-taught Genius of the South Kara E. Walker.[3] Combining black and white silent film conventions, animation, and shadow puppets, *8 Possible Beginnings* operates as both the presentation of eight discrete origin stories that could stand alone, and as a loosely chronological national allegory that begins with the Middle Passage, takes us through the invention of the cotton gin, and ends at the conclusion of the 19th-century with a chapter channeling the Uncle Remus stories. Its intertextual references to Walt Disney's *Song of the South* (1946) and D. W. Griffith's *Birth of a Nation* (1915) further extend the film's historical scope and accentuate our highly mediated access to our national origins, signaling the cultural and ideological work conditioning our notions of history. The film's narrative core is a sexual encounter between an enslaved man and his master, which produces a gleefully sinister cotton baby—an animated cotton boll that smiles and dances—which is planted in a field, watered by the enslaved man, and eventually grows into a tall tree that becomes a lynching site for multiple black men.

Although cotton is part of a Southern visual lexicon, along with hoop skirts and Spanish moss, and the cotton baby is reminiscent of imagery on mid-nineteenth century advertising trade cards which combined images of black

Figure 12.1. Cotton Baby, still from *8 Possible Beginnings*.
Artwork © Kara Walker, courtesy of Sikkema Jenkins & Co., New York.

people with the commodities they produced and consumed, Walker's animation of the cotton boll-as-baby elaborates these images into an excessive fable of creation and translates a recognizable pictorial icon into an obviously fantastic imaginative production.[4] In so doing, Walker raises questions about the racial body itself.

As with her silhouette tableaux, the formal properties of *8 Possible Beginnings* are central to her intervention. Walker employs animation to denaturalize the animating myths of national foundation, analogizing the processes of birth and artistic creation to complicate our understanding of the relationship between origins, identity, imagination, and invention. Literally the state of being full of life, animation is the act, or process, of imparting life, as well as a visual illusion. As a visual technology that creates the impression of movement or life through the production of sequential, fixed images displayed in rapid succession, animation proves an apt medium for commenting on the mythological dimensions of racialization. Even before the arrival of the cotton baby via an unnatural male pregnancy, the film's first and second parts, "Along a Watery Road" and "Motherland," combine shadow puppetry and animation to reimagine the Middle Passage as a disturbing and scatological birth of a nation: "African America." Opening on a shot of a cut-paper ship bobbing on papery waves, the film almost immediately fades to black and gives way to the next shot: an image of enslaved people—black figures marked "Authentic," "Black," "African," "Negroes," "Faker," and "Wannabe"—lying prone in the ship's womb-like bowels. In the next sequence, an intertitle declares, "Cap'n say: Toss dem uppity niggers!" The black figures are expelled. A hulking, black female form marked "The Motherland" rises up out of the sea to consume them. Gulping the bodies of discarded slaves into her mouth, chewing and digesting them (their shadow puppet bodies moving through her intestines), she defecates the African American slave who will become the father of the cotton baby, a physical manifestation of the consolidation of race, nation, and capital in an American origin story. Making visible what Lindon Barrett calls the "key turns of imagination," which enabled slavery and, therefore, the consolidation of the United States, Walker revises the creation of "America" as the creation of "African America," recovering the black origins of a history that has been sanitized and whitewashed.[5]

In its savvy commentary on the birth of the nation, *8 Possible Beginnings* presents historical narratives—origin stories—as inextricable from the same key turns of imagination fundamental to the political economy of racial slavery. The film argues that the cultural and ideological work on which the United States is founded is as central to (and is inseparable from) the constitution of the United States as the wealth produced from selling enslaved people and the commodities that they produced. The ideological work of culture and

202 *Janet Neary*

the political work of nation building are linked through the figure of invention. Inventions in industrial technology, such as the cotton gin, are likened to inventions in visual technology, such as Griffith's "The Birth of a Nation." Through its referential juxtapositions and radical reimagining, *8 Possible Beginnings* calls attention to the nexus between the very real bodily dangers of the objectification of blackness—black people discarded, thrown overboard during the Middle Passage, worked to death, abused, lynched—and the material consequences of the mythological production of race.

Walker is perhaps best known for her unflinching portrayal of ambivalent sexual encounters between female slaves and their masters, which force viewers to consider the systemic rape of enslaved black women while complicating the power dynamics within the master-slave relationship. By transforming a non-reproductive homosexual encounter into a reproductive act in *8 Possible Beginnings*, Walker shifts desire onto mythical terrain. The arrival of the cotton baby interrupts what could otherwise be taken to be a crude visual depiction of the most literal account of racial capitalism—black people are fucked in the service of white wealth accumulation. Walker's translation of the rationalized narrative of sexual reproduction into allegory upends the logic of racial slavery, provoking the paradoxical recognition that the desire at work in racial slavery exceeds the purely economic, while simultaneously locating irrational desire as the point of origin for US political economy. As Barrett has argued, capitalism forged both the nationalist organization of modernity and the modern subject—both of which depended on the exclusion of African-derived people from the concept of "the people" (in the case of the nation) and human being (in the case of the subject), noting, "The matter is not economic simply but rather involves . . . the key turns of the imagination that demand the impossibility—violently secured—of racial blackness being a feature of readily recognized human being."[6]

In her essay "All the Things You Could Be by Now if Sigmund Freud's Wife Was Your Mother," Hortense Spillers writes that racial slavery, "like a myth, marks so rigorous a transition in the order of things that it launches a new way of gauging time and human origin: it underwrites, in short, a new genealogy defined by a break with Tradition—with the Law of the Ancestors and the paternal intermediary."[7] In their very different analyses, both Roland Barthes and Spillers discuss myth as the obfuscation of origins through an ideological sleight of hand. If myth, as Barthes contends, "is constituted by the loss of the historical quality of things," and racial slavery is "as violent and disruptive as the never-did-happenstance of mythic and oneiric inevitability," as Spillers argues, then to counter the foundational myths of US racial and national constitution, one must recover the imaginative and ideological

work of naturalization and make the subject of myth strange once again.[8] Walker's rendition of the sexual exploitation of an enslaved man simultaneously interrupts the matrilineal genealogy of racialization and the patrilineal genealogy of national formation. By supplying an obviously fantastic story, Walker counters the quotidian myths that continue to naturalize the outrageous acts underpinning US national consolidation, productively alienating us from well-worn narratives of national origin. Collapsing Spillers's conceit that slavery is *like* a myth, Walker presents racial slavery *as* myth.

As a commodity-come-to-life, the cotton baby reverses the principle of chattel slavery. The absurdity of the animate commodity is signaled by its genesis in another unnatural event: male pregnancy. Forwarding a tongue-in-cheek commentary on both "slave labor" and the "founding fathers," Walker presents King Cotton (who begins as a cotton baby) as the product of black and white male paternity. As in all of Walker's work, the calculus between desire and coercion is presented ambivalently, though the exploitative aspects of the encounter are suggested by the enslaved man's exclamation to the midwife during the pains of childbirth: "Massa Knocked me up!" This specter of male pregnancy challenges the cornerstone of slave law—*partus sequitur ventrum*, meaning, the child follows the condition of the mother—in which the master's sexual exploitation of enslaved women is enshrined, making sexual abuse not only legally sanctioned, but financially advantageous for the master as any children issuing from such exploitative encounters increase his property and are cast out of protected patrilineal structures of inheritance. While the logic of racial slavery maintains that there is nothing deviant about the master exerting his rights over his property, for Walker to rewrite this foundational scene of exploitation insists on the aspects of sexual desire and violence that cannot be rationalized or contained. Moreover, by representing what has been deemed abnormal or deviant sexual behavior as central to the constitution of the social and economic fabric of the United States, Walker harnesses the radical potential of sexuality to unsettle received historiographies of slavery as reducible to a relationship of economic exploitation.[9] The relationship between the male slave and his master extends the logic of racial slavery—and particularly its stance on miscegenation—to its breaking point.[10] In Walker's account, the individual and the national subject, as well as the sexual deviant and the racial subject, spring from the same source.[11]

While the sexual encounter between the enslaved man and the master functions allegorically, the systemic abuse of black women is addressed in far more internal (and personal) terms. The most haunting episode in *8 Possible Beginnings* is part 6, "A Darkey Hymn," which Vivien Fryd observes "differs from the others because of its refusal to provide humour, ambiguity, or consensual sexual encounters."[12] As a kind of interchapter disconnected from

the film's central narrative, the scene suggests the imminent rape of a young, enslaved girl by her master. It is decidedly non-allegorical and eschews obviously fantastic elements that animate the film's other parts, instead relying on darkness and sound to convey the trauma at the center of our national myth. Here, the maternal is rendered as neither as myth nor spectacle. Walker refuses to animate the routine violence against enslaved women that was hidden in plain sight or mobilized as spectacle in the service of abolition; however, she uses herself and her daughter to emphasize the ways that it continues to impinge on the present moment, injecting a sense of concrete historical time to counter the timelessness constitutive of myth.

Depicted with silhouette puppets against a minimal background, a young, black girl walks slowly, downcast, to the edge of a field; the master (the same silhouette puppet from the earlier scene) emerges from darkness on the left side of the screen, his hands reaching out threateningly as he pursues her. His body looming over her, they move deliberately, with the inevitability of history, toward the edge of the field. The girl stoops lower and lower to the ground to duck the master's reach, until, nearly at the field's edge, the screen goes dark for the final ten seconds of the scene.

Figure 12.2. "A Darkey Hymn," still from *8 Possible Beginnings*.
Artwork © Kara Walker, courtesy of Sikkema Jenkins & Co., New York.

Unlike the scene depicting sex between the enslaved man and his master, we do not see the sexual assault that is implied will follow. Walker withholds the spectacle of the girl's exploitation, refusing to offer up this traumatic moment in the service of anyone else's understanding or titillation. Instead, she conveys the nature of black women's trauma through a densely associational and suggestive web of audio that expresses the ongoing effects of enslaved women and girls' sexual abuse. Throughout the scene, the spiritual "All I Want" plays, the lyrics imploring, "All I want is more faith in Him. . . . Angel have mercy on this little child," overdubbed with Walker's and her own young daughter's voices articulating the vulnerable and confused tumult of the girl's inner monologue.[13] The song's dirge-like lamentation contrasts sharply with Walker and her daughter's matter-of-fact tones. Weaving over each other, repeating and converging, Walker and her daughter seem to be reading, asynchronously, from a script of the girl's stream of consciousness:

> I wonder how long it will last . . . I can't talk about it . . . Don't expect too much . . . A cross between a monkey and a bloodhound . . . I can't talk about it. Everything is good . . . I wish I weren't so short . . . I can't help but thinking . . . People scrutinize me . . . A cross between a monkey and a bloodhound . . . I expect nothing in return . . . I can't feel my toes . . . Very little works out in my life . . . I understand very little . . . I wish I weren't so short . . . People scrutinize me . . . Perfection is a godly thing . . . My momma is calling . . . I wish I were white . . . I understand very little . . . Perfection is a godly thing . . . Sometimes I pretend the world is upside down . . . I wish I were white . . . Sometimes I pretend the world is upside down . . . Maybe all this will drain away and I will disappear . . . I'll bet he wishes the same thing . . . Maybe all this will drain away and I will disappear . . . I wonder how wishes are made . . . I bet he wishes the same thing. I wonder how wishes are made . . . Next time everything will be right. Next time everything will be right . . . I want to say something. A pole cat hangs from a branch by its tail. I went hunting once. I had an itch, a little to one side. No, just down here. I wish I could get this thing off me. I can't stand this feeling . . . I hope and I pray . . . I guess this is how it always is . . . go with the flow . . . I think he is going to hurt me . . . I wonder what it will feel like . . . I guess this is what happened to Abby.

Both internal monologue and index of the external racism that the girl must metabolize, the scene registers racism's psychic—as well as physical and sexual—assault. The repetition and convergence of their words, combined with the striking intimacy of Walker using her and her daughter's own voices, intimate the ongoing effects of sexual abuse and express the transgenerational dimension to black women's sexual trauma, which reverberates into the artist's (and her daughter's) present.

The intimacy and interiority of the scene take shape against the distancing and alienation of the racial epithet in the chapter title, "A Darkey Hymn," a tension deepened by Walker's use of "All I Want" as the title hymn. While the traditional spiritual expresses a private crisis of faith, the version Walker selects for the film is the arrangement sung by the Hall Johnson Choir for Walt Disney's 1946 live-action animated musical film *Song of the South*. In the same way Walker's 2014 blockbuster public art piece "A Subtlety, or *The Marvelous Sugar Baby*, an Homage to the unpaid and overworked Artisans who have re-fined our Sweet tastes from the cane fields to the Kitchens of the New World on the Occasion of the demolition of the Domino Sugar Refining Plant" was cre-ated for a particular place and time—an appropriation of the master's tools—*8 Possible Beginnings* was produced for an exhibit at REDCAT, the Roy and Edna Disney Cal/Arts Theater, and constitutes a caustic comment on Disney's gaily racist film. Thus we come to understand that what might at first appear to be a deeply personal account of transgenerational trauma is actually mediated through a series of referential relays: *Song of the South* is an adaptation of the Uncle Remus stories, themselves adapted by Joel Chandler Harris. The bound-ary between internal and external is blurred.[14] Walker's use of "All I Want" re-centers the sexual abuse of enslaved women and girls as the cultural and material substrate for the vision of plantation life exported in *Song of the South*.

In the film's final part, "Story of Brer Rabbit, Brer Fox, and how Briar Patch County came to be called that," Walker further ironizes *Song of the South* and the Uncle Remus stories to indict the exploitative relationship between artist/storyteller and viewer/consumer. In it, a young white boy, "'Lil Timmy," sits at the foot of Uncle Remus on a porch, pleading, "Tell me one of your long tales Uncle Remus, Pleeese." Uncle Remus answers that he "feels mighty wore out today." Not taking no for an answer, 'Lil Timmy cries, "I'll tell Miss Sally if you don't open your mouth and . . . and you old coon! I own you you dirty prick!" Walker, who has been barely noticeable manipulating the shadow puppets throughout the film, is most visible in this part. The coercive relationship underwriting the black man's storytelling is linked, through its representation as a sexual encounter, to the foundational scene of sex between slave and master as well as to Walker's own position as a black creator satisfying the demands of her white viewers. 'Lil Timmy sits on Uncle Remus's lap and grinds away while Uncle Remus tells the story of how Briar Patch County used to be known as Dead Nigger Gulch. The animated interchapters show a fox and a rabbit stringing a black man with multiple penises on the cotton tree until he stops moving. In this complicated story within a story within a story, Walker presents so-called black art—and specifically stories exposing racial violence—as titillating to white audiences and ultimately destructive to the artist.[15]

Writing about Walker's earlier tableaux, Darby English observes that "one hears a great deal about art that lures onlookers into fantasy scenarios; Walker's tableaux, however, derive their power from the elements of reality that obtain in them if thinly. . . . [Walker] reveals fixed images of slavery as supplying a discourse of 'race relations' with an anachronous underlying order and a poignant lack of historical specificity."[16] *8 Possible Beginnings* operates in the same register, but takes this earlier proposition further. Troubling the line between fantasy and reality through her explicit project of myth-making, Walker reveals fantasy's real power to annihilate. The mythic story of the cotton baby which develops into the lynching tree—mediated through Uncle Remus's tale—both reveals the ideological work of sanitization and situates that work as inextricable from the commodity culture it supports. Walker exploits the "poignant lack of historical specificity" which is a hallmark of myth to force an acknowledgement of racial slavery's violent and specific exploitations. Putting our received myths in tension with fantastic scenarios, Walker enables us to see what has been occluded. In so doing she makes history strange enough to see the brutality of our origins.

Art—and Walker's role as an artist—is both implicated in and the victim of the dominant power relationships driving US political economy. Rendering the artist's role as animator as analogous to the enslaved father in the film who gives life to the cotton baby, Walker uses a scatological metaphor of birth to describe her work as well, writing, "One theme in my artwork is the idea that a Black subject in the present tense is a container for specific pathologies from the past and is continually growing and feeding off those maladies. . . . [M]urky, toxic waters become the amniotic fluid of a potentially new and difficult birth, flushing out of a coherent and stubborn body long-held fears and suspicions."[17] However, once she gives birth, Walker, like the slave father, does not have control over her production. The impish cotton baby grows into the lynching tree. Walker's work identifies, but cannot fully control or inoculate against, the workings of racial terror.

In her essay "Mama's Baby, Papa's Maybe: An American Grammar Book," whose title is adapted for the title of this essay, Spillers reflects on what it means to be a "marked woman," to occupy a body whose visual appearance has been made into a surfeit of meanings, sexual and racial identifications that locate her socially and become a "metonymic figure for an entire repertoire of human and social arrangements."[18] She opens the essay by invoking the many names black women are called, such as "Sapphire" and "Peaches," which she sarcastically deems the "national treasure of rhetorical wealth," noting, "My country needs me, and if I were not here, I would have to be invented."[19] Nearly twenty years later, Walker enacts a similar project. Echoing Spillers's

sarcasm, we might deem Walker's work an engagement with the "national treasure of iconographic wealth." Building on her earlier silhouette work, Walker recalls and repurposes racist iconography in *8 Possible Beginnings* in order to dismantle the surplus of images that attempt to colonize the psyche of the enslaved girl at the film's center, the putative ancestor of Walker and her daughter who, at least filmically, inhabit her trauma. Walker's turn to invention counters the "layers of attenuated meanings"—what Spillers calls "markers so loaded with mythological prepossession"—which her silhouettes catalogue. In *8 Possible Beginnings* Walker shows how myths are made to both reveal the constitution of the racial body and to denaturalize the quotidian acts of exploitation that animate our history.

Pitched at the intersection between the material history of slavery and the ideological production of the mythical black body, Walker's invention of the cotton baby prefigures her mammy-as-sphinx, the massive sugar-coated centerpiece of "A Subtlety." Emerging at precisely the juncture between the material and the fantastic, Walker's mammy-sphinx and cotton babies elucidate the intimate relationship between hothouse economies of desire and the stark ledgers of commodity culture. Both figures frustrate the association between racial glyphs and the physical body, but the mammy-sphinx created a public sensation, while the cotton baby received relatively little notice.[20] Yet it is worth tracing Walker's figures of invention to this earlier moment. If we understand "A Subtlety" as New World eschatology—a melting, ephemeral production on the occasion of a defunct factory's imminent demolition—*8 Possible Beginnings* provides the corollary origin story, both works meditating on the inextricability of individual and national identity from the physically, sexually, and economically exploitative dynamics of racial slavery. Walker's "wispy elves of the American South, with cotton blossoms for heads and leafy black limbs" highlight the enduring, exploitative jouissance constitutive of the New World.[21]

Presented as both commodification and waste—a compound of racial subjection, sexual exploitation, and commodity fetishism—Walker's cotton babies constitute the contemporary residue of the psychosexual economy of slavery. As animated figures to which Walker gives life (again, the role of the artist is uncomfortably parallel to that of the slave father in the film), Walker's cotton babies challenge traditional historiographies of slavery as well as established representational and monetary economies of art. *8 Possible Beginnings* explores the ways material substrates come to life through conceptual turns of imagination. The artist's creation of the cotton baby occasions a meditation on invention and inventiveness itself—the origin of the cotton baby juxtaposed and imbricated with the invention of the cotton gin and the invention of "African America." Walker's inventiveness urges us to

ask us what is the relationship between flesh and myth? Between material and imagination? Between landscape and nation? What is beneath the "layers of attenuated meanings" that have accrued and been mistaken for hard kernels of historical fact?[22] And what is the potential for inventiveness to undo this particular historical order?

NOTES

1. On scale in Walker's tableaux see Darby English, *How to See a Work of Art in Total Darkness* (Cambridge: Massachusetts Institute of Technology Press, 2007), 96.

2. Christina Sharpe, *In the Wake: On Blackness and Being* (Durham, NC: Duke University Press, 2016), 9. While other critics have used this formulation—a "past that is not past"—most often in discussions of the Jewish Holocaust, Sharpe's usage in relation to being in the wake of racial slavery is particularly apt. Quoting Michel-Rolph Trouillot, Sharpe foregrounds *positionality* and therefore embodied experience: "In the wake, the past that is not past reappears, always, to rupture the present. *'The Past—or, more accurately, pastness—is a position. Thus, in no way can we identify the past as past.'* (Trouillot 1997, 15)."

3. Kara Walker, *8 Possible Beginnings; Or the Creation of African America. A Moving Picture by the Young, Self-taught Genius of the South Kara E. Walker*, 2005. 16mm film and video. 15:57 minutes. Sikkema Jenkins & Co., New York.

4. On advertising trade cards see Kyla Wazana Tompkins, *Racial Indigestion: Eating Bodies in the 19th Century* (New York: New York University Press, 2012). In her chapter "'What's De Use Talking 'Bout Dem 'Mendments'?: Trade Cards and Consumer Citizenship at the End of the Nineteenth Century," Tompkins writes, "As an early form of advertising, trade cards emerged in the late 1860s when chromolithography became cheap and relatively easy to produce on both the small and large scale. Slipped into shopping bags at grocery stores across the country, included in product packaging, and, most importantly, featured at the 1876 and 1893 expositions, the brightly colored imagery paired, as Jackson Lears has written, commercial products with 'fables of abundance,' including exotic and Orientalist imagery, scenes of idyllic domestic spaces, representations of mother goddesses, and other stereotypes of femininity, fecundity, and childhood," 149.

5. Lindon Barrett, "Mercantilism, U.S. Federalism, and the Market within Reason: The 'People' and the Conceptual Impossibility of Racial Blackness," in *Conditions of the Present: Selected Essays*, ed. Janet Neary (Durham, NC: Duke University Press, 2018), 327.

6. Barrett, 333–334.

7. Hortense Spillers, "'All the Things You Could Be by Now if Sigmund Freud's Wife Was Your Mother': Psychoanalysis and Race," in *Black, White, and In Color: Essays on American Literature and Culture* (Chicago: University of Chicago Press, 2003), 425.

8. Roland Barthes, *Mythologies*. Trans. by Annette Lavers (New York: Hill and Wang, 1957), 143. Hortense Spillers, "'All the Things You Could Be by Now if Sigmund Freud's Wife Was Your Mother': Psychoanalysis and Race," *Boundary 2*, 23.3 (Autumn, 1996): 75–141. For another account of the iconography of slavery as myth see Marcus Wood, *Blind Memory: Visual Representations of Slavery in England and America, 1780–1865* (New York: Routledge, 2000), 8.

9. On the imbrication of racial and sexual identity in the nineteenth century and, therefore, the radical potential of sexuality in African American cultural production see Aliyyah Abdur-Rahman, *Against the Closet: Black Political Longing and the Erotics of Race* (Durham, NC: Duke University Press, 2012).

10. On the relationship of same-sex desire and plantation culture as represented in twentieth-century plantation literature see Michael P. Bibler, *Cotton's Queer Relations: Same-Sex Intimacy and the Literature of the Southern Plantation, 1936–1968* (Charlottesville: University of Virginia Press, 2009).

11. On the simultaneous constitution of the individual and the national subject, see Barrett, "Mercantilism, U.S. Federalism, and the Market within Reason: The 'People' and the Conceptual Impossibility of Racial Blackness," in *Conditions of the Present: Selected Essays*, ed. Janet Neary (Durham, NC: Duke University Press, 2018), 320–351.

12. Fryd, 152.

13. "All I Want," traditional, new arrangement and lyrics by Ken Darby, performed by the Hall Johnson Choir, in *Song of the South* (Walt Disney), 1946. While Walker has given enough interviews that her voice is recognizable, I credit a *New York Times* review of Walker's 2007 retrospective at the Whitney ("Kara Walker: My Complement, My Enemy, My Oppressor, My Love," October 11, 2007–February 3, 2008) for the information that the girl's role in the film is voiced by Walker's daughter. Holland Cotter, "Black and White but Never Simple," *New York Times*, October 12, 2007.

14. On the concept of "blur" within art history, and its significance for understanding the fiction of the individual more generally, see Fred Moten, *Black and Blur* (Durham, NC: Duke University Press, 2017).

15. On the term "black art" see Darby English, *How to See a Work of Art in Total Darkness* (Cambridge: Massachusetts Institute of Technology Press, 2007). English writes that "in this country, [black artists are often overdetermined by "the idea of black culture,"] and black artists' work seldom serves as the basis of rigorous, object-based debate. Instead, it is almost uniformly generalized, endlessly summoned to prove its representativeness (or defend its lack of the same) and contracted to show-and-tell on behalf of an abstract and unchanging 'culture of origin,'" 7. Walker is aware of—and invested in—this conundrum and relishes in it, dwelling in the exploitative dynamics of black art in this piece and others.

16. English, 88.

17. Kara Walker, *After the Deluge* (New York: Rizzoli, 2007), 9.

18. Hortense Spillers, "Mama's Baby, Papa's Maybe: An American Grammar Book," *Diacritics* 17, no. 2, Culture and Countermemory: The American Connection (Summer 1987): 64–81, 66.

19. Spillers, "Mama's Baby, Papa's Maybe," 65.

20. Writing in the *New York Times*, Blake Gopnik called "A Subtlety" "one of the most substantial works of art to hit New York in years," "Fleeting Artworks, Melting Like Sugar: Kara Walker's Sphinx and the Tradition of Ephemeral Art," *New York Times*, July 11, 2014. For the critical reception of *8 Possible Beginnings* see Yasmil Raymond, "Maladies of Power: A Kara Walker Lexicon," in *Kara Walker: My Complement, My Enemy, My Oppressor, My Love*, ed. Philip Vergne (Minneapolis: Walker Art Center, 2007); Peter Erickson, "The Black Atlantic in the Twenty-First Century: Artistic Passages, Circulations, Revisions," *Nka* 24 (2009): 56–71; Riché Richardson, "Kara Walker's Old South and New Terrors," *Nka* 25 (2009): 48–59; Maggie Nelson, *The Art of Cruelty: A Reckoning* (New York: W. W. Norton and Co., 2011), 244–48; Rebecca Peabody, "The Art of Storytelling in Kara Walker's Film and Video," *Black Camera* 5, no. 1 (Fall 2013): 140–163; Vivien G. Fryd, "Bearing witness to the trauma of slavery in Kara Walker's videos: *Testimony, Eight Possible Beginnings*, and *I Was Transported*," in *Interrogating Trauma: Collective Suffering in Global Arts and Media*, ed. Mick Broderick and Antonio Traverso (New York: Routledge, 2013), 145–160.

21. Malik Gaines, "Kara Walker at REDCAT: *8 Possible Beginnings or the Creation of African-America*," *The Independent*, 1 December, 2005. http://www.independent-magazine.org

22. Hortense Spillers, "Mama's Baby, Papa's Maybe," 64–81, 65.

BIBLIOGRAPHY

Abdur-Rahman, Aliyyah I. *Against the Closet: Black Political Longing and the Erotics of Race*. Durham, NC: Duke University Press, 2012.

"All I Want," performed by the Hall Johnson Choir, new arrangement and lyrics by Ken Darby, in *Song of the South* (Walt Disney), 1946.

Barrett, Lindon. "Mercantilism, U.S. Federalism, and the Market within Reason: The 'People' and the Conceptual Impossibility of Racial Blackness." In *Conditions of the Present: Selected Essays*. Edited by Janet Neary. Durham, NC: Duke University Press, 2018.

Barthes, Roland. *Mythologies*. Translated by Annette Lavers. New York: Hill and Wang, 1957.

Bibler, Michael P. *Cotton's Queer Relations: Same-Sex Intimacy and the Literature of the Southern Plantation, 1936–1968*. Charlottesville: University of Virginia Press, 2009.

Cotter, Holland. "Black and White but Never Simple," *New York Times*. October 12, 2007.

English, Darby. *How to See a Work of Art in Total Darkness*. Cambridge: Massachusetts Institute of Technology Press, 2007.

Erickson, Peter. "The Black Atlantic in the Twenty-First Century: Artistic Passages, Circulations, Revisions." *Nka: Journal of Contemporary African Art* 24, no. 1 (2009): 56–71.

Fryd, Vivien Green. "Bearing witness to the trauma of slavery in Kara Walker's videos: *Testimony, Eight Possible Beginnings*, and *I Was Transported*." In *Interrogating Trauma: Collective Suffering in Global Arts and Media*. Edited by Mick Broderick and Antonio Traverso. New York: Routledge, 2013.

Gaines, Malik. "Kara Walker at REDCAT: *8 Possible Beginnings or the Creation of African-America*," *The Independent*, December 1, 2005. http://www.independent-magazine.org.

Gopnik, Blake. "Fleeting Artworks, Melting Like Sugar: Kara Walker's Sphinx and the Tradition of Ephemeral Art," *New York Times*, July 11, 2014.

Moten, Fred. *Black and Blur*. Durham, NC: Duke University Press, 2017.

Nelson, Maggie. *The Art of Cruelty: A Reckoning*. New York: W. W. Norton & Company, 2011.

Peabody, Rebecca. "The Art of Storytelling in Kara Walker's Film and Video." *Black Camera: An International Film Journal (The New Series)* 5, no. 1 (2013): 140–163.

Raymond, Yasmil. "Maladies of Power: A Kara Walker Lexicon." In *Kara Walker: My Complement, My Enemy, My Oppressor, My Love*. Edited by Philip Vergne. Minneapolis: Walker Art Center, 2007.

Richardson, Riché. "Kara Walker's Old South and New Terrors." *Nka: Journal of Contemporary African Art* 25, no. 1 (2009): 48–59.

Sharpe, Christina. *In the Wake: On Blackness and Being*. Durham, NC: Duke University Press, 2016.

Spillers, Hortense J. "'All the Things You Could Be by Now if Sigmund Freud's Wife Was Your Mother': Psychoanalysis and Race." In *Black, White, and In Color: Essays on American Literature and Culture*. Chicago: University of Chicago Press, 2003.

———. "Mama's Baby, Papa's Maybe: An American Grammar Book." *Diacritics* 17, no. 2 (1987): 65–81.

Tompkins, Kyla Wazana. *Racial Indigestion: Eating Bodies in the 19th Century*. New York: New York University Press, 2012.

Walker, Kara. *8 Possible Beginnings; Or the Creation of African America. A Moving Picture by the Young, Self-taught Genius of the South Kara E. Walker*, 2005. 16mm film and video. 15:57 minutes. Sikkema Jenkins & Co., New York.

———. *After the Deluge*. New York: Rizzoli, 2007.

Wood, Marcus. *Blind Memory: Visual Representations of Slavery in England and America, 1780–1865*. New York: Routledge, 2000.

Index

abolitionists: cartoons for, 105–22; debates on, 105–6; radical, 60–61, 192–93

An Account of the Arctic Regions (Scoresby), 38–41

Adams, John, 29–30

Adams, John Quincy, 107–8

Adorno, Theodor, 89

advertising trade cards, 209n4

Africa, 64

African Americans: Black self-expression, 184–85; freedom of, 56–57; Jefferson on, 25. *See also* Black feminism

African's [sic] March in Turkey (musical piece), 54–56, *55*; interpretation of, 65; military movement and, 63–68

Agassiz, Louis, 143–44

agrarian republicanism, 28–29

Aldrich, Elizabeth, 58–59

amalgamationists, 63

Amalgamation Polka (Clay, E.) (art), 58–63, *61*

Amalgamation Waltz (Clay, E.) (art), 58–63

American Anti-Slavery Society, 107–8

American Enlightenment, 20

American Geographical Society, 39–40

American Museum, 125–27

The American Phrenological Journal, 142–43

American Revolutionary War, 18, 80, 105

American Studies, 10n10

animals: in art, 27–28, 41–42, 45–46; Melville on, 46–47

animation. *See* cartoons

Anthony, Susan B., 183–84

Appiah, Anthony, 9

Appleby, Joyce, 30

architecture: analogies of, 34n14; comparisons of, 29–30; expression through, 28–29; interpretation of, 26; Jefferson on, 22–23; liberal subjectivity in, 29–30; neoclassicism, 80; octagonal, 26; prejudices in, 23–24; privacy through, 31; of Renaissance movement, 26; sensationalist theory in, 26; shapes in, 23–24

archives, 3; development of, 5; of slavery, 1–2; stereography, 90

Arctic exploration, 37–52

The Arctic Regions: Illustrated with Photographs Taken on an Art

213

About the Contributors

Kirsten Pai Buick is professor of art history at the University of New Mexico. Author of *Child of the Fire: Edmonia Lewis and the Problem of Art History's Black and Indian Subject*, she is currently at work on a study of Kara Walker.

Irene Cheng is associate professor of architecture at the California College of the Arts. Her current book in progress is called *The Shape of Utopia: Architectures of Radical Reform in Nineteenth-Century America*.

Martha J. Cutter is professor of English and Africana studies at the University of Connecticut. She is the author of three books: *Unruly Tongue: Language and Identity in American Women's Writing* (1998), *Lost and Found in Translation: Contemporary Ethnic American Writing and the Politics of Language Diversity* (2005), and *The Illustrated Slave: Empathy, Graphic Narrative, and the Visual Culture of the Transatlantic Abolition Movement, 1800–1852* (2017).

Brigitte Fielder is assistant professor of comparative literature at the University of Wisconsin–Madison. Her work has appeared in various journals and edited collections. Her first book, "Relative Races: Genealogies of Interracial Kinship in Nineteenth-Century America," will be published by Duke University Press. She is currently working on a second book, on overlapping discourses of race and species in the long nineteenth century.

Jennifer Greiman is associate professor of English at Wake Forest University and author of the book *Democracy's Spectacles: Sovereignty and Public Life in Antebellum America* (2010).

Wyn Kelley, senior lecturer in the literature section at the Massachusetts Institute of Technology, is author of *Melville's City: Literary and Urban Form in Nineteenth-Century New York* (1996) and of *Herman Melville: An Introduction* (2008). Editor of the *Blackwell Companion to Herman Melville* (2006), she has published essays in a number of journals and collections, including the *New Cambridge Companion to Herman Melville* (2013).

Kya Mangrum is assistant professor in the English Department at Westmont College. Her book in progress is titled *How Deep and Dark: Slavery, Photography, and the Limits of Narrative.*

Kelli Morgan, a recent Ph.D. in African American studies from the University of Massachusetts at Amherst, is now Associate Curator of American Art at the Indianapolis Museum of Art at Newfields.

Janet Neary is associate professor in English at Hunter College. Her recent book is titled *Fugitive Testimony: Race, Representation, and the Slave Narrative Form* (2016).

Shirley Samuels is professor of English and American studies at Cornell University. She is the author of *Facing America: Iconography and the Civil War* (2004), and *Romances of the Republic: Women, the Family, and Violence in the Literature of the Early American Nation* (1996). Samuels edited *The Culture of Sentiment: Race, Gender, and Sentimentality in Nineteenth Century America* (1992) and the *Companion to Abraham Lincoln* (2012).

Adena Spingarn received her Ph.D. from Harvard. Her book manuscript is titled *Uncle Tom in the American Imagination.*

Cheryl Spinner is Professional Track Faculty in the English Department at the University of Maryland, College Park. She holds a doctorate in English and a certificate in Feminist Studies from Duke University. Her current book project *Debunk Me Not: The Birth of Pseudoscience and the Death of Magic* explores the communities at the margins of normative science whose supernatural belief systems were written out of Western modernity's project of secularization in the nineteenth and early twentieth centuries.

Christine Yao has a book forthcoming from Duke University Press titled *Disaffected: The Cultural Politics of Unfeeling in Nineteenth-Century America.* She is a lecturer in English at University College London.

CPSIA information can be obtained
at www.ICGtesting.com
Printed in the USA
LVHW081912120221
679185LV00004B/46